Emblems of
AMERICAN
COMMUNITY
in the Revolutionary Era

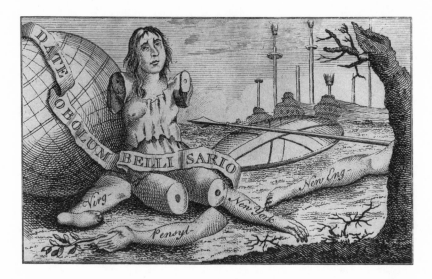

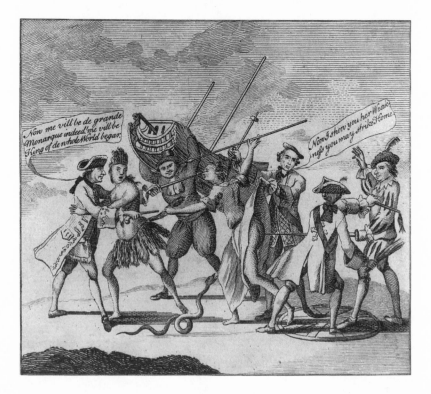

Emblems of
AMERICAN
COMMUNITY
in the Revolutionary Era

A Study in Rhetorical Iconology

LESTER C. OLSON

Smithsonian Institution Press · *Washington and London*

Frontispiece. *"The Colonies Reduced"* and *"Its Companion,"*
Political Register 3 (December 1768): frontispiece. Medium:
magazine; size: 3 7/8" × 2 3/8" and 3 7/8" × 3 1/2", respectively.
Photograph courtesy of the Library of Congress.

© 1991 by the Smithsonian Institution
All rights reserved

Editor: Jan McInroy
Production Editor: Duke Johns
Designer: Linda McKnight

Library of Congress Cataloging-in-Publication Data
Olson, Lester C.
 Emblems of American community in the revolutionary
era: a study in rhetorical iconology / by Lester C. Olson.
 p. cm.
 Includes bibliographical references and index.
 ISBN 1-560-98066-4
 1. Emblems—United States — History — 18th
century. 2. United States—History—Revolution, 1775–
1783—Art and the revolution. I. Title.
 CR69.U6038 1991
 704.9'46'0973—dc20 90-24923

British Library Cataloguing-in-Publication Data is available

Manufactured in the United States of America
98 97 96 95 94 93 92 91 5 4 3 2 1

⊗ The paper used in this publication meets the minimum
requirements of the American National Standard for
Permanence of Paper for Printed Library Materials
Z39.48-1984

For permission to reproduce illustrations appearing in this
book, please correspond directly with the owners of the
works, as listed in the individual captions. The Smithsonian
Institution Press does not retain reproduction rights for these
illustrations individually, or maintain a file of addresses for
photo sources.

To Keith Allen Rosemore

CONTENTS

ix ILLUSTRATIONS

xiii PREFACE

xix ACKNOWLEDGMENTS

1 INTRODUCTION

4 The Power of the Media during the Eighteenth Century
14 The Underlying Rhetorical Structure of the Images

21 1. THE COLONIES ARE A SNAKE

24 The Image of the Snake in America
57 The Image of the Snake in Britain
71 Conclusion

75 2. THE COLONIES ARE AN INDIAN

79 The Image of the Indian in Britain
103 The Image of the Indian in America
119 Conclusion

125 3. THE COLONIES ARE A CHILD

133 The Image of the Child in Britain
164 The Image of the Child in America
192 Conclusion

201 4. UNCOMMON IMAGES OF THE COLONIES

203 The Colonies Are a Part of the British Empire
209 The Colonies Are Distinct and United
219 The Colonies Are the Limbs or the Child of Britannia
225 The Colonies Are a Neoclassical God or Goddess
236 The Colonies Are an Indian or a Rattlesnake
238 The Colonies Are Animals
251 Conclusion

257 NOTES

293 INDEX

ILLUSTRATIONS

FRONTISPIECE

"The Colonies Reduced" and *"Its Companion"*

FOLLOWING PAGE 42

1. "JOIN OR DIE," in the *Massachusetts Spy Or, Thomas's Boston Journal*
2. "The wicked Statesman, or the Traitor to his Country at the Hour of DEATH," in the *Massachusetts Calendar*
3. "JOIN, or DIE," in the *Pennsylvania Gazette*
4. "Se rejoindre ou mourir," in *Livre curieux*
5. "JOIN or DIE," in the *Boston Gazette*
6. "[Ornament]," in *A Collection of Designs in Architecture*
7. "TWENTY SPANISH MILLED DOLLARS"
8. "FIFTEEN POUNDS *Currency*"
9. "State of Massachusetts Bay. Received of *Nathanael Baker* the Sum of *thirty pounds ten shillings*"
10. "THE PROVIDENTIAL DETECTION"
11. "COMMODORE HOPKINS, *COMMANDER in* CHIEF *of the* AMERICAN FLEET"
12. *Benjamin Franklin*
13. *"The* BRITISH LION *engaging* FOUR POWERS"
14. "Lord Chatham and America"
15. "America," in *A Collection of Emblematical Figures*
16. *"The able Doctor, or America Swallowing the Bitter Draught,"* in *The London Magazine*
17. "The COURT COTILLION, Or the Premïers new Parl + + + + + t Jig"
18. "[*When fell Debate & civil Wars shall cease*]"
19. *"The Parricide. A Sketch of Modern Patriotism"*

ILLUSTRATIONS

FOLLOWING PAGE 138

20. *"Bunkers hill, or the blessed effects of Family quarrels"*

21. "[America to her Mistaken Mother]"

22. "THE PRESENT STATE OF GREAT BRITAIN"

23. *"A Picturesque View of the State of the Nation for February 1778"*

24. "BRITANNIA PROTECTED *from the* *Terrors of an* INVASION" or "*A loud-crying Woman & a Scold shall be sought out to drive away the Enemies*"

25. "THE ENGLISH LION DISMEMBER'D *Or the Voice of the Public for an Enquiry into the Public Expenditure*"

26. "Die Wage der Macht" or "*La balance de la puissance*"

27. *"The* HORRORS *of* WAR *a* VISION *Or a Scene in the Tragedy of K: Rich[ar]d: 3"*

28. "The General P--s, or Peace"

29. "The SAVAGES *let loose,* OR The *Cruel* FATE *of the* LOYALISTS"

30. "[Hommage de l'Amérique à la France]"

31. "L'ANGLETERRE SUPPLIANTE"

32. "THE DEPLORABLE STATE of AMERICA or SC--H GOVERNMENT"

33. "[*The able Doctor, or America Swallowing the Bitter Draught*]," FREEBETTER'S NEW-ENGLAND *ALMANACK, for the Year 1776*

34. *"THE* FEMALE COMBATANTS"

35. *"Poor old England endeavoring to reclaim his wicked American Children"*

36. *Libertas Americana*

37. "[American Medals]"

FOLLOWING PAGE 234

38. "MAGNA *Britannia: her Colonies* REDUC'D"

39. "BRITTANNIA MUTILATED. *or the Horrid (but true) Picture of Great Brittain. when Depriv'd of her Limbs.* BY HER ENEMIES"

40. "STATE COOKS, or THE DOWNFALL of the FISH KETTLE"

41. "THE CURIOUS ZEBRA. *alive from America! walk in Gem'men and Ladies, walk in*"

42. New York's "FIVE DOLLARS" Note

43. "One Third of a DOLLAR" and "Two Thirds of a DOLLAR"

44. "SIX MEDALLIONS shewing the chief national servises of his new Friends the old ministry"

45. "AMERICA *in* FLAMES"

46. "AMERICA. To Perpetuate to Posterity the Memory of those Patriotic Heroes, who Fought, Bled, & Died"

47. "[The Arms of the United States]"

48. "[Britannia Attacked by her Enemies]"

49. "The Apotheosis of George Washington and Benjamin Franklin"

50. "AMERICA TRIUMPHANT and BRITANNIA in DISTRESS"

51. "*REDEUNT SATURNIA REGNA*"

52. "*REDEUNT SATURNIA REGNA. On the erection of the Eleventh PILLAR of the great national DOME*"

53. "The GREAT PALLADIUM of our happy land"

54. "THE WISE MEN *of* GOTHAM *and their* GOOSE"

55. "LES POULLES AUX GUINEES. L'Avarice perd tout en voulant tout gagner"

56. "*THE HORSE* AMERICA, *throwing his Master*"

PREFACE

This book had its inception in the form of a question. I wanted to know why the images of the snake that designated the British colonies in America had proved so immensely popular throughout America during the eighteenth century. To those familiar with the Judeo-Christian tradition, the image of the snake ought to have had connotations of wickedness, yet here was a predominantly Christian culture that seemed to welcome the image as a representation of themselves. To answer this question, I recognized that it would be necessary to compile a list of visual messages wherein the American colonies had been represented as a snake. In the course of compiling the list, I found that the scope of my inquiry broadened, and I began to understand the magnitude of the study before me.

I learned that the image of the snake was only one of many motifs that recurred during the eighteenth century to designate those colonies that became the United States. Commonplace images depicted the colonies as a snake, an Indian, and a child, while less common images portrayed them as a neoclassical goddess, an eagle, a beast of burden, and an exotic animal. Still other images were used rarely—sometimes only once or twice—to designate the colonies: a zebra, a horse, a cow, a yelping dog, a buffalo, a kettle of fish, and the goose that laid golden eggs, to name a few. During the two decades between the Stamp Act controversy and the conclusion of the American Revolution, nearly four hundred such visual messages were produced and distributed in America, France, and Britain. The images appeared in currency, medals, paintings, statues, flags, drums, powder horns, illuminated displays, textiles, housewares, and, above all, illustrations in magazines, pamphlets, almanacs, newspapers, and broadsides.

Yet, apart from the commendable surveys and catalogs for particular types of visual messages—such as Herbert M. Atherton's *Political Prints in the Age of Hogarth: A Study of the Ideographic Representation of Politics* and

Mary Dorothy George's *Catalogue of Political and Personal Satires Preserved in the British Museum*—these visual messages had not been systematically studied by a student of art history, rhetoric, or American studies. There was nothing on the role of such messages in the constitution and transformation of the body politic, despite the fact that, as visual media, they had the power to reach not only the literate but also the illiterate and semiliterate segments of the populace, a power that the written word simply lacked. Here was an opportunity to study how images of the body politic were employed in Britain and America to suggest the attributes and actions of the emerging nation.

To be sure, some of the images were calculated to communicate with the learned and the affluent members of the society, to the exclusion of the uneducated or less fortunate. The emblematic devices, for example, often combined a pictorial image with a Latin motto. Heraldry, too, was a strong example of this technique, being a highly specialized tradition of symbolism with underlying rules dating back to the Middle Ages. Further, the impoverished or illiterate had little access to the delicate porcelain statues and fine tapestries of the period. But most of the pictorial messages included in this study were distributed widely among all ranks of people: designs on paper and metal currency, military flags, and especially political cartoons, which were posted in pubs, shop windows, and coffeehouses.

Emblems of American Community contributes to the existing scholarship on art history, rhetoric, and American studies, not simply by identifying and describing almost four hundred pictorial images representing America between 1754 and 1784 but also, more importantly, by studying the role of these images in British and American cultures. During the Revolutionary era, all political factions in Britain and America resorted to visual symbolism to communicate their ideas about the nature of American unity. Literate members of the society carried on public debates about the meanings and the political import of the various pictorial images representing America, and they recorded their ideas in the newspaper, magazine, and pamphlet literature. These debates enable us to understand how the literate segments of the population interpreted the images used to represent America.

In addition, statistical analysis of the attributes of the motifs can provide a basis for inferences about the messages conveyed to other segments of the populace. For instance, the image of America as an Indian was

usually a female, but during the war the Indian was often male. Between 1765 and 1777, only four of twenty-two British prints portrayed the Indian representing America as a man, roughly 18 percent. In contrast, between 1777 and 1783, after the outbreak of military violence, twenty-two of forty-three British prints portrayed the Indian as a man, roughly 51 percent and almost triple that of the previous decade. This change in the attribute of the motif corresponded not only to an increase in military aggressiveness during the war but also to the changing political stature of the emerging nation in light of patriarchal beliefs and values.

Several historical and cultural studies have investigated ideology during the American Revolution, since Bernard Bailyn of Harvard University published his classic study, *The Ideological Origins of the American Revolution*, in 1967. Among these are helpful studies by Janice Potter, Linda Kerber, Jay Fliegelman, Edwin Burrows and Michael Wallace, Melvin Yazawa, and A. Owen Aldridge. Such works have based their claims upon the written documents of the period—pamphlets, newspapers, broadsides, magazines, letters, and diaries. Bailyn, for example, examined the pamphlet literature to support his contention that a mutual fear of conspiracy in England and America was the most fundamental cause of the Revolution. While such studies of ideology have shed considerable light on the thought of literate populations during the Revolutionary era, they have ignored the illiterate and semiliterate populations.[1]

Emblems of American Community has extended and revised scholarship on ideology by studying the pictorial messages of the Revolutionary era. It concludes that all major motifs of the period displayed pervasive concerns about whether Americans held the same status as the English. To judge from the pictorial record, these concerns were as fundamental in Britain and America as any apprehensions of conspiracy. During the Revolution, the image of America's stature was redefined in that the child attained adulthood, the Indian broke his chains and escaped servitude, and the rattlesnake struggled with the British lion and survived.

Historians of the eighteenth century have endorsed a view of the image as predominantly emotional, transformative, and at times subversive, as did Mary Dorothy George in her admirable volume, *English Political Caricature to 1792: A Study of Opinion and Propaganda*, when she observed, "All political caricature tends to be radical, oppositionist, disruptive. In

the eighteenth century, the bias against authority was more extreme." Although I am less willing than former generations of scholars to judge these materials to be propaganda (because "propaganda" may suggest an element of calculated detachment), the English and the Americans did often design pictorial images to influence belief and action during the Revolutionary era because such images were an efficient way to reach diverse segments of the populace. As Philip G. Davidson observed in *Propaganda and the American Revolution, 1763–1783*, "The vehicle of the suggestion is almost as important as the suggestion itself. Appeals may be roughly divided into two types—dramatic, oral, and pictorial, reaching the literate and illiterate alike, and written, reaching directly only the literate. The choice depends upon the group to be reached and the opportunities for reaching it."[2]

Emblems of American Community focuses upon images of the body politic throughout the inception, constitution, and transformation of the emerging nation during the Revolutionary era—one of the most dynamic periods in America's past. It investigates the political significance of the visual arts by synthesizing methodologies from the disciplines of art history, rhetoric, and American studies. Iconology, or the study of visual representation, has been defined in various ways, but those definitions share a common etymology. "To begin with the explanation of the term Iconology," wrote George Richardson in 1777–79, "it is derived from two Greek words, which signify speaking pictures or discourse of images." Rhetorical iconology emphasizes that such speaking pictures may be used in endeavors to influence a people to feel, believe, or act in desired ways. At the heart of rhetorical iconology are the ambiguities of appeals for agreement among people whose interests, concerns, values, feelings, and expectations may be in conflict.[3]

Although the rhetorical tradition originates in the study of public speeches about civic matters, *Emblems of American Community* illustrates how concepts from the rhetorical tradition can illuminate pictorial persuasion and thereby contributes to a growing body of literature that explores the interdisciplinary value of the intellectual traditions devoted to the study of rhetoric. The research for this book complements the existing scholarship on the verbal rhetoric of the American Revolution by investigating the visual rhetoric of the period. Several scholars, among them Stephen E. Lucas, James R. Andrews, and Ronald F. Reid, have investigated the

rhetorical use of verbal messages during the Revolutionary era, but the rhetorical use of visual messages during the period has remained to be studied by scholars of rhetoric. Herein lies one of the principal contributions of this book.[4]

Rhetorical iconology has many affinities with a body of research devoted to the study of material culture, an approach to historical research that regards the materials of everyday life as valuable evidence of the underlying beliefs of a society. As Jules Prown has observed, "The underlying premise is that objects made or modified by humans reflect, consciously or unconsciously, directly or indirectly, the beliefs of individuals who made, commissioned, purchased, or used them, and by extension the beliefs of the larger society to which they belonged." Material culture provides a means by which to study illiterate segments of a society, groups of individuals who did not leave written records, and predominantly oral cultures.[5]

Thomas J. Schlereth has given eloquent expression to my own convictions about the value of such scholarship: "In order to redress the historical inequity of ignoring a large segment of the population who produced no literary legacy, scholars have therefore turned to studying, to use Leland Ferguson's felicitous phrase, 'the things they left behind.' "[6] Studies in material culture focus upon vernacular artifacts, not as objects to be appreciated only for their aesthetic qualities but as symbolic "texts" produced within a cultural milieu, as Robert Blair St. George and Simon J. Bronner have observed. Unfortunately, studies in material culture have not drawn upon methods of rhetorical interpretation that could enable us to research the relationship between the persuasive objectives of the makers and the perspectives of the audiences.[7]

Emblems of American Community explores a connection between motif and motive. It reveals how each repetitive image promoted a corresponding political orientation. Motif and motive have a common etymology. The words "motive" and "motif" were formed from the past participle form, *motus*, of the Latin verb *movere*, which may be translated "to move," a central image in treatises about rhetoric throughout the centuries. The images used to represent the united British colonies in America as a snake, an Indian, and a child were motifs in the technical sense that each of them was an element that recurred in the visual messages produced and distrib-

uted in America, France, and Britain. Precisely because these were the most commonplace images for the British colonies in America, they were the dominant visual images of the emerging nation. Their widespread distribution on the mundane objects of the period indicated that they embodied dominant motives in the formation of an American community.[8]

I have followed fairly standard conventions in transcribing the eighteenth-century texts, retaining the original spelling, capitalization, punctuation, and italics. I have not employed "[*sic*]" in this book; whenever a word, phrase, or sentence appears within quotation marks, the reader may assume that the spelling, punctuation, and grammar have been double-checked for accuracy and reflect the form of expression in the original text.

I have used brackets to serve numerous functions. First, I have placed them around a title of a work to indicate that a formal title is not imprinted on the document itself. In some cases, I have supplied a title based upon a first line of verse written on the print itself (e.g., "[*When fell Debate & civil Wars shall cease*]"), the title of another print with a very similar design (e.g., "[*The able Doctor, or America Swallowing the Bitter Draught*]" on an almanac that did not specify this title from the earlier versions of this print), or the title conventionally employed by historians and critics to identify the document (e.g., "[The Arms of the United States]"). Second, I have used brackets to indicate where I am supplying a missing letter or letters, as for example when a print refers to "C–nw–y" [Conway] or "McRea" [McCrea]. Third, I use brackets when a document refers to an abbreviated form of a word, such as "Parlmt" for "Parliament," which I render as "[Parliament]." Fourth, as a matter of style, I have placed brackets around the names of the eighteenth-century authors *only* in the notes to identify those attributions that are based upon information other than that imprinted on the document itself. This is less cumbersome than always writing "attributed to" in the text itself, since the vast majority of the documents were anonymous during their original distribution.

ACKNOWLEDGMENTS

The preliminary research for this book was supported by fellowships from the University of Wisconsin–Madison: a Knapp Fellowship for 1983–84, a Vilas Foreign Travel Fellowship to conduct research at the British Museum and Library during 1984, and a Domestic Travel Fellowship to study at various institutions on the East Coast during 1983–84. The University of Pittsburgh supported subsequent research through grants and fellowships from the International Exchange Foundation, the Office of Research Development, and the Faculty of Arts and Sciences Grants Committee during the summers of 1985, 1986, and 1987. The National Endowment for the Humanities, the American Council of Learned Societies, and the Speech Communication Association have supported the project through travel grants and national awards, among them the Dissertation Award for 1985 and the Karl Wallace Award for 1986. I am grateful to these institutions for their confidence in the merit of the project.

I want to thank the organizations that provided a forum for ongoing scholarly conversations and the participants for their questions and suggestions. I presented research for this book at the conferences of the International Society for the History of Rhetoric when we convened at Oxford in 1985 and at Tours in 1987. I also presented the preliminary research at the conferences of the American Studies Association, the Speech Communication Association, the Eastern Communication Association, the Western Speech Communication Association, the Canadian Society for the History of Rhetoric, the American Society for Eighteenth-Century Studies, and the International Visual Communication Conference.

I should like to thank the librarians, curators, and archivists who welcomed me to their institutions and allowed me to examine the materials in their care. These institutions in Britain, France, and America have allowed me to study their holdings and have granted permission to describe,

quote, or reproduce photographs of materials from their collections: the A. S. Alexander Library, the American Antiquarian Society, the American Philosophical Society, the Archives Nationale (Paris), the Bibliothèque Nationale (Paris), the Boston Public Library, the British Library, the British Museum, the Colonial Williamsburg Foundation, the Connecticut Historical Society, the Henry Francis duPont Winterthur Museum, the Historical Society of Pennsylvania, the John Carter Brown Library, the John Hay Library, the Library Company of Philadelphia, the Library of Congress, the Massachusetts Historical Society, the Metropolitan Museum of New York, the Musée des Arts Décoratifs, the Musée Nationale de la Coopération Franco-Américaine à Blérancourt, the National Archives, the New-York Historical Society, the New York Public Library, the Public Record Office (Kew and London), the Scottish Record Office, the Smithsonian Institution, the Victoria & Albert Museum, the Virginia Historical Society, the Wedgwood Museum, and Yale University Press.

Edwin Black, whose support has been generous and unwavering throughout the development of this project, has offered many suggestions of great value. Michael C. Leff has done much to improve the quality of my critical thinking and to gladden my spirits during the years of our association. For the many stimulating conversations we have shared, especially those concerning the topic of metaphor, I am indebted. I appreciate assistance from Donald Crawford, Stephen Lucas, and Emiko Ohnuki-Tierney, who generously gave their time to discuss historical and technical aspects of this project.

Welcome assistance has been offered by my friends and colleagues— Valerie Lucas, Nancy Dunbar, Lori Taft, Hilary Radner, and Gary Chappell—who secured necessary information, provided helpful references and advice, read drafts for grant proposals, and made my travels more enjoyable. Edwin Black, Michael Leff, Thomas Benson, Thomas Kane, and Herbert Rubin wrote letters on behalf of the project to various funding agencies. The chairs in the Department of Communication at the University of Pittsburgh, Thomas Kane and Herbert Rubin, provided resources to facilitate my scholarship. Van Beck Hall, Al K. DeRoy, Daniel Russell, and Joseph Neville provided useful advice on writing grant proposals. Katheryn Linduff and Kathy McLauphlin gave insightful answers to my questions about the process of publishing a book.

ACKNOWLEDGMENTS

I want to thank Wilcomb Washburn for suggesting the Smithsonian Institution Press and Daniel Goodwin for guiding me through the review process in a congenial, supportive, and efficient manner. Devona Colston answered a number of queries and helped me to select the illustrations. Jan McInroy, the copy editor, provided invaluable assistance in making the manuscript clear, consistent, and concise. I am grateful too to Aida Donald, the editor-in-chief at Harvard University Press, who in her own way lent her editorial expertise to this project.

Keith Rosemore and Diane Dowdey have both read the entire manuscript and offered many insightful suggestions. I remain indebted to them for their kindness and candid criticisms throughout the years. Above all, I would like to thank my parents, Donald and Helen Olson, who aroused my curiosity about vernacular artifacts. When we lived together in rural Minnesota, they gave me the time to devote to my education throughout those years when they could have made more use of my assistance.

To others who have helped through their scholarship, correspondence, or conversations, thank you.

INTRODUCTION

For when any number of Men, have by the consent of every individual, made a Community, they have thereby made that Community one Body, with a power to act as one Body, which is only by the will and determination of the majority. For that which acts any Community, being only the consent of the individuals of it, and it being one Body must move one way; it is necessary the Body should move that way whither the greater force carries it, which is the consent of the majority: or else it is impossible it should act or continue one Body, one Community.

—JOHN LOCKE, *TWO TREATISES*

The life of the body politic could be brought into being only by the consent of the majority within a community, according to John Locke, the most frequently quoted philosopher in Britain and America throughout the Revolutionary era. To Locke, the body politic—its moment of inception—could be created only by the joining of wills within a community to protect mutual interests and to achieve mutual aspirations. The life of the body politic could be sustained only through the individual's continued compliance with the will of the majority, because it was vital that the community be enabled to act decisively for its own military defense and the internal regulation of resources. If significant numbers of individuals fought over fundamental issues within the community, the body politic could die.

During the two decades before the American Revolution—before a single shot was fired at Lexington and Concord, even before the political issues became so divisive that the conflict within the British empire became irreconcilable—pictorial images that designated the British colonies in America as a body politic were distributed widely in Britain, France, and America in a wide variety of forms. These images, which represented the British colonies in America as a snake, an Indian, and a child, differed from earlier representations of the American colonies in that they neither depicted each colony as a discrete entity nor depicted the colonies as a part of a larger entity, the British empire. Rather, the images portrayed the British colonies in America as a singular body politic, as a united community that was distinct from the rest of the empire. As such, these images constituted the earliest visual expressions of a belief that an incipient identity existed among those colonies, which became the United States.

It was not the first time that images of the body politic had undergone change in anticipation of controversies about the organization of the British empire. During the sixteenth century, for example, images that designated the Catholic church as a body politic had been the subject of dispute throughout the conflicts in Britain that culminated in the establishment of the Church of England. Yet again, during the seventeenth century, images that designated England as a body politic had been the subject of controversy throughout the decades before the English civil war. But this time, the images of the body politic suggested not merely the modification of the British empire's religious and political organization but rather the complete separation of one part of the British empire from the other. This time the images of the body politic anticipated the emergence of a new nation.[1]

And yet these images were not nationalistic, if nationalism is taken to mean a conscious or deliberate aspiration to establish an independent country. The images representing the colonies originated long before any widespread desire among the colonists for a separation from Britain. Furthermore, most of the images originated in Britain and continental Europe, not in America, because the major centers of political power and artistic production were in London and Paris. Rather, these images were emblems of an emerging, though inchoate, sense of American community: They expressed a recognition of mutual interests, concerns, and values among the colonies throughout the American Revolution.[2]

Each of the commonplace motifs—the snake, the Indian, and the child—was especially useful to promote a corresponding political orientation, even though each evoked multiple meanings throughout the period. The word "conservative" poses special problems when used to describe political commitments during the Revolution, because each of the major factions was attempting to conserve certain political traditions. In one sense, those who ultimately favored national independence sought to conserve fundamental rights that they believed were guaranteed by the British constitution. To these people, separation from the British empire became necessary to protect American rights from continual infringements by a corrupt British ministry. From the concern during the Stamp Act controversy over taxation without representation to the concerns during the Intolerable Acts over the alteration of the colonial charters and the vindictive handling of Boston, these people saw themselves as protecting cherished constitutional rights. Yet "conservative" may also be used in another sense. Those who ultimately favored keeping America within the British empire were attempting to perpetuate a traditional support for the sovereignty of the British Parliament over the American colonies. These people, especially the American Loyalists and most British politicians, sought to preserve fundamental ties of trade, law, language, and, at times, religious commitment. Despite financial impositions and felt injustices, these people believed allegiance to the king was a fundamental tie that ought to be perpetuated.

If the word "conservative" is taken in this latter sense, to specify a desire to sustain the existing relations of power within the British empire, the image of the snake was the most radical of the commonplace motifs, while the image of the child was the most conservative. Alongside these commonplace motifs were less common images that portrayed other visions of the emerging nation, representing the united colonies as an exotic animal, a beast of burden, a source of nourishment, an eagle, and a neoclassical goddess. These images revealed underlying tensions that complicated the formation of an American community and ultimately gave it a heterogeneous character. Yet most of them concurred in the intimation that American culture was inferior to British culture until the mounting controversy, political independence, and finally the endorsement of republicanism led image makers in America, France, and England to redefine the United States with predominantly neoclassical images.

Because these images were distributed through a wide variety of media, it will be useful to begin with a general description of how image makers in Britain and America used statues, paintings, illustrations, flags, housewares, illuminated displays, and medals to influence public attitudes and beliefs. The relative importance of these kinds of artifacts—considered as means of communication—will be analyzed in light of the cultural practices in Britain and America during the eighteenth century: the frequency and ease of production, the range of distribution, the sheer numbers of germane visual messages, and, above all, the content and form. This description of the visual media will be followed by an outline in necessarily broad terms of the underlying rhetorical structure of the images that designated the American colonies, a structure that will be revealed more fully in the ensuing chapters.

The Power of the Media during the Eighteenth Century

During the controversy surrounding the Boston Port Act of 1774, perhaps better known today as one of the Intolerable Acts, an adept Loyalist writer in Massachusetts, Daniel Leonard, attested to the power of the media in shaping the opinions of people in that colony. Writing over the pseudonym "Massachusettensis" in a series of letters published initially between December 12, 1774, and April 3, 1775, in the *Massachusetts Gazette and Boston Post-Boy*, and subsequently in two pamphlets, *The Origin Of The American Contest With Great-Britain* and *Massachusettensis*, Leonard observed,

> The eloquence of the bar, the [pulpit] and the senate, the charms of poetry, the expressions of painting, sculpture and statuary have conspired to fix and rivet ideas of independance upon the mind of the colonists. The overwhelming torrent supplied from so many fountains rolled on with increasing rapidity and violence, till it became superior to all restraint. It was the reign of passion; the small, still voice of reason was refused audience.

4

As was the case with many American Loyalists, Leonard distrusted the power of images in such media as "painting, sculpture and statuary," because he viewed such images as emotional and transformative, not rational and conservative. To "do justice" to the "ingenuity" of the political opposition, Leonard acknowledged that "they were intimately acquainted with the feelings of man, and knew all the avenues to the human heart: — Effigies, paintings, and other imagery were exhibited."[3]

Throughout the Revolutionary era, image makers used the visual media for numerous political purposes, many of which had little to do with overtly depicting the emerging nation as a body politic, but nonetheless contributed to the creation of the body politic by inculcating a revolutionary mentality. In the colonies, for example, portraits and statues were produced and displayed in praise of leaders who had defended America's interests, while portraits and statues of other, opprobrious individuals were removed from public forums or destroyed. In 1765, during the controversy surrounding the Stamp Act, the *London Chronicle*, the *Public Ledger*, and *The Annual Register . . . for 1765* reported that the freeholders of Boston had passed a resolution to obtain portraits of General Henry Seymour Conway and Colonel Isaac Barré to "be placed in Faneuil-hall, as a standing monument to all posterity, of the virtue and justice of our benefactors, and a lasting proof of our gratitude." After the repeal of the Stamp Act in 1766, statues and portraits in honor of William Pitt were commissioned by several colonial governments, because he too had championed America's cause in the British Parliament.[4]

Colonists also expressed their intense dissatisfaction with specific leaders—sometimes even the king—through their treatment of portraits and statues. In 1769, for instance, during the controversy surrounding the Townshend Duties, the lieutenant governor of Massachusetts-Bay, Thomas Hutchinson, was amazed when three merchants in the council of the colony's government demanded that the portraits of Charles I and James II be removed from the council walls. Despite Hutchinson's arguments that the portraits of the kings ought to be left in the official chambers, the artworks were banished. Later, in 1774, when a revolutionary mob found a portrait of Hutchinson in his house in Milton, "they stabbed it with bayonets and tore out one of the eyes."[5] In New York, a statue of King George III had been completed and dedicated as recently as April 6, 1770,

"to perpetuate to the latest Posterity, the deep Sense this Colony has of the eminent and singular Blessings received from him during his most auspicious Reign." Only six years later, in 1776, the same statue of the king was destroyed by an angry mob, following the proclamation of the Declaration of Independence. In other American cities, the king was burned in effigy, his portrait was buried, or his Royal Arms were torn from architectural structures.[6]

Such acts of praise and censure through the production or destruction of portraits and statues were significant political statements, because they had the power to influence the public image of key leaders in Britain and America. Such acts contributed to the creation of a revolutionary mentality in America, but they did little to inculcate a belief that the British colonies in America constituted a body politic, because these acts focused upon key individuals in government, not embodiments of entire communities, and upon literal representations of that subject matter, not figurative ones, except when allegorical images were placed in the background, on a decorative frame, or the pedestal. More helpful than portraits and statues in creating the belief that the colonies constituted a body politic were political prints, with their extensive reliance upon metaphor and allegory, the principal devices that enabled image makers to depict the distinct colonies in America as a unified community.[7]

Above all, it was the political prints—consisting for the most part of etchings, line engravings, woodcuts, and mezzotints, but also encompassing more recently developed techniques such as stipple engravings and aquatints—that were most frequently employed to transmit images designating the united British colonies in America. The extensive reliance upon political prints to promote beliefs and attitudes about the colonies developed not only because prints were inexpensive but also because they could be produced and distributed rapidly in response to timely issues—qualities that enabled political prints to rival newspapers and pamphlets as sources of information about current affairs. During the eighteenth century, political prints had a dual function as a commercial product and as a powerful means to transmit ideas to the public. But political prints were most intimately connected to the pervasive public opinions of the moment, because the printmakers' ability to capture and express popular sentiments quickly was the key to their commercial success. Displayed in print shops and

coffeehouses in British and American cities, distributed even more widely through pamphlets, almanacs, magazines, newspapers, paper currency, and broadsides, the political prints were the single most influential vehicle for the image makers to express their beliefs about the American colonies throughout the Revolutionary era.[8]

Yet there were noteworthy differences in the frequency, form, and function of these modes of distribution. In the political pamphlets—the least important means of pictorial communication in Britain and America throughout the eighteenth century—engraved illustrations sometimes appeared on the frontispiece or title page, as in Benjamin Church's *Elegy to the Infamous Memory of Sr. F---- B-----*, published probably in Boston in 1769, and Isaac Hunt's *The Political Family: Or A Discourse, Pointing Out the Reciprocal Advantages, Which Flow from an Uninterrupted Union Between Great-Britain and Her American Colonies*, published in Philadelphia in 1775. Most political pamphlets, however, were devoid of illustrations. Although the form was perhaps the most important means of written communication among literate members of American and British societies, the pamphlets rarely contained pictorial messages of any sort. Even so, in the pamphlet literature, polemicists often articulated images designating the colonies as a body politic, usually by describing in words the relationship between America and Britain as that between a child and a parent—images that expressed the perspectives of literate members of the British and American societies.[9]

A means of pictorial communication more important than pamphlets was almanacs, printed annually as either single sheets or small booklets. The almanacs sometimes contained woodcut illustrations of an allegorical nature, especially almanacs produced in New England, such as WEATH-ERWISE'S *TOWN AND COUNTRY ALMANACK*, FREEBETTER'S *NEW-ENGLAND ALMANACK*, *Edes & Gill's North-American Almanack*, the *Bickerstaff's BOSTON ALMANACK*, and the *Massachusetts Calendar; or an ALMANACK*. To a lesser extent, almanacs in other colonies included woodcut illustrations, as for instance in the *PHILADELPHIA ALMANACK for the YEAR of Our Lord 1780* and *The CONTINENTAL ALMANAC FOR THE Year of our LORD*, 1782. These woodcuts—the earliest type of printmaking that developed in America—provided unrefined images in comparison with those of line engravings and etchings, but they were significant

nonetheless, since the Bible and the almanac were often the only reading matter in colonial homes.[10]

More important for pictorial communication than either pamphlets or almanacs were magazines, in which political prints—usually line engravings—were widely distributed throughout Britain and America, most frequently as frontispieces, decorations on title pages, and literal and allegorical illustrations of essays, less frequently as emblems, devices, and rebuses. These last, the rebuses, consisted of a combination of pictures, letters, and words that formed a puzzle for viewers to decipher. Prints about recent political developments were widely distributed through monthly British magazines, especially *The Westminster Magazine*, *The London Magazine*, and *The Political Register*, and, to a lesser extent, *The Oxford Magazine*, *The Town and Country Magazine*, *The Hibernian Magazine*, *The Universal Magazine*, and *The Rambler's Magazine*. In contrast, magazines in America were few in number and published for the most part from Boston and Philadelphia, but they still provided a noteworthy means of distribution for pictorial messages. *The Royal American Magazine* of Boston and *The Pennsylvania Magazine* of Philadelphia carried literal and figurative illustrations throughout the controversy following the passage of the Intolerable Acts and the early stages of the war; *The United States Magazine* did so toward its conclusion; and *The Columbian Magazine* did so during the ratification of the Constitution. Of these American magazines, *The Royal American Magazine* produced the largest number of illustrations pertaining to imperial politics, most of them engraved by Paul Revere, who designed allegories and portraits of those whom he regarded as the supporters and the enemies of America. Several of these were original prints; most of the political allegories, however, were derived from prints that had been produced in British magazines and broadsides.[11]

A means of pictorial communication even more significant than pamphlets, almanacs, and magazines—at least throughout America—was newspapers. The importance of newspapers developed not simply because they sometimes carried individual woodcuts in particular issues, as had been the case with the woodcuts of the segmented snake in "JOIN, or DIE." Nor was it simply because editors often copied texts and images from the newspapers of neighboring colonies, although that practice was an important factor in the distribution of pictorial appeals in America. Above all,

the newspapers had such importance because certain of them carried the same allegorical image repeatedly, week after week, on their mastheads. In all the largest colonies that was the case—examples included the *Massachusetts Spy Or, Thomas's Boston Journal*, the *New-York Journal*, the *Pennsylvania Journal*, and the *Virginia Gazette*. Newspapers were published more frequently than almanacs and magazines, and they provided the means of support for many American printmakers. Between 1763 and 1775, the number of master printers at work in colonial America nearly doubled, while the number of newspapers that they published soared from twenty-one in 1763 to forty-two in 1775.[12]

In America, a medium of pictorial communication that rivaled the newspaper in importance after 1775 was paper currency, produced and circulated in large quantities by each of the colonies and by the Continental Congress. Although paper currency was primarily a medium of exchange, it almost always was decorated with images—the vast majority in the form of emblems and devices consisting of pictorial elements and a motto, usually written in Latin. Numerous designs of this type represented America on the colonial currency, many of them highlighting the number of colonies in the union: a thirteen-string harp, a thirteen-step pyramid, a circle consisting of thirteen hearts, thirteen bees hovering near the same hive, thirteen candles united on a single candelabra, and thirteen arrows bound together with a cord. Perhaps the best known of these images was the design depicting the united colonies as thirteen interlinked rings in the form of a circle, which appeared on several denominations of the Continental dollar on February 17, 1776. There was no comparable use of currency in Britain to represent the colonies during the Revolutionary era.[13]

While the newspapers and the paper currency were the most important means by which prints were distributed in America, the broadside was the single most important form in which allegorical prints were distributed in Britain, where the golden age of caricature was developing in the aftermath of William Hogarth's widely admired engravings. In the form of broadsides—large, single sheets that could be quickly mass-produced and distributed in response to issues of the moment—political prints were sold across the counter in print shops, passed from hand to hand in the street and in public forums, displayed prominently in local coffeehouses and pubs, and, in certain instances, shipped abroad to America and France for sale

there. Nearly 140 print shops and print publishers were active between 1774 and 1783 in London alone, where large numbers of such shops conducted business along the Strand, Fleet Street, Piccadilly, and Cheapside. The British print designers and publishers who most actively produced images designating America on their broadsides were James Gillray, J. Barrow, Thomas Colley, Elizabeth D'Archery, Thomas and John Bowles, William Hitchcock, William Richardson, Matthew and Mary Darly, E. Hedges, and William Humphrey, among numerous others. Most of these broadsides had brief captions with a few short lines of verse or written explanation; a few, however, had song lyrics or essays printed in crowded type beneath the illustration.[14]

In America, in contrast, isolated pictorial messages on broadsides were produced in Boston, New York, and Philadelphia by such image makers as Paul Revere, John Singleton Copley, Amos Doolittle, John Norman, James Claypoole, Jr., Henry Dawkins, and a man known only by his surname, Wilkinson. Most of these prints were derivative in content from earlier works that had been produced in London, and only a few contained images designating the united colonies. Other illustrated American broadsides simply recorded the images that colonists had displayed during public demonstrations and celebrations, as did Paul Revere's "A VIEW *of the* OBELISK *Erected under* LIBERTY-TREE *in* BOSTON *on the Rejoicings for the Repeal of the* ———— *Stamp-Act*," produced in Boston during the spring of 1766.[15]

Images of the British colonies in America as a body politic were distributed widely in Britain and America during the decades before the American Revolution, not only through art objects, currency, and reading materials but also through such diverse media as flags, textiles, housewares, illuminated displays, and medals. After 1775, the regiments and fleets from the colonies displayed a wide variety of images designating America on military flags. Although flags were primarily a means to identify and direct the regiments and fleets, they were almost always rich in symbolic significance. Innumerable emblems appeared on the flags—the rattlesnake and the Indian were commonplace, as were motifs emphasizing the number of colonies. Most of these images were painted in oil on the silk material, but sometimes they were embroidered into the fabric. At times, the images on the flags were patterned after designs on paper currency—well-known

examples included the thirteen interlinked rings and the thirteen stars in a circle.[16]

Housewares and textiles were less frequently employed than prints or flags to transmit images designating the American colonies, and most images on these household items came into such use only after the Revolution. Sometimes especially popular prints were reproduced subsequently on housewares and textiles at factories in Britain, France, and China. For instance, the thirteen interlinked rings on the paper currency recurred on porcelain and creamware plates, bowls, and pitchers produced in Britain and China, as well as on a military flag known as the Color of the 2nd New Hampshire Regiment of 1777. One of the most widely copied prints of the period, *"A Picturesque View of the State of the Nation for February 1778,"* was produced in numerous variant forms on broadsides in Britain, France, Holland, and America before it was mass-produced on creamware plates at Liverpool. Few known textiles were imprinted with allegorical designs about the American colonies or the Revolution. The most noteworthy of such fabrics—"Libertas Americana" and "Hommage de l'Amérique à la France"—were produced in France at Jouy and Mulhouse.[17]

Illuminated pictures—painted on thin paper and pasted over a framework that was lit from within—were exhibited in parades and on elaborate sets during demonstrations and celebrations. For instance, during the celebrations after the repeal of the Stamp Act, the *Virginia Gazette* for June 6, 1766, described an elaborate set, "illuminated at night, which showed a complicated arrangement of George III, the Sun, Pitt, America, Agriculture, Manufacturing, Tyranny, Slavery, and Oppression." On May 22, 1766, the *Massachusetts Gazette and Boston News-Letter* described Paul Revere's print "A VIEW *of the* OBELISK" as a rendering of the illuminated display in Boston during the celebration of the repeal. According to the *Boston Gazette* of March 14, 1774, illuminated displays were also exhibited in connection with the Boston Massacre; one included "a figure of America pointing to her slaughtered sons." Other illuminated displays in Boston contained representations of America as a woman, sketches of which are extant among the papers of Pierre Eugène Du Simitière. Unfortunately, because these displays were not preserved, it is difficult to ascertain their content and form, as well as their general significance as a means of visual communication.[18]

Medals were usually commemorative in subject matter and function, and although more than a dozen were produced in Britain, France, and America during the Revolutionary era, the process was so time-consuming and costly that the subject matter tended to be either very general or safely referring to the past. Perhaps the most significant was *Libertas Americana*, a medal proposed and financed by Benjamin Franklin in 1782–83. In his role as *ministre plenipotentiaire*, Franklin distributed originals of *Libertas Americana* in the centers of power in France and the United States in 1783, when he gave originals of it to the king and queen of France, members of the French ministry, the president of the United States, and each of the members of Congress. This medal rapidly achieved international recognition as an expression of American gratitude to France for military, political, and diplomatic assistance.[19]

The year that Benjamin Franklin and Augustin Dupré took to produce *Libertas Americana* was not an unusually long time. Other medals, such as those to honor Anthony Wayne and Daniel Morgan, took several years to produce, because they had to go through the time-consuming stages of official proposal by Congress, selection of a skilled medalist in France, negotiation of acceptable finances, preliminary pencil or ink sketches for the design, preparation of wax and plaster casts for the medal, casting and engraving of the medal itself, and, at last, the formal presentation of it to the honored leader. For instance, Congress authorized the medal for Morgan on March 9, 1781, but it was not completed until 1789. A letter from John Francis Mercer to Daniel Morgan on April 24, 1783, described the general pattern of distribution for such medals, when Mercer alluded to Congress's vote of medals "to those whose distinguished merit has drawn that mark of Applause and gratitude from their Country during the late War." When more than one medal was struck from the same die, the economic value of the substance of the medal—gold, silver, bronze, or copper—usually corresponded to the degree of honor or the political rank of the recipient. Because of the sheer cost and the limited distribution, medals were less useful than other means of visual communication to influence public beliefs, except perhaps when the designs were more widely reproduced subsequently on prints or textiles.[20]

The same or similar designs recurred in different types of visual media. The segmented snake, for example, which was distributed in Amer-

ica as "JOIN, or DIE" in the *Pennsylvania Gazette* on May 9, 1754, was probably appropriated and modified from "Se rejoindre ou mourir," a design in a seventeenth-century French emblem book such as *Livre curieux et utile pour les sçavans, et artistes*, published in Paris in 1685, or *Recueil d'emblêmes[,] dévices, médailles, et figures hieroglyphiques*, published in two editions in Paris in 1696 and 1724. After its publication in the *Gazette*, the image of the segmented snake underwent several changes in form and function as it was appropriated for use in other newspapers in 1754, 1765, and 1774. Eventually, the image became that of a rattlesnake and appeared on several colonial flags, the frames on portraits of military, political, and diplomatic leaders, caricatures on about a dozen broadsides, the dedication page of a book, the paper currency of North Carolina, South Carolina, and Georgia, treasury notes in Massachusetts, the War Department Seal, and porcelain plates.[21]

Certain differences characterized the quantity of visual messages produced in Britain and America, largely resulting from the degree to which the art of printmaking had developed in Britain and in the colonies. While Britain was experiencing the golden age of caricature and satire, America was still in a relatively early state of cultural development. As a consequence, far more political prints were produced in Britain than in America. Even within America, differences were evident among the colonies: the largest concentrations came from Boston, New York, Philadelphia, and, to a lesser extent, Williamsburg. Perhaps because printing had been developed earlier in Massachusetts than in the other colonies, Massachusetts produced more visual messages about imperial politics than any other individual colony, followed by Pennsylvania and New York. The rest of the colonies produced considerably fewer visual messages of a political nature.

Additional differences in the quantities of visual messages resulted from the temperament of the rival political factions, especially in America but also to some extent in Britain. Far more visual messages were produced in America to represent the views of the Patriots than those of the Loyalists, because the Loyalists relied upon public addresses, sermons, and pamphlets, rather than popular symbols and rituals, to reach their audiences. As a consequence, the Loyalists' sermons were perhaps their most useful way to influence the illiterate and semiliterate segments of the populace. In Britain, a somewhat similar, but less extreme difference characterized the number

of prints produced by rival interests, precisely because the print was an especially useful tool for castigating and criticizing those in political office. Yet after the military conflict broke out in America, the patriotism of the British image makers became a more fundamental force than opposition politics.[22]

THE UNDERLYING RHETORICAL STRUCTURE
OF THE IMAGES

The chapters that follow will reveal the underlying rhetorical structure of the images that designated the British colonies in America. The first chapter focuses upon the most radical image that represented the colonies as a singular body politic—the image of the snake, which connoted guile, deceit, and treachery. The second chapter investigates a somewhat less radical image, that of an Indian—an image that allowed some possibility for reason and negotiation but that was nonetheless divisive because it portrayed the colonies as the racial and sexual other, a being whose inferiority was a matter of habitual belief. The third chapter explores the most conservative of the commonplace motifs, the image of the child, which evoked the bonds of blood, heritage, affection, and mutual interest between America and Britain. The final chapter considers experimental images that represented the united British colonies in America situating the uncommon and commonplace images within an underlying rhetorical structure that was transformed during the Revolution by the intensification of utilitarian concerns in Britain and by the emergence of republican values in America.

Throughout the decades before the Revolution, the image of the snake was the device of a political faction that conceived of itself as oppressed within the established political and social order, an oppression emphasized by the physical lowness of a snake and by the slogan "Don't Tread on Me." Although the image of the snake representing the united colonies was consistently secular in its emphasis upon American concerns and virtues, it resonated with religious associations of guile and wickedness, which contributed to its evocative power. Indeed, Whigs and Loyalists in America

engaged in a newspaper debate over the meanings of the motif. The Whigs sought to connect the image with the geographical form of America and with such humane values as prudence, vigilance, and eternity, while the Loyalists attempted to connect the image of the serpent with Judeo-Christian connotations of guile, deceit, and treachery. The image of the snake evoked associations that were predominantly secular and sometimes religious in character, a mingling of American virtues tinged with hints of a felt wickedness. Under what the colonists came to believe were oppressive circumstances, guile became the only alternative, and concealment became valued as a means of survival.

While the image of the snake designating the united colonies originated in America, where the image was defined, appropriated, and opposed primarily among the colonists, the images designating the colonies as the Indian and the child were developed later in America than in Britain, where those images were distributed most extensively by the English. The image of the Indian was derived from the image of the Fourth Continent, comprising the entire Western Hemisphere. The single most salient use of the image representing the British colonies in America was to portray colonial culture as foreign and therefore inferior to British culture. The nature of this inferiority was amplified in various ways, but the ideas that the colonies were alien and uncultivated were central.

These intimations of inferiority were most frequently expressed by depicting the Indian as a young woman, especially during the decade of dissent from 1765 through 1775, when most of the images were portrayed as a female. Depictions of the Indian amplified her inferiority within the predominantly patriarchal British and American societies: her naïveté, her weakness and indecisiveness, her susceptibility to seduction by rogues, even her vulnerability to sexual violation by British politicians took on additional significance in light of the patriarchal social structure in Britain and in America, a significance that illustrators only made more apparent by their tendency to change the sex of the Indian to an aggressive and powerful male throughout the war. The image of the Indian designating the British colonies in America evoked a complex congeries of thoughts about the racial and sexual other, a stranger, whose inferior status was a matter of habitual belief.

In Britain, with the outbreak of military violence in 1775, the image of the Indian was modified to portray the colonies descending from mere inferiority to savagery. As important, the British illustrators imposed the image of the Indian designating the colonies upon Americans until some of them began to employ it to represent themselves, although they modified the image in revealing ways. In 1765, image makers in America were complacent about the colonies' image as an inferior within the British empire, but they were disturbed by insinuations that the colonies were alien. By the time of the military conflicts of 1776, the reverse had established itself: Image makers in America were disturbed by the role of inferior, but they endorsed feelings of alienation.

In contrast to the images of the snake and the Indian, the image of the child usually stressed the bonds of blood, heritage, affection, mutual interest, and moral obligation between the child and its parent. The image of the child tended to emphasize underlying commonalities between America and Britain, rather than the evident divisiveness between them. Consequently, the child was the most conservative of the three commonplace motifs used to portray the united colonies as a body politic, if "conservative" is taken to mean desiring to maintain the existing political and social order within the British empire regardless of felt injustices or hardships.

Initially, both the colonial and the British image makers found the image of the child useful in certain ways. For the colonists, the image of the child designating America provided a rationale for protection at British expense, since it portrayed the colonies as vulnerable. Using the image of the child provided excuses for the colonies' blunders, and it allowed for excessive expressions of dissent, since it depicted the colonies as young, naïve, and inexperienced. To the British, the image of the parent was useful to sanction Parliament's authority over America, since a parent could exert authority over his or her child. Above all, the image of the parent was useful to justify Britain's mercantile policies, which sought to control commerce with the colonies, since a parent could legally appropriate the product of his or her child's labor.

But later, during the controversy that culminated in the independence of the United States, when British and American writers, orators, and illustrators described the relationship between Britain and America as that between a parent and a child, these image makers brought expectations

about the family to bear on the conduct of Britain and the colonies. The image of the family therefore influenced convictions about the nature of the problems besetting the empire such that a practical conflict about commerce, constitutional law, and political authority became transfigured into an ethical conflict about proper conduct characterized by unyielding accusation and resentment. In this way, the image of the family distorted perceptions of the most fundamental issues disrupting the empire and, to the extent that it transformed ideological, economic, and political issues into matters of moral indignation, impeded the search for adequate solutions.

Alongside the most commonplace images, designating the British colonies in America as a snake, an Indian, and a child, an array of experimental images denoted the united colonies. In some prints, the colonies were portrayed as the limbs of Britannia, a choice that stressed more emphatically than any other image of the period that British and colonial interests were interrelated to such an extent that survival required the unity of the empire. Other prints depicted the colonies through various personifications, as youthful, naïve, or unsubstantial, much like the image of the child, or as a victim of British figures. Many prints represented the colonies as barnyard, aquatic, and exotic animals that almost always put the colonies in a utilitarian light by suggesting that they were a beast of burden or a source of nourishment. As such, the British government could use or devour them. Still other visual messages incorporated neoclassical imagery, especially allusions to the Roman Republic and Empire. Sometimes such neoclassical images designating America were shown precipitating the decline of the British empire in ways analogous to the decline of the Roman Empire. At other times, America was portrayed building or constituting a distinct empire based upon republican principles.

Certain general tensions surfaced in the images designating those British colonies in America that became the United States, the most fundamental centering on the issues of unity and distinctiveness within the body politic, however it was to be conceived. These were conflicts between a desire for common benefits through cooperation within the body politic and a desire for individual benefits through local control—conflicts between one locus of supreme authority or several loci of diffused authority. While the unity or separateness of the entire British empire was at issue, in America the unity or separateness among the colonies themselves was also

a matter in doubt. Related to these dynamic issues was yet another set of tensions, which centered on the matter of heritage. Images of indigenous forms of life, such as a rattlesnake or an Indian, stressed a special American heritage to emphasize the cultural differences between the colonies and Britain. Other images, such as the child or the limbs of Britannia, stressed a special British heritage to identify the American colonies with the rest of the empire. Still other images, especially after 1775, portrayed the colonies with neoclassical images, as though to avoid connecting the colonies with a corrupt British government on the one hand or a reputedly uncivilized people on the other. Yet a third locus of imagistic tension—in addition to those of unity and heritage—focused on the stature of the colonies within the British empire. Most prints suggested that the colonies were inferior in comparison with Britain: a wayward child, a foreign Indian, a lower order of animal. Yet because the colonies were useful to Britain's commerce, military power, and international reputation, and because they fought initially to protect their rights under the British constitution and only later to establish their independence, the tensions about stature were redefined in visual messages as a child who has attained adulthood, an Indian who has broken his chains to escape servitude, and a rattlesnake that has struggled with a lion and survived.

Most experimental representations of the American colonies reflected and sustained commonplace ideas that were emphasized by the dominant motifs. These less prevalent images designating the colonies as a person or an animal resembled the dominant images in that they implied that the American colonies formed a single body politic. Yet these experimental images developed some commonplace ideas that were not made apparent by the dominant motifs. Images in Britain stressed a utilitarian attitude toward the colonies, while others in America alluded to ancient Rome and the emerging belief in republicanism. To be sure, the images of the colonies as an Indian or a child suggested that they were useful to Britain, because they provided labor, products, and commerce, but the utilitarian images designating America as various animals differed in the degree of authority that they granted to Parliament: An animal could be slaughtered and devoured without insinuations of cannibalism or infanticide. The image of the colonies as an Indian sometimes suggested neoclassical allusions, when the Indian wore neoclassical garb or was in a neoclassical setting. The

emphatic neoclassical images of America, however, suggested the decline of the British empire in ways analogous to the decline of the Roman Empire, and certain neoclassical personifications of the United States depicted the building of a new Rome in America based on republican principles. These uncommon images were of special significance, because the justification of utilitarian convictions in Britain and the emergence of republican convictions in America became transformative principles. Even so, these images—like the dominant images of the United States—entailed political commitments by emphasizing certain concerns, values, and interests of the emerging nation while they obscured other aspects of the body politic.

THE COLONIES
ARE A SNAKE

"*Who 'scapes the lurking serpent's mortal sting?*
Not he that sets his foot upon her back."

—SHAKESPEARE, *HENRY VI, PART III* (2.2.15)

I n light of the religious and literary heritage of most American colonists, imagery of serpents had an ambivalent quality throughout the Revolutionary era. Within the Judeo-Christian tradition, especially as manifested in the English literature of the time, the serpent represented evil and such base human traits as guile, deceit, and treachery. In *Paradise Lost*, for instance, John Milton alluded in 1667 to the well-known narrative in Genesis, wherein the serpent beguiled humankind. About the fall from grace, Milton inquired, "Who first seduc'd them to that fowl revolt? / Th' infernal Serpent; he it was, whose guile / Stird up with Envy and Revenge, deceiv'd / The Mother of Mankinde"—a passage that the editor of the *Pennsylvania Gazette* mentioned during the political turmoil on the eve of the American Revolution. Shakespeare used the image of the serpent repeatedly as a symbol of treachery, deceit, and guile in his plays, among them *Richard II* (3.4.76), *Henry VI, Part II* (3.2.269), *Troilus and Cressida* (5.1.90P), *Romeo and Juliet* (3.2.73), *King Lear* (5.3.84), and *Julius Caesar* (2.1.31–34). In the sermon "Sinners in the Hands of an Angry God," the Puritan preacher Jonathan Edwards reproached his American congregation in 1747 with the remark "The God that holds you over the pit of Hell . . . is of purer eyes than to bear to have you in his sight; you are ten thousand times so abominable in his eyes as the most hateful venomous serpent is in ours."[1]

Despite this heritage, some American colonists adopted various images of a snake to represent the united British colonies in America during the Revolutionary era. In 1754, 1765, and again in 1774–75, newspaper editors designated the colonies with the image of a segmented snake in illustrations commonly known as "JOIN, or DIE." During the summer of 1774, at least three major newspapers—the *New-York Journal*, the *Massachusetts Spy*, and the *Pennsylvania Journal*—began using the image of a segmented snake on their mastheads, where it recurred week after week for several months (fig. 1). In fact, the *New-York Journal* replaced the king's Royal Arms on its masthead with the image of the snake, an act that the *New-York Gazetteer* described as rebellious. During the military violence that followed the battles at Lexington and Concord, especially from 1775 through 1777, numerous military flags depicted the American colonies with the image of a venomous rattlesnake warning, "Don't Tread on Me." By the early 1780s, the image of the rattlesnake suggested patriotism to the American cause in engraved and painted portraits of American military, political, and diplomatic leaders—among them George Washington, Samuel Adams, and Benjamin Franklin—even though only a decade earlier a snake in portraiture had been a symbol of wickedness, to be trampled or destroyed. Why did some colonists adopt the snake to designate the British colonies in America, given its traditional associations with evil?[2]

An incongruous quality about the image of the snake became pronounced, for example, in Massachusetts, where the image was widely distributed in 1774, both on the masthead of the *Massachusetts Spy*, where a segmented snake represented the colonies, and again on the cover of the *Massachusetts Calendar; or an ALMANACK for the Year of our Lord Christ 1774*, where a snake, coiled about Governor Thomas Hutchinson's leg, represented wickedness (fig. 2). In both cases Isaiah Thomas was the editor, and in both cases Paul Revere prepared the engraving. The different uses for the serpentine imagery were the result of neither editorial preference nor artistic temperament. Rather, the image of a snake was sufficiently ambivalent to accommodate two different usages, one benign and the other more sinister.[3]

A similar instance of disparity surfaced nine years earlier in the *Constitutional Courant*, a newspaper that argued on September 21, 1765, for united colonial protest against the British government's Stamp Act

policy. On the one hand, the *Courant* dramatized the need for the united colonial protest by using a version of "JOIN OR DIE" for its logo. On the other hand, it condemned those who threatened American safety as "vipers of human kind." Similarly, even though variations of "JOIN OR DIE" had circulated in Boston newspapers on at least three occasions, always to urge united colonial action, Whigs in that community condemned Hutchinson for his "serpentine wiles" during the Stamp Act controversy, and John Hancock publicly alluded in 1774 to "the serpents who, whilst cherished in your bosoms, were darting their invenom'd stings into the vitals of the constitution."[4]

Some colonists commented on the ambivalent quality of the images of the snake. On December 27, 1775, an anonymous writer in the *Pennsylvania Journal* speculated about the significance of the rattlesnake on a colonial marine drum. Alluding to heraldry, the writer observed, "[I]t is a rule among the learned in that science 'That the worthy properties of the animal, in a crest-born, shall be considered,' and 'That the based ones cannot have been intended.' " He added, " '[T]he worthy properties' of a Snake[,] I judged[,] would be hard to point out."[5] The anonymous writer's effort to discount the undesirable associations of the snake suggests my thesis: Although the motif representing the united British colonies in America as a snake was consistently secular in its emphasis upon American concerns, interests, and virtues, it resonated with religious associations of guile and wickedness that contributed to its rhetorical power. The image of the snake evoked ideas that were usually secular and sometimes religious in character—a mingling of American virtues tinged with hints of wickedness.

In American political life, those who distributed the image of the snake designating the colonies adamantly and consistently described it as secular in its significance. Initially, in 1754, colonists suggested that the snake's long, sinuous body corresponded to the colonies' geographical form. More important, the image dramatized the need for colonial unity in the face of an outside threat from the French and the Indians. Later, in 1765, the snake represented a political faction protesting within the British empire: To those American colonists who employed the image of the snake during the Stamp Act controversy the British government had momentarily become the outside threat. Then, during the colonial reactions to the In-

tolerable Acts passed by Parliament in 1774, colonists used the image to express defiance in America by publishing it repeatedly on the mastheads of three newspapers. As the colonies became more unified, especially after the formation of the Continental Congress in 1774 and the outbreak of military conflict in 1775, the parts of the segmented snake became unified. Although the unified snake could have been associated easily with the Judeo-Christian tradition, wherein the serpent represented evil, the images were portrayed in the distinctly secular forms of an ouroboros and a rattlesnake. By 1780 the snake appeared in engraved portraits and oil paintings to suggest patriotism to the United States. After the Revolution, however, the snake rarely represented the United States. Instead, it was placed in opposition to the eagle, the new national emblem.

Throughout these transformations in the rhetorical uses of the motif, the image of the snake evoked secular associations, which corresponded to the salient concerns, interests, and values of those Americans who used the image. Even so, commentary throughout the period, especially during an intercolonial newspaper debate that erupted in 1774, alleged that the image of the snake expressed guilt or wickedness felt by the colonists about their changing relationship with Britain. American Loyalists charged that the image revealed hidden aspects of America's conduct toward Britain—guile, treachery, and sedition. In Britain, the religious associations were also pronounced, for example, in the correspondence of Josiah Wedgwood, the famous originator of Wedgwood earthenware, who expressed his sympathy for the American colonies and who produced an image of the rattlesnake on an intaglio seal. Yet in a letter of August 8, 1777, Wedgwood recognized the religious associations with the image when he wrote to his partner, Thomas Bentley, "The Rattle Snake is in hand. I think it will be best to keep such unchristian articles for *Private trade*."[6]

THE IMAGE OF THE SNAKE IN AMERICA

Newspaper editors used the image of the segmented snake, "JOIN, or DIE," to illustrate political commentary sporadically for about twenty-two years,

from 1754 until 1776. Each time that the image became prominent in American political life, the editors modified some features of its appeal such that the image that in 1754 had been only an oblique comment upon the relationship between Britain and America became by 1774 an expression of widespread discontent within British America. An image that seemed innocuous in its implications for the British empire in 1754 became increasingly ominous during the controversies surrounding the Stamp Act of 1765, the Townshend Duties of 1767, and the Intolerable Acts of 1774.

The design of the segmented snake, "JOIN, or DIE," was published for the first time in the colonies in the *Pennsylvania Gazette* on May 9, 1754 (fig. 3). This image was usually attributed to Benjamin Franklin, who may have derived it from a seventeenth-century device with the motto "Se rejoindre ou mourir" in Nicholas Verien's *Livre curieux et utile pour les sçavans, et artistes*, published in Paris in 1685, or from Verien's subsequent collection of images, *Recueil d'emblêmes[,] dévices, médailles, et figures hieroglyphiques*, published in two editions at Paris in 1696 and 1724 (fig. 4). The images of the segmented snake in the *Pennsylvania Gazette* and in these French collections were similar, except that the motto was translated from French into English and the body of the snake was cut into eight pieces rather than two.[7]

Franklin actively sought to distribute the image of the segmented snake, and his contemporaries attributed it to him. On May 8, 1754, the evening before the image was to be published in the *Gazette*, Franklin mailed a copy of "JOIN, or DIE" to Richard Partridge, Pennsylvania's agent in London, with a request that he have it published in the "most publick Papers." On November 18, 1765, during the controversy over the Stamp Act, the lieutenant governor of Massachusetts-Bay, Thomas Hutchinson, subsequently attributed the motto to Franklin: "The riots at N York have given fresh spirits to the rioters here. An uniformity of measures it is said will be effectual and join or die is the motto. When you and I were at Albany ten years ago we did not Propose an union for such Purposes as these." Thomas Hutchinson not only connected the motto "JOIN, or DIE" to Franklin's design before the Albany Congress, he also emphasized a disparity between the initial use of "JOIN, or DIE" in 1754 and the subsequent use of it only a decade later, in 1765.[8]

Franklin's *Gazette* initially circulated "JOIN, or DIE" to denote the colonies shortly before the Albany Congress, which was scheduled to convene that summer in response to the French and Indian War. Before the month of May had ended, variations of "JOIN, or DIE" had been printed in the *New-York Gazette*, the *New-York Mercury*, the *Boston Gazette*, and the *Boston Weekly News-Letter*. By August the image had been alluded to in the *Virginia Gazette* and the *South Carolina Gazette*. In the eight-segment snake in the *Pennsylvania Gazette* the head represented New England, and each of the seven remaining parts corresponded to a single colony, which was identified by its initial letter or letters. The arrangement of the seven parts corresponded from head to tail to the sequence of colonies from north to south: New York, New Jersey, Pennsylvania, Maryland, Virginia, North Carolina, and South Carolina. The images of the segmented snake that subsequently appeared in the *New-York Gazette* and the *New-York Mercury* varied slightly from the original: Some of the initial letters were placed at different points within the woodcut, although in the same sequence, from north to south. Somewhat more substantial revisions were made in the versions of the motif in the *Boston Weekly News-Letter* and the *Boston Gazette*. The image of the snake in the *Boston Weekly News-Letter* had the words "Unite & Conquer" coming from the snake's mouth. The version in the *Boston Gazette* depicted the snake with an open and threatening mouth, urging "Unite and Conquer" (fig. 5).[9]

As this phrase suggested, the snake represented both unity and opposition. Since the image was circulated in opposition to the French and the Indians, it was not initially a symbol of protest or rebellion within the British empire. Rather, it portrayed the need for action against an outside threat. The British empire in America could be protected only by a well-coordinated military response by several of the colonies, so there was nothing invidious about what the image implied for the colonies' relationship to Britain in 1754. Even so, by depicting the colonies apart from the rest of the British empire, the image tacitly suggested that colonial interests were sometimes distinct from British interests and implicitly embodied the concerns of a political faction within the empire.

The image of the snake dramatized the need for colonial unity by keying into a specific folk belief. "JOIN, or DIE" referred to "the contemporary notion that a 'joint snake' might be broken in pieces and yet live if

the parts came together again." In this light, the illustration was a figurative analogy or proportional metaphor: The colonies were to their fate what a segmented snake was to its fate. The caption stated the conclusion: The colonies could join, or they would die. Because the folk belief was specific and secular, the image had no direct associations with religious beliefs within the Judeo-Christian tradition. No biblical passages referred to segmented snakes.[10]

A text accompanying the image in the *Pennsylvania Gazette* reinforced the need for colonial unity in opposition to the French and the Indians: "The Confidence of the French in this Undertaking seems well grounded on the present disunited State of the British Colonies, and the extreme Difficulty of bringing so many different Governments and Assemblies to agree in any speedy and effectual Measures for our common Defence and Security."[11] Newspaper editors reprinted this comment with all four of the other woodcuts of "JOIN, or DIE." The remarks also appeared in the *Boston Evening-Post* of May 20, 1754, and the *South Carolina Gazette* of May 28–June 4, 1754, but without the woodcut.[12] The article that accompanied the image of the segmented snake encouraged viewers to see the snake as an embodiment of the colonies' need for a unified defense against a foreign threat.

Similar sentiments were stated in the *South Carolina Gazette* of June 11–20, 1754—sentiments that were excerpted in the *Boston Gazette* of August 13, 1754:

As the Motions of the *French* on the *Ohio* River, and the Measures they are at present pursuing there, threaten to disturb the Tranquillity of the *British* Provinces; it is greatly to be wish'd that the *British* Provinces would unite in some System or Scheme for the Public Peace and Safety. Such an Union would render us respected by the *French*, for they are no Strangers to our Power, tho' they may perhaps suspect our Prudence; let us give them this Proof of our Wisdom, and they will hardly make any Experiment of our Strength.[13]

As Isaiah Thomas observed, "JOIN, or DIE" was published to "rouse the British colonies, and cause them to unite in effectual measures for their defence and security, against the common enemy."[14]

The segmented snake was an appropriate metaphor for the colonies in additional senses. The image corresponded to the geographical form of the colonies: a long, narrow strip of land separated into individual political units. Because a snake lacked many specialized parts, it was also a useful device for representing a kind of egalitarianism—not a system wherein all individuals were portrayed as equal, but one wherein whole colonial governments were depicted as equal. Had only one colony been represented as the head, it would have been construed as making decisions for the remainder of the colonies. But because the northern colonies were represented collectively as the head, the image distributed the power implied by the head and so mitigated some of the difficulties posed by the difference between the head and tail.

Even so, the *Virginia Gazette* and the *South Carolina Gazette*—newspapers in colonies that formed the snake's tail—did not print the image of the snake, although both alluded to it. Instead, the *South Carolina Gazette* of August 22, 1754, used a line of eight dashes to represent the eight parts of the segmented snake, placing colonial initials alternatively above and below each dash.[15] Since the paper never indicated whether South Carolina or New England was the snake's head, this version of the device was equivocal: Readers could have inferred that South Carolina was the head of the snake instead of the tail. Since the *South Carolina Gazette* printed several woodcuts in that issue—a standing Negro, a running Negro, a lion, and a unicorn—the newspaper probably had the technical capacity to print the actual device, had the editor chosen to do so. Although matters of cost or convenience could have been additional factors, perhaps the editor omitted the image of the snake because being a tail was not a flattering image of South Carolina.

Eleven years later, in September and October 1765, the segmented snake represented the British colonies in America again, this time in protest against the Stamp Act, which was to go into effect on November 1. The image was circulated as the masthead on two of three versions of the *Constitutional Courant*, a radical newspaper published on September 21, 1765, probably by William Goddard. Later, on October 7, 1765, the snake device was reprinted with a description of the *Courant* in the *Boston Evening-Post*. On October 7, 1765, the *Newport Mercury* of Providence,

Rhode Island, also alluded to the publication of the *Courant*, but without reference to the snake device. The images of the snake in the *Courant* and in the *Boston Evening-Post* had the usual eight parts, but they differed from the earlier versions of the device in that the motto "JOIN OR DIE" appeared above the snake instead of below it.[16]

The text with the image of the snake in the *Courant* indicated that the image represented the need for united colonial protest against the Stamp Act and that it did not represent a general desire to revolt against the British government. Although a British newspaper subsequently depicted the *Courant* as one of the most radical protests during the Stamp Act controversy, the *Courant's* masthead described its message as "Concerning Matters interesting to LIBERTY, and no wise repugnant to LOYALTY." Just the same, Isaiah Thomas recollected in 1810 that the *Courant* "contained several well written and spirited essays against the obnoxious stamp act, which were so highly colored, that the editors of newspapers in Newyork, even Holt, declined to publish them." Clearly, then, in 1765 a radical political faction had appropriated the image of the snake to express its opposition to the British government's policy of American taxation.[17]

The *Courant* sought to justify opposition to the Stamp Act by contending that the colonies should not be taxed without representation in Parliament and by arguing that the British institutions did not always act in the best economic interests of the colonies:

> It is a rule that no man in England shall be capable of serving as a representative in parliament, without having a considerable property in England; the reason of this rule is plain; because he will be affected in his own fortune, by the laws he is concern'd in making for the public, the good of which he will consult for his own sake: —But consider this rule with respect to America: Have all the members of parliament property there? Will they each feel part of the burdens they lay upon us? —No. But their own burdens will be lightened by laying them upon our shoulders, and all they take from us will be gains to themselves: Heaven defend us from such representatives![18]

To suggest how firmly the anonymous writer held such convictions, the author in the *Courant* affirmed, "It is better to die in defence of our rights, than to leave such a state as this to the generations that succeed us."

Yet dissatisfaction with the Stamp Act in 1765 did not seem to warrant challenging the entire relationship between the colonies and England. The *Courant* assured the public,

> We have the highest respect and reverence for the British parliament, which we believe to be the most august and respectable body of men upon earth, and we desire that all their rights, privileges and honors may forever be preserved to them, and to every rank and order of men in the kingdom of Great-Britain, whose welfare, prosperity, and honor we sincerely wish, and should rejoice in. We consider ourselves as one people with them, and glory in the relation between us; and we desire our connection may forever continue, as it is our best security against foreign invaders, and as we may reciprocally promote the welfare and strength of each other. Such are our sentiments and affections towards our mother country. But, at the same time, we cannot yield up to her, or to any power on earth, our inherent and most valuable rights and privileges. [19]

This pattern—coupling an adamant challenge to parliamentary authority with affirmations of steadfast allegiance to the British empire—characterized much of the rhetoric during the decade of protest from 1765 to 1775, especially during colonial responses to the Stamp Act in 1765 and to the Townshend Duties in 1767, as was expressed in the widely circulated pamphlets by Daniel Dulany and by John Dickinson. Since the protest of the period was characterized by the pattern of challenging Parliament but maintaining allegiance, in the manner of a loyal opposition, the pattern was compatible with an image of a segmented snake representing united colonial protest. [20]

The image of the segmented snake, "JOIN OR DIE," appeared briefly in Boston in 1769 on the verso of Benjamin Church's *Elegy to the Infamous Memory of Sr. F---- B-----*, a poetic attack in forty-five quatrains on Governor Francis Bernard of Massachusetts. Although this use of the image was limited to the Massachusetts area, it expressed an ambivalent quality in the serpentine imagery of the time. The image of the snake on the verso emphasized the need for colonial unity, while serpentine imagery in the

poetic stanzas denigrated the governor. Further, the image on the verso continued the association of "JOIN OR DIE" with expressions of political dissent, since the poem expressed antipathy for the royal governor of Massachusetts and since it portrayed him as a mere tool of the British government. Below the image of the segmented snake were the lines:

> Not the harsh Threats of Tyrants bearing Rule,
> Nor Guile-cloak'd Meekness of each cringing TOOL
> Shall shake Our Firmness, or divide That Love
> Which the Strong Ties of social Friendship prove.[21]

This stanza evoked alternative ways of interpreting the image of the snake. On the one hand, the image could have corresponded to "Strong Ties of social Friendship" among the colonies, since the initials of the colonies corresponded to various parts of the snake. On the other hand, the image of the snake could have corresponded to the "Guile-cloak'd Meekness of each cringing TOOL," since the snake often was associated with guile in the religious and literary traditions of the period.

Although the former interpretation may have seemed more probable on the verso, because of the proximity of the colonies' initials, the latter interpretation may have seemed plausible in light of verses such as Stanzas 20 and 21:

> Thou, Old in Sin! the vilest Course didst take,
> But TRUTH much wrong'd constrain'd thee to forbear;
> And conquer'd all thy vain Attempts to break
> The CHAIN which links our UNITY and CARE.

> So, when foul Minds degenerate by Use,
> They catch each Form of Malice in Disguise;
> Conviction springs from infamous Abuse
> And 'gainst FREE STATES their Strategems devise.

These stanzas were the most overt references to colonial union in the entire poem. But the metaphor representing the American colonies was a chain,

not a snake, while these same stanzas sustained the image of Governor Bernard and his supporters as serpentine in nature. They were described as "Old in Sin" and "Malice in Disguise." In Stanza 27, Church alluded to the governor's "Subtilty or Pride" and claimed, "No Mediums false plain Enmity can hide." All of this language may have evoked the tradition associating the serpent with evil. Church observed in Stanza 25, "A Sinner's thought most horrible appears / When Guilt, like Snakes, lies gnawing him within." Although one could have construed the word "Snakes" as alluding to the colonies, since they reminded the governor of his guilt, it may have seemed more likely that "Snakes" was to be associated with "A Sinner's thought" or with "Guilt," since "Snakes" was a plural, while the image was a singular snake. Clearly, Benjamin Church's poem reflected and sustained a tension between the benign and the sinister interpretations of the serpentine imagery before the American Revolution.

The image of the segmented snake did not have widespread public circulation again until June 1774, when it was used to represent colonial unity in reaction to the Intolerable Acts, especially the Boston Port Bill. In 1774, the segmented snake was printed regularly on the mastheads of three colonial newspapers: the *New-York Journal*, the *Massachusetts Spy*, and the *Pennsylvania Journal*. Although the Intolerable Acts were especially oppressive to the citizens of Massachusetts-Bay, a newspaper editor in the neighboring colony of New York was the first of the three to adopt the snake on the masthead. John Holt used the image in the *New-York Journal* from June 23, 1774, until December 15, 1774, when he introduced a different serpentine image, which remained on the masthead until August 29, 1776. The snake in the initial image on the *New-York Journal*'s masthead had nine rather than eight segments—the newspaper added Georgia to extend the tail. The *New-York Journal* also altered the motto beneath the image: "UNITE OR DIE" replaced "JOIN, or DIE."

Because this image of the snake replaced the Royal Arms on the masthead, the snake device was placed in direct opposition to an image of the king. On January 19, 1775, the *New-York Gazetteer* suggested to its readers that the image of the snake on the *New-York Journal* was a rebellious response to British rule:

'Tis true, that the ARMS of a good *British King*,

Have been forc'd to give way to a SNAKE—with a STING;

Which some would interpret, as tho' it imply'd,

That the KING by a wound of that SERPENT had died.[22]

The *New-York Gazetteer* depicted the image of the snake in opposition to the king, rather than Parliament. By doing so, the *Gazetteer* suggested the extent to which rebellious sentiments had grown in the American colonies, since criticism of the king characterized the final step in the development of a revolutionary mentality. Furthermore, the *Gazetteer* intimated that the image of the snake inculcated a sense of united colonial power, though the newspaper deplored such seditious expressions of it.

The *Massachusetts Spy* had a segmented snake on its masthead from July 7, 1774, until its last issue at Boston on April 6, 1775. Although all of the earlier images of the snake had left the principle of opposition implied in the pictorial composition (none of them had actually depicted the adversary), the version by Paul Revere in the *Massachusetts Spy* placed an elongated, segmented snake in battle with a dragon. Isaiah Thomas, the publisher of the *Massachusetts Spy*, explained:

> On the 7th of July, 1774, during the operation of the Boston port bill, so called, and just after the landing of four additional regiments of troops, with a train of royal artillery, a new political device appeared in the title of this paper—a snake and a dragon. The dragon represented Greatbritain, and the snake the colonies. . . . The head and tail of the snake were supplied with stings, for defence against the dragon, which appeared furious, and as bent on attacking the snake.[23]

Until this version, the tail of the snake had been tapered, possessing neither a rattle nor "stings." Although the stings conveyed a sense of political power, the snake's stings on this masthead conveyed a certain ambiguity, since similar stings had appeared on representations of Satan's tail and on serpents, which were Christian expressions of wickedness, as in Paul Revere's own earlier work "A WARM PLACE—HELL," printed in 1768. Regardless of whether Revere coincidentally or deliberately used such religious imagery

on the masthead of the *Massachusetts Spy*, the image of the snake was vulnerable to religious associations with evil.

The *Pennsylvania Journal*, published by William and Thomas Bradford, had a segmented snake on its masthead from July 27, 1774, until October 18, 1775. Like the mastheads on the *New-York Journal* and the *Massachusetts Spy*, this one also depicted the snake designating the colonies with nine segments, and like the *New-York Journal*'s masthead, this one replaced the motto "JOIN, or DIE" with "UNITE OR DIE." Since all three of these mastheads were responses to the Intolerable Acts, which went into effect on June 1, 1774, the appearance of the segmented snake in Pennsylvania, Massachusetts, and New York represented intercolonial solidarity in the struggle with the British government. The prominent placement of all these images of the snake on the mastheads of colonial newspapers, where they appeared week after week for several months, demonstrated that the images were symptoms of widespread discontent.

By fall 1774, the first of two issues arose in a newspaper debate over the meanings of the snake device. Although the King James Bible did not contain any references to segmented snakes, and although the segmented snake specified a folk belief about the capacity of a severed snake to unite its parts, some readers interpreted the image in light of Judeo-Christian texts in which it represented evil. Regardless of whether these people drew such interpretations in a genuine effort to understand the image or deliberately to discredit the device of an opposing political faction, the assertions suggested that it was possible to expose and exploit the implications of guile and wickedness. For example, the *New-York Gazetteer*, a political and commercial rival of the *New-York Journal*, commented:

> Ye sons of Sedition, how comes it to pass,
>
> That America's typ'd by a SNAKE—in the grass?
>
> Don't you think 'tis a scandalous, saucy reflection,
>
> That merits the soundest, severest correction,
>
> NEW-ENGLAND's the Head too;—NEW ENGLAND's abused;
>
> for the *Head of the Serpent* we know *should be* bruised.[24]

The opening lines stressed the surreptitious nature of the serpent by echoing a line from Virgil's *Eclogues* (3.93). More important, the final lines alluded to Genesis 3:13–15, wherein the serpent brought about the fall of humankind. The pointed insinuation was that the *New-York Journal* had embraced wicked principles by using the image of the snake as a representation of the united colonies in America. Subsequently, on September 8, 1774, the *Boston Weekly News-Letter* reprinted the verse from the *New-York Gazetteer*, perhaps because the *Boston Weekly News-Letter* had carried "JOIN, or DIE" in May 1754 and now wished to dissociate itself from this new usage, perhaps because the paper was a competitor of the *Massachusetts Spy*, or perhaps because the *Boston Weekly News-Letter* wished to chide the editor of the *Spy*.

Eliminating or mitigating the religious associations of the segmented snake became a problem for the three newspapers that carried the device so prominently on their mastheads. Altogether, the *New-York Journal*, the *Massachusetts Spy*, and the *Pennsylvania Journal* published at least four responses in the form of verse. The accusation had struck a nerve. All three newspapers reacted to the religious connotations and the charge of surreptitiousness. All three denounced the character of the writer and publishers who had made the accusation of guile.

On August 31, 1774, the *Pennsylvania Journal* accepted the allusion to wickedness as legitimate, if those principles of surreptitiousness were ascribed to the British supporters:

> THAT New-England's abus'd, and by sons of sedition,
>
> Is granted without either prayer or petition.
>
> And that " 'tis a scandalous, saucy reflection,
>
> That merits the soundest, severest correction,"
>
> Is as readily granted. "How comes it to pass?"
>
> Because she is pester'd with snakes in the grass;
>
> Who by lying and cringing, and such like pretensions,
>
> Get places *once* honoured, disgraced with pensions.
>
> And you, Mr. Pensioner, instead of repentance,
>
> (If I don't mistake you) have wrote your own sentence;

For by such *Snakes* as this, New-England's abused,

And the head of these serpents, "you know *should* be bruised."[25]

By alluding to government corruption in the form of sinecure positions, the writer attempted to transfer the connotations of the wicked snake from the colonies to Britain and her defenders in America. But if, as this writer suggested, the British supporters had behaved like the wicked serpent of Genesis, then the image on the masthead ought to have compared the British supporters, not the colonies, to a serpent.

In a reply on September 15, 1774, the *Massachusetts Spy* denied the legitimacy of the religious allusion altogether:

Ye traitors! The Snake ye with wonder behold,

Is not the *deceiver* so famous of old;

Nor is it the *Snake in the grass* that ye view,

Which would be a striking resemblance of you,

Who aiming your stings at your own country's heel,

Its Weight and resentment to crush you—should feel.[26]

The final lines affirmed that the writer and editors for the *New-York Gazetteer* and the *Boston Weekly News-Letter* ought to be trampled by humankind—like the Judeo-Christian serpent of Genesis—because they were traitors.

The *New-York Journal* printed two verses in response to the accusation in the *New-York Gazetteer*. The first, on September 15, 1774, indicted the character of the writer for the *New-York Gazetteer*. The poem was prefaced by the remark "Mr. HOLT, You are requested to insert, in your paper, the following lines, which will oblige hundreds of your readers, and particularly A CORRESPONDENT." The remark implied that John Holt printed the verse out of regard for his readers' sentiments, not as a matter of retaliation by the newspaper—however much he may have delighted in the counterattack upon the integrity of James Rivington's *New-York Gazetteer*:

Without one grain of *honest* sense,

One virtuous view, or *just* pretence

To patriotic flame;

Without a patriot heart or mind,

(Your *snake* and *stones* have this defin'd)

Behold your TYPE with shame![27]

The words "Your *snake*" affirmed that the *New-York Gazetteer*'s interpretation of the snake was not that of the *New-York Journal*. The pun on the word "TYPE" referred to the type of person who could write such a verse in the *Gazetteer* and the type used to print it. Both were shameful to the writer for the *Journal*.

The September 29, 1774, issue of the *New-York Journal* also defended the image of a segmented snake to designate the united British colonies in America. That justification was reprinted subsequently in the October 27, 1774, *Massachusetts Spy:*

On *the* BRITISH MINISTRY, *and* New-England,

the Head *of the* AMERICAN SNAKE

AN EPIGRAM. 1774

Britain's sons line the coast of Atlantic all o'er,

Great of length, but in breadth they *now* wind on a shore

That's divided by inlets, by creeks, and by bays,—

A snake* cut in parts, a pat emblem convey—

The *fell junto* at home—sure their heads are but froth—

Fain this snake would have caught to supply *viper broth*

For their *worn* constitution—and to it they go,

Hurry *Tom*, without hearing his yes or his no,

On the *boldest* adventure *their* annals can show:

By *their wisdom* advised, he *their courage* displays,

For they seiz'd on the *tongue*, 'mong their first of essays;

Nor once thought of the *teeth* when *our snake* they assail—

Tho' the prudent catch snakes by the back or the tail—

To direct to the *head!*—our GOOD KING *must* indite'em—

They forgot that the *head* would most certainly *bite*'em.

This verse reminded the readers that the winding and segmenting of the snake corresponded to the colonies' geographic form. It amplified such associations by portraying Great Britain as an oppressive burden, since an asterisk in the poem referred to a note: "*some fifty years hence, when the body fills up, an elephant supporting Great-Britain on his back, will be a more proper emblem." The verse associated the snake with the ideals of wisdom and courage and portrayed the creature as acting in defense: "*our snake* they assail." The verse appealed to regional pride by implying that New England was the head since New England had borne the most severe of the parliamentary acts, as the Intolerable Acts would have confirmed for the Boston populace.[28]

On April 13, 1775, James Rivington's *New-York Gazetteer* printed an anonymous letter that alluded to "Thomas's Snake of Sedition," suggesting that Thomas's newspaper was inciting rebellion against the constituted authority. On April 6, 1775, Thomas had already printed the last *Massachusetts Spy* in Boston, and on May 3, 1775, when he resumed printing the paper in Worcester, the image of a segmented snake was no longer on the masthead. Only the motto remained at the top of the masthead among a series of exclamations: "Americans! - - - Liberty or Death! - - - JOIN, or DIE!" That Thomas eliminated the image of the snake to please his critics was unlikely, given his character. Instead, he used the revised masthead from May 3 until August 9, 1775, to urge unity among the colonies and to broaden the appeal of his newspaper by incorporating the famous line by Patrick Henry, a prominent Virginian, and by emphasizing the common denominator, "Americans."[29]

While this intercolonial newspaper debate was transpiring in Massachusetts, New York, and Pennsylvania, one of the most skillful Loyalist writers from Massachusetts-Bay, Daniel Leonard, portrayed the colonial protesters with the imagery of serpents. In a series of widely republished letters during 1774–75, Leonard articulated a Loyalist position over the pseudonym Massachusettensis. He was especially displeased with the committees of correspondence, a standing committee in every colony except Pennsylvania charged with corresponding with the representatives in other colonies to help concert the assemblies' plans, even when a governor had prorogued an assembly. Leonard alluded to these committees as "the foulest,

subtlest and most venomous serpent that ever issued from the eggs of sedition." Earlier in the same letter, Leonard affirmed:

> I saw the small seed of sedition, when it was implanted: it was, as a grain of mustard. I have watched the plant until it has become a great tree, the vilest reptiles that crawl upon the earth, are concealed at the root; the foulest birds of the air rest upon its branches. I now would induce you to go to work immediately with axes and hatchets, and cut it down; for a two-fold reason, because it is a pest to society, and lest it be felled suddenly by a stronger arm and crush its thousands in the fall.

Leonard wrote several additional passages describing those responsible for civic unrest in terms of the serpent. "These disappointed, ambitious and envious men," he wrote, "instil the poison of disaffection into the minds of the lower classes." He contended, "[D]isaffection to Great-Britain being infused into the body of the people, the subtle poison stole through all the veins and arteries, contaminated the blood, and destroyed the very stamina of the constitution." He characterized those who instigated the protests as "old in intrigue," adding, "The subtilty, hypocrisy, cunning and chicanery, habitual to such men, were practiced with as much success in this as they had been before in other popular assemblies." Because the *Massachusetts Spy* had carried an image of the snake on its masthead for almost a year, and because Leonard's allusions to serpents were distributed within the same community, he was almost certainly employing a commonplace connection between the Whigs and the serpent.[30]

In New York, another Loyalist writer definitely sought to portray as evil those colonial newspapers that had carried the snake on their mastheads. In a lengthy anonymous poem, *The Patriots of North-America: A Sketch. With Explanatory Notes*, published in a pamphlet in New York in 1775, the writer vilified the American rebels by connecting the image with the Judeo-Christian tradition in which it represented the Devil himself:

> With Vipers leagu'd, in borrow'd Name,
> They hiss and blast their Neighbour's Fame:
> Vipers like, - - - - - - - - -
> - - - - - - - - - or Dolt.

Fair Truth, exclude, from many a Press,
On Pain, of every dread Distress: . . .
Vile, false, pernicious Doctrines preach,
Rebellion rank, and Treason teach,
Malignant o'er the Land they crawl,
And wither, blast, and poison all.
 So when the Dev'l with horrid Joy,
Hatch'd, the dire project to destroy
Mankind, created frail and weak,
He took the Form of groveling Snake
And stung with Envy, Rage, Despair,
To see a World, so gay, so fair
A World as erst, alas, was this
The seat of Pleasure, Ease and Bliss:
A World, where spirits foul, from Hell
Were too impure, too black, to dwell
With Mortals, harmless as the Dove
'Midst Innocence, and Peace, and Love,
Till, they had made, the simple Elves,
As foul, and guilty, as themselves;
Triumphant, us'd the same Device,
And made a Hell of Paradise.

The writer definitely intended the imagery of serpents in this passage to evoke thoughts of the mastheads on the colonial newspapers, because he appended a note explaining the allusion to the readers:

> *Vipers leagu'd.* p. 4. L. 19.] Alluding to the Figure of a Snake, with which certain Printers of American News Papers, adorn their Publications, designed to allure a certain Set of Customers, and to enlist a certain Crew of Writers, who have contributed in a most criminal Degree, to subvert the Laws of this Country, have already, enflamed it, into the most dangerous Convulsions, and threaten to complete its final Destruction. These Standards were erected perhaps in Imitation of certain well known Signs in Blood-Bowl-Alley of London, and in la Rue

D'Enfer of Paris. The Resorts of Bullies, Spies, Informers, Incendiaries, Highwaymen, and Murderers. This Custom is not common to all the Publishers of News-Papers; some of the Fraternity, equally malignant in their Designs, and more successful in their Operations, hang out no Sign at all. They are of old established Credit. Their Wine needs no Bush.

One strategy of the Loyalists was to discredit the newspapers that used an image of the snake on their mastheads by describing "UNITE OR DIE" such that its central implication was wickedness, not life through unity. Seen as an embodiment of evil, "UNITE OR DIE" summarized an array of vile motives: envy, deception, guile, treason, rebellion.[31]

The Loyalist preacher Jonathan Boucher articulated such implications of the serpentine imagery in 1774, when he relied upon an allegorical use of Genesis in his sermon to a congregation in Maryland: "Independency is the forbidden fruit which our tempters hold out to us: and it is our duty, hardly in a less degree than it was the duty of our first parents, to calculate the probability there is, that their promises shall be made good to us, and we *be as gods*. Let us also calculate how much more probable it is that *in the day we eat thereof we shall surely die*." Joseph Galloway of Pennsylvania also alluded to such serpents in connection with the Continental Congress, whose resolutions he deplored. "But," he assured the readers of his *Candid Examination Of The Mutual Claims Of Great-Britain, And The Colonies: With A Plan Of Accommodation, On Constitutional Principles*, "the veil is too thin. The herbage is not sufficiently thick to conceal the covered snake, from the eye of the candid and sensible enquirer."[32]

As the unity of the colonies' protests and war efforts became more well established through the formal organization of the Continental Congress, a second difficulty arose in connection with the segmented snake, which had designated the united American colonies sporadically from 1754 to 1776. The earlier uses of this motif had made it a rhetorical topos, or commonplace, that dramatized the need for united colonial action in opposition to a mutual threat posed initially by the French and the Indians and subsequently by the British government. In these earlier instances, the image had portrayed a mutual concern among the colonists: the establish-

ment of concerted action among distinct legislatures, which were obligated to respond to the needs and desires of distinct colonial communities.

These circumstances began to change through the creation of formal organizations, as had been attempted earlier in 1754 with the Albany Congress and in 1765 with the Stamp Act Congress. In September and October 1774, the first Continental Congress convened in Philadelphia to promote the mutual interests of the intercolonial community. In April 1775 the battles at Lexington and Concord transpired in Massachusetts, adding a sense of urgency to the colonies' circumstances. In May a second Congress convened to determine how best to protect American interests in light of the recent military confrontations. By taking such decisive actions, the colonists actively forged political and military organizations for concerted action against the British government and its military forces. Yet the more well developed these formal means for action became among the colonies, the less appropriate the image of a segmented snake became to dramatize their political condition. But if the image of the snake became unified, it would no longer specify a particular folk belief. Instead, it could even more easily become associated with the serpents that represented evil within the Judeo-Christian tradition.

On December 15, 1774, shortly after the first Continental Congress convened at Philadelphia, the *New-York Journal* replaced the segmented snake on the masthead with a united one. In doing so, John Holt selected an image with definite, secular associations with eternity: a snake biting its tail, sometimes called an ouroboros. According to Isaiah Thomas, "[T]he snake was united, and coiled with the tail in its mouth, forming a double ring; within the coil was a pillar standing on Magna Charta, and surmounted with the cap of liberty; the pillar on each side was supported by six arms and hands, figurative of the colonies."[33] The central image—the pillar resting on the Magna Charta and held up by twelve hands—had appeared only a month or two earlier on the title page of the *JOURNAL of the PROCEEDINGS of the CONGRESS, Held at Philadelphia, September 5, 1774.* Evidently, the transformed image of the snake on the *Journal*'s masthead implied that the unity of the American colonies had become established through the Continental Congress. As important, the image on the masthead implied that the *New-York Journal* had aligned itself with the Congress—a political stance that became increasingly provocative as the

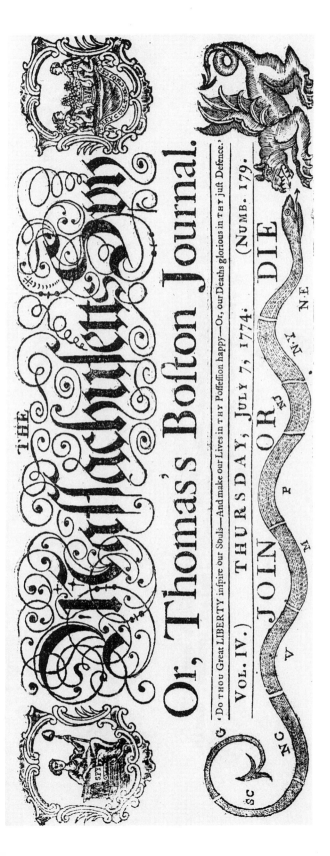

1. "JOIN OR DIE,"
Massachusetts Spy Or, Thomas's
Boston Journal, July 7, 1774, until
April 6, 1775, masthead. Maker:
Paul Revere; publisher: Isaiah
Thomas; medium: newspaper;
size: 3 7/8" × 10". Courtesy of
the Library of Congress.

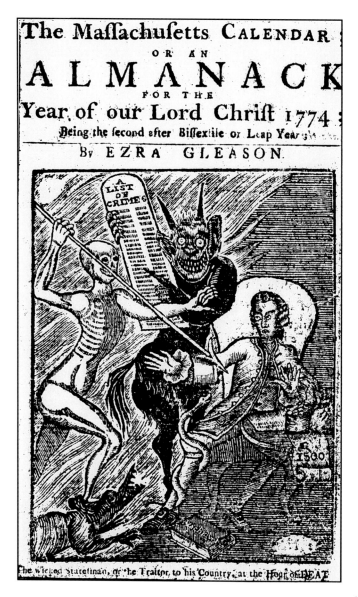

The Maſſachuſetts CALENDAR;
OR AN
ALMANACK
FOR THE
Year of our Lord Chriſt 1774:
Being the ſecond after Biſſextile or Leap Year.
By EZRA GLEASON.

A
LIST
OF
CRIMES

The wicked Stateſman, or the Traitor to his Country, at the Hour of DEATH.

2. "The wicked Statesman, or the Traitor to his Country at the Hour of DEATH," *Massachusetts Calendar; or an ALMANACK for the Year of our Lord Christ 1774; Being the second after Bissextile or Leap Year*, title page. Maker: Paul Revere; publisher: Isaiah Thomas; medium: almanac; size: 3 3/4″ × 3″. Photograph courtesy of the American Antiquarian Society.

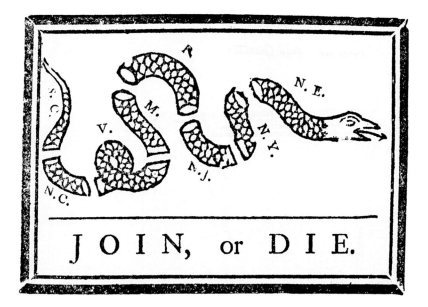

JOIN, or DIE.

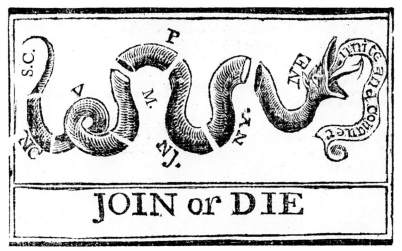

JOIN or DIE

3. Top: "JOIN, or DIE," *Pennsylvania Gazette*, May 9, 1754, p. 2, col. 2. Maker: [Benjamin Franklin]; publisher: Benjamin Franklin and David Hall; medium: newspaper; size: 2 7/8″ × 2″. Photograph courtesy of the Library of Congress.

5. Bottom: "JOIN or DIE," *Boston Gazette*, May 21, 1754, p. 3, col. 1. Medium: newspaper; size: 2″ × 3″. Photograph courtesy of the Massachusetts Historical Society.

4. "Se rejoindre ou mourir," *Livre curieux* (Paris, [1685?]), plate 62, figure 7. Publisher: Nicholas Verrien; medium: book; size: 1″ diameter. Photograph courtesy of the British Museum, Department of Prints and Drawings. Subsequently, Nicholas Verrien published "Se rejoindre ou mourir" in two editions of *Recueil d'emblêmes[,] dévices, médailles, et figures hieroglyphiques* (Paris, 1696 and 1724), plate 61, figure 7 in both editions.

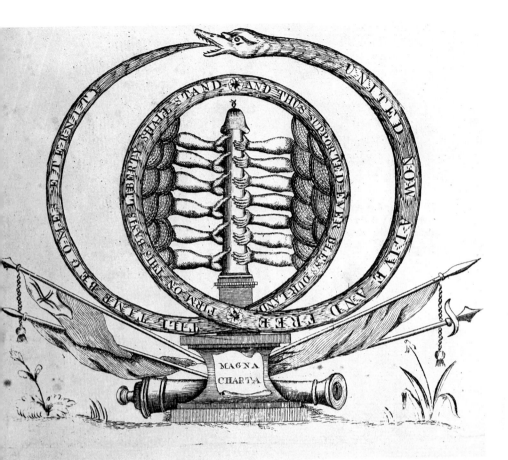

6. "[Ornament]," *A Collection of Designs in Architecture* (Philadelphia: Robert Bell and John Norman, 1775), dedication page. Maker: [John Norman]; medium: book. Photograph courtesy of the New York Public Library.

GEORGIA. 1776. No. 491

THIS CERTIFICATE intitles the Bearer to TWENTY SPANISH MILLED DOLLARS, or the Value thereof, according to Refolution of CONGRESS.

South Carolina N° 4641

£15

THIS BILL intitles the Bearer to FIFTEEN POUNDS Currency by a resolution of CONGRESS. March 6 1776

£15

7. Top: "TWENTY SPANISH MILLED DOLLARS," Georgia Currency, 1776. Medium: paper money; size: 5 1/2″ × 3″. Photograph courtesy of the American Antiquarian Society.

8. Bottom: "FIFTEEN POUNDS currency," South Carolina, 1776. Medium: paper currency; size: 3 7/8″ × 4 1/2″. Photograph courtesy of the Smithsonian Institution.

State of Massachusetts Bay

No 2140 £30..10 1777

RECEIVED of *Nathanael Baker* the Sum of *Thirty pounds ten shillings* for the Use and Service of the **State** of *Massachusetts-Bay*, and in Behalf of said **State** I do hereby promise and oblige Myself and Successors in the Office of Treasurer, to repay to the said *Nathanael Baker* or Bearer, by the First Day of *March*, **A. D.** 1782, the aforesaid Sum of *Thirty pounds ten shillings* with Interest Annually at **Six** per **Cent.** per Annum.

J. Scollay
Eze Price
I Boyer

Committee

Witness my Hand

Treasurer

DEATH TO COUNTERFEIT THIS.

9. "State of Massachusetts Bay. Received of *Nathanael Baker* the Sum of *thirty pounds ten shillings*," Massachusetts Treasury Note, December 4, 1777. Medium: treasury note; size: 9″ × 6″. Photograph courtesy of the American Antiquarian Society.

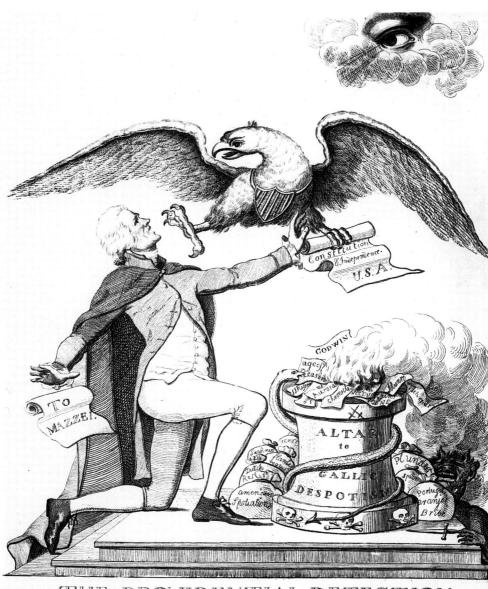

THE PROVIDENTIAL DETECTION

10. "THE PROVIDENTIAL
DETECTION," [c. 1797–1800].
Medium: print; size: 16 1/4" ×
14". Photograph courtesy of the
Library Company of
Philadelphia.

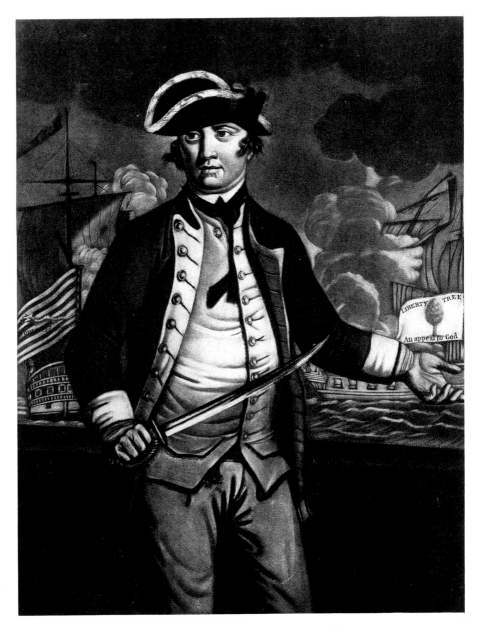

11. "COMMODORE HOPKINS,
*COMMANDER in CHIEF of the
AMERICAN FLEET*," August 22,
1776. Maker: Joh. Martin;
publisher: Thomas Hart;
medium: mezzotint; size: 13 3/4"
× 10". Photograph courtesy of
the Library of Congress.

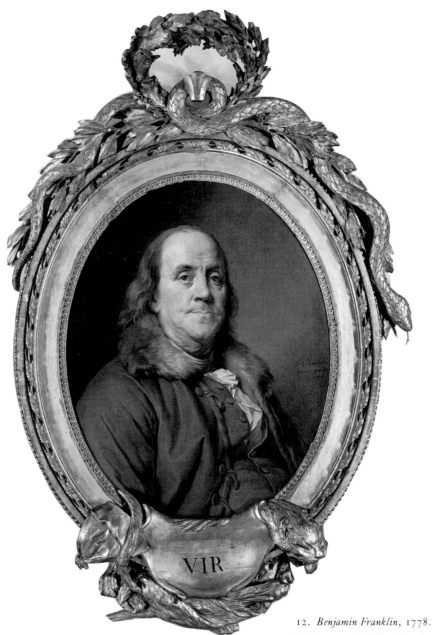

12. *Benjamin Franklin*, 1778.
Maker: Joseph Siffred Duplessis;
medium: oil on canvas; size: oval
23″ × 28 1/2″. Photograph
courtesy of the Metropolitan
Museum of New York.

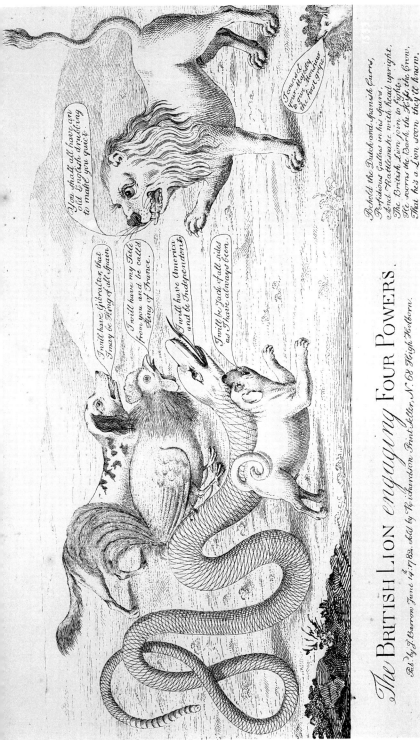

The BRITISH LION *engaging* FOUR POWERS.

Pub.d by J Barrow June 14.th 1782. Sold by Richardson Printseller, N.º 68 High Holborn.

13. "The BRITISH LION engaging
FOUR POWERS," June 14, 1782.
Publisher: J. Barrow; seller:

Richardson; medium: print; size:

14 1/2" × 9". Courtesy of the

Library of Congress.

14. "Lord Chatham and
America," circa 1766. Medium:
Derby porcelain. Photograph
courtesy of the Victoria & Albert
Museum.

15. "America," in Richardson's
edition of Ripa, *A Collection of
Emblematical Figures*, 2 vols.
(London, 1777–79), 1: fig. 60.
Medium: book; size: 4″ ×
3 1/8″. Photograph courtesy of
the Library of Congress.

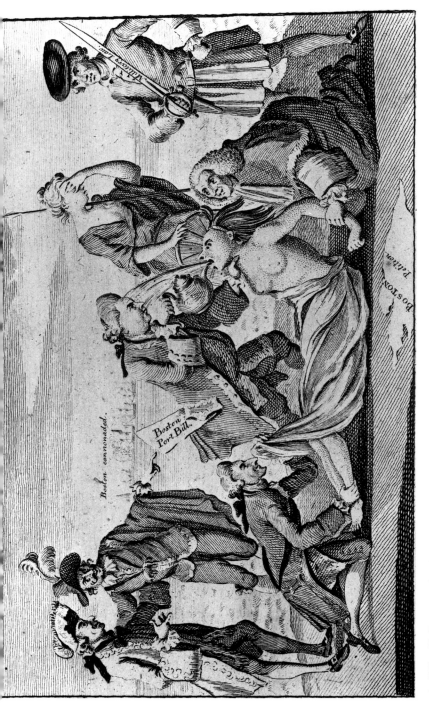

16. "The able Doctor, or America
Swallowing the Bitter Draught,"
The London Magazine 43 (April

1774): opposite 185. Medium:
magazine; size: 5 7/8" × 3 3/4".
Courtesy of the Library of Congress.

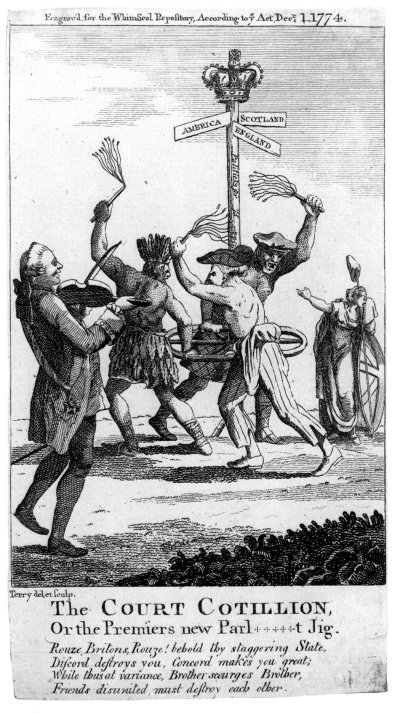

Terry del.et sculp.

The COURT COTILLION,
Or the Premiers new Parl++++++t Jig.

Rouze, Britons, Rouze! behold thy staggering State,
Discord destroys you, Concord makes you great;
While thus at variance, Brother scourges Brother,
Friends disunited, must destroy each other.

17. "The COURT COTILLION, Or the Premïers new Parl + + + + +t Jig," December 1, 1774. Medium: print; size: 6 1/2″ × 4 1/2″. Photograph courtesy of the British Museum, Department of Prints and Drawings.

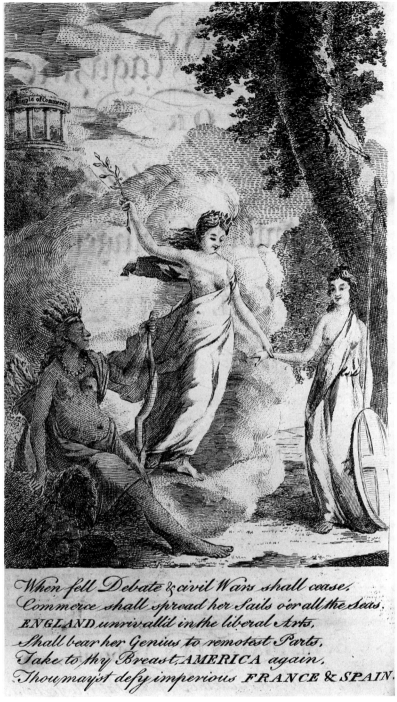

When fell Debate & civil Wars shall cease,
Commerce shall spread her Sails o'er all the Seas,
ENGLAND unrivall'd in the liberal Arts,
Shall bear her Genius to remotest Parts,
Take to thy Breast, AMERICA again,
Thou mayst defy imperious FRANCE & SPAIN.

18. "[*When fell Debate & civil Wars shall cease*]," *The London Magazine* 44 (January 1775): frontispiece. Medium: magazine; size: 7 1/2″ × 4 3/4″. Courtesy of the Library of Congress.

19. *"The Parricide. A Sketch of
Modern Patriotism,"* Westminster
Magazine 4 (April 1776):
opposite 217. Medium:
magazine; size: 3 3/4″ × 6 1/8″.
Photograph courtesy of the
Library of Congress.

divisions between America and Britain continued to deepen from 1774 to 1776. Subsequently, the image of the snake biting its tail recurred in 1775 in Philadelphia in a book about architecture dedicated to John Hancock, but the central image of the pillar was upheld by thirteen hands instead of twelve, because Georgia had joined the intercolonial union (fig. 6).[34]

As John Vinycomb observed in his work on heraldry, "[A] serpent in a circle with its tail in its mouth is the well understood symbol of unending time." To ensure that the emblem in the *New-York Journal* would not be interpreted otherwise, the *Journal* had inscribed on the snake's body: "UNITED NOW ALIVE AND FREE / FIRM ON THIS BASIS LIBERTY SHALL STAND / AND THUS SUPPORTED EVER BLESS OUR LAND / TILL TIME BECOMES ETERNITY." In this way the *Journal* defined the image in a secular manner and implicitly dissociated it from any implications of evil. John Holt, the editor, may have been responding to the problem posed by the unfavorable religious interpretations in the rival New York newspaper, since he eliminated the earlier emblem in favor of another that was unmistakably free of religious meanings. More important, Holt sought to depict a growing sense of political unity among the disparate colonies by eliminating an obsolete emblem that had advocated unity and by replacing it with one that presented such unity as an achievement.[35]

On January 19, 1775, the *New-York Gazetteer* reacted in verse to the revised masthead on the *New-York Journal*:

to Neighbour H O L T

On his EMBLEMATICAL TWISTIFICATION.

'Tis true, JOHNNY HOLT, you have caus'd us some pain,

by changing your HEAD-PIECE again and again;

But then to your praise it may justly be said,

You have given us a Notable TAIL-PIECE in stead.

'Tis true, that the ARMS of a good *British King*,

Have been forc'd to give way to a SNAKE—with a STING;

Which some would interpret, as tho' it imply'd,

That the KING by a wound of that SERPENT had died.

But NOW must their Malice all sink into Shade,

By the HAPPY Device which you lately display'd

43

And TORIES themselves be convinc'd you are slander'd
Who see you've ERECTED the RIGHT ROYAL STANDARD.[36]

The first quatrain mocked the frequent changes on the *Journal*'s masthead and quipped that the headpiece was a tailpiece—to note the snake's long tail forming the double ring. The next quatrain reminded readers that the *Gazetteer*'s criticism of the snake on the earlier masthead had underscored implications of rebellion against the king. The final quatrain struck a conciliatory note in the debate, praising the most recent masthead as a vindication of Holt; indeed, the new masthead was acceptable even to his political adversaries.

It was ironic that the *New-York Gazetteer* endorsed the image as acceptable to the "TORIES." Holt's most recent image featured a motif from the journals of the Continental Congress, which had been resolute in its opposition to the British government's policies. Perhaps the *Gazetteer* endorsed the image before the resolutions of the Congress had become widely recognized throughout the colony. Perhaps, too, the *Gazetteer* found it difficult to oppose eternal intercolonial unity when it was founded upon the Magna Charta, as suggested by the placement of a document labeled "MAGNA CHARTA" under the pillar upheld by the twelve hands. The allusion to the Magna Charta in Holt's masthead made further criticism of the image a delicate undertaking and, at the same time, allowed the *Gazetteer* to end its role in the debate over the meanings of the serpentine imagery. By insinuating that its criticism had influenced Holt to replace the masthead, the *New-York Gazetteer* vaunted its ostensible power to persuade the *Journal* to reconsider the earlier design. At the same time, by praising the most recent masthead, the *Gazetteer* minimized the likelihood that the editor of the *Journal* would become provoked to continue the intercolonial newspaper debate in verse.

Those who approved of the Continental Congress needed to depict intercolonial unity not merely as an aspiration but as an enduring achievement. The transfigured image in the *New-York Journal* was one way to resolve the iconographic problems posed by the formation of the Congress and by the religious interpretations in the rival newspapers. But a snake biting its tail was neither a threatening nor a powerful image. In the late winter of 1775

several other images of unified snakes began to appear throughout the colonies. These images were more portentous than an ouroboros, most of them displayed in the form of rattlesnakes on military flags. The regiments and fleets of the American army and navy displayed upwards of eight such flags—at least five army flags and three or more navy flags. Since none of the earlier versions of a segmented snake had depicted a rattle on the snake's tail, the image was transformed from a genus in the earlier woodcuts to a species on the flags.[37]

To judge from contemporaneous portraits and commentaries about the military flags, the image of the rattlesnake was exhibited on flags in South Carolina, North Carolina, Virginia, Pennsylvania, and Massachusetts—and possibly in Georgia and Rhode Island as well. All of the navy and army flags depicted the rattlesnake coiled and prepared to strike—except for two navy flags, the Continental Navy Jack and the South Carolina Navy Ensign. These two flags combined the image of an undulating rattlesnake with a motif that stressed the number of distinct colonies in the union. The Continental Navy Jack depicted the rattlesnake on a field of thirteen red and white stripes with the usual admonition, "Don't Tread on Me," while the South Carolina Navy Ensign placed the undulating rattlesnake upon a field of thirteen blue and red stripes with the same warning. Otherwise, the field of these army and navy flags consisted of a single solid color—white, crimson, or yellow—sometimes with an additional image in the upper corner, such as the Union Jack on the Westmoreland County Flag.[38]

All of the flags that had a motto or slogan featured the well-known warning "Don't Tread on Me." This admonition suggested that the British policies were oppressive and that the British were the aggressors, since they had been duly warned and would be harmed only if they stepped on the colonies. The poisonous rattlesnake was deadly, even if it was small. Sometimes this warning was used in combination with regional images and ideas, such as the pine tree on the Massachusetts Navy Flag and "Liberty or Death" on the Culpepper Minute Men Flag. The pine tree had been displayed on the flags of New England since as early as 1704, perhaps to specify a political and commercial concern in Massachusetts. The motto on the Culpepper Minute Men Flag alluded to the famous remark of Patrick Henry on March 23, 1775, when he had advocated establishing a state militia in Virginia. Other slogans and abbreviations on the flags—"Cul-

pepper Minute Men" on one flag and "J.P.I.B.W.C.P." on another, the Westmoreland County Battalion Flag—simply related those flags to a specific group of servicemen: the first regiment of the Virginia Militia and John Proctor's First Brigade, Westmoreland County, Pennsylvania, respectively.[39]

On December 27, 1775, an anonymous writer in the *Pennsylvania Journal* articulated several reasons for using the image of the rattlesnake to represent the British colonies in America. The lengthy article revealed an underlying rationale for a fundamental transformation of the image of the snake. The commentary implied that the image of the rattlesnake was a fitting response to many of the criticisms that had been articulated about the segmented snake. The image of the rattlesnake vitiated the accusations of surreptitiousness that had arisen in the newspaper debate of 1774, because a rattlesnake "never wounds till she has generously given notice, even to her enemy, and cautioned him against the danger of treading on her." That image also mitigated the insinuations that the colonies were instigating seditious behavior, because, according to the writer in the *Pennsylvania Journal*, a rattlesnake "never begins an attack, nor, when once engaged, ever surrenders: She is therefore an emblem of magnanimity and true courage." The image also eliminated the problems that had arisen from the distinction between the head and body, a distinction that in the newspaper debate had been construed as implying that New England was more prominent in the protests than the rest of the colonies were. Instead, the thirteen colonies corresponded to the thirteen rattles on the rattlesnake, a more clearly egalitarian idea than the segmented snake had suggested, because every colony had equal stature as a rattle. In addition, the earlier image had required that the snake be further divided every time another colony joined the intercolonial union. With the rattlesnake it was possible to accommodate the additional colonies through additional rattles. The writer in the *Journal* commented, "I confess I was wholly at a loss what to make of the rattles, till I went back and counted them and found them just thirteen, exactly the number of the Colonies united in America; and I recollected too that this was the only part of the Snake which increased in numbers." Finally, the image of the rattlesnake may have resolved the problems posed by religious interpretations of the snake in the newspaper

debate of 1774, since no rattlesnakes lived in the Old World and since the King James Bible contained not a single reference to rattlesnakes.[40]

Even as the image of the rattlesnake seemed to resolve difficulties, it sustained certain associations that were important to the colonies, such as the independent stature of the colonial governments, although they were united to protect their mutual political interests. The writer in the *Pennsylvania Journal* affirmed, " 'Tis curious and amazing to observe how distinct and independant of each other the rattles of this animal are, and yet how firmly they are united together, so as never to be separated but by breaking them to pieces." Furthermore, the image of the rattlesnake sustained thoughts of wisdom, endurance, and vigilance. The writer in the *Journal* observed, "[T]he antients considered the serpent as an emblem of wisdom, and[,] in a certain attitude[,] of endless duration." He speculated that the rattlesnake "has no eye-lids—She may therefore be esteemed an emblem of viligance."

The rattlesnake on the flags supplemented the meanings of the serpentine imagery that had represented the united American colonies throughout the earlier controversies. The rattlesnake was useful to refute beliefs about the apparent military weakness of the united colonies in comparison with the strength of the British empire. The anonymous writer in the *Journal* observed that the rattlesnake conceals its "weapons" in the roof of its mouth so that it "appears to be a most defenceless animal; and even when those weapons are shown and extended for her defence, they appear weak and contemptible; but their wounds however small, are decisive and fatal." The rattlesnake represented the secret strength and power of the united colonies: Just as a rattlesnake could kill a substantial enemy, so also could the united colonies harm Great Britain if necessary to protect themselves. Among his other speculations, the writer in the *Pennsylvania Journal* asserted: "The poison of her teeth is the necessary means of digesting her food, and at the same time is certain destruction to her enemies—This may be understood to intimate that those things which are destructive to our enemies, may be to us not only harmless, but absolutely necessary to our existence." The writer's remark was vague, but "those things" may have been construed as either colonial rights or liberty, since those interests had become so vital to American colonists and so destructive to the rest of the British empire.

Retribution was implicit in the meanings of the rattlesnake on the flags, since the anonymous writer for the *Pennsylvania Journal* portrayed the snake as acting in defense and retaliation. Hints that the rattlesnake represented colonial retribution against Britain surfaced in an interpretation that the writer in the *Journal* attributed to "a neighbour of mine":

> He instantly declared it as his sentiments, that the Congress meant to allude to Lord North's declaration in the House of Commons, that he never would relax his measures until he had brought America to his feet, and to intimate to his Lordship that were she brought to his feet, it would be dangerous treading on her. —But, I am positive he has guessed wrong, for I am sure the Congress would not condescend, at this time of day, to take the least notice of his Lordship in that or any other way.

The writer attributed these comments to "a neighbour" so that the threat to Lord North could be combined with the insult that North was unworthy of Congress's attention. The rattlesnake represented retribution, since it was a means of retaliation for Lord North's policies governing the American colonies.[41]

Above all, the image of the rattlesnake dramatized a difference between the American and British cultures, since rattlesnakes were indigenous only to the New World. The writer in the *Pennsylvania Journal* observed, "[T]he Rattle Snake is found in no other quarter of the world besides America, and may therefore have been chosen, on that account, to represent her." Portrayal of the united colonies as a rattlesnake allowed no basis for identification with the rest of the British empire, since the image represented a distinctly American form of life. This was therefore the most critical transformation of the snake motif, because it focused the attention of the Americans and the English upon some of the underlying differences between the American and British cultures. Using the formidable rattlesnake as an image for the united American colonies was a vivid expression of a military commitment to rebellion, no longer merely a symbol of protest or defiance.

Although regional pride may have prevented "JOIN, or DIE" from becoming a popular image in the southern colonies, since they were portrayed as

the tail of the segmented snake, the image of the rattlesnake was produced and distributed throughout the southern colonies after 1775, in Georgia, South Carolina, North Carolina, and Virginia, especially on paper currency and colonial flags, but also on the masthead of a newspaper in Virginia and on a gorget in Georgia. After the image of the segmented snake had been changed from the general type of snake into a rattlesnake, and after the correspondence between each of the colonies and a single segment had been replaced with the correspondence between all of the colonies and the rattles, serpentine imagery attained widespread popularity in the South. The specific form of the rattlesnake did vary from state to state: Sometimes the snake was undulating across a striped field; other times it was coiled and prepared to strike; still other times it was entwined around an embodiment of the enemy.

In Georgia, an image of a coiled rattlesnake was circulated in 1776 on the paper currency, the "CERTIFICATE" for "TWENTY SPANISH MILLED DOLLARS" (fig. 7). The rattlesnake's head was raised as though poised to strike, its mouth was open, and its rattle was lifted. Inscribed above the rattlesnake was the Latin motto "NEMO ME IMPUNE LACESSET." This image of the snake was imprinted with blue, maroon, green, or orange ink, depending on the series of paper currency. The motif recurred the following year on Georgia's "CERTIFICATE" for "SEVENTEEN SPANISH MILLED DOLLARS" as well as the colony's "CERTIFICATE" for "FIVE DOLLARS, in CONTINENTAL Currency" on June 8, 1777. The image was circulated yet again in Georgia on May 4, 1778, on the "Twenty Dollars" notes to be paid with money from the "Sale of the forfeited Estates." In addition, one of the military figures of Georgia, John Habersham, of the First Georgia Regiment, evidently wore a gorget engraved with the design of a coiled rattlesnake and "DON'T TREAD ON ME"; such a gorget appears in a portrait of him painted sometime between 1777 and 1779.[42]

In South Carolina, another type of rattlesnake was circulated on the paper for "FIFTEEN POUNDS *Currency*" on March 6, 1776 (fig. 8). This rattlesnake entwined its body around the fleeing British lion, that commonplace representation of British military valor and the king. The lion was powerless, perhaps even cowardly. Above this image was a Latin motto, "MAGNIS INTERDUM PARVA NOCENT." In South Carolina, additional images of a rattlesnake were displayed on the South Carolina Navy Ensign

and the Gadsden Flag, presented by Colonel Christopher Gadsden to the Congress of South Carolina on February 9, 1776.[43]

In North Carolina, a coiled rattlesnake was circulated on the paper currency, the "TWENTY DOLLARS" note issued on April 2, 1776. The body of this rattlesnake was tightly coiled, with the head toward the center of the body, as though prepared to spring toward an unspecified assailant. The admonition "DON'T TREAD ON ME." was inscribed above the snake within a double circle, which circumscribed the entire design. On April 2, 1776, "ONE EIGHTH *of a* DOLLAR" portrayed a snake biting a scabbard, to embody the violence of wartime conflict between America and Britain. Sometime after 1775 in North Carolina, the image of the rattlesnake at the base of a pine tree was displayed on flags in Bladen and Brunswick counties.[44]

In Virginia, a rattlesnake was used on the masthead of Purdie's *Virginia Gazette* from June 7, 1776, until September 19, 1777. The snake was coiled in a single circular loop on a standard held up by two other animals, a bear and a deer. Below the snake was the familiar warning "DON'T TREAD ON ME." Beneath this imagery on the masthead, the editor printed, "*High* HEAVEN *to* GRACIOUS ENDS *directs the* STORM!" By requesting God's guidance during the war, the editor not only invoked the will of God to guide the patriots' actions, he also circumvented reactions to the masthead as the editor's tacit endorsement of wicked, serpentine principles. In Virginia, the image of the rattlesnake was painted on the Culpepper Minute Men Flag, combined with Patrick Henry's remark "Liberty or Death." If southern leaders and image makers had reservations about being represented as the tail on "JOIN, or DIE," they showed no such hesitation about the image of the rattlesnake.[45]

Even as the image of the rattlesnake achieved widespread circulation throughout the South, it retained its popularity in the northern colonies, where it was displayed on the flags and the treasury notes from Pennsylvania and Massachusetts, respectively. In Pennsylvania, the Westmoreland County Battalion Flag depicted the rattlesnake poised to strike at the British Union Jack in the upper corner of the otherwise crimson field. In addition, a portrait of Colonel Walter Stewart of the Second Pennsylvania Regiment had yet another type of rattlesnake imagery on the flag in the background. To judge from that portrait, the Second Pennsylvania Regiment's flag had

a solid white field, a coiled snake at the center, and a blue curve beneath it. The image of the rattlesnake was also painted on some of the equipment for the navy, according to an anonymous writer in the *Pennsylvania Journal* on December 27, 1775, who did not specify the fleet: "I Observed on one of the drums belonging to the marines now raising, there was painted a Rattle Snake, with this motto under it, 'Don't tread on me.' "[46]

On the treasury notes for Massachusetts-Bay, the image of the rattlesnake was circulated in at least three major forms, all of which depicted the rattlesnake biting its tail in the form of a circle to suggest eternity. These images modified the earlier image from the masthead of the *New-York Journal*, since the snake on the treasury notes was no longer a genus, some general type of snake with a tapered tail. Instead, it was a species with a clearly visible rattle. On one series of treasury notes, used in Massachusetts as early as June 1, 1777, and as late as January 17, 1778, Nathaniel Hurd engraved a design by Paul Revere within the circle formed by the rattlesnake's body: a minuteman with a sword in one hand and a copy of the declaration of "Independence" in the other. Alongside the minuteman was the Latin motto "EINSE PETIT PLACIDANSUB LIBERTATE QUITEM."[47] A second type of imagery on the treasury notes was printed in 1777, but it may never have been used within the community. Within the circle formed by the rattlesnake's body, a lion and a horse were tied by ropes to the trunk of the pine tree—possibly a flawed allusion to the lion and unicorn on the Royal Arms. If so, the lion and horse may have signified colonial victories over British forces.[48] On the third series of treasury notes, variants of which were used as early as December 1, 1777, and as late as February 5, 1780, the image of a lone pine tree was inserted within the circle formed by the rattlesnake's body (fig. 9).[49]

The pine tree—a symbol long associated with Massachusetts-Bay— had a connotation of royal privilege, because British laws had restricted the harvest of white pine trees since 1691. By law, these tall, durable trees were reserved for the masts of vessels in the king's navy, even though the colonists believed that there were far more pine trees than necessary for the king's navy and that a valuable market for them existed in the West Indies. The pine tree, inserted within the circle formed by the rattlesnake's body, specified a political grievance against the policies of the British government. At the same time, the pine tree specified a potential source of wealth and

industry for the colonists, if they could successfully free themselves from imperial rule.[50]

Even though the image of the rattlesnake seemed to resolve most of the difficulties that had become associated with "JOIN, or DIE" during the newspaper debate of 1774, Loyalists continued to discredit the image used by their political adversaries. In New York, James Rivington's *Royal Gazette* printed letters from readers professing to report their dreams about rattlesnakes in the political life of the colonies. On January 23, 1779, "A Dreamer" narrated a nightmare in which a court of justice condemned several colonial leaders in the Continental Congress to become animals. President John Jay's alleged crime was serpentine: He was guilty of deception. Accordingly, the court ordered him to "transmigrate into the most insidious and most hateful of animals, a Snake; but to prevent his being able any longer to deceive, and thereby destroy, a large set of Rattles was affixed to his tail that it might warn mankind to shun so poisonous a being."[51] In this dream, the snake's rattle—which the *Pennsylvania Journal* had described previously on December 27, 1775, as an emblem of courage and justice, because it warned the enemy in advance—was appropriated and redefined as a punishment by a court of justice for past deceptions, a punishment that would prevent others' being duped in the future.

In a subsequent issue, on January 30, 1779, the *Royal Gazette* printed another dream about political rattlesnakes, this one reported by "Somnolentus," who began by referring to the previous article. "Last Night [while I was] reading the Dream in Saturday's Gazette, I was amused and tickled by several passages; and began to consider, what character some personages still acting on the political stage, might assume if transformed in a like manner." At that moment, Somnolentus claimed, he became drowsy and fell asleep, only to have a dream of his own. Somnolentus reported how certain leaders became transformed into various animals, and he concluded, "I heard the sound of rattles, and being informed it was some of the *Congress*, changing into *Rattle-Snakes*, like their President, the fear and abhorrence one naturally feels at such noxious reptiles, operated so strongly on my nerves that I awoke, and thought my dream so remarkable, that I wrote it down."[52]

A Loyalist writer from Massachusetts, Peter Oliver, described the political opposition in Massachusetts repeatedly with images of rattlesnakes and serpents. In his *Origin & Progress of the American Rebellion*, written in 1781, Oliver described John Hancock, "attached to the hindermost Part of Mr. *Adams* as the Rattles are affixed to the Tail of the Rattle Snake." As for Samuel Adams, in Oliver's estimation, he "was all serpentine Cunning." To Oliver, Samuel Cooper was also "serpentine," a man who knew no equals in deception, since "No Man could, with better Grace, utter the Word of *God* from his Mouth, & at the same Time keep a two edged Dagger concealed in his Hand. His Tongue was Butter & Oil, but under it was the Poison of Asps." On the whole, Peter Oliver averred, "*Massachusetts* had too much of the Cunning of the Serpent, to leave any Insinuation unapplied to bring the rest of her Sisters into the same Condemnation with herself, & involving them in the Guilt of the same Rebellion."[53]

Loyalists attested to the emotional power of the image of the rattlesnake, which elicited such powerful feelings as abhorrence. To these Loyalists the image remained vile and treacherous. They denied altogether the favorable characteristics described by the Patriot writers and instead associated the rattlesnake with the treachery and deceptions of despised leaders within the Congress. Above all, the Loyalists sought to restrict the meanings of the rattlesnake by referring to political leaders and the Congress, because they were convinced that those in the Congress did not represent the sentiments of the colonists. To the Loyalists, the Congress merely represented the views of a potent and treacherous faction within America. By then, however, the image of the rattlesnake had migrated to England, where it represented not merely a faction within America but rather the body politic of the united colonies. Moreover, in America other colonists began to employ the image in engraved portraits and oil paintings to suggest the patriotism of military, political, and diplomatic leaders.

By 1780, the meanings of the serpentine imagery had become completely inverted in America, as may be illustrated by the portrait engravings and paintings. In 1781 an obscure engraver, Richard Brunton of Connecticut, designed a frontispiece for an American reprint of Charles Wharton's *Poetical Epistle to his Excellency George Washington, Esq.* The portrait of "GEORGE WASHINGTON Comander and Chief of ye Armies of ye UNITED

STATES of AMERICA" was atypical of Brunton's other engraved prints, since the rest were for the most part ornamental and decorative designs. The rattlesnake rested on the upper part of an oval that framed Washington's face and upper torso. The snake's long body was coiled about a liberty pole surmounted by a liberty cap. "DONT TREAD ON ME," printed in bold at the top of the rectangular outer frame, echoed the familiar warning.[54]

The portrait of Washington was not altogether idiosyncratic, however, because it was derived from a similar portrait engraved by William Sharp for an earlier version of the same pamphlet, printed in London in 1780, and, more important, because other American engravers and painters had also integrated serpentine imagery in portraits of military heroes. Another portrait of Washington, engraved and published in Boston by John Norman and Thomas Bedwell, also associated Washington with the image of the snake. In the broadside *"PHILADELPHIA ALMANACK for the YEAR of Our Lord 1780"* George Washington's portrait rested within an oval above the body of one long, undulating snake. Another snake, an ouroboros, encircled a design to the right of Washington. The bodies of a third and a fourth snake appeared to the left of Washington, one biting its tail to signify eternity, the other coiled within the circle formed by its companion.

Artists also included the image of the snake in oil paintings of other military figures. For instance, John Habersham served in the First Georgia Battalion or Regiment throughout the Revolution, initially as a captain and subsequently as a major. In a portrait of him rendered sometime between 1777 and 1779, he wore a gorget engraved with a coiled rattlesnake and the motto "DON'T TREAD ON ME." An image of a rattlesnake also appeared in Charles Willson Peale's portrait of Colonel Walter Stewart, who served as commander of the Second Pennsylvania Regiment in 1777 and 1781. Near the largest of the white tents in the background was a white flag with a coiled rattlesnake in the center and a blue curve beneath it, probably inscribed with the familiar warning.[55]

Similarly, the imagery of rattlesnakes appeared in portraiture of individuals who were political leaders, not military figures, such as John Norman's portrait of "The Honble. SAMUEL ADAMS, Esqr. First Delegate to Congress for Massachusetts," published in *An Impartial History of the War in America* in 1781. Beneath the image of Samuel Adams were a scale

hanging from an olive branch to signify justice in peace and a rattlesnake gazing into a mirror, perhaps an image of Adams as a man of reflective action, perhaps an image signifying that Adams mirrored the character of America in his speeches and writings.[56]

By 1780 the snake had become an emblem appropriate in the apotheosis of military and political figures such as George Washington, John Habersham, Walter Stewart, and Adams—especially striking since colonial and British illustrators possessed a tradition of engraved portraits wherein killing or trampling a snake represented the triumph of virtue. Such devices were engraved on the decorative frames for the portraits of Patriots and their British defenders such as Samuel Adams, James Otis, John Hancock, and John Wilkes. In America, the meanings of the image had become completely inverted within a decade: A symbol of guile had been transfigured into a symbol of patriotism to the United States. Under some circumstances, serpentine values had their merits.[57]

By 1780, the image of the snake seemed well established as a representation of the United States, but after 1783 the image was employed to denote the United States only rarely in America. The process of replacing the rattlesnake with the eagle appears to have been under way by 1782, since George Washington's life guards carried a flag with the motto "Conquer or Die"— reminiscent of "JOIN, or DIE," but with the image of an eagle instead of a rattlesnake. During May 1789, the image of the snake was engraved on a flag in the print "*An East View of GRAY'S FERRY near Philadelphia with the* TRIUMPHAL ARCHES & c. *erected for the Reception of General Washington, April 20th, 1789.*" In 1802 the image of a snake appeared inconspicuously in John James Barralet's "Apotheosis of George Washington." The placement of the snake behind the eagle may have suggested that it had been supplanted by that official emblem. Finally, the War Department Seal, which was used during the war as early as 1779 and was still in use in 1931, was the last known appearance of the image of the snake as an emblem of the United States, except for reproductions in histories of the American Revolution.[58]

The image of the snake rarely represented the United States after 1783, but it did recur frequently as an emblem of political faction, espe-

cially during campaigns for the presidency. For example, in an anonymous print, "THE PROVIDENTIAL DETECTION," published sometime between 1797 and 1807, a snake and an eagle were contrasting pictorial elements (fig. 10). The eagle, which had been selected for the national emblem on June 20, 1782, prevented Thomas Jefferson from destroying the United States Constitution on an "ALTAR to GALLIC DESPOTISM." In contrast, the snake coiled its body around the altar, in proximity to a series of skulls and crossbones. The eagle was associated with the salvation of the Constitution from the fire on the altar, while the snake was associated with its destruction and with Satan himself. Simply put, the illustration expressed "the Federalist belief that if Jefferson became President, his radical thinking would endanger the Constitution."[59]

Such serpentine imagery recurred in a political illustration dated 1807, "LOOK ON THIS PICTURE, AND ON THIS," which contrasted George Washington and Thomas Jefferson. Washington was depicted under a laurel halo that emitted rays of light. Under his image were books labeled "Order," "Law," and "Religion." On each side of the books were a lion and an eagle, the images of the British empire and the United States, probably to portray the diplomatic relationship between them. In contrast, the portrait of Thomas Jefferson, who had a dour look on his face, was placed under a smoldering candle. Beneath his portrait were volumes labeled "Sophisms," "Notes on Virginia," "Tom Paine," "Condorcet," and "Voltaire," figures and ideas often distrusted as radical. On each side of the volumes were a coiled snake and an alligator. While Washington was associated with virtuous symbols, Jefferson was associated with wicked ones.

The image of the snake was not, then, an emblem of the United States after the war for independence. Rather, the snake once again depicted a political faction. As important, it was placed in distinct opposition to the official national emblem. Indeed, these illustrations depicted the snake and the eagle as antithetical principles engaged in the fundamental struggle between evil and good. Perhaps the image of the eagle supplanted the image of the snake to suggest a change in Americans' perception of their circumstances: After the United States achieved political independence from Britain, it was no longer necessary for the citizens of the United States to value the qualities of a serpent.[60]

THE IMAGE OF THE SNAKE IN BRITAIN

During the early stages of the French and Indian War, on May 8, 1754, the evening before "JOIN, or DIE." was to be distributed for the first time in America through the *Pennsylvania Gazette*, Benjamin Franklin enclosed a copy of the image of the segmented snake in a letter to Richard Partridge, who had been Pennsylvania's agent in London since 1740: "With this I send you a Paragraph of News from our Gazette, with an Emblem printed therewith, which it may be well enough to get inserted in some of your most publick Papers." Franklin asked Pennsylvania's agent in London to distribute the image of "JOIN, or DIE." in Britain. There, the political circumstances in the British government were unlikely to have made government officials receptive to the image. If Partridge had distributed the image of the snake in the "most publick Papers," as Franklin requested, it would have evoked fundamental apprehensions in British political life, precisely because it made visual a desire for intercolonial unity.[61]

In 1754 British concerns about intercolonial union were characterized by ambivalence, as they had been periodically since the early days of the settlement. As early as 1633, George Downing had sought to silence British anxiety about the prospect of colonial independence for New England, when he categorically denied that New England would renounce Charles I: "[I]t is a causeless fear without precedent that a colony planted in a strange land was ever so foolishly besotted as to reject the protection of their natural prince." Yet British apprehensions of American independence recurred throughout the century because such independence could someday be in the colonies' own best interests. As John Trenchard and Thomas Gordon observed on December 8, 1722, in *Cato's Letters, Or, Essays on Liberty*, a series of well-known letters published originally between 1720 and 1723, "The Interest of Colonies is often to gain Independency; and is always so when they no longer want Protection, and when they can employ themselves more advantageously than in supplying Materials of Traffick to others: And the Interest of the Mother-Country is always to keep them dependent, and so employed."[62]

In 1754, among some of the highest officials in the British government, a fundamental ambivalence arose from incompatible concerns about

promoting intercolonial unity for defense against the French and the Indians or sustaining disunity among the colonies to maintain British domination over them. On the one hand, government officials believed that intercolonial unity could improve the British government's ability to defend the colonies from foreign incursions, since unity could enable the government to draw upon resources in relatively unthreatened colonies to protect those endangered by foreign encroachment. Certain British officials, especially those on the Board of Trade, believed that intercolonial unity could facilitate the administration of the colonies. On the other hand, some officials observed, colonial unity could harm the British government's ability to control the colonies, since unified colonies could become a political force within the empire.[63]

Some of the highest British officials discussed these conflicting concerns in August and September of 1754, even before they received the colonists' proposal for the Albany plan. Discussions among the leading minister and his advisers considered the evident advantages of intercolonial union for defense against the incursions of the French and the Indians, but the plans for union foundered when the Speaker of the House of Commons expressed one of the concerns about union to Newcastle on September 9, 1754: A bill for colonial union would encourage debate over the "ill consequences to be apprehended from uniting too closely the northern colonies with each other, an Independency upon this country to be feared from such an union." Because a debate in the House would expose British apprehensions of colonial independence, and because no clear consensus emerged from the discussions among the leading officials, the plans for colonial union were finally set aside, thus explaining Newcastle's inattention in October to the plans for union produced by the colonists at the Albany Congress.[64]

In 1755 Henry McCulloh, a Scotsman who had devoted many years to government service in South Carolina, endeavored to link the French threat to the dangers of colonial union. In *The Wisdom and Policy of the French in the Construction of Their Great Offices*, McCulloh ascribed certain disquieting information to an unnamed French officer, who alleged that a French scheme existed "to use their utmost endeavours to make themselves Masters of the *English* Islands in the *West-Indies*, and to encourage the *English* Colonies on the Continent of *America* to unite and form a Republican

Government; . . . Such Schemes appear at present to be wild and extravagant, yet there are many things in the Womb of Time, which may favour the ambitious Views of *France* in such Enterprises." Unless the British government impeded such French maneuvering, McCulloh worried, one of the consequences would be the "Foundation for a kind of Independency of the Colonies on the Continent of *America*."[65]

Those who felt such anxiety could not be assuaged by the image of the segmented snake, "JOIN, or DIE." Although the image urged united colonial action against the French and the Indians, not the British, it was nevertheless likely to arouse apprehensions, because it seemed to propose intercolonial unity apart from the rest of the British empire. Indeed, such apprehensions were evoked inadvertently by Governor William Shirley of Massachusetts in 1754—the same year that Franklin advised Partridge to distribute "JOIN, or DIE" in Britain. Although Shirley seemed to be proposing intercolonial unity to protect the colonies from the French and the Indians, he contributed to apprehension in the highest levels of government when he remarked, "Such an Union of Councils besides the happy Effect it will probably have upon the Indians of the Six Nations may lay a Foundation for a general one among all His Majesty's Colonies, for the mutual Support and Defence against the present dangerous Enterprizes of the French on every Side of them." Did Shirley intend for the Albany Congress to provide a means to institute a mechanism for united colonial action in future years? Or were his concerns a more limited effort to provide a means to reallocate funds and military forces among the colonies in the event of an attack? The British cabinet held a meeting on June 13 to consider the implications of Shirley's comments about a colonial union.[66]

In such a political environment, wherein apprehensions of intercolonial unity and American independence had become a concern, those who attempted to refute or deny the possibility of independence may have inadvertently contributed to the concerns about such a separation. In 1760, for instance, Benjamin Franklin described the colonies to assuage British concerns about the prospect of American independence:

> I shall next consider the other supposition, that their growth may render them *dangerous* [to Britain]. Of this I own, I have not the least conception. . . . Those [colonies] we now have, are not only under different

governors, but have different forms of government, different laws, different interests, and some of them different religious persuasions, and different manners. Their jealousy of each other is so great that however necessary an union of the colonies has long been, for their common defence and security against their enemies, and how sensible soever each colony has been of that necessity, yet they have never been able to effect such an union among themselves, nor even to agree in requesting the mother country to establish it for them. . . . If they could not agree to unite for their defence against the *French* and *Indians*, who were perpetually harassing their settlements, burning their villages, and murdering their people; can it reasonably be supposed [that] there is any danger of their uniting against their own nation, which protects and encourages them, with which they have so many connections and ties of blood, interest and affection, and which 'tis well known they all love much more than they love one another?[67]

Yet this series of commonplace arguments, which denied the prospect of American independence, implicitly articulated some conditions under which independence could occur.

Before the Stamp Act controversy of 1765 some influential political advisers urged Parliament to refrain from any actions that could unify the British colonies in America. For instance, Thomas Pownall's *Administration of the Colonies*, a pamphlet that underwent six editions between 1764 and 1767, was emphatic that the colonies "*must be guarded against having, or forming, any principle of coherence with each other above that, whereby they cohere in this center* . . . they should always remain incapable of any coherence, or of so conspiring amongst themselves, as to create any other equal force, which might recoil back on this first mover." He added, "[I]t is essential to the preservation of the empire to keep them disconnected and independent of each other: they certainly are so at present." Pownall recommended as a fundamental administrative principle that "the colonies in their government and trade, should all be united in communion with and subordinate to the government of the mother-country, but ever disconnected and independent of each other by any other communion than what centers here."[68]

After Pownall urged Parliament to uphold the principle of British

strength by maintaining its central authority and by sustaining the colonies' disunity, except through their relationship to Parliament, Pownall assured his readers that the likelihood of an intercolonial union was nominal. He alluded to

> the different manner in which they are settled, the different modes under which they live, the different forms of charters, grants and frame of government they possess, the various principles of repulsion,—that these create the different interests which they actuate, the religious interests by which they are actuated, the rivalship and jealousies which arise from hence, and the impracticability, if not the impossibility of reconciling and accommodating these incompatible ideas and claims. . . . And nothing but a tampering activity of wrongheaded inexperience misled to be meddling, can ever do any mischief here.[69]

While Pownall believed that Parliament should be careful to prevent the development of intercolonial unity in America, he assured his readers in 1764 that the possibility of such unity was remote. Only a year later, in 1765, despite Pownall's advice in *The Administration of the Colonies*, Parliament's Stamp Act adversely affected all British colonies in America and therefore constituted an issue that unified them in opposition to the British government. The tax law created precisely the sort of shared grievance that Pownall had cautioned the government to avoid because it could unify the colonies in a political struggle with Parliament.

During the ensuing controversy over the Stamp Act of 1765, British concerns about colonial union were articulated in descriptions of "JOIN OR DIE," which had been appropriated for the masthead of the *Constitutional Courant* in September 1765. Shortly after the publication of the *Courant*, prominent American officials wrote to Benjamin Franklin in London to alert him to the radical usage of "JOIN OR DIE," perhaps because they anticipated the British reactions to the image of the snake, or perhaps because they associated the image with the one in Franklin's *Pennsylvania Gazette* a decade earlier. Enclosing a copy of the *Courant* with "JOIN OR DIE" on the masthead, the acting governor of New York, Cadwallader Colden, wrote to Franklin on October 1, 1765:

Sir,

My regard to you makes me give you the trouble of the inclosd Printed
Paper, one or more bundles of which, I am well informd, were deliver'd
to the Post Rider at Woodbridge [New Jersey] by James Parker, were dis-
tributed by the Post Riders in several parts of this Colony [New York],
and I beleive likewise in the Neighbouring Colonies: the doing of which
was kept Secret from the Post Master in this Place. It is beleived that
this Paper was Printed by Parker after the Printers in this Place had re-
fused to do it, perhaps you may be able to Judge from the Types. As he
is Secrettary to the General Post Office in America, I am under a neces-
sity of takeing notice of it to the Secrettary of State by the return of the
Packet which is daily expected, and I am unwilling to do this without
giving you previous notice by a Merchant Ship which Sails Tomorrow.[70]

The letter depicted the publication of the *Courant* as a secretive and seditious
act. It also suggested to Franklin some potential for political embarrass-
ment, possibly because Franklin was deputy Post Master under the Crown
and his personnel had been implicated in the printing and distributing of
the *Courant*, possibly because Franklin himself had designed the emblem
that appeared so prominently on the masthead of the seditious publication.
In London, where Franklin was serving as a colonial agent, he received
another letter dated November 18, 1765, from the lieutenant governor of
Massachusetts-Bay, Thomas Hutchinson, who also informed Franklin
about the radical appropriation of "JOIN OR DIE" and who connected the
motto to Franklin's design before the Albany Congress of 1754. Not one,
but two high-ranking colonial officials informed Franklin that "JOIN, or
DIE" had been appropriated for radical purposes.[71]

Franklin himself sought insofar as possible to circumvent the radical
implications of "JOIN OR DIE" by designing and distributing a different
image of the British empire represented as one body politic, an image
commonly known as "MAGNA *Britannia: her Colonies* REDUC'D." This im-
age depicted the colonies as parts, or limbs, of Britannia. The separateness
of the colonies, not only from England but also from each other, was
emphasized by labeling Britannia's four severed limbs "Virg-," "Pennsysl,"
"New York," and "New Eng." These colonial parts were subordinate to
Britain, since the colonies constituted the extremities, while Britain was the
head and torso. Yet because together the parts formed one body, the print

underscored the interdependence of the colonies and England and so iden-tified the cause of one with the cause of the other. This image of the empire portrayed perfectly the relationship of the colonies that Pownall had envi-sioned earlier in *The Administration of the Colonies*.

Both "JOIN OR DIE" and "MAGNA *Britannia*" showed each colony as a part of a larger unity. The colonies were separated even among them-selves. But while the implied need to unify the snake was restricted only to the colonies, the implied need to unify Britannia entailed the union of the colonies with the entire British empire. While the segmented snake ob-scured any relationship of the colonies to England, Britannia's severed body emphasized colonial interdependence with Britain. Indeed, the colonies could form a union only through Britannia's body. Most important, while the segmented snake could act independently if they united themselves, Britannia's severed body implied that autonomous colonial action was im-possible. "MAGNA *Britannia*" was, in part, an attempt to mitigate the radical implications of "JOIN OR DIE" as interpreted by a British public.[72]

Although Franklin distributed "MAGNA *Britannia*" in Parliament to urge the repeal of the Stamp Act, to create an ethos of responsible colonial opposition to the British law, and to repudiate the radical appropriation of "JOIN OR DIE," the image of the snake had already taken on a life of its own in British politics. Early during the Stamp Act controversy, at least two British publications had described "JOIN OR DIE" as a radical threat to British rule. "Rationalis" brought the image of the snake to the attention of the British public by commenting about it in the *Public Ledger* of London on November 16, 1765. Subsequently, this commentary about "JOIN OR DIE" was sent to America, where excerpts were reprinted in the *Pennsyl-vania Journal* on February 20, 1766. Rationalis described the snake device on the *Constitutional Courant* by emphasizing its ominous implications:

A printed paper is just now fallen into my hands, from North America; the Title of which is, THE CONSTITUTIONAL COURANT: *containing matters interesting to Liberty, and no wise repugnant to Loyalty*. It is dated, Saturday, September 21, 1765, and marked No. 1. printed by *Andrew Marvel*, at the sign of the Bribe-refused on Constitution-Hill, North America: and is a half sheet, containing an introduction and two political pieces, with an ill-executed stamped emblematical device in the middle

of the front, representing a writhing serpent divided into eight parts, marked with the following initials, NE, NY, NJ, P, M, V, NC, SC, and over all these words, JOIN OR DIE.

Rationalis went on to suggest how a contemporary British public would have interpreted the *Courant*:

> From the extraordinary publication which I have mentioned, . . . and indeed from all intelligence we receive from that quarter of the world, we must have reason to believe, that union is forming, which, according to the wisest opinions, it must ever be for our greatest interest and security [to] give no cause for being effected, and therefore the policy must have been erroneous which has contributed thereto.[73]

The article criticized the Stamp Act for inadvertently promoting an intercolonial union, which could threaten the British empire's political stability. To Rationalis, the intercolonial union advocated with "JOIN OR DIE" could jeopardize the British government's ability to control its dominions in America.

The Annual Register . . . for 1765 also described "JOIN OR DIE" on the *Constitutional Courant*—the only American publication to receive attention in the *Register* that year—when it reported that subsequent to the passage of the Stamp Act:

> Essays soon followed, not only against the expediency, but even the equity of it, in several news-papers, one of which bore the significative title of "The Constitutional Courant, containing matters interesting to liberty, and no wise repugnant to loyalty, printed by Andrew Marvel, at the sign of the Bribe refused, on Constitution-Hill, North-America;" and wore a still more significative headpiece; a snake cut in pieces, with the initial letters of the names of the several colonies, from New-England to South-Carolina, inclusively, affixed to each piece, and above them the words JOIN or DIE. To these were added caricatures, pasquinades, puns, bons mots, and such vulgar sayings fitted to the occasion, as by being short could be more easily circulated and retained, at the same time that, by being extremely expressive, they carried with them the weight of a great many arguments.[74]

Edward Barnard regarded these comments as a summary of British responses to the publication of "JOIN OR DIE" during the Stamp Act

controversy, because in 1782 he reprinted these comments from *The Annual Register* in his history, *The New, Comprehensive and Complete History of England.*[75]

By 1766, the anxiety in Britain about colonial union had changed to consternation, as when Nicholas Ray argued in *The Importance Of The Colonies of North America, And the Interest of Great Britain with regard to them, Considered,* "[O]ur greatest Security and Power over them, must consist in their Disunion as Colonies; but unhappily the Stamp Act has absolutely driven them to cry out for Union, and accordingly their Councils are now united in a Congress at *New York.* They will now feel their Power, and become sensible of the *Dutch* Motto, that *Unity Gives Strength.*"[76]

Within a year after the Americans had begun to display the image of the rattlesnake on the army and navy flags of the united colonies, the image migrated to Britain and France, where the English and the French began to use it in portraits, caricatures, and a Wedgwood intaglio seal. The image of the rattlesnake was reproduced through various media, such as diplomatic correspondence and a newspaper article from the *Pennsylvania Journal* on December 27, 1775. In England, the *London Chronicle* of July 25–27, 1776, reprinted substantial excerpts from the *Journal* to explain the image of the rattlesnake to British readers. The day after the *Pennsylvania Journal* had published the lengthy commentary about the image, Achard Bonvouloir—the secret diplomatic agent for France, who had arrived recently in Philadelphia—reported that the colonies "have given up the English flag, and have taken for their devices a rattlesnake with thirteen rattles, and mailed arm holding thirteen arrows." The American commissioners in Paris, Benjamin Franklin and John Adams, wrote to Congress to request information about the colors of the United States, and they subsequently described some of the flags, among them the South Carolina Navy Ensign, in a letter to the ambassador of Naples: "Some of the States have vessels of war distinct from those of the United States. For example, the vessels of war of the State of Massachusetts-Bay have sometimes a pine tree; and those of South Carolina a rattlesnake, in the middle of thirteen stripes."[77]

Images of a rattlesnake recurred on the printed portraits of American military and diplomatic leaders, notably on portraits of Commodore Ezek Hopkins and General George Washington that were produced and distrib-

uted on prints in France and Britain. Between 1777 and 1783 at least a dozen British cartoons portrayed the colonies as a rattlesnake, often allied with the French cock in a struggle with the British lion. About the same time, to judge from the variety of extant copies, several versions of "Tu la voulu," a popular print, were widely distributed in France under such other titles as "OMNE ANIMAL POST COÏTUM TRISTE PRÆTER GALLUM," "MAGNIFICAT," and "Ô qu'el d'Estain." Although the image of the rattlesnake of America would seem to have elided the religious connotations with evil, because rattlesnakes were indigenous only to the New World and because there were no biblical allusions to rattlesnakes, some British citizens interpreted the image in the light of Judeo-Christian descriptions of the serpent.[78]

In Britain, the image of the rattlesnake continued to evoke treachery, as it had among Loyalists in the American colonies, but the British prints did not distinguish among political factions within America. One exception was "A Political Concert," published in England on February 18, 1783, which recognized rival political factions within America when it alluded to Benedict Arnold as "Benidick Rattle Snake" and portrayed him with a serpentine head and tail. Yet even here the most salient implication of the imagery was treachery. The emphasis on treachery was manifested again in "AN EXTRAORDINARY Gazette, or the DISAPOINTED POLITICIANS," with snakes infesting "A MAP of AMERICA" in the background. With the migration of the image to Britain, the distinctions among rival factions within the colonies became obscured in the larger concern about international conflicts.

One of the earliest appearances of the rattlesnake flags in Britain, if not the first, was in a printed portrait titled "COMMODORE HOPKINS, COMMANDER IN CHIEF of the AMERICAN FLEET" (fig. 11). The mezzotint, executed by Jon. Martin Will and published by Thomas Hart on August 22, 1776, depicted Hopkins in his uniform with ships in the background. Behind Hopkins was a striped navy flag with an undulating rattlesnake and the motto "Dont Tread on Me"—either the Continental Navy Jack or the South Carolina Navy Ensign. Near his other side was one of the New England flags decorated with a tree and the mottoes "LIBERTY TREE" and "An appeal to God." The image of the rattlesnake recurred in France in another printed portrait of Hopkins, titled "HOPKINS COMMANDANT EN

CHEF la Flotte Américaine." Although the composition of this portrait differed from the British print, it was probably derived from the print, since it had a mirror image of Hopkins's head and torso within an oval frame and the same flags appeared at the base of the oval.[79]

The rattlesnake also occurred in a series of similar portraits of General George Washington, derived from paintings by John Trumbell and Charles Willson Peale. In Britain sometime in 1780, William Sharp designed the earliest of these prints for the frontispiece of Charles Wharton's *Poetical Epistle to his Excellency George Washington, Esq.*, published in London in 1780. The image of Washington appeared within an oval, at the top of which was a rattlesnake coiling its body about a liberty pole surmounted by the liberty cap. Beneath the oval and to Washington's left was a flag with thirteen stars. Such imagery associated the general with the American cause, as did the title of the print, "GEORGE WASHINGTON Commander and Chief of ye Armies of ye UNITED STATES OF AMERICA." Later, in 1783, Sharp's portrait of Washington was reproduced in *The Constitutions of the Several Independent States of America*.[80]

William Sharp's frontispiece of Washington was copied by at least two other engravers, who produced slightly modified variants of it for distribution in France and America. Noel Pruneau produced a mirror copy of it for distribution from Paris sometime in 1780 or shortly later.[81] Pruneau simply reversed and refined the imagery of the composition in Sharp's portrait. The title was translated from English into French, "GEORGE WASHINGTON commandant en chef des armées des Etats-unis de l'Amérique." In America Richard Brunton engraved yet another copy of Sharp's frontispiece, this one for an American edition of Wharton's poem. The copies by Brunton and by Pruneau both employed the image of the rattlesnake, but Pruneau omitted the motto "Don't Tread on Me." This series of portraits was of some international significance, since variations of it were produced and distributed in Britain, France, and the United States.

Through its appearances in the portraiture of prominent military and diplomatic leaders, the image of the rattlesnake became internationally recognized as a symbol of the emerging nation. To the British viewers, the image was not one of patriotism, since these leaders, notably Ezek Hopkins and George Washington, were engaged in a political and military struggle to separate from Britain. Rather, the rattlesnake was an outward sign of

American treachery. In France, however, the image of the rattlesnake was presented in a manner that supported favorable interpretations. For example, in 1778 Joseph Siffred Duplessis created a portrait of Benjamin Franklin to be exhibited in Paris at the Salon in 1779 (fig. 12). The portrait was placed within a wooden rattlesnake frame to associate the famous American diplomat with the United States. "VIR," a word denoting man with the attributes of virility and virtue, was painted on this frame.[82]

In Britain, the rattlesnake represented the united American colonies in numerous caricatures that amplified upon American treachery in dealing with Britain. Around December 1777, a striped rattlesnake flag was used beside a British Union Jack as the hair decorations for a formidable woman in "THE TAKEING OF MISS MUD I'LAND," published by W. Humphrey in London. The woman seems to have used her bare bosom to attract the men on the ships within firing range. With her breast still exposed, she lifted her skirt to reveal the deadly cannon astride which she sat. A stream of smoke from the mouth of the cannon indicated that it was being fired toward the British fleet in the Delaware River near Mud Island. She was therefore identified with the American cause, even though her hair decorations associated her as much with the British as with the Americans. Perhaps the placement of the Union Jack in her hair was further evidence of her perfidy. Despite the woman's deceitful use of the flag and her exposed bosom, the British fleet under Howe's command prevailed over the Americans: The print celebrated the British victory at Mud Island.

The colonies were presented as a unified snake again in the rebus "[Britannia to America]," published in London by Matthew Darly on May 6, 1778. Darly's caricature was a satire on the mission of the peace commissioners who had been sent to America with conciliatory propositions in the spring of 1778, after France had acknowledged the United States as an independent state in a treaty on February 6, 1778. An ouroboros represented colonial union in the sixth line from the bottom. The placement of this snake biting its tail in a pictorial and verbal puzzle would have engaged viewers unfamiliar with the image of the snake in an effort to articulate its significance. The sentence has been interpreted "IC [I see] he [the Frenchman] w[ants] toe b[ring] on an enm[eye]ty [toe] [awl] [a snake with its tail in its mouth ? union] [bee]tween [yew] & [eye]." This expressed a

68

British concern that America could be deceived by the French into betraying the "[Moth]er."[83]

Many of the British prints combined the rattlesnake motif with other animals that represented political leaders or European countries. For instance, in "THE FLIGHT of the CONGRESS," published by William Hitchcock in London on November 20, 1777, the American leaders were drawn as animals "routed out from the 'Cave of Rebellion' by the British Lion. The ass [was] labeled 'Hancock,' the boar 'Putnam,' the fox 'Adams,' and the armadillo 'Washington.' " The script beneath the print stated that these animals were "herding underneath the Tree, / Of Treason, alias Liberty." The creatures were conspiring against the king, but

> Their foul revolt, their Monarch hears,
> And strait upon the plain appears
> Aloud the British Lion roars
> Aloft the German Eagle soars;
> When Lo! midst broken Oaths and curses,
> The Rebel rout at once disperses.

Even as the creatures scattered in the presence of the lion, an owl flew off to "Paris," probably Franklin in search of assistance from France. A rattlesnake, inscribed with the word "Independence," dangled helplessly from the beak and talons of the German eagle to suggest the fate of those colonies that had conspired against the British empire.[84]

On June 14, 1782, "*The* BRITISH LION *engaging* FOUR POWERS," published by J. Barrow and sold by Richardson in London, depicted the American rattlesnake in alliance with the enemies of England: the French cock, the Spanish spaniel, and a Holland pug dog (fig. 13). This gang of creatures all confronted the lone British lion. The rattlesnake affirmed, "I will have America and be Independent." Undaunted by the alliance, the British lion commented, "You shall all have an old English drubbing to make you quiet." The verse beneath the print echoed the lion's confidence:

> Behold the Dutch and Spanish Currs,
> Perfidious Gallus in his Spurs,

And Rattlesnake with head upright,

The British Lion join to fight;

He scorns the Bark, the Hiss, the Crow,

That he's a Lion soon they'll know.

Although the snake openly announced its motivations, it displayed its treachery just the same by acting in concert with Britain's rivals and enemies in Europe.

On May 8, 1783, J. Barrow published another print titled with a rebus, "The [Ass]-headed and [Cow-Heart]-ed Ministry making the British [Lion] give up the Pull." The same menagerie was engaged in a tug-of-war with the British lion, beleaguered by its own public officials. The lion condemned the leaders in the British government: "Who leads a Lion, should himself be bold, / But you are Dastards, and it shall be told." Even the enemies credited the British leaders with their modicum of success. The Spanish spaniel confessed, "He is stronger than Gibraltar, but happy for us he is intangled by his leaders." The Gallic cock concurred, "The old Raskel's Roast Beef keeps him too strong for us all; but his leaders are Asses." The Holland pug dog whined, "I wish I could have stood Jack on both sides and smok'd my pipe." The rattlesnake commented with the sly insight of a statistician, "The harangues of the British Patriots help me more to Independancy than 40000 Men."

On rare occasions a British print portrayed the rattlesnake alone in its battle with British forces, or allied with a human representation of France. A British cartoonist, probably James Gillray, depicted the colonies as *"The AMERICAN RATTLE SNAKE"* on April 12, 1782, about a year before the conclusion of peace negotiations. The lone snake's reticulate body was coiled about the surrendering British forces of Burgoyne and Cornwallis. The snake gloated, "Two British Armies I have thus Burgoyn'd, / And room for more I've got behind." The snake's body had encircled two armies in its coils. Dangling from the snake's tail was a sign advertising "An Apartment to lett for Military Gentlemen." Beneath the sign, another empty coil remained for other British troops. The verse beneath the print reported, "The Serpent in the Congress reigns / As well as in the French."[85]

"The American Rattlesnake presenting Monsieur his Ally a Dish of Frogs" dramatized the alliance between France and America that was so

obnoxious to the British. Published by J. Barrow on November 8, 1782, this print portrayed the snake as a courtier of the Frenchman, since the rattlesnake alluded to the huge basket of frogs between them as a present. The rattlesnake commented, "Monsieur be pleas'd to accept the Frogs / I just have kill'd them in the Bogs." The Frenchman responded with warmth, "I give you thanks my good Ally, / Some will make Soup the rest a Fry." The Frenchman's gastronomic pleasure from devouring frogs was a commonplace source of British disgust. More important, the alliance was disturbing evidence of American treachery, since Congress had sought and received the assistance of Britain's hereditary enemy. Beneath the print a note explained, "The Rattlesnake is a Character chosen by America."

"*The* TEA-TAX-TEMPEST, *or* OLD TIME *with his* MAGICK-LANTHERN," published by William Humphrey on March 12, 1783, also depicted the rattlesnake in rebellion against Britain. Father Time used the light from his lantern to reveal the snake among a cast of characters, while he informed the viewers in his audience, "There you see the thirteen Stripes and Rattle-Snake exalted." A blast from an exploding teapot flung the poisonous snake toward the British troops. Beside the teapot, a French cock crowed with delight at a military confrontation that inevitably stood to strengthen France's position in international politics: If America succeeded in its rebellion, the British empire would lose a valuable source of wealth; if America failed, the military clash would still weaken the British empire by draining its economic and military resources and by fomenting animosity and distrust within it, the seeds of future disruption.

CONCLUSION

During the American Revolution, the image of the snake was the device of a political faction that conceived of itself as oppressed at the bottom of the established political and social order, a circumstance emphasized by the physical lowness of a snake and stressed by the motto "Don't Tread on Me." The colonists who used the image of the snake believed that the circumstances within the British empire had become so deplorable that they warranted a commitment to serpentine values. The faith of these colonists in

the integrity of the political system had been shaken by the series of conflicts during the decade of dissent from 1765 to 1775. There were increasing signs of corruption in the British government, the dramatic threat to freedom of speech exemplified by the persecution of John Wilkes, and, above all, the unrelenting encroachment upon constitutional rights in the areas of taxation and self-government. These colonists believed that the power to alter colonial charters was the power to subvert the will of the governed. They recognized that the power to tax was the power to destroy.

Under such oppressive circumstances, guile became the only alternative, deception became a practical necessity, concealment became valued as a necessary means of survival. The colonists who used the image of the snake saw a need for such concealment: Most of the prints in America were prepared by anonymous engravers. To a people who conceived of themselves as oppressed within the existing political and social order, representing themselves as a snake was a useful political strategy, because the image of the snake evoked an instinctive fear among the higher orders. To the extent that these colonists felt guilty about conniving, conspiring, or rebelling against the highest authorities within the British empire, or to the extent that they acted on behalf of their independence from those authorities, they identified themselves with the guile of the serpent in Eden. And yet even those colonists who deplored Eden's serpent may have accepted guile and cunning as necessary means of survival, so identifying themselves with another biblical serpent, described by Jesus to his disciples in Matthew 10:16: "Behold I send you forth as sheep in the midst of wolves: be ye therefore wise as serpents, and harmless as doves."

The image of the snake stressed egalitarianism among the colonial governments throughout its transformations, although it never suggested equality among individuals. Perhaps because the head of the segmented snake had become exalted in the newspaper debate of 1774, or perhaps because the image did not solve the problems posed by distinctions between the head and body, the image of the segmented snake gave way to thirteen nondescript rattles, stars, arrows, and stripes—all of equal size, stature, and placement—and eventually the image of the snake was supplanted by the rattlesnake, an animal without a political history wherein the head and tail corresponded to specific colonies. More important, the rattlesnake, like the eagle that followed it, represented a form of life indigenous to America,

a form of life that allowed no basis for identification with the rest of the British empire.

When the image of the rattlesnake migrated to Britain, there were fundamental changes in illustrators' use of it to portray the international conflict. In Britain, the rattlesnake was not used in public prints to suggest political divisiveness among the colonists about proper conduct toward Britain. Instead, the illustrators used the rattlesnake to depict the colonies as a unified embodiment of a treacherous enemy to the British government. The conduct of the British colonies in America had been that of a deceitful adversary who had refused to obey the constituted laws of the highest authority within the British empire, and who subsequently had sought and received economic and military assistance from France, Britain's most powerful rival in Europe. In the illustrations produced in London, the rattlesnake acted in cowardly concert with a gang of other creatures—a French cock, a Spanish spaniel, and a Dutch pug dog—against the lone British lion.

In the colonies, in contrast, the rattlesnake always had been a solitary creature, or it was engaged in a one-to-one struggle with a representation of Britain, usually a lion or a dragon. As important, in the colonies the rattlesnake remained a symbol of a political faction that the Loyalists actively opposed through their published verses and dreams denouncing the image as an emblem of sedition. Every side of the imperial dispute portrayed the dangers posed to itself. The prints in England depicted the British lion beleaguered by beasts and by its own inept ministers, while the prints in America portrayed a rattlesnake disturbed about being trampled upon by unrestrained British authority. Eventually, the Atlantic Ocean provided a clear point of division—both physical and symbolic—between the rival interests of the dominant political factions. Under this special circumstance, the image of the snake became for a brief time the device of a political faction and an emerging nation.

The image of the snake designating the United States lost its widespread popularity after national independence had ended the oppressive circumstances that had made serpentine values seem so necessary for survival. The eagle, which became the official national emblem in June 1782, continued the emphasis on egalitarianism among the state governments, since it was a motif derived from flags during the Roman Republic and

73

since the emergence of republican ideals characterized pervasive political commitments in America during the war years. The image of the eagle was equivocal, because it resonated with lingering ideas of royalty: Throughout the Middle Ages the eagle had been used in heraldry to represent royal descent. Ambivalence characterized the eagle as well: Thirteen arrows in one talon represented the military strength of the original thirteen states, an olive branch in the other represented peace.[86]

It was as though after the Revolution the colonists sought an image of righteousness to replace one of wickedness. The serpent symbolized the most low and the most base; the eagle, the most high and virtuous. Several years after the American Revolution, Shelley would write of the serpent and the eagle in *Revolt of Islam*, a poem about the French Revolution. According to Rudolf Wittkower, "[I]n a conscious reversal of the traditional meaning the snake becomes the symbol of the achievements of the French Revolution as opposed to the reactionary forces of the Napoleonic era, of which the eagle was the symbol." Was the effort to transvalue values, to turn hierarchies upside down, a special feature of the iconology of the American Revolution, or did such endeavors recur under revolutionary circumstances?[87] Shelley's poem suggested the latter:

> when priests and kings dissemble
> In smiles or frowns their fierce disquietude;
> When round pure hearts a host of hopes assemble;
> The Snake and Eagle meet—the world's
> foundations tremble!

THE COLONIES
ARE AN INDIAN

Savages we call them because their manners differ from ours, which we think the perfection of civility; they think the same of theirs.

—BENJAMIN FRANKLIN

A s Robert F. Berkhofer, Jr., has observed in *The White Man's Indian: Images of the American Indian from Columbus to the Present*, "Native Americans were and are real, but the *Indian* was a White invention and still remains largely a White image, if not a stereotype." This distinction between native Americans and Indians is vital when considering the image of the Indian that designated the British colonies in America, because that image was shaped by colonial and British convictions about native Americans, not by native Americans themselves. Accordingly, here the word "Indian" will specify colonial and British beliefs about and representations of native Americans. The word will not refer to native Americans, because as Berkhofer has remarked, white people understood the Indian as the antithesis of themselves. White people believed that they lived within a coherent social order and a highly developed civilization and that Indians lived in a society characterized by anarchy and savagery (fig. 14).[1]

In sixteenth-century Europe, an image of the Indian was used conventionally to personify the Fourth Continent, America, comprising the entire Western Hemisphere. Two hundred years later, that image was still used to designate America, but one new development was that the image became modified so that it sometimes referred specifically to the British colonies in America. Examples of such modifications included the addition

of attributes, such as a liberty pole or a colonial military flag, or the addition of a text that described the Indian as the child of Britannia. None of these attributes applied to the entire American continent, only to the British colonies there. Although the image of the Indian in these modified forms occurred often, especially during the two decades following the Stamp Act controversy of 1765, no single additional attribute always accompanied it. Even so, the frequent use of this image of the Indian to refer specifically to the British colonies in America warrants an analysis separate from that of the Fourth Continent, provided that the meanings of the image are understood in light of its derivation.[2]

The image of the Indian that specified the British colonies in America was informed in part by its derivation from the broader image of the Indian designating the Fourth Continent. In 1777–79, in keeping with a two-hundred-year tradition of using the Indian to represent the entire Western Hemisphere, George Richardson described the Four Continents in his edition of Cesare Ripa's *Iconology: or, a Collection of Emblematical Figures Containing Four Hundred and Twenty-Four Remarkable Subjects, Moral and Instructive; in Which Are Displayed the Beauty of Virtue and the Deformity of Vice*. Richardson's description suggested American inferiority to Europe. He described the Fourth Continent, America (fig. 15), as follows:

> The fourth and last part of the world is represented almost naked, of a tawny complexion, and a fierce aspect; has her head and other parts of the body adorned with the various coloured feathers, according to the custom of the country. In the left hand she holds a bow, and in the right a bunch of arrows, these being the arms of both men and women in many of the provinces. . . . Where the Europeans have not spread the knowledge of the Christian faith, the inhabitants are extremely different in their religion, and very much in the dark with respect to the knowl-edge of the true God, and religious worship.

In contrast, Richardson offered this description of the woman designating Europe:

> For learning and the arts, the Europeans have been most renowned; all the scholastic sciencies they have brought to great perfection, and the

invention and improvement of many useful and ingenious arts, particu-
larly navigation, are wholly owing to the genius and industry of the
inhabitants in this principal part of the world, which is represented by
the figure of a matron magnificently dressed, having a crown of gold
upon her head. She is standing by an elegant temple, indicating the
sanctity of their religion, the wisdom and ingenuity of the inhabitants,
and the excellency of their government.

Because religious truth, political power, and intellectual accomplishment
were highly valued by Europeans, Richardson's description of the Four
Continents made the personification of Europe seem superior to that of
America. On a larger scale, the image of the Indian designating the Fourth
Continent portrayed America as inferior to Europe in ways that were similar
to the Indian's portrayal of the colonies as inferior to Britain; these images
emphasized the differences in race in particular and culture in general.[3]
 Above all, it was the British illustrators who defined, refined, and
amplified the pictorial representation of the Indian as the British colonies
in America. In Britain, the colonies were designated as an Indian in
broadside illustrations earlier than in the colonies. The earliest unequivocal
British example of an Indian representing the colonies in a print was
"BRITAIN'S RIGHTS maintaind; or FRENCH AMBITION dismantled," de-
signed by Louis Peter Boitard and published on August 11, 1755. In
contrast, in America the earliest unequivocal example of an Indian repre-
senting the colonies in a print was John Singleton Copley's version of "THE
DEPLORABLE STATE of AMERICA or SC—H GOVERNMENT," published in
November 1765 and derived from a British print with the same title. In
fact, British illustrators exercised considerable influence over the way co-
lonial illustrators used the image of the Indian to designate the colonies,
since half of the colonial prints employing that image were derived from
British originals. Furthermore, in Britain the image of the Indian was the
single most frequently used representation for the colonies in political
prints. British illustrators depicted the colonies as an Indian in no fewer
than sixty-five political prints published between 1765 and 1783. In con-
trast, there were only seventeen known British prints in which the colonies
were represented as a snake, and only thirteen in which they were designated
as a child. Accordingly, this chapter will describe first how the image of

the Indian was used in Britain to influence beliefs about the colonies, and only then will it describe how the image of the Indian was used in America.[4]

British and American illustrators appropriated the image of the Indian during the period from 1765 to 1783 in their endeavors to achieve some general persuasive ends. They encouraged the public to think about the colonies in terms of commonplace beliefs, attitudes, and convictions about Indians, thus influencing popular sentiment. In Britain and in America, the image of the Indian emphasized some of the commonalities among the American colonies and some of the differences between the colonial and British cultures. The image of the Indian always assumed a sense of unity among the colonies, even when the merits of such unity were a debatable issue among the American colonists themselves. During the Stamp Act controversy, for example, no fewer than eleven British prints and three colonial prints portrayed the colonies as an Indian to represent them as a unified body politic—this at a time when some colonists portrayed the colonies as a segmented snake precisely to dramatize the need for such unity.

British and American illustrators used the image of the Indian to portray the colonies' relationship to an array of people and nations, usually to personifications of Britain, France, Spain, and Holland. The Indian's feelings toward Britain ranged from affection to hatred, the acts from courtship to murder. Often the image of the Indian was used to emphasize that all of the American colonies were affected similarly by the British Parliament's legislation. In addition, illustrators typically portrayed the Indian's property as signs of his or her character. For instance, after 1777 the Indian often carried a thirteen-stripe flag, a possession that corresponded to a shift from the colonial desire for liberties under the British constitution to the colonial demand for liberties under a new nation. Even the sex of the Indian representing the colonies was subject to change: As a victim throughout the decade of dissent, from 1765 to 1775, the colonies often were represented as a young woman; as an adversary throughout the war years, they were frequently portrayed as an aggressive man. In short, a wide range of polemics was possible with the image of the Indian by altering the character's attributes and acts.

The single most salient use of the Indian was to portray colonial civilization as foreign and therefore inferior to British civilization. The nature of this inferiority was amplified in various ways, but the idea that

the colonies were alien and uncivilized was central. Intimations of inferiority were frequently expressed by images of the Indian as a woman, especially during the decade of dissent. The Indian's naïveté, her weakness and indecisiveness, her susceptibility to seduction by rogues, even her vulnerability to sexual violation by British politicians took on additional significance in light of the patriarchal social structure in Britain and in America, a significance made more apparent by the tendency of illustrators to change the sex of the image to that of an aggressive and powerful male during the Revolutionary War. In this way, the image of the Indian designating the British colonies in America evoked a complicated congeries of convictions about the racial and sexual other, a stranger, whose inferior status was a matter of habitual belief.

THE IMAGE OF THE INDIAN IN BRITAIN

In Britain, the political and satirical print provided a lively vehicle for criticizing the ministry, Parliament, sometimes even the king. Illustrators found in the political print a vivid and simple way of castigating some public officials while exalting others. British prints about the American controversy were concerned more with the villains and heroes in the British government than with the colonies. Their sympathetic treatment of the American colonies often was a means for scathing criticism of public officials. Although the illustrators were anxious about the British colonies in America, primarily for economic reasons pertaining to commerce and taxation, the central thrust of the prints was about matters of British governance. The image of the Indian was instrumental in sustaining criticism of the government and only inadvertently revealed the perceptions of the image makers in Britain with regard to the American colonies.[5]

The image of the Indian was a stereotype of a people indigenous to America. Since in Britain the Indian was the symbol most commonly used to represent the colonies in America, the British apparently regarded the colonies as foreign or alien to British ways, even though they constituted a part of the British empire. Such beliefs appear to have been pervasive.

Speaking before Parliament in 1766, Benjamin Franklin observed that the British colonies in America "consider themselves as a part of the British empire, and as having one common interest with it; they may be looked on here as foreigners, but they do not consider themselves as such." Similarly, James Otis wrote in 1764 that the colonies "are well settled, not as the common people of *England* foolishly imagine, with a compound mongrel mixture of *English, Indian* and *Negro*, but with freeborn *British white* subjects." These remarks by colonists indicated one reason that the image of the Indian was employed so pervasively in England: The Indian portrayed the colonies as foreign.[6]

Viewed as foreign, the colonies could be considered inferior to Britain. Nationalism was a central value in Britain during the eighteenth century, and British satires abounded with demeaning stereotypes of people from other nations—among them the foppish and effete Frenchman, the portly and money-hungry Dutchman, the primitive and pagan Indian. During the Stamp Act controversy this ethnocentric impulse manifested itself through the use of the image of the Indian to represent the colonies. For example, the Indian's inferior status was implied by the slavelike role in "The Great Financier, or British Economy for the Years 1763, 1764, 1765," printed in London during October 1765. The Indian was yoked with two heavy billets of wood labeled "Taxed without Representation," implying that the American colonies labored under a coercive measure lacking propriety under constitutional government. The Indian stooped on one knee from the combined weight of the yoke and the huge bag of "Dollars" that she was carrying and remarked, "The Commerce will out weigh it," implying that trade with the colonies could restore balance to the scale in Grenville's hands by outweighing the British empire's debts.[7]

Although this Indian was being treated as an inferior, she possessed merchandise of considerable importance to the British economy. Despite this beneficial contribution to the commerce of the empire, the ministry abused the Indian through either thoughtlessness or avarice. A stamp tax collector in the background criticized the ministry's stamp tax, "Damn me Jack better to pillage the French" than to tax the colonies. A twenty-four-line verse beneath the print commented on the ministry's ignorance and abuse of the American colonies:

America groans & petitions in vain,

Her grief is his Toy, & her Loss is his Gain;

For ways & means curious his Brain he ne'er racks,

He stops all her wealth & then lays on his Tax.

The final line suggested that the Stamp Act harmed the colonies by a loss of trade and by a tax on whatever commerce remained. Because the Indian herself offered commerce as a solution to the budget problems, the print appealed to mercantile interests in London: The merchants profited directly from trade with the British colonies, while the government benefited from the duties on that commerce. Because the stamp tax was represented as a yoke, the print criticized the country interest that at the time dominated Parliament, since the landed gentry had supported the stamp tax in hope of reducing their own land taxes through an alternative source of revenue.

Although the image of the Indian portrayed the colonies as foreign in order to sanction her subordination, several other factors may have sanctioned British authority over the Indian in "The Great Financier." Most important and most obvious, the colonial legislatures as they existed in 1765 had implicitly acknowledged the right of the British Parliament to legislate for the colonies, since they had cooperated with the legislation in the past, even though the propriety of taxation by Parliament remained a subject of intense dispute. Therefore, it was understood that a representation of Parliament could normally exert authority over the Indian designating the British colonies. In addition, the print illustrated a pattern of British appropriation and control of America's economic resources—a pattern exemplified in the print when the British politicians sought by law to appropriate and to control the products of the Indian's labor, a pattern that may have been reinforced by its resonances with habitual behavior in British households, since the patriarchal social and legal structure in Britain allowed the man in the household to appropriate and to control the products of the woman's labor. Furthermore, once the British government conceived of the image designating America as an inferior, whether because of the race or the sex of the image, the government could exert authority over the Indian with the ostensibly benign intent of improving her for her own benefit. It could condescend to civilize her.

This attitude could be seen in two early illustrations about the expanding British empire, both published in London in the fall of 1755. In "BRITISH RESENTMENT *or the* FRENCH *fairly* COOPTD *at Louisbourg*," Britannia with open arms and a smile welcomed into her protection two Indians who represented Americans. Similarly, Britannia was shown as benign protector of an unarmed Indian child in "BRITAIN's RIGHTS maintaind; or *FRENCH AMBITION* dismantled." The Indian taunted the French cock, "Petty bird, how will you get home." The British lion had already pulled the cock's tail feathers, labeled "Niagara," "OHIO," and so on. In both these prints, the expansion of the British empire was portrayed as benign protection of the Indian. Viewed in this light, "The Great Financier" condemned the ministry for abusing rather than protecting and improving the Indian.

In addition, several British prints explicitly sanctioned the government's authority over the Indian by affirming that the Indian was the child of Britannia. Such allusions to a family relationship between the Indian and Britannia—in 17 percent of the sixty-five British prints published between 1765 and 1783—warranted the just exercise of parental authority over the colonies. For instance, in *"Goody Bull or the Second Part of the Repeal,"* published in London on March 18, 1766, William Pitt referred to the Indian as Britannia's daughter to imply a child's customary subordination to a parent, a relationship that corresponded to the colonies' political subordination to Britain. This print, like so many produced during the Stamp Act controversy, criticized the British ministry for abusing the American colonies. Pitt, on crutches and helping Britannia to her feet, inquired: "Why you Old Devil, what have you a Mind to turn your Daughter a Drift?" so insinuating that Britannia may have been behaving improperly as a mother. Britannia, who had thrown herself to the ground in outrage, exclaimed, "Oh! the Hussy, She dares me to my Very face." Colonial defiance in this illustration was the disobedience of a wicked child. The Indian, who stood behind Britannia, affirmed, "I will sooner turn Strumpet to all the World than bear this Treatment." The emphasis on Britannia's abusive treatment may have been a mitigating circumstance that explained the child's bad behavior. More important, however, the threat to become a debauched woman affirmed a British concern that the colonies could prostitute themselves by trading freely with other countries in retal-

iation for the Stamp Act—an act by which the Indian would have forfeited her virtue as a woman to attain revenge upon her own family. By implication, the Stamp Act endangered both the British merchants' interest in profit from commerce with America and the British government's interest in revenue from duties.

During the Stamp Act controversy the inferiority of the Indian was manifested in additional ways. In "*The* STATE *of the* NATION [*Anno Domino*] *1765 & c.*," the Indian was not the master of his own fate. Instead, Grenville, Pitt, and other leaders in a divisive government determined his future. Grenville asserted, "I'll enforce," while he pointed a sword at the Indian. This act demonstrated the ministry's commitment to implement the tax. William Pitt stood between Grenville and the Indian to intercede on the Indian's behalf. Holding a liberty pole in his hand, Pitt insisted, "You have no right," to suggest the absence of an adequate legal justification for the tax. Britannia wept on the Indian's shoulder to express her sympathy for the colonies. Similarly, the fate of the Indian was decided by leaders of a divisive government in "*THE BALLANCE, or the Americans Triumphant*," published in London on March 18, 1766. In the background right, on an island representing America, the Indian was among those who rejoiced to see William Pitt tip the balance of power in Parliament in favor of repealing the Stamp Act.

The Indian's low character was suggested by her scanty garb and bottle of "Rum" in "THE NEW COUNTRY DANCE, *as DANCED at* C**** July the 30th 1766," printed in London by J. Pridden on July 30, 1766. In sharp contrast to the other prints, this illustration criticized William Pitt's courtship of the Indian. Pitt professed, "I stood staunch in your Cause." The Indian confirmed, "Yes, we finely hum'd Old England." Britannia demonstrated that this courtship between Pitt and the Indian had overturned the political order of the British empire by standing on her head and complaining, "I'll dance no longer If America takes the Lead." Similarly, "The TRIUMPH of AMERICA" criticized the Indian and Pitt for disrupting the established political order. The Indian sat in a landau behind Pitt, who drove the horses with a whip, an arrangement suggesting that the colonies exerted influence in Parliament through Pitt's leadership. Pitt whipped the horses, which represented political leaders, all held responsible for the disastrous direction in government, while the landau sped toward a

precipice. By implication, the Indian's appropriate place was that of a subordinate who could cause no such harm to the British empire.

During the decade of dissent, from 1765 until 1775, most of the British prints were critical of the leaders in Parliament and sympathetic to the colonies. Some condemned the entire government by portraying attacks on an unarmed Indian, while others criticized particular parliamentary leaders. For instance, the entire government was culpable for the assault on the Indian in *"Its Companion,"* published in the December 1768 issue of *The Political Register* beneath a version of Benjamin Franklin's *"The Colonies Reduced"* (frontispiece). Parliament's passage of the Townshend Duties was transfigured as Britannia's endeavor to spear the weaponless Indian. The Indian fled into the arms of France, who protected her with his sword and pistol, so illustrating the potential international consequences of a dispute within the empire.

In other prints, specific villainous ministers were responsible for the attack upon the British colonies in America. For instance, in April 1774 *The London Magazine; or, Gentleman's Monthly Intelligencer* printed *"The able Doctor, or America Swallowing the Bitter Draught"* (fig. 16), which was reprinted subsequently in the May 1774 issue of *The Hibernian Magazine or Compendium of Entertaining Knowledge.* Several prominent British leaders assaulted a lone female Indian. Lord North, the first minister, poured scalding tea down her throat, while Lord Mansfield pinned her arms and Lord Sandwich peered up her cloth drape. Standing with his sword in hand to the right, Lord Bute observed these portents of rape. Britannia averted her face in shame, possibly an expression of sympathy for the Indian, possibly an expression of embarrassment and guilt for the conduct of her public officials.

In these two prints, the depiction of the female Indian suggested that the British colonies in America were considered vulnerable and defenseless, more liable to seek protection from other European nations than to defend themselves. These suggestions were doubtless reinforced by stereotypical associations with sex and race. Yet the Indian's sex and race dictated proper conduct by the British politicians, since men within the British culture were forbidden to treat women violently, and since the ostensibly superior race expected themselves to provide model behavior in the presence of the

lesser races. In this light, the print condemned the politicians for attempting to gang-rape a woman and for behaving so primitively toward an Indian.

Still other prints criticized the government for provoking the colonies, portraying the Indian armed and prepared to defend colonial liberty. As early as August 12, 1769, the Indian assumed a militaristic stance in *"The Chevalier D'—n producing his Evidence against certain Persons."* The aggressive male Indian aimed a drawn bow at Hillsborough, the secretary of state for the North American colonies. Although the Indian received the assistance of other male figures, he neither requested nor needed their help. Indeed, his actions were part of the chaos of the moment.

Most prints during this period criticized the ministry for careless, thoughtless, or destructive actions, but some distributed blame to all involved parties. The Indian was overtly violent in "The [Parliament] dissolvd, or, The DEVIL turn'd FORTUNE TELLER," a prophesy wherein the Indian trampled on a British soldier, while several human forms fell from a building in the Indian's hands. These violent images were portents of military conflict and its physical consequences. Since the role of the Devil was ambiguous, both England and the colonies were held responsible for the wickedness of military confrontation within the empire. On the one hand, because the Devil had conjured up the demonlike Indian, and because they held similar wands, the Indian could have been interpreted as doing the Devil's work. In that light, the print condemned the colonies. On the other hand, because the Devil stood with the ministers, and because one of the ministers' ankles had been tied by a cord to a demon hidden under a table, the Devil could have been seen as an associate of the ministry, implying that the British government's measures were wicked because they had brought about this military conflict. The title of the print indicated that the print placed primary blame upon the British ministry, whose dissolution of Parliament had increased the likelihood of armed conflict.

Similarly, the question of culpability was ambiguous in a print ironically titled "The COURT COTILLION, Or the Premïers new Parl + + + + +t Jig," published on December 1, 1774 (fig. 17). Representations of the colonies, Scotland, and England lashed each other with whips in an endless circle chase, an image that dramatized the senselessness of faction within the empire and distributed culpability among all of the involved parties. Music for the cotillion was provided by Lord North, who

fiddled and smiled, an allusion to Nero (who fiddled while Rome burned) and an unequivocal indictment of his ministry. A verse beneath the print exhorted,

Rouze, Britons, Rouze! behold thy staggering State,
Discord destroys you, Concord makes you great;
While thus at variance, Brother scourges Brother,
Friends disunited must destroy each other.

The violent imagery was an appeal for reconciliation among the factions within the empire, because the imagery portrayed the conflict as futile and destructive for all the concerned parties.

In contrast, in two frontispieces published in 1774 and 1775 on the eve of the American Revolution, *The London Magazine* appealed for reconciliation within the British empire by depicting an ideal image of the relationship between Britain and America and by evading altogether the question of culpability. Indeed, to judge only from the images in these prints, there was no friction among the British dominions, but the verses on each print suggested otherwise. In January 1774, *The London Magazine* carried "[Britain, America, *at length be Friends*]" on the frontispiece. The print portrayed a dignified Indian unarmed and shaking hands with Britannia, who remained seated in the Indian's presence. A ship in the background and the cornucopia of Plenty in the foreground focused upon Britain's and America's mutual interest in commerce to promote unity between them. One year later, in January 1775, *The London Magazine* made a similar appeal in another frontispiece, "[*When fell Debate & civil Wars shall cease*]" (fig. 18), but the insinuations of relative power were either reversed or mitigated, since the Indian remained seated in Britannia's presence. There was more physical distance between the Indian and Britannia than in the earlier frontispiece, but even so, a woman holding a peace symbol stood between them. In the background a classical temple suggested a shared western heritage to promote unity between the two women, but the Indian's garb and race diminished the force of such a pictorial appeal. The presence of the third character contributed an element of harmony and balance in both of these compositions. The idealistic style and content, the

allusions to friendship and reconciliation were appeals for order in an atmosphere portending political disruption.

After the outbreak of armed violence in the spring of 1775, certain British prints categorically condemned the Indian for wickedness. The most severe was a print in *The Westminster Magazine or the Pantheon of Taste*, a magazine that had been sympathetic to the colonial cause only a year earlier. For example, in *"The Whitehall Pump,"* published at London in May 1774, the Indian was the victim of either foolishness or carelessness on the part of British officials. Lord North and his ministry attempted to revive Britannia, who drank from a pump, her fallen body unintentionally crushing the Indian. Inadvertently, North doused the Indian too. Since North pumped the water and since a portrait of King George III surmounted the pump, the print indicted North's ministry and the king for these foolish efforts. In contrast, after the outbreak of the war, during the spring of 1776 *The Westminster Magazine* published *"The Parricide. A Sketch of Modern Patriotism,"* wherein the Indian attacked Britannia with a dagger in an attempt to kill her, an unequivocal indictment of the American colonies (fig. 19). A representation of discord in the left background of the composition amplified the barbarous nature of the act and the anarchy of the moment.

Such overt violence recurred in another print published probably in 1775, *"Bunkers hill, or the blessed effects of Family quarrels"* (fig. 20). Britannia attacked the Indian with a spear, while the Indian defended herself with a dagger and a tomahawk. These prints both evoked the family metaphor—in *"The Parricide"* to define and condemn America's act as an especially vile form of murder, in *"Bunkers hill"* to portray France and Spain as opportunistic meddlers who sought to benefit from the disorder within the family. Both prints castigated prominent officials in the British government, the former by portraying British officials restraining Britannia so that she would be vulnerable to the Indian's dagger, the latter by showing British leaders on a cloud in the company of the Devil and Lord Bute, who smiled at the injurious conduct.

"Bunkers hill" criticized the other European nations for their involvement in the dispute by implying that they were at least partially responsible for the colonies' treatment of Britannia. Spain held a rope tied around the Indian's upper torso, while France seized the opportunity to stab Britannia

through the breast with his sword. These men, designating European nations, took advantage of the conflict between the women, who seemed either too preoccupied with each other or too foolish to recognize the serious danger that their personal squabble posed for both of them.

After the outbreak of armed conflict in 1775, several changes in the Indian's attributes suggested corresponding changes in the uses of the image. During the war, for example, the Indian's weaponry changed in two ways. Sometimes the Indian held two weapons, one in each hand, as in "*Bunkers hill*," in which the Indian held a dagger and a tomahawk. Another change was that the Indian began to wield a wider variety of weapons. Between 1765 and 1770, if the Indian had a weapon at all, it was almost always a bow and arrows. Between 1777 and 1783, in contrast, the Indian sometimes carried a scalping knife, a tomahawk, a spear, or a whip—weapons consonant with the imagery of the primitive Indian, weapons that emphasized the savagery of the military conflict.

Another change in the Indian's attributes was the addition of a military flag in several prints after 1777, which suggested a change from the colonies' demand for liberties under the English constitution to their demand for liberties under a new nation. The addition of such flags to the image of the Indian simply reinforced the colonial aim for independence. For instance, in the rebus "[America to her Mistaken Mother]," published by M. Darly on May 11, 1778, the colonial Indian with a flag in her hand asserted, "[I am at age to know my own interests]" (fig. 21). Subsequently, a flag was among the Indian's possessions in at least seven other prints produced in Britain. The military flag functioned during the final war years to show that the colonies' demand for independence remained central and that efforts at reconciliation would not result in reunification of the British empire. For instance, the Indian and Britannia embraced in "*The* RECONCILIATION *between* BRITANIA *and her daughter* AMERICA," published circa 1782, but the Indian's striped flag and liberty pole indicated that reunification of the empire had not transpired and would not.

Other changes in the imagery had to do with the antithetical attributes of a chain and a liberty pole. The Indian was yoked in "The Great Financier," physically pinned to the ground in "*The able Doctor, or America Swallowing the Bitter Draught*," and threatened with a spear in "*Bunkers hill*." But as early as July 5, 1769, the Indian was depicted breaking all

restraints in "The TRIUMVERATE or BRITANIA in *DISTRESS*." The shattered chains lay on the ground beside the Indian, even as she snapped the oppressive yoke:

Behold—stern America there,

Tho' doomed to feel the mighty stroke,

The galling chain, the hateful yoke,

But with resentment and disdain,

Breaks the yoke, throws off the chain,

For free, she ever will remain.

None of the twenty-one British prints published between 1777 and 1781 portrayed the Indian chained or restrained by a British representation, a change that corresponded simply to the British government's loss of control over the colonies. With that loss of control went the loss of extensive economic benefits to Britain from the mercantile system.

In the prints between 1765 and 1775, the liberty pole was proximate to the Indian, but it was held by William Pitt, Britannia, or Liberty. The colonies wanted the liberty pole, or they were concerned about liberty, but they did not possess it. In 1779, "THE PRESENT STATE OF GREAT BRITAIN" portrayed the Indian stealing the liberty cap (fig. 22). Liberty was not rightfully his. The Indian's accomplice, a Dutchman, picked the pockets of the inattentive Englishman, while a Frenchman distracted the inept Scottish guard. Subsequently, the Indian possessed a liberty pole in no fewer than nine other prints throughout the war years. The Indian had demanded liberty, taken, and realized it.

Yet another change in the imagery was the frequency with which the Indian was a man after 1777. Between 1765 and 1777, only four of twenty-two British prints portrayed the Indian as a man, roughly 18 percent. In contrast, twenty-two of forty-three prints portrayed the Indian as a man between 1777 and 1783, roughly 51 percent, almost triple that of the previous decade. This change, like the addition of the military flag and the use of various weapons, corresponded to the increase of military aggressiveness during the Revolutionary War. Congress, the center of organized American opposition to Britain, was almost always a man when it was

represented as an Indian. For example, a male Indian represented Congress in "*A Picturesque View of the State of the Nation for February 1778,*" one of the most widely distributed engravings during the Revolution (fig. 23). This print underwent several editions in Britain, France, Holland, and the United States with such titles as "MAL LUI VEUT MAL LUI TOURNE DIT LE BON HOMME RICHARD," "*La Vache à lait représente le Commerce de la Grande-Bretagne,*" "*Explication de ce tableau touchant l'etat de la Nation d'Angleterre,*" "TOESTAND DER ENGELISCHE NATIE," "Wegens de Staat der ENGELSCHE NATIE in't Jaar 1778," "POOR OLD ENGLAND! Or 1778. *Or the Bl-s-d Effects of a Wise Administration,*" "A PICTURESQUE VIEW of the State of GREAT BRITAIN for 1778. Taken from an English copy," and "A PICTURESQUE VIEW of the State of GREAT BRITAIN for 1780." In all of these versions of the print, the Indian was responsible for sawing off the horns of a British cow, which represented the commerce of Britain. France, Spain, and Holland robbed Britain by milking the cow and then taking the milk. Again, the Indian was the accomplice of a gang of thieves. Again, Britain was the victim of villains.[8]

This series of extraordinarily popular prints pointed to yet another change in the imagery: Whereas previously British illustrators had depicted the Indian engaged in an unequal struggle against a gang of plotting government officials in Parliament, after 1777 illustrators typically depicted Britain engaged in an unequal struggle against the Indian and a gang of European nations. The Indian's alliance became ubiquitous in prints and engravings through the end of the war in 1783. As an illustration of how misleading these pictorial images sometimes were, Spain and America were represented as acting in concert, although Spain never had a formal alliance with the British colonies in America. The omnipresent theme of an alliance served many intimately related rhetorical functions, most of which were nuances of its central use: to denigrate the Indian and the European allies, while vaunting British military might in the face of unequal odds.[9]

In many prints the Indian and the allies were cowards, who were unable to battle Britain successfully even on the unequal terms of three or four against one, depending upon whether the illustrator included Holland. Among these prints was a series published in January and February 1780, which showed the alliance intimidated by John Bull, a virile, masculine

representation of the British national character. In *"JOHN BULL TRIUM-PHANT,"* the Indian and the French ally trembled with dismay and fear as John Bull tossed into the air a Spaniard, whose money spilled out of his pockets. The print criticized Bute, Mansfield, and North, who restrained the bull by pulling on its tail to protect America and France from its wrath. Although most of the prints portrayed John Bull as a strong and deadly Britain, *"The BULL ROASTED; or the POLITICAL COOKS Serving their CUSTOMERS"* depicted British leaders cooking the bull to feed the Indian and her allies. More typical was *"The BULL OVER-DROVE: or the DRIVERS in DANGER,"* printed on February 21, 1780, and reissued two years later on February 21, 1782. The bull purged North and Sandwich from office, much to the satisfaction of the British public, who yelled, "Huzza," behind them. On the right the Indian and the allies expressed apprehension and mutual distrust in the presence of the bull's unrestrained power. Similarly, on March 1, 1780, *"The Bull Broke Loose"* depicted the bull charging toward Lord North, who fled toward the waiting Indian and the other foes of the British government—the Indian held a scalping knife, the Spaniard wielded a spear, the Frenchman pointed a rapier.

Several British prints exalted British military might by portraying navy heroes defeating the Indian and her allies. In *"JACK ENGLAND Fighting the FOUR CONFEDERATES,"* printed on January 20, 1781, one British sailor defeated all four allies. They were weak even as a group. The Indian moaned on the ground, "This fall has hurt my back." The Frenchman vomited and said, "Dem Jersey pills have made me sick." Spain, with a black and bleeding eye, exclaimed, "[B]y St. Jago he has almost blinded me." The Dutchman admitted, "I have almost forgot how to fight."

In other prints the Indian and allies were weak, defeated, exerted futile efforts, or were roundly punished. For instance, the British admiral Rodney whipped the Indian and the allies in *"Rodny's new Invented Turn about"* or *"The Little Admiral giving the Enemy's of Great Britain a Flagellation,"* printed in July 1782.[10] In "LABOUR IN VAIN *or let them tug & be Da-nd,"* printed on November 27, 1782, the Indian and the allies tugged on ropes that were anchored to Britain in a futile effort to budge the entire island. A British sailor, Britannia, and Neptune himself mocked the Indian

and the European allies. Even the British lion was amused by the allies' foolish efforts.

In yet another print, "BRITANNIA PROTECTED *from the* *Terrors of an* INVASION," or "*A loud-crying Woman & a Scold shall be sought out to drive away the Enemies*," three English women drove the Indian and the allies out of England (fig. 24). The gang of men could not stand up to the British women, whose clothing identified them with the lower economic classes. This difference in the sex of the combatants was at once both a tribute to the British women's strength and a slight to the foreign men. The Indian was so inadequate in comparison with the women that he could not defeat Britain even with considerable assistance from foreign allies.

British illustrators denigrated the Indian by portraying the alliance dismembering a living entity. The Indian and the allies stole not merely the property of the empire but a living part of the empire. In "BRITANIA'S ASSASSINATION, or————*the Republicans Amusement*," printed on May 10, 1782, the Indian and the allies fled from British officials with various parts of Britannia's body, the Indian with her head and arm, the Spaniard with her leg. The print was ambiguous about whether Britannia was to be regarded as a statue or a woman, but the choice of the word "assassination" suggested the latter. Synecdoche figured in a theft corresponding to the colonies' attempt for independence. Divisiveness among the allies characterized France's pursuit of the Indian. France yelled, "You Damn Dog. You run away with all de Branche," alluding to the peace symbol in Britannia's stolen hand. Meanwhile, Holland stole Britannia's shield.

Similarly, "THE ENGLISH LION DISMEMBER'D *Or the Voice of the Public for an Enquiry into the Public Expenditure*" portrayed the Indian dismembering the British lion to steal its paw (fig. 25). Beside the Indian, the allies expressed a desire to have a limb from the lion as well—portents of further diminution of the British empire if the leaders in the government did not suppress further violence. Yet Lord North trudged onward, a heavy bag marked "Budget" over his shoulder, oblivious to the wound the Indian had inflicted on the lion, which North continued to pull on a leash behind him. In both of these prints, the colonies were depicted twice, once as an Indian and again as a paw or as a head and arm. This representation conveyed an ambiguity in the status of the colonies: To some, the colonies were a separate and independent nation; to others, they remained a rebel-

lious part of the empire. In both prints, the act of becoming an independent nation was equivalent to becoming an assailant and a thief.

British prints portrayed the Indian in other demeaning ways. The Indian was the ungrateful, parricidal daughter of Britannia as well as the brazen courtesan of France and Spain in "BRITANIA *and Her* DAUGHTER. *A Song*." The lyrics asserted that the Indian's licentious courtship of France and Spain would result in her subordination to them rather than independence. The lyrics also asserted that the Indian had been duped by her allies. The female Indian was naive and "kept from" her family duties by her male allies, an interpretation that enabled the British illustrator to hold France and Spain primarily responsible for the military violence, while still castigating the Indian for her low moral character. The song ended with a wish for the reunion of the Indian and Britannia, which may have been seen as a parent's loving forgiveness of a wayward child.

In British prints, the claim that the Indian had been duped by her allies recurred in a way that made the reunification of the empire seem attainable, since a duped people could become better informed about their political circumstances. If America had indeed been duped, if an underlying cause of the rebellion was the naïveté, ignorance, or misplaced trust so often attributed to the Indian designating America, then the remedy for the conflict was to educate the Indian about Britain's benign policies and to protect the Indian from the misrepresentations by Britain's European enemies. Further, if the Indian had been duped by the enemies in Europe, then America was not entirely culpable for the controversy, even if she had caused the war through her ignorant action, because she had been misled by designing men. Above all, the portrayal of the colonies as a duped Indian indicated that the British viewed the colonies as manifesting a childlike gullibility, rather than a mature insight into the danger posed to their political rights and economic well-being.

That the Indian was duped, that she and her allies were morally debased, that they were thieves and assailants, all contributed to a sense of British righteousness in the exercise of military might. The setting of *"The Ballance of Power"* compared the right and might of Britain with that of the Indian and her allies—a print that resembled an engraving distributed in Germany and France under the title "Die Wage der Macht" and "*La balance de la puissance*" (fig. 26). Alone, Britannia weighed down one end

of the balance, thereby lifting the Indian and her allies on the other end and providing visual evidence that Britain had more military weight than the allies together did. Furthermore, because justice often was depicted with a scale, the setting implied that justice was on the side of Britain. In fact, Britannia carried a weapon inscribed "The Sword of Justice." This suggestion of British righteousness was amplified by the Indian, who sulked and confessed, "My ingratitude is justly punished." The text of *"The Ballance* of *Power"* asserted:

America is dup'd by a treacherous train

Now finds she's the Tool both to France and to Spain

Yet all three can't weigh down the Scale:

So the Dutchman jumps in with the hope to prevail.

Even though the poem castigated the Indian for her unjust conduct, it ended with a wish that the American colonies would reunite with the empire. In the conclusion, the Indian's naïveté and her membership in the family made it conceivable, though not probable, that the empire could be reunited.

It was commonplace to depict a Dutchman endeavoring to tip the balance of power in favor of the Indian and her allies. Somewhat similarly, for instance, the Dutch were portrayed attempting to shift the balance of power in an earlier print, "The POLITICAL SEE-SAW or MINHIR NIC FROG TURN'D BALANCE MASTER," published by W. Wells on November 6, 1779. Yet the placement of the Dutchman toward the center of the seesaw suggested some ambiguity about his role, because he was not decisively on either extreme end of the dispute. Another print, "Dutch GRATITUDE display'd," published on May 4, 1780, criticized the Dutch for being neutral instead of assisting Britain. On the left, a Dutchman requested the assistance of the Englishman because the Dutchman was threatened by Spain and because he was having difficulty governing his own colonies. On that earlier occasion, the Englishman reassured the Dutchman, "I am your friend Mynheer I'll help you up and beat your foes." On the right, in contrast, the Englishman requested similar aid from the Dutchman during the American Revolution. But the Dutchman decided to remain neutral,

thereby failing to demonstrate his gratitude for past English help. The Indian holding a tomahawk confidently asserted, "It shall never have my colonies again."

By 1782 extreme and usually derogatory views of the Indian's character were commonplace in British political prints. Some of these wartime prints suggested that the Indian was a demonic figure of transcendent wickedness. One instance of such a portrayal was *"LIBERTY EN-LIGHTNED,"* published in 1781 during the election of ministers to Parliament. So monstrous was the Indian that instead of feet he had the claws of a bird of prey. In sharp contrast, *"The HORRORS of WAR a VISION Or a Scene in the Tragedy of K: Rich[ar]d: 3,"* depicted the Indian as a victim of a diabolical government (fig. 27). With a dagger embedded in her breast, the Indian inquired: "Canst thou behold this mangled breast— this dreadful carnage of my children & feel no keen remorse! Oh forego this bloody warfare, else can revolted nature e'er forget her wrongs or close in amity the dire catastrophe of recent woes." This print was atypical of most wartime prints in its sympathetic treatment of the Indian, suggesting that the British government ought to feel guilty about having abused the Indian and having murdered her children.

After 1782, many engravings began to dramatize the changes from war to peace by altering the Indian's relationships to personifications of Britain, France, and Spain. As early as April 20, 1780, "PREROGATIVES DEFEAT or LIBERTIES TRIUMPH" portrayed the political ascendancy of Charles Fox and the political demise of Lord North as a signal that there had been a fundamental shift within the British government toward reconciliation with the American colonies. The optimism about a peace settlement was suggested in the print when the Indian remarked, "Now we will treat with them," as though the change in leadership was sufficient to motivate new attempts to forge a peace agreement.

Such an expectation of reconciliation was evident in "ANTICIPATION; or, the CONTRAST to the ROYAL HUNT," published in May 1782. As the title suggested, the illustration was a sequel to "The *ROYAL HUNT*, or a *PROSPECT* of the *YEAR* 1782," printed only three months earlier, on February 16, 1782. Both designs were attributed to Viscount George Townshend. In "The *ROYAL HUNT*," the Indian and the allies had at-

tempted to destroy the "Temple of Fame" by pulling on a rope attached to a supporting pillar labeled "Gibraltar." "America" had been among those pillars that had fallen. But in the sequel the Indian's role changed from destroyer of the Temple of Fame to an approving observer of reconstruction. Standing near the same pillar under the Temple, the Indian held a symbol of peace. In the foreground, "C-nw-y" [Conway] erected the pillar marked "AMERICA," while other figures erected the other pillars to reconstruct the temple.

In some prints, British illustrators portrayed the Indian restrained by his or her allies during the peace negotiations. The prints intimated that America desired a peace settlement but could not act independently of the allies because of their coercive power. The British ministry's effort to negotiate a separate peace agreement with the American colonies was portrayed as a group of cooks offering the Indian food in "THE STATE COOKS MAKING PEACE _____ PORRIDGE," published in July 1782. The Indian declined the offer of porridge by saying, "I'll have none without my friends like it." The allies rejected the meal, an act that prevented the successful conclusion of peace negotiations with the colonies. Beneath the print a poem likened the Indian and the allies to stubborn children who ought to be punished:

Ah! what can the Cooks do in such a hard case!
If such folks will not eat tho! F-x has said grace
Why give them what obstinate Children deserve
Beat them well, & if they wont eat it then let em Starve.

With apparently less success, the allies restrained the Indian again in "*The* RECONCILIATION *between* BRITANIA *and her daughter* AMERICA," published probably in 1782. Although the Indian and Britannia embraced to suggest a resolution between them, the Indian's allies endeavored to keep them apart. The Frenchman pulled at a scarf around the Indian's waist, while the Spaniard tugged on a rope around France's torso.

Later, to illustrate the progress of peace negotiations and to celebrate the final agreement in 1783, former enemies ate, sang, and even urinated together. On February 11, 1783, in "*PEACE Porridge all hot. The best to*

be got," the national personifications ate porridge together. In the left fore-ground, the Indian affirmed, "I rest Contented with a dish of Independent Soup." On January 16, 1783, in "The General P--s, or Peace," five per-sonifications of the different countries urinated into the same pot, thus creating a primitive form of identification among them (fig. 28). A male Indian representing the United States remarked, "I call this a free and Independent P--."

Other prints focused on the reconciliation between the Indian and Britannia. For instance, on February 18, 1783, the Indian and Britannia sang together in *"A Political Concert."* They held the same liberty pole, even though they sang different lyrics. The Indian intoned, "O give me death or liberty, O give me & c.," while Britannia sang, "Brittons never shall be slaves." Another example of harmonious reconciliation was "WON-DERS, WONDERS, WONDERS & WONDERS," published on November 9, 1782, and reissued in 1783 with the addition of word balloons. In both versions, Britannia and the Indian shook hands. In the version with the word balloons, Britannia requested, "Come, come shake hands, and let's be Friends." The Indian replied, "With all my Heart, I've gaind my Ends."

Other prints pointed out that the peace agreement had diminished the stature of the British empire, because it had recognized the independence of the United States. On April 16, 1783, "THE BLESSINGS OF PEACE" depicted the Indian receiving the homage of Benjamin Franklin and the kings of France and Spain. Meanwhile, in England the sun was setting on the empire to suggest its imminent decline. Similarly, *"The* BELLIGERANT PLENIPO'S"* emphasized that the Indian had diminished the British king's power. Under a thirteen-stripe flag surmounted by a liberty cap, the Indian cradled one half of King George III's crown and claimed, "I have got all I wanted empire!" The king wore the remaining half of a crown and announced, "I give them Independence." On December 1, 1783, "DOMINION of the SEAS" depicted the Indian and the allies in a boat, where they tipped their flags in respect for Britannia's dominion over the "SEAS," capitalized perhaps to emphasize that the dominion was not over the colonies.

In other prints British illustrators portrayed the Indian as less than gracious about the victory over Britain. The Indian was self-serving and

disloyal to his allies in "PROCLAMATION of PEACE," published on October 21, 1783. The Indian dismissed the allies by remarking, "I have got my Liberty and the Devil Scalp you all." In "*The Grand Cricket Match*," published in the January 1784 issue of *The Rambler's Magazine*, the Indian gloated about the recent victory, "If you play'd for the 13 Provinces you'd lose."

Finally, at least two prints concentrated upon the ramifications of the peace agreement for the Loyalists in the United States. On January 10, 1783, "SHELB--NS SACRIFICE *Or the recommended Loyalists, a faithful representation of a Tragedy shortly to be performed on the Continent of America*," depicted Lord Shelburn smiling while the United States in the form of two Indians butchered the Loyalists. Britannia stabbed Shelburn in the neck as she screamed, "Inhumane smiling Hypocrite thus to disgrace my unsullied fame." In short, the print condemned Shelburn for failing to protect the Loyalists with appropriate provisions in the peace settlement. Similarly, in March 1783 the United States was represented as barbaric Indians in "The SAVAGES *let loose*, OR The *Cruel* FATE *of the* LOYALISTS" (fig. 29). One Indian had hung four Loyalists. Another Indian was preparing to scalp an unarmed Loyalist, who had fallen to the ground. A third Indian was raising a tomahawk to strike another Loyalist, who cried, "O Cruel Fate! is this the Return for Our Loyalty." A couplet amplified, "Is this a *Peace*, when Loyalists must bleed? / It is a Bloody Piece of work indeed."

In their display of inhumane and barbarous acts, these two prints evoked the full savagery that had become associated with the image of the Indian as used to specify native Americans. Such stereotypes were depicted, for example, in "THE ALLIES—*Par nobile Fratrûm!*" published by I. Almon on February 3, 1780—a print that criticized the British government's alliance with the native Americans. George III feasted with an Indian ally on human meat, while two other savages wrung blood from the corpse of a white baby and drank from a human skull. An excerpt from *A Narrative of the Capture and Treatment of John Dodge, by the English at Detroit*, also published in London by Almon in 1779, commented, "The Party of Savages went out with Orders not to spare Man, Woman, or Child. To this cruel Mandate even some of the Savages made an Objection, respecting the butchering the Women & Children; but they were told the Children would make Soldiers, & the Women would keep up the Stock."

Images of the ruthless Indians were distributed in "The CLOSET," printed by I. Williams on January 28, 1778. In the upper left, Indians murdered Jane "McRea" [McCrea] on her wedding night when the Loyalist woman was en route to join her fiancé. With her hands still folded in prayer, she screamed, "O horrid! is this the Marriage Ceremony," while Indians menaced her with a tomahawk and scalped a fallen white man. The Indians did not distinguish between men and women, or, as important, between the enemies and the friends of the British government. In the scene depicted directly below the murder of McCrea, another group of Indians roasted a white man on a spit that they had rammed through his body from his rectum to his open mouth. Whether the white man had been alive at the moment when the Indians impaled him was left to the imagination. The image of these ruthless and savage Indians, who designated native Americans, was indistinguishable from the image of the Indians who represented the United States in the two prints from 1783.

In Britain, the image of the Indian that designated the United States evoked other commonplace convictions about Indians, some of them as derogatory as King James I's infamous allusion in 1604 to America's natives as "beastly *Indians*, Slaves to the *Spaniards*, Refuse to the World, and as yet Aliens from the holy Covenant of God." In less severe but nonetheless invidious moments, Indians were classified with children in terms of reasoning ability and moral sensibility, as when Samuel Johnson remarked, "Pity is not natural to man. Children are always cruel. Savages are always cruel. Pity is acquired and improved by the cultivation of reason." Consonant with such an image of the Indian were the allusions to the Indian that represented the United States as naïve, duped, or the "child" of Britannia.[11]

Throughout the Revolutionary era, Indians were described as leading a "licentious life," as, for example, in the popular English translation of Pehr Kalm's *Travels into North America* in 1771. Consonant with this description of the Indians was the image of the United States as an Indian woman who threatened to become a strumpet in some prints and who assaulted her own mother in others. In keeping with convictions about the Indian's licentiousness was also the image of the United States as a female Indian who engaged in a promiscuous courtship of France and Spain. She sought to fulfill her desires for material well-being through her sexual

favors to the enemies of Britain—images that were overt expressions of British anxieties about maintaining a monopoly over American commerce.[12]

In Britain, above all, the Indians were portrayed as savoring war. Such convictions about them occurred in Thomas Pownall's *Administration of the Colonies* in 1765:

> The Indian's whole life is a warfare, and his operations never discontinued. In short, our frontier settlements must ever lie at the mercy of the savages: and a settler is the natural prey to an Indian, whose sole occupation is war and hunting. To countries circumstanced as our colonies are, an Indian is the most dreadful of enemies. For, in war with Indians, no force whatever can defend our frontiers from being a constant wretched scene of conflagrations, and of the most shocking murders.[13]

Speaking before the House of Lords in 1777, William Pitt condemned the conduct of the British government: "[T]hey have let the savages of America loose upon their innocent unoffending brethren; loose upon the weak, the aged, and defenseless; on old men, women and children, upon the very babes upon the breast, to be cut, mangled, sacrificed, burned, roasted, nay, to be literally eat. These, my Lords, are the allies England now has." The image of the United States as blood-hungry Indians who attacked Britannia in some prints and sought to murder the Loyalists with scalping knives and tomahawks in others gives further evidence of Indians as savage and hostile.[14]

In a time of war, it was not and is not unusual to denigrate the enemy. But these prints did so by employing images that represented the United States in the form of a third party, the native American. The image of the Indian was connected intimately to British convictions about native Americans, who were regarded as not Noble Savages but ruthless ones. If the Noble Savage is taken to mean an Indian who led a way of life superior to that of the white man, the image of the Noble Savage was nascent in England. Even though that image was well developed in France during the period of the American Revolution, that development was insular. For instance, the image of the Noble Savage was employed in France during the eighteenth century in textiles such as "Hommage de l'Amérique à la France" (fig. 30) and in medals such as Augustin Dupré's *Brigadier General*

Daniel Morgan, Dupré's *Médaille diplomatique*, and Nicholas Marie Gatteaux's *Brigadier General Anthony Wayne*. In France the image of the Noble Savage recurred especially in political prints such as "L'AMÉRIQUE INDÉPENDANTE," "L'ANGLETERRE SUPPLIANTE" (fig. 31), "L'ANGLETERRE EXPIRANTE," "VIVE LA PAIX À JAMAIS," and "INDÉPENDANCE DES ÉTATS-UNIS."[15]

In contrast, however, only certain elements of the Noble Savage were present during the eighteenth century in England, where the preponderance of the imagery depicted the ruthless savage, as evidenced by the relative abundance of captivity narratives and by numerous occurrences of the Indian in political prints. One element of the Noble Savage was his oratorical ability, which had been noted with respect in *The London Magazine* of 1759 and *Scots Magazine* of 1776, as well as in Cadwallader Colden's *History of the Five Indian Nations of Canada*, published in London in 1747. Colden observed, "The People of the *Five Nations* are much given to *Speechmaking*, ever the natural Consequence of a perfect Republican Government." But the Indian as used to represent the United States did not orate. The Noble Savage was reputed to have tremendous stamina and to endure torture with unflinching dignity. But the Indian representing the United States cowered in fear, trembled in dismay, or complained about back injuries. Finally, the Noble Savage was believed to cherish liberty above most things. Colden affirmed in *The History of the Five Indian Nations of Canada* that the Indians have "such absolute Notions of Liberty, that they allow of no Kind of Superiority of one over another, and banish all Servitude from their Territories." Edmund Burke wrote in *An Account of the European Settlements in America* in 1757 that adult Indians "experience nothing like command, dependence, or subordination; even strong persuasion is industriously forborne by those who have influence amongst them, as what may look too like command and appear a sort of violence to their will."[16]

Similarly, the image of the Indian that represented the colonies evoked notions of liberty. But the British government's economic and political priorities for America were such that demands for liberty were not regarded as noble either by the majority in Parliament or by the typical English citizen. British prints sometimes suggested that the United States had embraced a kind of liberty different from the constitutional monarchy of Britain. For instance, "ARGUS," attributed to James Gillray and published

on May 15, 1780, portrayed an Indian who observed British ministers' endeavors to grasp the crown of a sleeping George III. The Indian commented, "We in America have no Crown to Fight for or lose," to emphasize that the citizens of the United States possessed a different conception of liberty than did the British. The kind of liberty embraced by the Americans differed from that of the Noble Savage, however, in that the Americans came in increasing numbers to support a neoclassical conception of republican government.

In summary, the conviction that the civilization in America was inferior to the civilization in Britain was manifested in various forms of pictorial communication throughout the American Revolution, especially in the political prints produced on broadsides in London. In light of the ethnocentric tendency of the British people during the eighteenth century, the Indian was considered an inferior, because he or she designated a foreigner. The Indian's primitive weapons reinforced this image of inferiority: usually a bow and arrows, a tomahawk, or a scalping knife. During the Stamp Act controversy, the Indian's role was always that of a subordinate, sometimes that of a slave, at still others that of a child. The Indian's inferiority was amplified by the sex of the image, because the Indian was often depicted as a vulnerable, promiscuous, and naïve woman, especially on broadsides from 1765 through 1775. In these political prints, the Indian was portrayed as gullible, duped, and licentious. Alone, the Indian, despite great ability and strength, was unable to secure independence. Only with the assistance of France, Spain, and Holland, almost always shown as men, could the Indian accomplish that goal. After the peace agreement, the Indian representing the United States was vicious and unrelenting in the murderous assault on Loyalists. In short, these images of the Indian alleged that colonial civilization was alien to British civilization—America was more depraved, more barbaric, more savage. Such insinuations of inferiority were made concrete through the garb, possessions, conduct, sex, and race of the Indian that represented the United States. Additional insight into the portrayal of the United States as foreign and inferior through the image of the Indian may be obtained by next considering how American colonists appropriated and redefined it to represent themselves.

THE IMAGE OF THE INDIAN IN AMERICA

If the image of the Indian suggested that the colonies were alien and therefore inferior to Britain, why did the colonists adopt the image of the Indian to refer to themselves? The most obvious answer is that the dominant culture in Britain distributed the image with such regularity and insistence that eventually some of the colonists began to use it themselves. The evidence of such cultural influence is unequivocal: More than half of the germane broadsides published by Americans were derived from British originals. Upon closer examination, however, more-complex patterns characterized the colonists' appropriation and modification of this image.

At first, as the colonists incorporated the image of the Indian into their political prints, they retained certain elements of inferiority, but they modified the image so as to reduce or eliminate insinuations that the colonies were alien to British culture. Initially, in 1765, the colonies' role as an inferior within the British empire was not especially troublesome to most of the colonists, since they had become accustomed to the mercantile principles of imperial government, but the role of alien was deeply disturbing, because such an image could enable British politicians to deny Americans the constitutional rights guaranteed to British citizens. Colonial spokesmen professed to recognize the due subordination of America within the British empire, but they insisted that they be treated with all the usual rights and privileges of the English.

Later, however, with the series of controversies during the decade of protest from 1765 to 1775, some colonists came to question their role of inferior within the British empire and altered the image of the Indian accordingly. Certain political prints and events during that period exploited the image of the Indian as a disguise that enabled the colonists to act in violation of the established legal code within the empire. The colonists' most notorious use of such a disguise occurred during December 1773, when a group of colonists dressed as Indians destroyed large quantities of tea in Boston Harbor, an act known today as the Boston Tea Party. Finally, during the war years, the *Massachusetts Spy* carried an image of an Indian on the masthead, where it was printed week after week for several months.

This image of the Indian manipulated the roles of alien and inferior to dramatize the colonial situation within the British empire and to endorse a pervasive feeling of alienation.

During the Stamp Act controversy, even the most outspoken and respected of the American protesters endorsed the belief that it was appropriate for the colonies to be subordinate to Britain. In the most widely reprinted American pamphlet that opposed the British Parliament's Stamp Act legislation—Daniel Dulany's *Considerations On The Propriety Of Imposing Taxes In The British Colonies, For the Purpose of raising a Revenue, by Act Of Parliament*—the lawyer from Maryland asserted that the original colonists "knew, that in Consequence of their Relation to the Mother-Country, They and their Posterity would be subordinate to the supreme national Council, and expected that Obedience and Protection would be considered as reciprocal Duties." Dulany was emphatic that the colonies do "acknowledge Themselves to be subordinate to the Mother Country." He professed to be undisturbed by the role of inferior, which he acknowledged without equivocation.[17]

But most colonists, Patriot and Loyalist alike, were disturbed by any insinuation that the colonies were foreign to Britain, because they believed that their British heritage guaranteed for them the same rights that citizens enjoyed in England. Daniel Leonard, an American Loyalist, explained as late as 1775, "An alien is one born in a strange country out of the allegiance of the King, and is under many disabilities though residing in the realm." He added, "[W]e are a part of the British empire[,] are not aliens but natural-born subjects."[18]

So fundamental was the conviction that the colonists were entitled to the same rights as British citizens that the idea often functioned as a premise in colonial argumentation about the Stamp Act. Daniel Dulany, for instance, argued, "The Right of Exemption from all Taxes *without their consent*, the Colonies claim as *British* subjects." He explained, "[T]hough the Right of the Superior to use the proper Means for preserving the Subordination of his Inferior is admitted, yet it does not necessarily follow, that he has a Right to seize the Property of his Inferior when he pleases, or to command him in every Thing, since, in the Degrees of it, there may very well exist a *Dependance* and *Inferiority*, without absolute *Vassalage* and *Slavery*." In 1765, then, the colonists were complacent about their role as

inferior to Britain, but they were concerned about any insinuations that the colonies were alien to Britain. Such sentiments were also expressed emphatically in the pictorial communication of the Revolutionary era.[19]

The British colonies in America were depicted as an Indian in at least three colonial prints published during the Stamp Act controversy of 1765–66. All three of the prints sustained certain elements of colonial subordination to Britain, but two of them modified the image of the Indian to reduce or eliminate insinuations that colonial culture was alien to British culture. These two prints were both versions of "THE DEPLORABLE STATE of AMERICA or SC—H GOVERNMENT," published originally in London (fig. 32). John Singleton Copley's version of this print, published in Boston on November 1, 1765, was derived from a composition with a similar title that had originated in London on March 22, 1765. In Philadelphia on January 20, 1766, yet another version of "THE DEPLORABLE STATE of AMERICA" was published, this one derived by Wilkinson from Copley's version. During the spring of 1766, Paul Revere engraved a third germane print, "A VIEW *of the* OBELISK," which he distributed from Boston during the public celebrations of the repeal of the Stamp Act.[20]

In his "THE DEPLORABLE STATE of AMERICA or SC—H GOVERNMENT," Copley modified the original composition from London in some revealing ways. The similarities between the two prints corresponded to some salient ideas that recurred throughout the British empire during the Stamp Act controversy. More important, the differences between the prints revealed Copley's efforts to adapt the pictorial message to the colonists at Boston. Copley's version was his only overtly political engraving, an idiosyncratic work in the career of the eminent American portrait painter. To judge from "THE DEPLORABLE STATE of AMERICA," Copley acknowledged the idea of colonial subordination to Britain, but he rejected the idea that the colonies were an alien culture. Copley modified the original image of the Indian to eliminate some stereotypical attributes, such as the Indian's nakedness and skin coloration.

There were several noteworthy similarities between these two prints. Both featured the relationship between the Indian and Britannia, because the colonies and the British Parliament were engaged in a confrontation throughout the Stamp Act controversy. Britannia urged the Indian to accept

a box labeled "Pandora's Box," an allusion implying that the contents of the
Stamp Act would be harmful to the American colonies. The Indian refused
the Stamp Act in a nonviolent way, although mob violence was shown in
the background of Copley's engraving. Rather, the Indian appealed to
Minerva, the goddess of wisdom, for protection from Britannia's gift—
probably an unintended irony, since the image of Britannia was derived
from that of Minerva. Such an appeal sustained an image that the colonists
were engaged in a political strategy of deference rather than outright defi-
ance—however coercive their tactics actually were during the riots of 1765,
as suggested in the background of Copley's print. Ultimately, these prints
expressed fundamental distrust of the British government's motives toward
the colonies.[21]

Other similarities between the two prints sustained recurring com-
monplace ideas about the causes and the consequences of the Stamp Act. In
both prints, Lord Bute's acts of villainy were responsible for the passage
of the Stamp Act in Parliament. In the upper right of these compositions,
a small boot in a radiant star represented the influence of Lord Bute, the
intimate Scottish adviser of King George III. In the London version, the
star shed its dire influence on Mercury, while in Copley's print the star
"shed its baneful influence on Britannia." In these illustrations, the conse-
quences of the Stamp Act were portrayed as the loss of liberty and com-
merce—two of America's most vital concerns. As the Indian refused the
"gift" from Britannia, the Indian gazed with concern at a personification
of Liberty, who was dying beside her. Meanwhile, a figure beside the
liberty tree wondered if it would continue to stand in the harsh blast of
wind that had accompanied the Stamp Act. Mercury, a well-known symbol
of commerce, departed with reluctance from America, suggesting that the
colonies were losing valuable trade.[22]

The differences between Copley's version and the London version of
the print illustrated Copley's concern for making the message pertinent to
the colonists at Boston. For example, "To Liberty" was inscribed directly
on the trunk of the tree in the London version, but Copley engraved a
plaque on the tree with the words "THE TREE of Liberty," along with the
date of a Boston riot about the Stamp Act. This addition brought the
significance of the local disturbance to the imperial dispute. Another local
allusion appeared in the background, where a stamp tax collector fled on

horseback and bellowed, "Fort George will save me." Fort George was a nearby island in Boston Harbor where British troops had been stationed. In both prints, a representation of France—either the king of France in the London print or the "flying Genius of France" in Copley's print—bribed Lord Bute with a bag of gold. Copley's print amplified this concern about the Scottish adviser's role in the British government by suggesting a general anxiety about Scottish influence in the government. In Copley's print, the death of Liberty had been caused by a serpent that had slithered out from beneath a thistle, a conventional symbol of Scotland. Meanwhile, William Pitt's dog performed the somewhat heroic act of urinating on the thistle.[23]

There were several other differences between the two prints, but the way Copley modified the image of the Indian revealed most about underlying differences in British and American conceptions of the body politic. In the London print, Britannia referred to the box only as "The S-p Act." By adding the words "Take it Daughter," Copley had the print affirm that the Indian and Britannia were members of the same family, thus amplifying the implications of Britannia's deceit: overtones of a wicked parent who was betraying her own child's best interests. Moreover, such an allusion to a family relationship mitigated any implications that the colonies were alien to British culture. In Copley's print, Britannia's motives toward the Indian were suspect; fragments of a torn Magna Charta trailed behind in her path to suggest her abandonment of constitutional principles. Finally, a poem in Copley's composition elaborated on the consequences of Britannia's deceit:

Contagion Box what PLAGUES dost thou contain.

HORROR without and RUIN all within

Some latent MISCHIEF in each corner lurks

In every cell a secret Venom works;

FATE lies in ambush in the Center hid,

And DEATH itself hangs hovering o're the lid.

The colonial print amplified the British government's culpability for abusing the Indian far beyond that suggested in the original London version.

Second, in the London print the Indian stood with a bow and arrows strapped on her back, while Britannia sat to her left. In contrast, in Copley's

print the Indian sat with the bow and arrows lying on the ground to her left, while Britannia flew over the ocean to impose the Stamp Act. Copley's composition emphasized that America was a victim of the British government's legislation more so than the London print, wherein an active Indian stood to refuse the Stamp Act. Third, the garb of the Indian differed between the two prints. While the Indian in the London print was bare-breasted, the Indian in Copley's print was draped as though she were a Greco-Roman figure. This difference suggested an effort by Copley to modify the image to make the Indian appear more European than she had in the original. Such an effort also characterized the coloration of her skin. Although the London print portrayed the Indian with much darker skin than that of other figures in the composition, in Copley's illustration the Indian's skin was not different from Britannia's. Copley may have replaced the Indian's features and garb with stereotypical European ones to minimize the impression that the colonies were an alien culture. In this light, the affirmation that the Indian was the "Daughter" of Britannia also eliminated insinuations that the colonies were an alien culture, while retaining an element of inferiority through the child's subordination to its parent.

Copley's version of the print appears to have been popular in the colonies. It was sold in Philadelphia during November 1765, and it was subsequently reproduced there by Wilkinson in a slightly revised form on January 20, 1766. As a result of copying the engraving, Wilkinson reversed the image of the entire composition so that England was an island to the left of the American continent. Other changes replaced Boston allusions with Philadelphia ones: Gone was the date of the Boston riot from the plaque on the liberty tree; added was a reference to the *Pennsylvania Gazette*. Wilkinson inscribed two additional verses into the crowded composition, commenting on Bute's influence in the British government and suggesting that stamp tax collectors should be hung. The skin color, garb, and conduct of the Indian remained essentially unchanged from Copley's version.

Did colonial and British illustrators typically differ in their portrayals of the skin and garb of the Indian that represented the British colonies in America? A quantitative comparison of British and colonial prints does reveal some consistent differences. Of colonial prints in which an image of the Indian represented the colonies, only 18 percent had an Indian whose

skin was darkened in comparison with others in the same print. In contrast, approximately 60 percent of the British illustrations had an Indian whose skin was darkened in comparison with others in the same print—more than triple the colonial percentage. Of the colonial prints, only 27 percent depicted the Indian in stereotypical Indian garb—less than one-third of the prints. Of the British prints, 68 percent portrayed the Indian in such stereotypical garb—more than two-thirds of the prints. Opposing tendencies characterized the use of the Indian by British and colonial illustrators to designate the colonies. British illustrators maximized the similarity of the image representing the colonies with stereotypical conceptions of Indians by darkening the skin and by using stereotypical Indian garb. Colonial illustrators minimized any similarities. The British illustrators emphasized associations with foreignness and inferiority while the colonists obscured such implications.[24]

The difference in the treatment of the Indian's skin color was especially suggestive. An emphasis on the Indian's skin color characterized a growing belief among white communities in the eighteenth century that Indians were racially different from white people and therefore innately inferior to them. Before the mid-eighteenth century, the journals, diaries, and literature in the colonies and in England indicated that white societies saw the Indian as tawny, but not as racially different. After the mid-eighteenth century, these white societies came pervasively to believe that Indians were racially different. They emphasized this difference by calling the Indian's skin "red." Accordingly, the appearance of darkened skin in the British prints suggested to the public that the American colonies were racially different and therefore innately inferior.[25]

In a third colonial print about the Stamp Act, "A VIEW *of the* OBELISK," Paul Revere also depicted the Indian with skin color similar to that of the other personages in the print, although he portrayed the Indian in a feather skirt. This print recorded the images from the four sides of an obelisk that had been erected on the Boston Common to celebrate the repeal of the Stamp Act. The print erroneously affirmed that the obelisk had been "erected under LIBERTY-TREE in Boston," when it actually had been erected on the Common with the unrealized intention that it would be moved eventually to the liberty tree. "A VIEW *of the* OBELISK" was advertised for sale on May 22, 1766, in the *Massachusetts Gazette and Boston News-Letter*,

shortly after Boston had received the news that Parliament had repealed the Stamp Act. The print was dedicated "To every Lover of LIBERTY," and the words "Liberty" or "Freedom" were inscribed on each side of the obelisk. The text on the obelisk began by evoking the goddess of Liberty, and later the text affirmed, "Be SLAVES! We dare to scorn it—dare to die." The text related how patriots saved colonial liberty by repealing the Stamp Act, and the portraits of sixteen statesmen who had rescued liberty were engraved at the top of the obelisk, four on each side. [26]

At the base on each side of the obelisk were scenes from a pictorial narrative about the Stamp Act. On side one, a concern for liberty characterized the British ministry's endeavor to enchain the Indian, who rested under a liberty pole, consisting of a spear with a Roman liberty cap over the point. Dressed in Scottish plaid, Lord Bute carried the ominous chains toward the Indian. On side two, the Indian implored William Pitt for help as she pointed to Bute and the other villains in the background. The chains on the ground substantiated their guilt. A thunderstorm above the villains was antithetical to the clear sky above the heroic William Pitt. Fame, the woman with a trumpet above Pitt, represented the portending triumph of good over evil. On side three, a classical figure rescued baby birds from a predator. On the final side of the obelisk, the Indian stood at ease beside the figure who had rescued the birds and another figure who held a liberty pole. In this engraving, the Indian's appeal to William Pitt suggested that the colonies were vulnerable because they could not act directly on their own behalf in Parliament. In addition, because the print emphasized the issue of liberty and portrayed the Indian deferring to William Pitt, Revere's engraving obfuscated the colonial violence and the nonimportation agreement that had added economic clout to the appeals for repeal. Revere's print provided no hint that the conflict ever had an economic aspect.

On December 16, 1773, the Sons of Liberty disguised themselves as Indians before boarding a British ship to toss several hundred chests of tea overboard. The image of the Indian was used as a disguise for the Sons of Liberty during their destructive and illegal course of action known as the Boston Tea Party. It was not the only occasion when the Sons of Liberty had disguised themselves as Indians to act outside of the legal code of the British empire, but it was the most highly visible instance of such conduct.

As early as 1768, Ann Hulton wrote, "Mrs Burch at whose house I was, had frequently been alarmd with the Sons of Liberty surroundg her house with the most hideous howlings as the Indians, when they attack an Enemy." As a disguise, the Indian role enabled the Sons of Liberty to intimidate their political opposition. The disguise seems to have released them from conventional codes of moral conduct.[27]

As a disguise, the image of the Indian underwent a significant transformation in its rhetorical usage. In a sense, the Indian disguise reversed the implications of inferiority for the wearer, who possessed a superior insight into his own character: He was someone other than he seemed to be to the casual observer. Alluding to the destruction of the tea at Boston only two days earlier, John Andrews wrote in a letter on December 18, 1773, "They say the actors were *Indians* from *Narragansett*. Whether they were or not, to a transient observer they appear'd as *such*, being cloath'd in Blankets with the heads muffled, and copper color'd countenances, being each arm'd with a hatchet or axe, and pair pistols, nor was their *dialect* different from what I conceive these genuisses to *speak*, as their jargon was unintelligible to all but themselves." The Indian disguise enabled the wearer to assume a reprehensible role, while distancing himself from that conduct, since the role was an assumed one, a persona, not the actual person. Peter Oliver observed subsequently in 1781 in his *Origin & Progress of the American Rebellion*, "After the Affair was over, the town of *Boston*, finding that it was generally condemned, said it was done by a Crew of Mohawk Indians; but it was the Rule of Faction to make their Agents first look like the Devil, in Order to make them Act like the Devil."[28]

Elsewhere in New England, those who opposed the duty on tea continued to don the disguise of Indians to confiscate and destroy tea. According to the *Boston Gazette* of February 14, 1774, a band of "Indians" seized and burned about 30 pounds of tea from a peddler who was passing through Shrewsbury. Similarly, an itinerant tradesman at Lyme, Connecticut, lost 100 pounds of tea to a mob. When the rumor spread in Weston, Massachusetts, that Isaac Jones had been selling tea at his tavern, thirty patriots "disguised with Paints" as Indians broke into his establishment and reduced it to a shambles. On March 6, 1774, Boston was the scene of a second tea party, when about sixty "Indians" went aboard the *Fortune* to toss "Twenty-eight Chests and a half" of the despised tea into the harbor.[29]

In Britain, the destruction of the tea at Boston confirmed the worst opinions about the American colonists. According to the *Public Advertiser* of London on January 25, 1775, one correspondent described the participants in the Boston Tea Party as "a Mongrel Tribe, the canting Spawn of old Oliver, mingled with the Blood of Indians, Negroes, Dutch, Molattoes, and the Refuse of our Gaols." To the writer in the *Advertiser*, the colonists' use of the Indian disguise only exacerbated a growing impression in England that the American colonies were alien to civilized British ways. The Americans had not only identified themselves with savagery by disguising themselves as Indians, they also behaved savagely by destroying that most civilized of beverages, tea.[30]

In June 1774, after the news that Parliament had passed the Intolerable Acts, Paul Revere depicted the Indian as vulnerable to the whims of parliamentarians in *"The able Doctor, or America Swallowing the Bitter Draught,"* published in *The Royal American Magazine; or, Universal Repository of Instruction and Amusement* and derived from an earlier work with the same title in *The London Magazine* of April 1774. The difference between the two prints was slight: Revere added the word "TEA" on the pot to eliminate the remote possibility that the doctor's treatment of the Indian might be seen as potentially beneficial. The three references to "Boston" in the print indicated that the molestation corresponded to British reactions to the Boston Tea Party. At the same time, the repeated reference to Boston emphasized a local concern of the city's citizens, which probably predisposed Revere to reproduce the engraving. Most important, the print underscored the senselessness of the Boston Port Bill. In the print, the government officials had no purpose other than the cruelty of rape.

Evidently, such a conception of the government officials' conduct was commonplace in America, because two additional versions of *"The able Doctor"* were published in Pennsylvania during August 1774 and in Connecticut during 1775. The print distributed from Philadelphia was an engraved broadside retitled to focus attention upon the Indian's determination to endure despite the officials' oppressive conduct, *"The Persevering Americans, or the Bitter Draught Return'd."* The version distributed from New London was an untitled woodcut on the cover of *FREEBETTER'S NEW-ENGLAND ALMANACK, for the Year 1776* (fig. 33). A text in the almanac

affirmed that the Indian was the child of Britannia to reduce the implications that the Indian was alien.

In another print published shortly after the passage of the Intolerable Acts in 1774, Indians defended themselves from an array of British personages in *"LIBERTY TRIUMPHANT*; or the Downfall of *OPPRESSION."* The map in the background was backwards in this print: America was on the right, England on the left. According to the numbered list of characters below the print, the Indian with a drawn bow in front of the tribe was "America represented by a Woman," and behind her were "The Sons of Liberty represented by the Natives of America in their savage garb." She said, "Aid me my Sons, and prevent my being Fetter'd," a remark implying that her stance was defensive and that the issue was one of liberty or slavery. Moreover, the female Indian demanded the help of the male Indians to defend her interests. On the opposing shore, Lord North held a chain, tangible evidence of his efforts to enslave the American people. Among the conspiring government officials was the Devil himself, whispering advice, an unequivocal indictment of the ministry for wickedness.[31]

In 1775, Paul Revere published two prints that sustained the image of America as the victim of the British government. More important, the prints revealed an underlying ambivalence about the propriety of using the image of the Indian to represent the colonies. In one of the two, *"America in Distress*," the image of the Indian was supplanted by a figure resembling Britannia, distinguishable from Britannia only by the Indian's feather headdress and the bow and arrows beside her. Only these two attributes suggested that the image was an Indian representing the colonies. One group of government officials sought to enact a bloodletting—the medical practice of making patients bleed to cure them—while another group of officials fought them with an axe. The print underscored divisiveness in Parliament. Once again the Indian was the potential victim of government forces beyond her own control. The opposition between the heroes and villains in Parliament and between the liberty and slavery of America was pictorially manifested: One group attempted to chain the Indian, and the opposing group rebuffed them while standing under the liberty pole.

By fully clothing the image of the Indian in this print Revere departed from his own earlier usage of the Indian in such prints as "A VIEW *of the*

OBELISK" and "A VIEW OF PART OF THE TOWN OF BOSTON IN NEW-
ENGLAND AND BRITTISH SHIPS OF WAR LANDING THEIR TROOPS! 1768"
in which the Indian wore stereotypical Indian garb. Revere may have
modified the image of the Indian in an attempt to mitigate one aspect of
the Indian's alleged inferiority: her nakedness. Colonists believed that na-
kedness was an indication of primitiveness and savagery, as when Thomas
Paine commented subsequently in 1776, "He, who hunts the woods for
prey, the naked and untutored Indian, is less a Savage than the King of
Britain." However, the changes in the image of the Indian were as likely
to have been a matter of convenience as a response to public sentiments
about nakedness: The image in *"America in Distress"* was derived from an
illustration titled *"Britannia in Distress,"* which had been published in *The
Oxford Magazine or Universal Museum* during 1770. The Indian's garb
was essentially unchanged from Britannia's clothing in the original print.[32]

Another print by Revere in 1775 revealed dissatisfaction with the
Indian as a symbol to designate the colonies. The imagery in this print
could not be explained by mere convenience, because neither the Indian
nor Britannia appeared in the original print from which Revere had derived
it. In January 1775, Revere published *"A certain Cabinet Junto"* in *The
Royal American Magazine; or, Universal Repository of Instruction and Amuse-
ment.* He had derived it from *"A retrospective View of a Certain Cabinet
Junto"* in the May 1773 issue of *The Oxford Magazine or Universal Museum.*
In Revere's print, Britannia definitely represented the colonies, not the
British empire, because the lines on the ground between Britannia and the
four ministers conveyed a physical distance between America and Britain.
More important, Britannia prayed, "Lord thou didst drive out the heathen
before us, our hope is in thee." That comment linked Britannia to the
American colonies, while it revealed why the attributes of the Indian des-
ignating America in Revere's other prints had been supplanted by Britannia
in this one: to minimize any association of the colonies with the Indian
"heathen before us." In addition, by using the image of Britannia to rep-
resent the colonies, the print encouraged an identification between the col-
onies and their British heritage. A voice from above Britannia reassured
her, "I have delivered, and I WILL deliver." The print affirmed God's active
support for the colonies in their just opposition to the plotting ministers
with their bill "for the total abolition of Civil & [Religious] liberty in

AMERICA." The bow and arrows resting beside Britannia were tangible evidence that God had driven out the "heathen" Indian.[33]

Because this engraving expressed ideas similar to those in an essay from the same issue of *The Royal American Magazine; or, Universal Repository of Instruction and Amusement*, it was likely that Revere replaced the image of the Indian with Britannia because as a professional illustrator he adapted the imagery to the particular message to be conveyed. The print and the essay alluded to God's manifesting his blessing upon the colonies by eliminating the Indian; the essay explained that the diseases that were rampant among Indians were of a divine origin. Both the print and the essay alluded to God's protecting the colonies during their conflict with Britain to express the conviction that God would involve himself in the affairs of humankind according to their merit. To convey such a message, the image of the Indian was unsuitable, since colonists regarded most Indians as pagans. Revere's print pointed out a source of tension in the appropriate selection of an image to represent the colonies and gave evidence of dissatisfaction with the image of the Indian.[34]

During the war years, the image of the Indian recurred in various media, especially on broadsides, flags, and at least one newspaper masthead. In a handful of prints, a colonist disguised as an Indian was employed to designate Congress. At least four military flags adopted an image of an Indian to denote the American colonies. In addition, the image recurred on the masthead of the *Massachusetts Spy*, published by Isaiah Thomas. These uses of the motif sustained and amplified the rhetorical meanings of the image during the war years by specifying certain American aspirations and by portraying the colonists' feelings of alienation from the British empire.

In colonial prints published in 1778 and 1780, a colonist disguised as an Indian was used to designate Congress. For example, two variants of prints derived from "*A Picturesque View of the State of the Nation for February 1778*" (fig. 23) were later reprinted in the American colonies, once as "A PICTURESQUE VIEW of the State of GREAT BRITAIN for 1778. Taken from an English copy," which was probably published in an American almanac for that year, and yet again in "A PICTURESQUE VIEW of the State of GREAT BRITAIN for 1780," published in WEATHERWISE'S *TOWN AND COUNTRY ALMANACK FOR THE YEAR OF OUR LORD 1781*. According to the

explanation on these prints, the milk cow represented the commerce of Great Britain; a man who wore colonial breeches and an Indian headdress represented "[t]he American Congress sawing off her horns which are her natural strength and defence; the one being already gone, the other just a going." A Dutchman milked the cow, while a Spaniard and a Frenchman took part of the produce. Similarly, the American Congress was a man wearing colonial garb and an Indian headdress in a print published in Boston and Philadelphia in 1778. The title was French—*"DEDIÉ AUX MILORDS DE L'AMIRAUTÉ ANGLAISE PAR UN MEMBRE DU CONGRÉS AMÉRICAIN"*—but the print was inscribed *"Dessiné d'après nature à Boston par Corbut en 1778"* and *"gravé à Philadelphie."* England was represented as half man and half vulture, a creature whose greed was thwarted: An Indian representing Congress trimmed his claws, while a Spaniard, a Frenchman, and a Dutchman clipped his wings and plucked his feathers. In both of these prints, only the feather headdress suggested the attributes of the Indian.[35]

Whether the viewer considered these representations of Congress as a colonist disguised with an Indian attribute or as an Indian with some European attributes was a somewhat arbitrary matter, because the mingling of the attributes in the compositions was ambiguous. However one regarded the representations, the imagery of the Indian featured only one isolated Indian attribute: the feather headdress. The colonial breeches and vest raised the possibility that the Indian attribute was a disguise, since the breeches and vest were rarely associated with the image of the Indian in other prints. Furthermore, the textual reference to the image as Congress, a group of white colonial leaders, reinforced the probability that the attribute was a disguise. Finally, the appearance of these prints after the Boston Tea Party made it likely that this representation was a colonist disguised as an Indian, with implications of concealment and cunning. These colonial versions of "A PICTURESQUE VIEW of the State of GREAT BRITAIN" were derived from a British print, but they too were published in 1778 and 1780, five or seven years after the Boston Tea Party.

The image of the Indian recurred on at least four military flags during the Revolution. As a group, these flags specified the Indian's defensive stance and identified salient motives, most commonly the concern to preserve liberty but also the desire to create a new empire and to achieve fame

throughout the world. The Gostelowe Standard Number Four depicted the Indian trampling on Britannia's shield, while Fame flew toward the Indian to present a liberty cap and to proclaim, "Be Liberty Thine." Britannia, clutching a broken spear in her hand, wept. Beneath this imagery was a motto that expressed an aspiration, "BEHOLD THE RISING EMPIRE." The Gostelowe Standard Number Eleven portrayed the Indian grasping the liberty cap, which was placed on a pillar. The motto affirmed, "THIS IS MINE AND I WILL DEFEND IT." Another flag, Webb's Additional Continental Regiment of 1777, portrayed the Indian wielding a sword and standing victorious over a beheaded king, whose crown lay beside his severed head. In all three of these flags, beside the Indian a dog designated fidelity to the American cause. Yet another flag, the Philadelphia Light Horse, portrayed the Indian holding a bow and arrows in one hand and a liberty pole in the other. Facing the Indian was the image of Fame. Beneath these motifs was the motto "FOR THESE WE STRIVE," to suggest American aspirations for fame and liberty.[36]

Finally, an image of the Indian was used to represent the colonies on the masthead of the *Massachusetts Spy* from May 24, 1781, until December 30, 1784. The editor of the *Spy*, Isaiah Thomas, described the device in *The History of Printing in America*: "The device on the left was a figure representing America, an Indian, holding the cap of Liberty on a staff with the left hand, and in the right a spear, aimed at the British lion, which appeared in the act of attacking her from an opposite shore. Round the device was, 'LIBERTY DEFENDED FROM TYRANNY.' " The liberty pole in the Indian's hand and the inscription "LIBERTY DEFENDED FROM TYRANNY" circling the image would have suggested that the colonies sought only to protect their rights, not to attack the lion without due cause. The masthead was particularly striking because the Indian imagery did not appear to be a disguise and because the engraving was by Paul Revere, who in 1775 had altered and supplanted the Indian imagery that represented the colonies. In this masthead, Revere again employed a typically British image of the Indian: The Indian had darkened skin, wore a feather skirt, and wielded a spear.[37]

If the image of the Indian underwent transformations in Paul Revere's pictorial works, the modifications were not without ambivalence, because in 1775 Revere had replaced the Indian with Britannia to promote a colonial

identification with a British heritage. But in the masthead from 1781 to 1784, the opposition between the Indian and the lion suggested complete alienation. Because the Indian was a human being engaged in a deadly struggle with a beast, the image encouraged the viewer to favor the Indian. Further, his relationship to the beast allowed for no possibility of reconciliation. The Indian may have been seen alternatively as defending liberty from the British military or from the king, since the British lion was often employed to represent either.

The use of the image of the Indian on the masthead during the Revolution was especially puzzling since by that time the Indian was regarded widely and unequivocally as an enemy. In 1776, the Declaration of Independence listed among the nineteen colonial grievances against the king that he had "endeavored to bring on the inhabitants of our frontiers the merciless Indian savages, whose known rule of warfare is an undistinguished destruction of all ages, sexes, & conditions." During the conduct of the war, General John Burgoyne was reported to have offered a reward to Indians for colonial scalps. One Pennsylvanian, pretending to be Burgoyne, satirized:

> I will let loose the dogs of Hell,
> Ten thousand Indians, who shall yell,
> And foam and tear, and grin and roar,
> And drench their maukesins in gore;
> To these I'll give full scope and play
> From *Ticondrage* to *Florida*;
> They'll scalp your heads, and kick your shins
> And rip your guts, and flay your skins.

The same issue of the *Pennsylvania Packet*, for August 26, 1777, also carried a proclamation attributed to Burgoyne wherein he threatened to use Indian forces. On September 10, 1777, a writer in the *Pennsylvania Journal* asserted that Burgoyne had "discontinued the reward he had offered" for scalps because he "had found by experience, that his rewards lessened the number of his emissaries—who not only scalped some of his tory friends, concealed among the inhabitants, but also scalped one another."[38]

In America, hatred among colonists toward the Indians was pervasive. During the war, Henry Dwight hoped that an American army would "[m]assacre those Infernal Savages to such a degree that [there] may'nt be a pair of them left to continue the Breed upon the earth." After the war, one British writer who had toured the United States wrote, "The white Americans have the most rancourous antipathy to the whole race of Indians; and nothing is more common than to hear them talk of extirpating them totally from the face of the earth, men, women, and children."[39] In light of the colonial antipathy toward Indians—an antipathy that was intensified by wartime conflict—why did Paul Revere and Isaiah Thomas choose to use the image of an Indian to represent the colonies on the masthead of the *Massachusetts Spy* for three years? Perhaps Thomas and Revere used the image to dramatize the colonial alienation from Britain. Perhaps the Indian was an emphatic image of a lowly and despised human that accordingly stressed the colonies' condition within the empire. Earlier the two men had selected an image of a snake for the masthead of the *Massachusetts Spy*, and the Indian—like the snake—dramatized a deplorable condition to advocate political change. Whatever the underlying intentions were, the image of the Indian in this composition conveyed a sense of deeply felt alienation between the colonies and Britain; in that sense it conformed to a recurring use of the image.

CONCLUSION

The image of the Indian representing the British colonies in America was employed in rich and varied ways in American prints and flags. Initially during the Stamp Act controversy, prints by Copley and Wilkinson used the image in such a way that it maintained elements of colonial inferiority to Britain, but they modified the skin and garb of the Indian to reduce the sense that the colonies were alien to British culture. In both prints the affirmation that the Indian was the daughter of Britannia sustained the sense of colonial subordination, while it developed a sense of identification between the colonies and Britain. In 1766 Paul Revere also used the image

to create an impression of colonial deference to the British government, a role in keeping with the colonies' subordination within the British empire.

By 1776, however, Revere published two prints that revealed dissatisfaction with the image of the Indian because of its associations with pagan and primitive practices, which were incongruent with the conviction that the colonies were blessed by God. As early as 1768, other Bostonians had used the image as a disguise and exploited its possibilities to intimidate the political opposition and to behave in otherwise improper ways. The colonial use of Indian imagery as a disguise may have mitigated insinuations of inferiority, since the character possessed a superior insight that he was someone other than he seemed. In 1778 and 1780, prints of Congress as an Indian also employed the attributes of the Indian as a disguise. After 1781, Paul Revere and Isaiah Thomas used the image on the masthead of the *Massachusetts Spy*, where it dramatized a feeling of colonial alienation from Britain. While colonial prints began in 1765 by being complacent about the colonies' role as inferior but disturbed by insinuations that they were alien, by 1781 the reverse had established itself: The prints reflected discomfort with the role of inferior but endorsed the sense of alienation.

In Britain, the image of the Indian was transformed in ways that portrayed the colonies descending from mere inferiority to savagery. To a large extent, the British illustrators imposed the pictorial representation of the colonies as an Indian upon the colonists until some of them adopted the image, much as the word "Indian" was imposed upon native Americans until some of them began to use it themselves. Over half the colonial broadsides in which America was represented as an Indian were derived from British originals. However, the colonists who chose to use the image designed it so that it had more stereotypical European features than it typically had in British prints. While most colonial prints depicted the Indian in European garb, most British prints showed the figure scantily dressed in stereotypical Indian garb: a tobacco or feather skirt. While most colonial prints did not distinguish between the skin color of the Indian and the Europeans or colonists in the same print, most British illustrators darkened the Indian's skin in comparison with that of others in the same print. While colonists minimized the implications that the colonies were alien to British civilization by eliminating certain stereotypical Indian at-

tributes from the image, British illustrators maximized such implications by emphasizing those same attributes.

These two tendencies can be exemplified in their most extreme forms. In England the extreme form of the barbaric Indian can be seen in the two prints published at London in February and March 1783: "The SAVAGES *let loose*, OR The *Cruel* FATE *of the* LOYALISTS" and "SHELB—NS SACRIFICE *Or the recommended Loyalists*." Both prints criticized colonial treatment of the Loyalists. In both prints the Indians were dark, and they wore stereotypical Indian garb. With a rope, a tomahawk, and a scalping knife, they ruthlessly butchered and strangled the Loyalists. In contrast, in the colonies the tendency was to reduce or to eliminate the Indian imagery, as could be seen in the prints published by John Singleton Copley in 1765 and by Paul Revere in 1775. In *"America in Distress"* only the headdress and bow and arrows sustained the association of the colonial representation with Indian imagery. Otherwise the representation had stereotypical European features: The skin was white; the garb was a gown or dress. In *"A certain Cabinet Junto"* the colonies were represented by Britannia, who prayed, "Lord thou didst drive out the heathen before us, our hope is in thee," forcefully suggesting colonial dissatisfaction with the image of the Indian as their emblem, since colonists regarded the Indians as "heathens" whom God had driven out of the colonies.

These two tendencies were salient developments in the image of the Indian during the Revolutionary era. As the word "tendency" implies, there were noteworthy exceptions. In the colonies, Paul Revere designed a masthead for the *Massachusetts Spy* in 1781 wherein the Indian had darkened skin and wore a feather skirt. In Britain, "THE COMMISSIONERS" portrayed the Indian in an exalted position as a means of satirizing the futility of the commissioners' mission to America in 1778. The Indian had white skin and wore a classical drape. But in certain forceful ways, these exceptions conformed to the pattern of altering the Indian's skin and garb. In "THE COMMISSIONERS" the white skin and classical drape were in keeping with the Indian's superior role, a role atypical of most British prints. On the masthead of the *Massachusetts Spy*, the Indian's darkened skin and feather skirt expressed colonial alienation from Britain by stressing dissimilarity between American and British cultures.

The single most common use of the image was to portray the colonies as alien and therefore inferior to British civilization, though the emphasis on those ideas shifted from the latter to the former in colonial imagery during the Revolutionary era. The cultural milieu wherein the image of the Indian was distributed supports such an interpretation of the image. Numerous individuals in Britain and in the colonies alluded to Indians as inferiors. The belief that the Indian possessed some exceptional qualities does date back to Columbus, but the belief in a Noble Savage—that is, the belief that the Indian possessed a character and way of life superior to that of the white person—did not emerge pervasively in America until later. As Robert F. Berkhofer, Jr., put it, "If Whites regarded the Indian as a threat to life and morals when alive, they regarded him with nostalgia upon his demise—or when that threat was safely past." To the extent that the Indian representing the colonies resonated with thoughts of Indians designating native Americans, the implication was that the colonial culture was inferior to the European culture.[40]

If the image of the Indian was understood as a symbol suggesting that the colonies were regarded as alien and inferior to British civilization, certain puzzles can be explained. Such implications would explain why Copley modified the Indian's garb and skin color in "THE DEPLORABLE STATE of AMERICA or SC—H GOVERNMENT" (see the London version in figure 32), and they would also explain why Revere experimented with the image in 1775. These modifications would have constituted an effort to minimize the associations of the image with stereotypical Indians so that colonial civilization would be less likely to be viewed as alien. Such implications also would explain the tendency to use the Indian imagery as a disguise, since the image allowed for freedom to engage in otherwise unacceptable conduct. That the Indian was regarded as alien and inferior in the colonial and the British cultures appears to have been pervasive. The principal variations in the image of the Indian had to do with how such implications were to be exploited or mitigated.

The image of the Indian that represented the colonies and its commonplace associations underwent many dynamic changes from 1765 to 1783. One way to summarize these changes is to conceive of them as the reawakening of a commonplace metaphor. Initially in 1765 the two-hundred-year-old tradition in Europe of using Indian imagery to represent

the Fourth Continent had made it a familiar metaphor for a place, innocuous by its habitual appearance in the visual works of the period. Subsequently the image of the Indian was suitable to express British thoughts about the colonies because of its implications of an alien and inferior people. After 1765 the image underwent changes that indicated a more specific referent, the colonies, and that also portrayed that more specific image in ways suitable to the illustrators' purposes. For instance, the addition of the colonial military flag to the image of the Indian distinguished it from the image of the Fourth Continent and also represented a shift in the appeal of the image—from the demand for constitutional liberty under a British government to national liberty. Such changes contributed to reawakening the significance of the metaphor and its range of implications.

Furthermore, during this period the image of the Indian representing the British colonies in America was transformed. In British prints, the Indian became barbaric and savage in overt ways. During the same period the associations of Indians with savage and vicious conduct became intensified as a result of border conflict between colonists and native Americans and also as a result of claims that the British were instigating Indian attacks upon the colonists. Such changes intensified the denigrating aspects of the image at a time when the colonists were undergoing an apotheosis of their American destiny. During the decade of debate, the colonists came in increasing numbers to see themselves as neither dependent upon Britain nor inferior to Britain. In addition, they came to see themselves as the last bastion for the protection of Liberty, who had fled from the corrupt European nations to American soil. By casting off the ingrained notions of colonial inferiority to Britain and by emerging victorious from the Revolution, the colonies had changed to such a degree that the image of the Indian became less suitable to represent them, because its associations with inferiority were no longer acceptable to Americans.[41]

THE COLONIES
ARE A CHILD

"*How sharper than a serpent's tooth it is
To have a thankless child!*"

—SHAKESPEARE, *KING LEAR*, 1.4.312

T he conviction that Britain was the mother country and that the British colonies in America were her children was commonplace among the English and the colonists before and during the American Revolution. In 1776, for instance, Thomas Blacklock wrote in his *Remarks On The Nature and Extent of Liberty, as compatible with the Genius of Civil Societies*, "Nothing, indeed, can be more analogous to the natural relation between a parent and a child, than the political relation between a country and its colonies. To the latter, from their infancy to their maturity, through every period of their progress, the tuition, the protection, the beneficence of the former is necessary."[1] Such affirmations of the parent-and-child relationship between Britain and America were ubiquitous in the language of the period. The analogy recurred frequently in the letters, diaries, newspapers, pamphlets, formal debates, speeches, proclamations, and broadsides of the period to emphasize the bonds of blood, heritage, affection, and moral obligation between America and Britain. For more than a century in Britain and in America, political figures alluded to images of a family to articulate the mutual bonds that unified the British empire.[2]

Although the texts of the period described the British colonies in America most frequently as an infant, child, or children under Britain's parental care, the pictorial messages of the period did not employ those as the most commonplace images to designate the American colonies. In Brit-

ain, the American colonies were represented much more frequently with images of an Indian than with images of children. In America, images of a snake were at least as common as images of children. Even so, the image of the family recurred often, especially among caricatures, illustrated song sheets, and medallions. How were these depictions of the family ties between Britain and the American colonies designed to influence thoughts about the feelings, rights, and responsibilities of the English and the Americans? How did polemicists employ images of a family in their endeavors to articulate the problems besetting the British empire and thereby influence efforts to invent solutions?

The English and the Americans alike recognized that the image of the family used to represent Britain and America supplied a commonplace justification for legislation that was beneficial for Britain's economy. In 1776, for instance, Thomas Blacklock elaborated his belief that the colonies were obligated to provide economic support to Britain, just as a child was obligated to do for its parent:

> [D]uring the minority of children, parents have a right to the product of their labours,—[a right] which, however, decreases, as the offspring rises to the capacity of independence, and the powers of self-government: Thus a parent-state has a right to demand from its colonies all the returns which they can properly make, for her maternal care and liberality, till the same crisis of their political existence arrive.[3]

Along similar lines, in 1768 John Dickinson reasoned in his *Letters from a Farmer in Pennsylvania, to the Inhabitants of the British Colonies*, a pamphlet that was distributed widely in America, England, and France:

> THE parent country, with undeviating prudence and virtue, attentive to the first principles of colonization, drew to herself the benefits she might reasonably expect, and preserved to her children the blessings, on which those benefits were founded. She made laws, obliging her colonies to carry to her all those products which she wanted for her own use; and all those raw materials which she chose herself to work up. Besides this restriction, she forbad them to procure *manufactures* from any other part of the globe, or even the *products* of *European* countries, which alone could rival her, without being first brought to her. In short, by a variety

of laws, she regulated their trade in such a manner as she thought most conducive to their mutual advantage, and her own welfare.[4]

To the Americans and the English like Dickinson and Blacklock, a critical function of the family imagery was to justify the economic benefits that Britain obtained from America.

Yet the Americans and the English also recognized that the image of the family was evoked routinely to justify the military protection that America obtained from Britain, since parents were expected to protect their children. Accordingly, political figures often sought to specify reciprocal benefits that could be derived from the family relationship between Britain and America. Isaac Hunt, a conservative Quaker from Philadelphia, described the most important of these benefits in his pamphlet *The Political Family: Or A Discourse, Pointing Out the Reciprocal Advantages, Which Flow from an Uninterrupted Union Between Great-Britain and Her American Colonies*, published in 1775:

> Children receive nourishment from the milk of their mothers, till they are capable of digesting other food! And they receive from the hands of their parents, protection from the insults and injuries, to which their feeble, infant state is exposed. They ought, therefore, when they have attained the state of youth, or manhood, to evidence their gratitude, by a pious love and filial obedience. But though, obedience be due to parents, parents ought not to provoke their children to wrath. The state of minority is temporary. When that state ceases, the right of chastisement and absolute command ceases also. But honor, reverence, esteem and support, when wanted, in return for nourishment, education, and protection are *perpetually* due to the parent.[5]

To Hunt, the image of the family provided a vehicle to describe the reciprocal interests of Britain and America. He also employed the image of the family to circumscribe their proper conduct in light of the biblical allusions to Ephesians 6:1 and Colossians 3:20–21: "Children, obey your parents in the Lord: for this is right" and "Fathers, provoke not your children *to anger*, lest they be discouraged."[6] Most important, to Hunt the image of the family implied that the reciprocal benefits between the parent

and the child were subject to modifications: Depending upon whether the child was in the early stages of growth or in maturity, the obligations of family members in the British empire would change with time.[7]

British writers such as Thomas Blacklock and Richard Price reasoned similarly that the child's state of nonage or maturity determined the proper relationship between parent and child. Richard Price applied the family analogy to the relationship between Britain and America in *Observations On The Nature Of Civil Liberty, The Principles Of Government, And The Justice And Policy Of The War With America*, more than twenty editions of which were published in English, French, and Dutch during 1776:

> Children, having no property, and being incapable of guiding themselves, the author of nature has committed the care of them to their parents, and subjected them to their absolute authority. But there is a period when, having acquired property, and a capacity of judging for themselves, they become independent agents; and when, for this reason, the authority of their parents ceases, and becomes nothing but the respect and influence due to benefactors.[8]

Similarly, Thomas Blacklock insisted, "It has been repeatedly acknowledged, that, whenever the period shall arrive, in which the colonies are found capable of supplying their wants, of protecting their state, and of regulating their affairs, this be the crisis of their political maturity; this the time of their emancipation from parental controul." But, he added confidently, "it will not be pretended that this is their situation at present."[9]

To other British writers, however, whether the colonies were in a state of nonage or maturity was an ambiguous question, as an anonymous author noted in 1777 in *The Case Stated On Philosophical Ground, Between Great Britain And Her Colonies: Or The Analogy Between States And Individuals, Respecting the Term of Political Adultness, Pointed Out*: "With regard to Colonies, the precise period of political adultness, has not been ascertained. For what power is competent to ascertain it? . . . Should we leave the decision of the matter to parent states, the term of Colonian puberty would never arrive." Ambiguities about the relative maturity of the British colonies in America created an underlying uncertainty: What precisely were the reciprocal duties of Britain and America at this time? Richard Price,

for example, concluded that if the English were to assume "that the order of nature in establishing the relation between parents and children, ought to have been the rule of our conduct to the Colonies, we should have been gradually relaxing our authority as they grew up." He added, "But, like mad parents, we have done the contrary; and, at the very time when our authority should have been most relaxed, we have carried it to the greatest extent, and exercised it with the greatest rigour. No wonder then, that they have turned upon us; and obliged us to remember, that they are not children." Thomas Blacklock reasoned similarly, "It is certainly agreeable to the analogy of nature, and to the voice of reason, that the authority of political, as well as natural parents, should be relaxed, as their offspring rises to maturity." He differed from Richard Price by concluding, "[I]t is by this very relaxation, too far carried, that the child is grown prematurely stubborn."[10]

Debates among political figures in Britain and America often centered around judgments about whether the parent or the child had fulfilled his or her reciprocal duties. An exchange in America between John Dickinson and Daniel Leonard revealed the subjectivity of such judgments about whether the child had provided adequately for the parent. Dickinson averred on behalf of Patriots in America, "As constantly as streams tend to the ocean," have the children in America "been pouring the fruits of all their labors into their mother's lap." To the contrary, Daniel Leonard argued on behalf of the American Loyalists, "had we been pouring the fruits of all our labour into the lap of our parent and been enriching her by the sweat of our brow, without receiving an equivalent, the patrimony derived from our ancestors must have dwindled from little to less, until their posterity should have suffered a general bankruptcy." Since Leonard was certain that the colonists were not impoverished, he insinuated that the children in America had not been as generous to their mother as Dickinson had claimed on their behalf.[11]

Whether the parents had fulfilled their responsibilities was also subject to debate in Britain and America, as suggested by the conflict between Richard Price and Thomas Blacklock over whether the parents had relaxed their authority over the child. A decade earlier, in 1766, Nicholas Ray had argued in *The Importance Of The Colonies of North America, And the Interest of Great Britain with regard to them, Considered*, "The *North Americans* say

they have been toiling for the Mother-Country; that the Fruits of all their Labour centers here; that therefore, if they are not considered as Children, their Treatment is that of Slaves." The anonymous author of *The Necessity Of Repealing The American Stamp-Act Demonstrated: Or, A Proof that Great Britain must be injured by that Act* reasoned similarly that the colonists "will never consent to enrich us, while they think we oppress them; they will never treat us with the respect due to a parent, while they think we treat them as slaves; nor will they carry on a friendly and profitable trade with us, while they think we treat them as aliens, and load them with chains." Ambiguities about the precise nature of the family responsibilities and what action was necessary to fulfill them allowed each side of the dispute to believe that the other had failed to fulfill customary expectations. Repeated failure to do so eventually became a sign of debilitating disease or moral corruption.[12]

The image of the family designating the empire provided a basis for powerful emotional and moral appeals by bringing fundamental beliefs about natural and divine law to bear on the imperial dispute. In 1774 Thomas Bradbury Chandler inquired in *The American Querist: Or, Some Questions Proposed Relative To The Present Disputes Between Great Britain And Her American Colonies*, "Whether some degree of respect be not always due from inferiors to superiors, and especially from children to parents; and whether the refusal of this on any occasion, be not a violation of the general laws of society, to say nothing here of the obligations of religion and morality?" In 1775 Jonathan Boucher reminded his congregation in Maryland of a commonplace religious conviction: "Kingdoms and empires are but so many larger families: and hence it is that our Church, in perfect conformity with the doctrine here inculcated, in her explication of the fifth commandment, from the obedience due to parents, wisely derives the congenial duty of *honouring the king and all that are put in authority under him*." James Macpherson asserted in the concluding line of *The Rights Of Great Britain Asserted Against The Claims Of America: Being An Answer To The Declaration Of The General Congress*, more than twenty editions of which were distributed in English, French, and Italian during 1775, "The law of God and of Nature is on the side of an indulgent Parent against an undutiful Child; and should necessary correction render him incapable of future offense, he has only his own obstinacy and folly to blame."[13]

Arguments such as these transformed political questions about finance, commerce, and constitutional law into moral questions about the reciprocal rights, obligations, and conduct of family members. Writing as "Cosmopolite," Joseph Cawthorne noted this transformation of the issues in *A PLAN To Reconcile Great Britain and her Colonies, And Preserve The DEPENDENCY Of America* in 1774, when he remarked that, upon the principle of a parent and child analogy, "gentlemen reason morally and not politically. The parallel is drawn from the feelings and virtues of human nature, and not from the necessity of modern policy; and therefore the comparison does more honor to the heart than credit to the head of a politician; who should remember that the *necessary* maxims of government are often, at least *apparently*, in direct contradiction to the rigid principles of morality."[14] In short, by depicting the relationship between Britain and America as the relationship between a parent and a child, colonial and British writers, orators, and illustrators brought expectations about the family to bear upon the conduct of Britain and the colonies. By doing so, they insidiously shifted perceptions of the problems besetting the empire as a practical conflict about financial policy, commerce, and constitutional law to an ethical conflict about proper conduct characterized by unyielding accusation and resentment.

Although the image of the family polarized political alignment during the Revolutionary era by bringing moral, commonplace ideas about the family to bear upon the imperial dispute, that same image also limited the political actions that the Americans and the English were prepared to undertake against each other. During the Stamp Act controversy in 1765, for instance, William Knox professed in *The Claim Of The Colonies To An Exemption from Internal Taxes Imposed By Authority of Parliament, Examined* to have "such confidence in the candor and paternal regard which some gentlemen bear to the colonies, that I have no apprehensions [that] advantage will be taken of the frowardness of their legitimate offspring; but that their dealings towards them will be like those of parents to their truant children, not rigorously just, but forbearing and affectionate." Richard Wells evoked the image of the family to urge restraint in America after the passage of the Intolerable Acts in 1774, when he commented in *A Few Political Reflections Submitted to the Consideration of the British Colonies*, "[F]ar be it from the heart of a child essentially to injure a parent; let our

incisions be no deeper than are just necessary to discharge the corrupted mass that collects about her vitals, and to couch the cataract in her eyes; and if her auditory nerves are too much clogged, let us inject a little of the *spiritus Americani*, and restore to her that necessary sense." The English and the Americans employed the image to circumscribe moderate but firm political action.[15]

As important, the image of the family as the British empire suggested the relative power of Britain and America, as Thomas Bradbury Chandler of New York pointed out in 1775 in his pamphlet *What think ye of the Congress Now? Or, An Enquiry, How Far The Americans are Bound To Abide by, and Execute the Decisions of, The Late Congress?* Chandler depicted the relative power of Britain and America to discourage the child's rebellion: "Whatever we may think of ourselves, it is not the opinion in England that our power at present is equal to theirs. Our threatnings therefore will appear to the mother country to be ridiculous and contemptible. If we have no power to execute, we have no right to threaten; and every effort in this way will expose our folly." Chandler's apprehension of ridicule was confirmed in Britain by the anonymous author of *Licentiousness Unmask'd; Or, Liberty Explained,* who held similar convictions about the relative power of Britain and America, but who used those convictions to scoff at the colonies' actions: "Their present threats of nonimportation and exportation, while we possess all the maritime force, is like a child threatening his parents that he will not eat, when he is locked up and can come at no food, but as the parent may think proper."[16]

During the Revolution, the image of the family defined the roles of the colonies and Britain in ways that made negotiation difficult if not impossible, since each side of the dispute came to see the other as morally corrupt and each side viewed its own conduct as a righteous attempt to reform the other. By polarizing the issues in moral terms, the family imagery shaped perceptions of the problems besetting the empire and so influenced diverse efforts to find solutions. Indeed, to the anonymous author of *Remarks On Dr. Price's Observations On The Nature Of Civil Liberty, & c.* in 1776, "The cause of the war was an attempt in the Americans of retiring from the subordinacy to the parent state."[17]

To British leaders in Parliament, the imperial controversy became transfigured into a question of how to reform an ungrateful, untrustworthy,

promiscuous, and disobedient child. In general, the solution of the Tories in Parliament was to reform the prodigal child through punishment justified by divine and natural law. As the *London Chronicle* announced, "It is now generally understood that the most spirited and coercive measures will be taken by the Mother Country, to bring back her refractory children to a proper sense of their duty." In contrast, the solution of the Whigs was leniency, because punishment risked forfeiting the child's natural affection for its parent and because, as Lord Chesterfield put it in December 1765, "I never saw a froward child mended by whipping; and I would not have the mother-country become a step-mother." Finally, to a few radicals in Britain and to the colonial protesters in America, the problem became how a virtuous child might reform a greedy, tyrannical, and corrupted parent prone to child abuse. John Dickinson suggested one solution for his fellow colonists in 1768 when he urged, "Let us behave like dutiful children, who have received unmerited blows from a beloved parent. Let us complain to our parent; but let our complaints speak at the same time the language of affliction and veneration." Complaining and petitioning gave way to mob violence, military confrontations, and a Declaration of Independence. These revolutionary developments only intensified the convictions of the British majority in Parliament that they were dealing with a troublesome and parricidal child, and so continued a cycle of accusation and resentment that culminated in national independence.[18]

THE IMAGE OF THE CHILD IN BRITAIN

During the decades before the American Revolution, the image of the child designating America emphasized that the colonies were vulnerable, inexperienced, and naïve so as to sanction benign British protection and guidance. The image of the child functioned in this way, for example, in "BRITAIN's RIGHTS maintaind; or *FRENCH AMBITION* dismantled," published on August 11, 1755, and perhaps the earliest emphatic image of the child representing America printed in Britain. Beside Britannia and beneath her outstretched arm, the Indian child taunted the French cock: "Pretty Bird How will you get Home again?" The child's small size and his

placement beside and beneath Britannia suggested that she protected and guided the child. The image of Britannia was equivocal in that it could have specified Parliament or Britain—an ambiguity that often allowed subsequent illustrators to shift their emphasis between the mother country and its government.

Entailed in Britannia's benign care was colonial subordination because, as Thomas Blacklock put it two decades later, in 1776, "When colonies are transplanted, the difficulties under which they labour are generally as insuperable, without the assistance of their native country, as those of children without the assistance of their parents." Blacklock specified the reasons for the children's dependency on their parent:

> Unacquainted with the nature of the clime and its products; ignorant of the advantages to be improved, or the inconveniencies to be avoided; unskilled in the art, the manner, the season of cultivating and preparing the materials which nature bestows; embroilled in war, or occupied in negociations with savages; fatigued with clearing lands, or building habitations; the assistance and protection of their maternal state are not only indispensibly necessary to their welfare, but even to their being, till long experience, and repeated instructions, have taught them to investigate and improve the native riches of their new establishment. [19]

The children were subordinate to the parent not only because they owed their very existence to the parent but also because of the necessary protection and instruction provided by the parent.

Ownership also figured in Britannia's relationship to the colonies. Behind the child in "BRITAIN'S RIGHTS maintaind," Mars and Neptune cut a map of the colonies with a sword to demarcate British ownership of American territory through the victory over France, who was represented as the Genius of France. Near Neptune and saddened by her losses, the Genius of France stood in her gown decorated with the emblematic fleur-de-lis. The territory and the child were the objects of struggle between Britannia and the Genius of France during the French and Indian War. But the Indian child was not listed among the character statements across the top of the print. Corresponding from left to right were the sentiments of each adult character: Britannia, Mars, Neptune, the Genius of France,

Monsr Le Politiciene, and Jack Tar. The omission of the child's sentiments suggested that he was not a major character, though Mars alluded to Britain's "Lawfull and much injured Son."

Often in later prints, Britain's ownership of the child was expressed by possessives such as "Britannia's" child, "her" child, or "our" child the colonies. Such British feelings of ownership were expressed by James Stewart when he wrote in 1776:

> I still *call them our Colonies*, if they are worth owning.—They are ours by Birth, by Nutrition, Tuition, Support and Protection!—They are ours by dear bought Purchase of many Millions of Money and Rivers of Blood, shed in their Defence! With all these undeniable Titles on our Side, we never drempt of more than grateful Returns of Duty, Affection, Fidelity, and moderate Support within the Limits of their Power, for their and our mutual benefit.[20]

As Stewart's remark also suggested, British protection of the American colonies was seen by the English as constituting a debt to be repaid through gratitude, affection, faithful adherence to mercantile principles, and moderate financial support.

Similar sentiments were explicit during the Stamp Act controversy of 1765–66, when the Reverend James Scott wrote over the pseudonym "Anti-Sejanus" in the *London Chronicle* on November 28–29, 1765, "That the Mother-country is entitled to the support of her colonies, as a parent to the obedience of her children, is not only demonstrable from reason, and the law of nations, but from history and experience." In a subsequent issue of the *Chronicle*, on January 28, 1766, Anti-Sejanus reiterated his disappointment with the colonial child: "I am equally grieved and surprised at the waywardness and ingratitude of the Americans, to make such an undutiful return to the mother-country, for that parental care and tenderness with which she has fostered and protected them. What unnatural towardness is it, to repine at so light and easy an imposition, after the abundant kindness which they have experienced?" In brief, the earlier depictions of America as a vulnerable and inexperienced child had sanctioned British protection and guidance, and these in turn had entailed British ownership, colonial indebtedness, and mutual moral obligation. These images of the colonies

ultimately provided British polemicists such as the Reverend James Scott and James Stewart with justification for their dissatisfaction with American conduct throughout the decade of dissent: The child, America, was a disobedient ingrate.[21]

On March 18, 1766, after the repeal of the Stamp Act, "*Goody Bull or the Second Part of the Repeal*" summarized many prominent aspects of the controversy surrounding the act and its repeal. Again the child of Britannia was an Indian, but in this print America was a female adolescent, who deplored Britannia's abusive treatment and who threatened to become a whore: "I will Sooner turn Strumpet to all the World than bear this Treatment." The Indian's threat to become a harlot expressed a common-place British concern that the colonies would engage in illicit trade with other nations. William Pitt on crutches asked Britannia if she intended "to turn your Daughter a Drift," so placing the onus of responsibility for resolving the conflict upon the parent. Beneath this illustration were printed the words of a ballad, "The WORLD turned upside down, OR The OLD WOMAN taught WISDOM." These lyrics detailed character traits and a unifying plot. They had been published previously in the *London Chronicle* for March 8–11, 1766, but without the illustration. During that same month the lyrics also were distributed with minor typographical changes in *The Gentleman's Magazine: and Historical Chronicle*, but again without the illustration.[22]

The ballad began with a stanza about the nature of the family quarrel:

GOODY Bull and her Daughter together fell out,

Both squabbled and wrangled, and made a damn'd Rout;

But the Cause of their Quarrel remains to be told;

Then lend both your Ears, and the Tale I'll unfold.

Derry down, &c.

The next three stanzas articulated in a simple story the ministry's position that the colonial child should have sustained herself, because she was capable financially and because she ought to have felt obliged by duty, gratitude, and law:

The old Lady, it seems, took a Freak in her Head,

That her Daughter, grown Woman, might earn her own Bread,

. .

The Daughter was sulky, and wou'dn't come to,

And pray what in this Case could the Old Woman do?

In vain did the Matron hold forth in the Cause,

That the young one was able; her Duty, the Laws,

Ingratitude vile, Disobedience far worse;

But, she might e'en as well have sung Psalms to a Horse.

Derry down, &c.

Because the child, an Indian, had refused to obey her mother, and because she had made herself a burden rather than a self-sufficient member of the family, she was degraded by comparison to a beast. More important, the claim that the British government only expected the colonies to be a self-sufficient and morally upright child placed the Stamp Act controversy in a light that obscured the issue of a precedent in constitutional law. While this ballad and the British government portrayed the stamp tax as an effort to distribute the empire's debts equitably among the dominions, the colonists depicted the tax as a dangerous precedent that would enable the British eventually to shift their financial burdens to Americans. While the ballad and the British government portrayed payment of the tax as the child's moral obligation to her family, the colonists depicted the tax as a dangerous and unconstitutional departure from tradition. While British ministers focused upon achieving what they regarded as a just end—equitable distribution of the empire's debts—the colonists were intent upon preventing what they regarded as an unjust means—taxation without representation.[23]

Disobedience and ingratitude were the worst of the daughter's offenses because tacit in them was the colonies' affront to the sovereignty of the British Parliament. The contention of the ballad and of the ministry that the colonies should be self-sufficient was a troublesome argument, since even as it sanctioned the tax, it also suggested that the colonies were nearing maturity. Under a consensual view of the family, such an admission implicitly conceded that the end of colonial subordination was approaching, for at maturity a child could establish his or her own home. Even so, the

consensual view of family held that gratitude remained an offspring's enduring obligation to a parent, and so the government's emphasis on gratitude remained a powerful basis for appeal. Emphasis on gratitude enabled critics of the colonies to remind the public of Britain's past financial support and military protection for the colonies. It enabled them to suggest that the colonies were not reciprocating for past kindness; indeed, they were reneging on a fundamental moral obligation. Gratitude to one's family had the stature of an important practical and moral tenet, since the family was the principal source of financial security during periods of hardship, unemployment, and old age.

Accordingly, the colonies' ingratitude eventually justified British resentment toward its colonial child, as for instance in 1776, when the anonymous author of *Licentiousness Unmask'd* enumerated several reasons for Britain to expect gratitude and then asserted that the colonies "forgot their benefactors and saviours, and with base ingratitude insult their mother country." He added, "[P]ride, riches, and vanity have turned their heads." The author protested, "[I]n return for our kindness, our care and compassion for them, they insult us; and for our good services they spit in our faces. With sentiments of affection and kindness in our breasts towards them, we embraced them in our arms, and placed them in our bosom; yet no sooner did they find themselves cherished and warmed, than they stung their benefactors."[24]

In the ballad "The WORLD turned upside down, OR The OLD WOMAN taught WISDOM," similar values of gratitude and obedience lay beneath the mother's appeals to the ungrateful and disobedient child. The lyrics justified British dissatisfaction with the colonies by articulating the child's petulant response.

> Young, froward and sullen, and vain of her Beauty
> She tartly reply'd, that she well knew her Duty,
> That other Folk's Children were kept by their Friends,
> And that some Folks lov'd People but for their own Ends.
> *Derry down*, &c.
> She sobbed and blubber'd, she bluster'd and swore,
> If her Mother persisted, she'd turn common Whore.

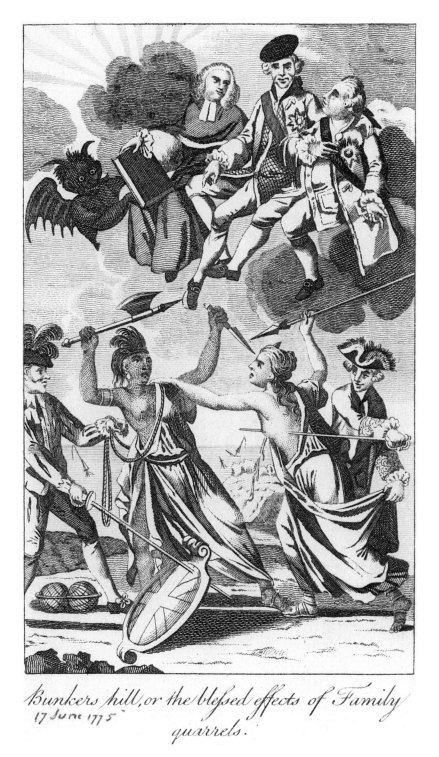

Bunkers hill, or the blessed effects of Family quarrels.
17 June 1775

20. *"Bunkers hill, or the blessed effects of Family quarrels,"* [circa 1775]. Medium: [magazine]; size: 5 5/8″ × 3 9/16″. Courtesy of the British Museum, Department of Prints and Drawings.

21. "[America to her Mistaken Mother]," May 11, 1778. Publisher: M. Darly; medium: print; size: 13 3/4″ × 9 3/4″. Photograph courtesy of the Library of Congress.

. Top: "THE PRESENT STATE
GREAT BRITAIN," [1779].
aker: J. Phillips; publisher: W.
umphrey; medium: print; size:
1/2″ × 16″. Photograph
urtesy of the Library of
ongress.

23. Bottom: "*A Picturesque View
of the State of the Nation for
February 1778*," *The Westminster
Magazine* 6 (February 1778):
opposite 64. Medium: magazine;
size: 3 7/8″ × 6 1/4″. Courtesy
of the Library of Congress.

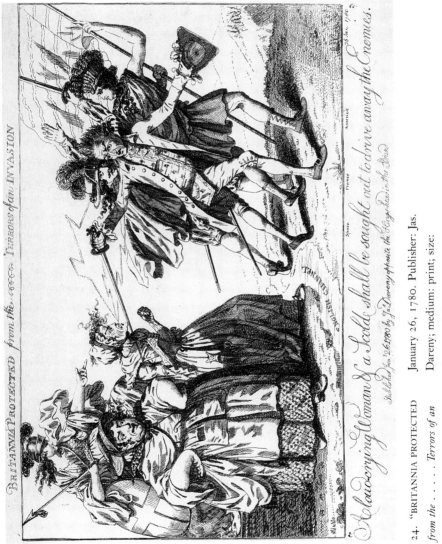

24. "BRITANNIA PROTECTED from the Terrors of an INVASION" or "A loud-crying Woman & a Scold shall be sought out to drive away the Enemies." January 26, 1780. Publisher: Jas. Dareny; medium: print; size: 8" × 12 3/4". Courtesy of the British Museum, Department of Prints and Drawings.

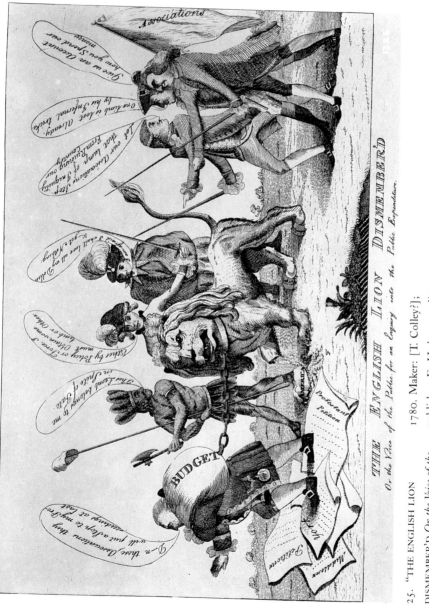

THE ENGLISH LION DISMEMBER'D

Or the Voice of the Public for an Enquiry into the Public Expenditure.

25. "THE ENGLISH LION DISMEMBER'D Or the Voice of the Public for an Enquiry into the Public Expenditure," March 12, 1780. Maker: [T. Colley?]; publisher: E. Hedges; medium: print; size: 9 1/8" × 13 3/8". Courtesy of the Library of Congress.

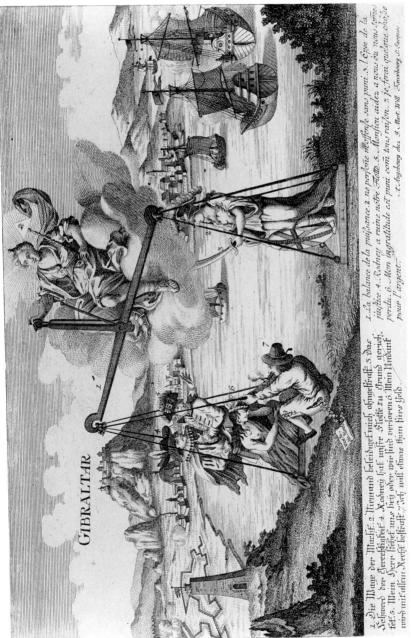

26. "Die Wage der Macht" or
"La balance de la puissance", à
Augsbourg chez J. Mart. Will
Fauxbourg S. Jacques, [circa

1780]. Medium: print; size:
8 1/2" × 13 1/4". Photograph
courtesy of the Library of
Congress.

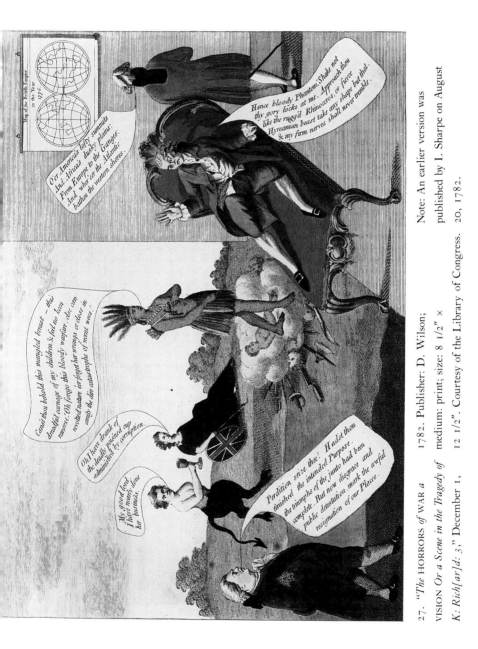

27. "The HORRORS of WAR a VISION Or a Scene in the Tragedy of K: Rich[ar]d: 3," December 1, 1782. Publisher: D. Wilson; medium: print; size: 8 1/2" × 12 1/2". Courtesy of the Library of Congress.

Note: An earlier version was published by I. Sharpe on August 20, 1782.

The General P—s, or Peace.

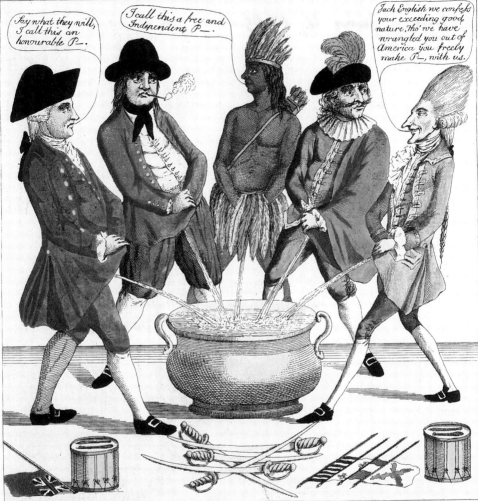

Come all who love friendſhip, and wonder and ſee,
The belligerent powers, like good neighbours agree,
A little time paſt Sirs, who would have thought this,
That they'd ſo ſoon come to a general P__?

The wiſe politicians who differ in thought,
Will fret at this friendſhip, and call it tonought,
And blades that love war will be ſtorming at this,
But ſtorm as they will, it's a general P—.

A hundred hard millions in war we have ſpent,
And America loſt by all patriots conſent,
Yet let us be quiet, nor any one hiſs,
But rejoice at this hearty and general P—

Tis vain for to fret or growl at our lot,
You ſee they're determin'd to fill us a pot,
So now my brave Britons excuſe me in this,
That I for a Peace am oblig'd to write Piſs.

28. "The General P--s, or Peace," January 16, 1783. Publisher: J. Barrow; medium: print; size: 8 5/8″ × 8 1/4″. Photograph courtesy of the Library of Congress.

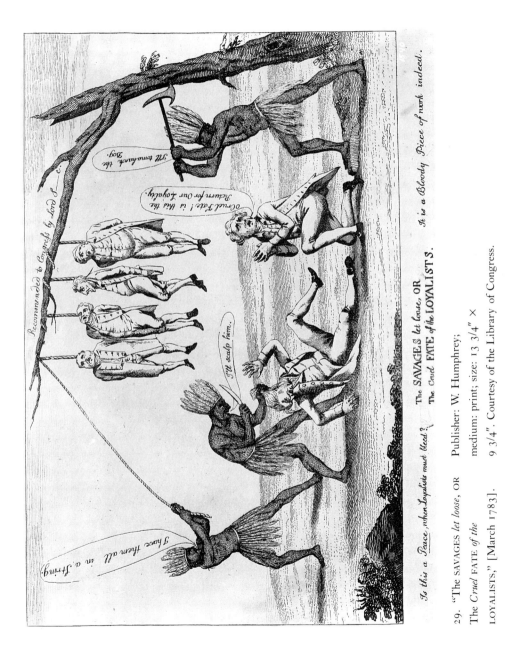

29. "The SAVAGES let loose, OR
The *Cruel* FATE *of the*
LOYALISTS," [March 1783].

Publisher: W. Humphrey;

medium: print; size: 13 3/4" ×
9 3/4". Courtesy of the Library of Congress.

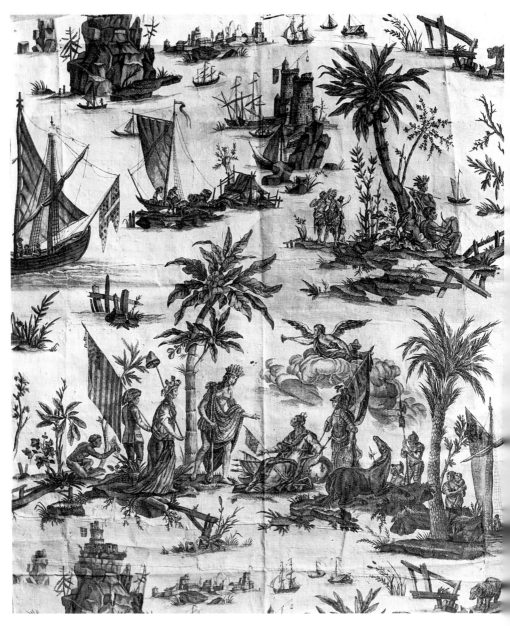

30. "[Hommage de l'Amérique à
la France]," circa 1782–90.
Maker: produced by Christophe-
Philippe Oberkampf at Jouy;
medium: textile; size: varied.
Photograph courtesy of the Museé
des Arts Décoratifs.

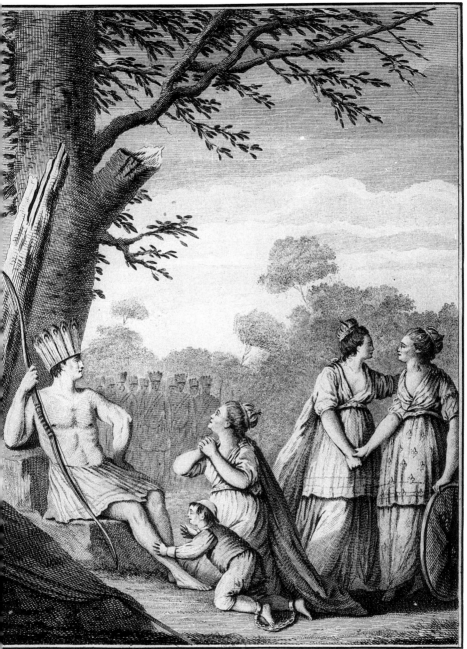

L' ANGLETERRE SUPPLIANTE.

Assiégée au dehors , embrasée au dedans
Est cent fois en un jour à son dernier moment.

Voltaire

. "L'ANGLETERRE 8 3/4". Photograph courtesy of

PPLIANTE," [circa 1780]. the Bibliothèque Nationale,

edium: print; size: 6 1/4" × Département des Éstampes.

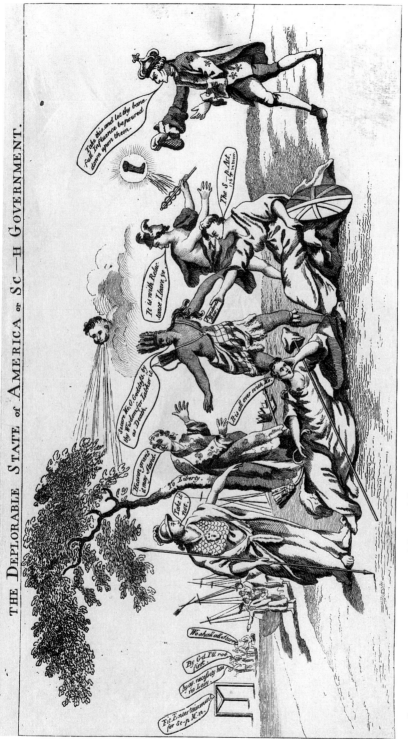

32. "THE DEPLORABLE STATE of AMERICA or SC--H GOVERNMENT," [March 22, 1765]. Medium: print; size: 13 3/4" × 7 1/4". Photograph courtesy of the British Museum, Department of Prints and Drawings.

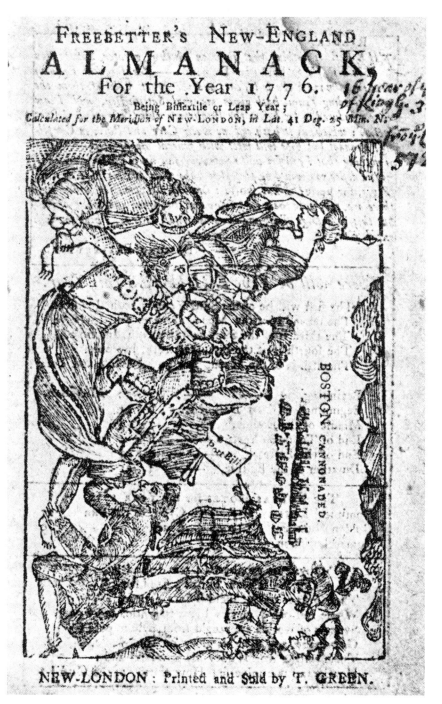

33. "[*The able Doctor, or America Swallowing the Bitter Draught*]," *FREEBETTER'S NEW-ENGLAND ALMANACK*, for the Year 1776 (New London: printed and sold by T. Green, [1775]). Medium: almanac; size: 5 1/2" × 3". Photograph courtesy of the Library of Congress.

THE
FEMALE COMBATANTS

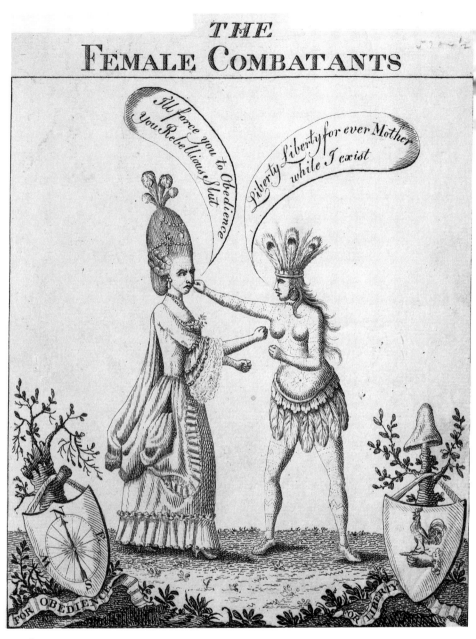

34. "*THE* FEMALE
COMBATANTS," January 26,
1776. Medium: print; size:
6 7/8″ × 5 7/8″ trimmed.
Photograph courtesy of the John
Carter Brown Library.

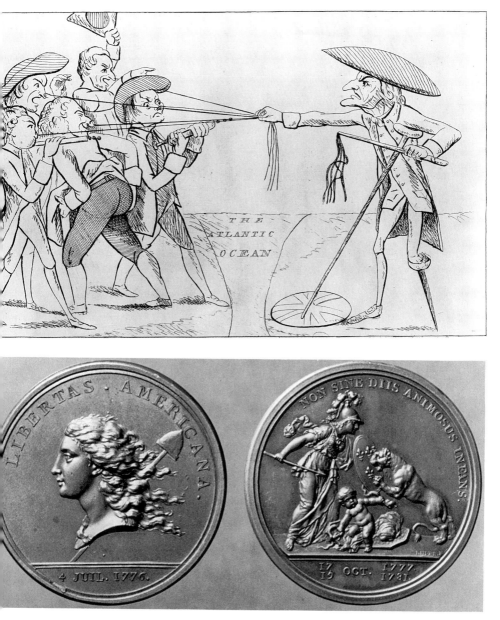

Top: "*Poor old England endeavoring to reclaim his wicked American Children*," September 1, 1777. Publisher: M. Darly; medium: print; size: 12 7/8″ × Photograph courtesy of the Colonial Williamsburg Foundation.

36. Bottom: *Libertas Americana*, obverse, 1782. Medium: medal; size: 1 7/8″ diameter. Photograph courtesy of the British Museum, Department of Coins and Medals.

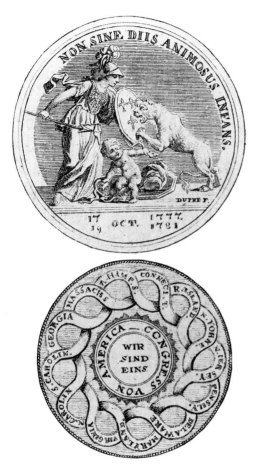

37. "[American Medals]," in
Matthias Christian Sprengel,
Allgemeines historisches Taschenbuch
(Berlin: Haude und Spener,
1784). Maker: D. Berger after
Augustin Dupré's medal;
medium: print; size: 4 1/4" ×
4 1/2". Photograph courtesy of
the Library of Congress.

These verses presented the child's responses to the Stamp Act, not to explain or justify her conduct but rather to continue denigrating her: She was froward, sullen, vain, promiscuous. The child's accusation of selfishness and her threat to become a whore reflected her corrupt character, further discrediting the American colonies for their response to the tax law. The child in this ballad never responded to the parent's criticism by articulating good reasons for her resistance, though some of the colonists in England had endeavored to refute the charge of ingratitude, by pointing for example to Parliament's formal recognition of the colonies' economic contributions during the French and Indian War.[25]

Subsequent stanzas portrayed William Pitt as an intermediary in the family quarrel who reasoned with the mother on behalf of the daughter:

Adsooks, ope thine Eyes, what a pother is here,

You have no right to compel her, you have not I swear,

Be rul'd by your Friends, kneel down and ask Pardon,

You'd be sorry I'm sure, should she walk Covent Garden.

Derry down, &c.

In response to Pitt, the mother complained and finally conceded:

Alas! cries the old woman, and must I comply,

But, I'd rather submit than the Hussy should die;

Pooh, prithee be quiet, be friends and agree,

You must surely be right, if you're *guided by me*.

Derry Down, &c.

Unwillingly aukward, the Mother knelt down,

While the absolute Farmer went on with a Frown

Come kiss the poor Child, then come kiss and be friends,

There kiss your poor Daughter, and make her amends.

But when the parent relented, the child responded with arrogance and an additional demand:

No thanks to you Mother; the Daughter replied;

But Thanks to my Friend here, I've humbled your Pride:
Then pray leave of this Nonsense, 'tis all a meer Farce,
As I've carried my point, you may now kiss my ----.
Derry Down, &c.

Because the child gloated about humiliating the mother, and because she demanded that her mother kiss her posterior, these stanzas sustained criticism of her to suggest the futility of parliamentary leniency toward America and to emphasize injured British pride. Above all, *"Goody Bull or the Second Part of the Repeal"* condemned Pitt's advice and the policy of repeal.

The ballad employed a commonplace of Pitt as interceding hero, only to discredit it by portraying the undesirable consequences of his guidance: Pitt was a meddler in a family quarrel. During the Stamp Act controversy, Pitt's role as interceding hero in a family quarrel was already a commonplace because of the fame that he had earned during his administration of the Seven Years War, known in the United States as the French and Indian War. This commonplace was portrayed favorably on medals designed by T. Pingo in 1766, when an image of Pitt's profile was engraved on the obverse and on the reverse was inscribed "THE MAN WHO HAVING SAVED THE PARENT PLEADED WITH SUCCESS FOR HER CHILDREN." Subsequently, in 1774, during the controversy surrounding passage of the Intolerable Acts, *The Oxford Magazine* of June 1774 reminded the public of Pitt's past service to the country by printing an engraved reproduction of the obverse and reverse of the medals. Pitt's role as either a meddler or a heroic intermediary in the family conflict became a provocative commonplace during the decade of dissent.[26]

After the Boston Tea Party in December 1773, Parliament's policy of paternal leniency gave way to a policy of punishment, manifested most emphatically through the laws that became known in America as the Intolerable Acts of 1774. Although punishment of a rebellious child was sanctioned by natural and divine law, three different prints in 1774 employed the image of the child to criticize the British government for abuse: *"The able Doctor, or America Swallowing the Bitter Draught," "The Whitehall Pump,"* and "The STATE PEDLARS, Or, the NATIONAL CONTRAST." All

three of these prints depicted the colonial child as the abused victim of oppressive or reckless British politicians.

"The able Doctor, or America Swallowing the Bitter Draught" was distributed in Britain in at least two extant forms, initially in the April 1774 issue of *The London Magazine* and subsequently in the May 1774 issue of *The Hibernian Magazine.* *"The able Doctor"* depicted the child of Britannia as a female Indian who had been forced to the ground by high-ranking government officials: Lord Mansfield pinned her arms to the ground, while Lord North forced hot tea down her throat and Lord Sandwich peered up the scanty cloth that covered her legs and waist. Britannia averted her eyes with shame while these men tormented her daughter. Lord Bute stood with his sword in hand to the right, where he observed these portents of rape without compassion, while a Spaniard and a Frenchman stood together and studied the struggle with interest.

The version of *"The able Doctor, or America Swallowing the Bitter Draught"* in *The London Magazine* was opposite a brief article titled "Lord Chesterfield's *Sentiments of the* American Stamp Act, & c.," wherein Chesterfield was reported to have said, "The administration are for some indulgence and forbearance to those froward children of their mother country: the opposition are for taking *vigorous* as they call them, but I call them *violent* measures, not less than *les dragonades*; and to have the tax collected by the troops we have there."²⁷ Although Chesterfield's comment pertained to the Stamp Act controversy a decade earlier, viewers probably saw it as germane to the illustration, because it was printed on the facing page and because again during the debate over the Intolerable Acts the child-rearing issue of leniency or punishment divided Parliament. To *The London Magazine*, punishment was unacceptable, a kind of rape.

In *The Hibernian Magazine* for May 1774, *"The able Doctor"* was reproduced in an almost identical form, but the engraving was accompanied by an altogether different text, a poem prefaced by the remark "An Explanation of a Political Print of the Able Doctor."²⁸ The poem elaborated on how the government officials abused Britannia's child:

BEHOLD America upon the ground,
Whilst deadly foes the wretched maid surround;
Law binds her arms, in Mansfield's form contest;

And Sandwich, blending violence and jest,

With one hand holds her feet; and dares to lift,

With th' other the oppressed maiden's shift.

A lustful grin upon his visage seen,

Shews the disgraceful passions lodg'd within.

Behind see Bute, with sword and pistols stand,

The law of arms enforces his command.

Allusions to a "lustful grin" and "disgraceful passions" amplified the wickedness of the men's actions, while the references to "law" magnified the seriousness of such conduct by government officials. Although the mother, Britannia, wept in sorrow or sympathy, she made no effort to stop her child's tormentors, perhaps because she was unable to prevent the men from doing what they would or perhaps because the British public were unable to persuade the politicians to behave properly.

In April 1774, *"The Whitehall Pump"* suggested that the colonies were a victim not of the British government's malice but of its foolish endeavor to revive the mother, whose body sprawled across the Indian's back. An accompanying text titled "The Whitehall Pump: A Vision" explained that to revive the parent, the ministry inadvertently burdened and doused the child. Acting under Scottish influence, Lord North was pumping water on "that daft, unruly body Mastress *Britannia* . . . with her child *America*, and all her boasted rattles and gew-gaws such as *Magna Charta, Coronation Oaths, Bill of Rights, Charters of Companies and Corporations, Remonstrances, Petitions*, and the like." By depicting the Magna Charta, the Bill of Rights, and other past milestones in British history as mere toys, *The Westminster Magazine* suggested that the ministry was not taking the constitutional issues seriously enough.[29]

Even after the Intolerable Acts were implemented in June, the child-rearing issue of leniency or punishment endured to become an issue in the fall election. On November 1, 1774, "The STATE PEDLARS, Or, the NA-TIONAL CONTRAST" graphically portrayed the issue dividing Parliament. In the center of the composition stood the British lion, a symbol of military valor, with a basket of weapons on his back. A tag on the basket read, "TOYS, for untoward Children." On the right, pulling the lion forward,

were two men in Scottish plaid. One of them wore a large boot, a commonplace allusion to Lord Bute. Because the word "Majority" was inscribed above them, the print insinuated that the parliamentary majority in favor of punishment were under Scottish influence. On the left, Britannia tugged on the lion's tail to restrain the military advance. Near her was the word "Minority," an allusion to those in Parliament who favored leniency. By referring to the much-hated Lord Bute in connection with the majority, and by employing the much-loved image of Britannia in connection with the minority, the illustrator expressed a political commitment to leniency.

Behind the policies of leniency or punishment were fundamentally different networks of thought, which had been uttered over and over again during the decade of dissent. Although the debate reached a peak between 1774 and 1776, the opposing rationales were based upon convictions that had been articulated early during the decade. At the heart of the rationale for leniency was the conviction that the parent had been less than perfect, at times perhaps even tyrannical, distrustful, neglectful, and greedy. Proponents of leniency contended that the mother should be tolerant, because she herself had caused the problems with the child. Punishment would not restore the child's respect for the parent. Besides, if the parent's leniency failed to reform the child, then punishment remained as an option to be exercised, but if punishment failed, there were no further options to be assayed. While the advocates of leniency sometimes allowed that the colonial child had failed to meet customary expectations, they placed the onus of moral culpability upon the parent.

In contrast, at the heart of the rationale for punishment was the conviction that Parliament was dealing with an ungrateful, disobedient, and promiscuous child, who had failed to reciprocate for the parent's kindness and who had failed to respond respectfully to requests for reform. Supporters of punishment reasoned that parental leniency had not reformed the child in the past controversies surrounding the Stamp Act and the Townshend Duties. Indeed, the parent's concessions in those earlier controversies had only made the child more bold and demanding. The parent had tried leniency repeatedly but had failed to reform the wayward child. Under the circumstances, punishment was morally and naturally proper and necessary, especially if the severity of the punishment was gauged to the

seriousness of the child's offense. Proponents of punishment sometimes allowed that the parent had a serious failing, but it was not tyranny, distrust, neglect, or greed. In their estimation the parent had been too indulgent in the past by not taxing the child earlier and by surrendering to the child's demands. Because the parent had spared the rod, she had spoiled the child.

The conflict between these opposing perceptions of the problems besetting the British empire was dramatized by an exchange between Charles Townshend and Isaac Barré during the debates in Parliament about repealing the Stamp Act—an exchange that illustrated how the image of the family had a central role in the parliamentarians' opposing rationales for punishment or leniency. Charles Townshend supported continuing the stamp tax—despite the colonial protests and mob violence of 1765—by asking Parliament a rhetorical question that focused directly upon the underlying economic concerns: "And now will these Americans, Children planted by our Care, nourished up by our Indulgence untill they are grown to a Degree of Strength and Opulence, and protected by our Arms, will they grudge to contribute their Mite to releive us from the heavy Weight of that Burden which we lie under?" From this way of thinking about the child evolved the rationale for punishment. These convictions—that Britain had been generous, protective, and nurturing, and so was entitled to obedience, gratitude, and economic support—endured as the heart of the rationale that justified the punishment of a child who had failed to meet expectations.[30]

In response to Townshend, Isaac Barré, who was known to have been a military officer in America during the French and Indian War, addressed Parliament:

> They planted by your Care? No! your Oppressions planted'em in America.—They fled from your Tyranny, to a then uncultivated and unhospitable Country; where they exposed themselves to almost all the hardships to which human Nature is liable; and among others, to the Cruelties of a Savage foe, . . .
>
> They nourished by *your* indulgence! They grew by your Neglect of'em:—as soon as you began to care about'em, that Care was Exercised in sending Persons to rule over'em, in one Department and another, who

were, perhaps, the Deputies of Deputies to some Member of this House, sent to Spy out their Liberty, to misrepresent their Actions and to prey upon'em. . . .

They protected by *your* arms! they have nobly taken up Arms in your Defence; have Exerted a Valour amidst their constant & labourious Industry for the Defence of a Country, whose Frontier, while drench'd in Blood, its interior Parts yielded all its little Savings to your Emolument.[31]

The rationale for leniency toward the colonial child developed from this way of thinking: Ultimately the parent's tyrannical, neglectful, distrustful, and greedy behavior was responsible for the child's wayward behavior. It was therefore the parent, not the child, who most needed to be reformed.

Proponents of leniency and punishment clashed over whether the colonial child had displayed its affection for the mother country. On behalf of the advocates for leniency, Nicholas Ray, Edmund Burke, and Richard Price insisted that the American colonies could still be persuaded to show their affection for the mother country. As early as 1766, in *The Importance Of The Colonies of North America, And the Interest of Great Britain with regard to them, Considered*, Nicholas Ray had urged Parliament "to acquire and retain, by Acts of Lenity and Mildness, the Affections of our Colonies, and not to alienate them by Severity." He pointed out that "the Iron Rod of Power" would "only make them the sooner refractory." He added that the American colonies could be held to the rest of the British empire "by the Ties of Consanguinity, Religion, Language, Manners, Customs, and Laws." In 1775 Burke reasoned similarly in *The Speech of Edmund Burke, Esq; On Moving His Resolution For Conciliation with the Colonies, March 22, 1775*, six editions of which were published in English and French within the year. The child's natural affection for the parent could be restored with time, if Parliament would relent rather than punish. In Burke's thinking, the child could still be bound to Britain by ties of affection, kindred blood, similar privileges, and equal protection.[32]

Supporters of punishment countered that either the child did not feel genuine affection for the parent or the child's affection was too faint a sentiment to unify the British empire. In the opinion of Josiah Tucker, Burke's reasoning was faulty:

You say . . . , "My hold of the Colonies is in the close Affection, which grows from *common Names*, from kindred Blood, from similar Privileges, and equal Protection. These are Ties, which, though light as Air, are as strong as LINKS OF IRON." Alas! dear sir, *England* has already to its Cost, found all these Ties and Connections to be Trifles light as Air! Yes, I say, —*England* has experimentally found them to be *no Links* at all, if put into Competition with *present Interest*; much less to be *Links of Iron*: —She has, I repeat and insist upon it, made this unwelcome Discovery concerning Colony Gratitude, even from the Moment that each Infant-Colony could stand alone, without the Assistance of the Parent-State.[33]

A year later, in 1776, when Richard Price offered arguments about the child's affection for the parent, he was rebuffed by the anonymous author of *Remarks On Dr. Price's Observations On The Nature Of Civil Liberty, & c.*, who contended with frustration, "Affection has proved but a poor tie, to restrain the Americans—Interest would be not a iota more binding."[34]

Advocates of leniency and punishment also disputed whether the child had demonstrated its gratitude to the parent state. Edmund Burke insisted that the American colonies had proven their gratitude and commitment to Britain by providing nourishment to the mother country for more than a century—probably an allusion to British profits from the colonies' compliance with trade regulations. In *The Speech of Edmund Burke, Esq*, Burke asserted, "For some time past, the old world has been fed from the new. The scarcity which you have felt would have been a desolating famine if this child of your old age, with true filial piety, with a Roman charity, had not put the full breast of its youthful exuberance to the mouth of its exhausted parent." Since the charge of ingratitude was untrue, it followed that Parliament had no reason to punish the colonies.[35]

Some advocates of leniency allowed that perhaps the child had not demonstrated its gratitude, but they denied that the parent was entitled to gratitude from the child. They contended that the colonies had never been protected or nurtured by Britain, except when Britain's own self-interest had made such assistance prudent. In 1766, Nicholas Ray had put it bluntly in his pamphlet *The Importance Of The Colonies of North America*: "[I]n all Debates at this Time, too much Stress is laid on that Protection, since whatever we did for them was with a View to serve ourselves." In 1775,

Temple Luttrell observed in Parliament, "America has been loudly charged with ingratitude towards the parent country, from whom she received protection during the conflict of war." Yet, he added, "she cannot be so ignorant of the real springs of war or peace, as to persuade herself that your numerous embattled legions . . . were supplied purely from motives of parental affection, or sympathetic benevolence." It followed from such reasoning that Britain had no reason to expect gratitude from America, since all the parent had done was attend to her own needs.[36]

A more complex line of argument was articulated by Joseph Cawthorne, who described the nature of gratitude and who brought gratitude into conflict with other, more fundamental concerns. Under the pseudonym "Cosmopolite" Cawthorne allowed that the mother had made substantial contributions to America, but he claimed that gratitude was not a right. Cawthorne observed "that the mother, in a natural and religious sense, is certainly deserving of the affections, gratitude and contributions of her daughters." "But," he inquired, "who will say she can claim it as a right? Gratitude is a merit, but it does not constitute an absolute right: much less should that right be allowed when a better claim and a clearer title militates against it." He then pointed to the colonies' more fundamental concern: "Self-preservation is the first law of nature, and the general preservation the first principle of government."[37]

To the proponents of punishment, however, the American colonies' persistent resistance to Parliament's legislation was incontrovertible evidence of the child's ingratitude. In a forceful vein, James Macpherson threatened in one of the most widely distributed pamphlets of the American Revolution, *The Rights Of Great Britain Asserted Against The Claims Of America*:

> The dangerous resentment of a great people is ready to burst forth. They already begin to ask, with vehemence, Is this the return we ought to expect from Colonies, whom with parental indulgence we have cherished in infancy, protected in youth, and reared to manhood? Have we spent in their cause so much treasure, and have they the ingratitude to refuse to bear a small portion of our burdens? Have we spilt so much blood of their enemies, and do they repay us by imbruing their hands in our own?[38]

Through the analogy to a parent's justified anger toward an undutiful child, such arguments transfigured the economic and legal problems into a feeling of indignation in a moral drama, a struggle between the righteous and the wicked, wherein the righteous could expect ineluctably to prevail.

Supporters of leniency and punishment argued over the legitimacy of the child's grounds for resistance to Parliament's legislation. Advocates of leniency asserted that the child was seeking to defend its most fundamental rights, such as no taxation without representation. In 1774, Edmund Burke emphasized in his widely distributed speech, *On American Taxation*, that representation was essential for just taxation under constitutional government, but, he added, "America is to have no representative at all. They are 'our children;' but when children ask for bread, we are not to give a stone."[39] The biblical allusion to Matthew 7:7 and Luke 11:11 insinuated that the British government had violated Christian teachings about the family, teachings that Burke transfigured from domestic life onto political conduct.

Evoking the centuries-old commonplace that Britain had indeed been a protective and nurturing mother, John Shebbeare defended the policy of punishment by denying that the issues disrupting the empire had anything at all to do with colonial rights. In 1775, Shebbeare's *An Answer To The Printed Speech Of Edmund Burke, Esq; Spoken In The House of Commons, April 19, 1774* quoted Burke's biblical allusion and refuted it: "When was this *asking* of *bread* returned by giving them a *stone*? Have they asked for representatives? —Have they not declared in congress, they will have none? Is the *stone* applicable in this instance? But when children are refractory; renounce their duty; and even oppose their parent with force, are they not to be chastised and brought back to obedience?"[40] To Shebbeare, the child's disobedience and ingratitude had nothing to do with constitutional issues such as representation. The child's bad behavior resulted instead from a perverse obstinacy, which warranted its punishment.

Shebbeare's *Answer* then sought to discredit another of Burke's arguments about rights within the family. Burke had employed the image of the family to suggest that the child's desire for representation in Parliament was a laudable desire to "assimilate" to the parent. Shebbeare quoted Burke at length to ridicule the very premises of his argument:

"When this child of ours, says he, wishes to assimilate to its parent and to reflect, with true filial resemblance, the beauteous countenance of

British liberty; are we to turn to them the *shameful* parts of our consti-
tution? Are we to give them our weakness for their strength; our op-
probrium for their glory, and the slough of slavery, which we are not
able to work off, to serve them for their freedom?" But when will this
child wish to become assimilated into one substance with its parent? Are
disobedience to the laws; a congress, subverting not only the constitution
of the colonies, but of Great Britain also; which acts with legislative
power; annuls the statutes of this kingdom, and erects itself into the
establishing of what they please; Are the seizing of the public money,
and taking of arms against this parent, the tokens of wishing to assimi-
late? Is this the mode "of reflecting, with true filial resemblance, the
beauteous countenance of British liberty?" To turn to them our *backsides*,
when they shall return to their duty, will be as culpable as were this
orator and associates, when they turned those *shameful* parts to them; and
fled to repeal the stamp-act & c.[41]

Shebbeare appropriated the image of the family to ridicule Burke's argu-
ment about representation and then to render his own redefinition of the
child's conduct. By doing so, Shebbeare accused Burke and others in the
Rockingham administration of cowardice during the Stamp Act contro-
versy, since Rockingham's short-lived ministry had overseen the act's repeal
in 1766.

The proponents of punishment, such as Macpherson and Shebbeare,
insisted that the struggle between Britain and America had nothing to do
with rights. On the matter of taxation, Macpherson asserted, "The Amer-
icans having been spared during the infancy of their Colonies on account
of their poverty, [now] endeavour to establish into an inherent right what
was actually an indulgence." Shebbeare reasoned similarly that the British
government had considered economic circumstances as the basis for the
colonies' past exemption from taxation, but he modified the thrust of his
argument to intimate that the colonists were now acting from motives of
selfishness and greed: "[D]o *states* and *kingdoms argue* that because their
colonies paid *nothing* in tax, when they had *nothing* to pay it with, that
therefore when they *overflow with a redundance of riches*, they still ought to
continue untaxed by that very sovereign authority which cherished, en-
couraged, and sustained them." The anonymous author of *Remarks On Dr.
Price's Observations* averred, "In the preceeding reigns, the Americans were
as yet in their infancy; no duties were laid, because we were convinced of

their incapability of paying them; but now, opulent, why should they not assist that government, to whom they are indebted for their very existence?"[42]

Supporters of leniency and punishment sometimes agreed with each other that the American child had been disobedient, but they disagreed about the underlying cause of that disobedience. Advocates of leniency pointed to the parent's failings—greed, distrust, neglect, and tyranny—as the cause of disorder within the British empire. If the parent's misbehavior was responsible for causing the child's misconduct, the onus of moral culpability lay with the parent to reform herself rather than with the child. William Dowdeswell reminded Parliament that "there are also peevish parents, and that the ill humour and disposition of a child is oftentimes brought about by the petulant obstinacy of a foolish parent." He explained, "The ridiculous doctrine that parents are apt to instil into their children of 'you shall do it—you shall do it,' is oftentimes the means of enforcing the same disposition in the child of 'I won't.' "[43] Therefore the solution was not to punish the child but rather to reform the mother.

Proponents of punishment sometimes allowed that the parent had been less than perfect, but to them the parent's principal failing was indulgence, precisely the failing that their opponents' policy of leniency had enacted during the earlier controversies. "No mother was ever more indulgent to her progeny," asserted Shebbeare, "than Britannia to her colonies." When Shebbeare and Macpherson specified the underlying causes of the conflicts, they both argued that the British government had been too indulgent by allowing the colonies to go untaxed. To these two ministerial writers, the government had contributed to the problems with the child by being too lenient, because of a desire for conciliation during the controversies surrounding the Stamp Act and the Townshend Duties. Macpherson wrote:

> With the indulgence and patience of a Parent, she soothed, flattered, and even courted them to a reconciliation. In pity to the weakness, in condescension to the folly, in consideration to the prejudices of a froward child, she held out the olive-branch when she ought, perhaps, to have stretched forth the rod of correction. Her pity, her kindness, and affection, were lost upon the Americans. They advanced rapidly from claim to claim, and construed her forbearance into timidity. Each Act that was

repealed furnished a subject for triumph, and not an object for gratitude. Each concession became the foundation of some new demand, till, at length, by assuming all to themselves by rebellion, they left the Mother-Country nothing to bestow.

Leniency had been tried and had failed miserably, because it had made the child even more bold, demanding, and unmanageable. Perhaps leniency had caused the subsequent disruptions. As the anonymous author of *Licentiousness Unmask'd* put it in 1776, concessions "will only serve to embolden an ungenerous and ungrateful party to insist upon further concessions, till they are enabled to throw off entirely their dependance on the mother country." Under the circumstances, punishment was morally and naturally proper and necessary. The image of the empire as a family enabled parliamentarians and pamphleteers to articulate opposing rationales about how to resolve the imperial conflict, but underlying these rationales was a desire to maintain the existing relations of political power.[44]

The outbreak of military violence in the spring of 1775 made the outcome of the continuing debate over an official policy of leniency or punishment moot: The government's actions had irrevocably decided the issue. The debate probably was sustained as long as it was to rally public opinion in Britain. To judge from the caricatures of 1775 through 1776, British public opinion shifted such that the child was no longer a victim. Rather the child was wicked—perhaps beyond redemption. This shift in popular sentiment was made evident in such wartime illustrations as "THE FEMALE COMBATANTS," "*Bunkers hill, or the blessed effects of Family quarrels*," and "*The Parricide. A Sketch of Modern Patriotism.*"

"THE FEMALE COMBATANTS," published early during the war, on January 26, 1776, illustrated the increasing violence of the conflict (fig. 34). Shouting "Liberty, Liberty for ever Mother while I exist," the colonial child struck her mother's face with her fist—not a subtle violation of the Fifth Commandment. The mother responded, "I'll force you to Obedience you Rebellious Slut"—an allusion to Britain's use of military force to subdue the colonies and to America's illicit trade with other nations. This demand for obedience was associated with the North ministry by the placement of a compass pointed north on the shield in the lower left corner of

the illustration. The North ministry had dominated Parliament during the passage of the Intolerable Acts and would continue to rule throughout the war. The mother's accusation that the daughter was a "Slut" may have meant a "bold and impudent girl," an apt description of a daughter who would hit her mother. "Slut" also could have referred to a "woman of low or loose character." In that light, the Gallic rooster on the Indian's shield in the lower right corner may have insinuated that the French had already made her "low and loose."[45]

The dialogue of "*THE FEMALE COMBATANTS*" expressed an opposition between liberty and obedience, an opposition that echoed on the banners in the lower corners: "FOR OBEDIENCE." near the mother, "FOR LIBERTY" by the daughter. From the colonial standpoint of liberty, Parliament's demand for obedience often was translated into evidence of tyranny. The colonists and their defenders in Britain frequently reminded Parliament that a child was not a slave. From the British standpoint of obedience to Parliament, however, the colonial demand for liberty translated as easily into the disrespectful behavior of an undutiful child. Obedience was one way in which a child demonstrated affection, respect, and gratitude toward a parent. As William Pitt, that champion of colonial rights, had put it on March 2, 1770, "[T]his is the mother country, they are the children; they must obey, and we prescribe." Pitt explained the ramifications of the image when he added, "[T]here must be something more than connexion, there must be subordination, there must be obedience, there must be dependence."[46]

In the opposition between liberty and obedience, each side of the dispute posed a test of the other's moral virtue, the passage of which required the loss of an important right. To be a good child, she was expected to obey her parent, but in the process she would have sacrificed the constitutional right of no taxation without representation; to be a good parent, the mother was expected to recognize the child's liberty, but in the process she would have sacrificed the sovereignty of Parliament. Each side of the dispute found itself in a bind. The daughter had to choose between becoming a disobedient child in the eyes of the British government and losing fundamental rights; the mother had to choose between becoming a tyrannical parent in the eyes of the colonists and losing parliamentary sovereignty. Further, because obedience was regarded as a way of expressing affection,

respect, and gratitude to parents, such bonds between the child and the parent lurked beneath the opposition between obedience and liberty, where they provided powerful reasons for ambivalence.

The combat between colonial and British troops inspired another wartime print of mother and daughter in conflict, but instead of fists these characters employed deadly weapons in *"Bunkers hill, or the blessed effects of Family quarrels,"* published probably during the early stages of the war. As the title suggested, this print was more concerned with pointing out the harmful consequences of conflict for the entire British empire than with placing blame upon one family member. Because both the mother and the daughter were armed and aggressive, the imagery sustained that balance: The Indian wielded a tomahawk in one hand and a scalping knife in the other, while Britannia aimed her upraised spear at the Indian's breast. The print indicted government officials on the cloud above them: From right to left were Lord North, Lord Bute, Lord Mansfield, and the Devil himself. France and Spain were meddlers in the family quarrel: France stabbed Britannia through the breast, while Spain held a rope around the Indian's waist. Above all, this print expressed a concern about the lost international power of the entire British empire—a concern that was amplified by the masts of sunken ships in the background.

In contrast, other prints continued to focus narrowly upon the role of the British Parliament in the family quarrel. These prints dissociated the ministers from the mother by depicting the parliamentarians in the same print with Britannia, as for instance in *"The Parricide,"* published in April 1776 in *The Westminster Magazine*. Armed with a tomahawk and an upraised dagger, the Indian trampled on Britannia's shield and broken liberty pole as she attacked her restrained and helpless mother. The word "parricide" in the caption evoked thoughts of an especially despicable murder. In the background a torch-waving figure emphasized the savagery of the colonial attack on Britannia. Above all, the illustration indicted several British parliamentarians, among them John Wilkes, Lord Grafton, and Lord Charles Fox, who was designated by the animal. These parliamentarians did nothing to stop America. In fact, they smiled at Britannia's portending death. Two of the parliamentarians held Britannia's arms such that she was unable to protect herself. The British lion would have rushed to defend her, but it was restrained by a British judge.

In *The Westminster Magazine*, "*The Parricide*" illustrated an excerpt from James Macpherson's widely distributed pamphlet *The Rights Of Great Britain Asserted Against The Claims Of America*. After one especially vivid passage, the editor told his reader to "[*See the Plate*]." That passage condemned the parliamentarians:

> With an effrontery without example in any other age or nation, *these men* assume the name of Patriots, yet lay the honour, dignity, and reputation of their Country under the feet of her rebellious subjects. With a particular refinement on Parricide, they bind the hands of the *Mother*, while they plant a dagger in those of the *Daughter*, to stab her to the heart; and to finish the horrid picture, they smile at the mischief they have done, and look round to the spectators for applause.[47]

Subsequently, the passage was quoted and endorsed by an anonymous writer in *Independency The Object Of The Congress In America. Or, An Appeal to Facts*, published in London. During the same year, 1776, Thomas Blacklock criticized the Americans by alluding to "the punishment of political, as well as natural parricides. This impious brood, who would not only shed the blood and tear the bowels of her that produced them, but invoke her implacable and hereditary foes to share the Cannibal feast, shall become the victims of that sacriligeous rage which they inspired and approved." To these writers and illustrator, the American child had become wicked—perhaps beyond reform.[48]

"*The Parricide*," "*Bunkers hill, or the blessed effects of Family quarrels*," and "*THE FEMALE COMBATANTS*" all dramatized the wickedness of a colonial child who either struck or sought to kill her own mother. Somewhat similarly, though through less serious forms of violence, an illustrator evoked the images of the parent and the child to portray America as a gang of rascals in two extant versions of "*Poor old England endeavoring to reclaim his wicked American Children*," published by M. Darly in April and September of 1777 (fig. 35).[49] Colonial conduct resembled the malicious antics of juveniles, who taunted and jeered at an aged man. They exposed a bare behind to him, and they shot their peashooters at him, even though he was so elderly and enfeebled that he had to hold himself up on crutches. The aged fellow sought to regain "his" colonies by tugging on several cords,

each attached to a hook through a boy's nose. He held a scourge—portents of a just punishment. A line from Shakespeare's *Henry IV* was inscribed beneath the engraving: "And therefore is ENGLAND maim'd & forc'd to go with a Staff."

This depiction of England as a decrepit man amplified the children's unkind conduct, but it also may have called into question England's ability to discipline the colonies. As an anonymous writer commented the same year in *The Case Stated On Philosophical Ground, Between Great Britain And Her Colonies:*

> States are subject to all the vicissitudes of the human body; like it must increase, decrease, and moulder into dust. Shall an old palsied man wrestle with the young and vigorous? the diseased with the healthy? the weaker with the stronger? —In other words, shall parent States be eternal? and shall Colonies never become parent States? Absurd and fanciful indeed! . . . Colonies may become greater, wealthier, and more powerful, than the birth-giving State.

The commentator suggested that if the British nation was a body politic, the temporal implications for the aging British government were ominous. The commentator observed, "The probability of success would indeed seem much against the *mother* country rising against her children; the *old* and *infirm*, against the *young* and *vigorous*, the *voluptuous* and *debauched*, against the *virtuous* and *temperate*."[50]

In certain respects, "*Poor old England endeavoring to reclaim his wicked American Children*" was an anomalous caricature. In most other prints during the Revolution, the child was portrayed as a female Indian, a singular entity. In "*Poor old England*," America was represented as a gang of boys to suggest differences among the colonies and their malevolent conduct toward Britain. Depictions of a singular child portrayed the colonies as a united community, while uncommon depictions of a group of children suggested some disunity among them, even when they were engaged in a common struggle with their parent. In most other prints during the war, the colonies' conduct corresponded to striking or attempting to murder the parent; in contrast, the malicious antics of these boys were out of keeping with the seriousness of the military violence then under way.

Finally, most other pictorial works depicted the parent as a mother, but in *"Poor old England"* a father sought to discipline the rascals. A maternal image such as Britannia diminished any association of the American controversy with the king, who frequently was described as "father" of the country. For that reason, paternal images were rare in the pictorial messages of the Revolutionary era. Perhaps for that reason, too, the caption of *"Poor old England"* specified that the elderly man denoted England to dissociate him from the king in particular.

And yet the images of the child and children in all four of these wartime illustrations differed dramatically from the image of the child in 1755. None of these images created an impression of colonial dependence on England, even though dependence could have been suggested by placing a violent child in Britannia's lap. None of them portrayed the colonies as innocent either. Instead, the colonial child displayed overtly wicked behavior, which eliminated the possibility that colonial misbehavior resulted from youthful inexperience. Finally, none of these images portrayed the colonial child as vulnerable. It was not the colonies' youth and inexperience that rendered British sovereignty necessary. Rather, the hooks through the noses of the colonial children rendered them vulnerable to the elderly man's endeavors to dominate them. That childlike dependency, innocence, and vulnerability were missing from these images was in keeping with the military violence of the time. Most important, these changes constituted a salient transformation in the image of America, because they signaled the approach of childhood's end.

While all of these British wartime prints were critical of the colonial child or children, at least one print remained critical of the parent—not for engaging in war with the colonies but for exercising poor judgment in light of the military conflict. "THE COMMISSIONERS," published by M. Darly on April 1, 1778, ridiculed the government's decision to send commissioners to negotiate a peace agreement with America. On his knees before the bare-breasted Indian, one British representative confessed, for example, "We have profaned your places of Divine worship, derided your virtue and piety, and scoff'd at that spirit which has brought us thus on our knees before ye." Another admitted, "We have Ravish'd, Scalp'd, and murder'd

your People even from Tender infancy to decrepid age, altho supplicating for Mercy." Yet another concluded, "For all which maternal services, we the Commissioners . . . doubt not your cordial duty & affection towards us, or willingness to submit yourselves again to recieve the same, whenever we have power to bestow it on Ye." This ludicrous reasoning mocked the commissioners' mission. More important, the Indian's placement atop bales of goods to be sent to Germany, Holland, France, Spain—none bound for England—implied that the commissioners sought the Indian's goodwill to regain the products of her labor, not necessarily because Parliament regretted past political conduct toward America.

With the possible exception of the formal treaty between the United States and France the same year, the voyage of the commissioners to America in 1778 inspired more family imagery in illustrations than any other single event since the initial battles in 1775, presumably because the commissioners sought to resolve fundamental differences and to reestablish family ties between America and Britain. Two other engravings that evoked the image of a family in connection with the commissioners' mission were both rebuses, puzzles consisting of a combination of pictures and words, which viewers could attempt to paraphrase. Published by M. Darly on May 6, 1778, "[Britannia to America]" was ostensibly a letter from Britannia to her daughter. The letter informed America of her "[Duty in not opposing all the good I long intended for your sole happiness]," so asserting that Britain's motives had been and would remain altruistic. The mother pleaded with the child to abandon her present line of conduct by appealing to the colonial child's sense of duty. Britannia implored America to "[Be a good girl. Discharge your soldiers and ships of war and do not rebel against your mother]." The rebus alluded to French courtship of the colonies, as when Britannia complained, "[You have given your hand to a base and double-faced Frenchman]." She admonished, "[Do not consort with that French rascal]." Britannia contended that the Frenchman "[wants to bring enmity to all union between you and I]," as though the suitor threatened to take America away from the family. By blaming a Frenchman for causing the conflict between the mother and daughter, the print obscured the issues of constitutional law and imperial finance that originally had caused the rupture in the relations between Britain and America. Instead, the cause

of the problems besetting the empire was French deception and seduction. Britannia signed the letter, "[I am your friend and mother]."

Within the week, M. Darly published a sequel, "[America to her Mistaken Mother]," on May 11, 1778. Britannia's child was represented as an Indian, who held a thirteen-stripe flag, an image affirming her intent to become an independent nation. The salutation, "[America to her Mistaken Mother]," implied that the British government or the British people did not understand the colonies. The first sentence revealed the colonial child's disrespect for her British mother, whom the daughter addressed as "[You silly old woman]." America continued, "[We are determined to abide by our own ways of thinking]," so attributing to the colonies a desire for self-determination. The Indian added, "[If you are wise, follow your own advice you gave to me. Take home your ships, soldiers. Guard well your own trifling and leave me to myself as I am at age to know my own interests]." The rebus adopted the image of the family to justify the colonial desire for independence, thus reversing its typical rhetorical usage in Britain. Previous prints had used the image of the family to sanction endeavors to keep the colonies within the empire, but in this rebus the child's age sanctioned independent action for the colonies, which professed to be mature. The letter's closing reflected the military conflict of recent days, "[I am your gratefully injured daughter, America]," probably a sarcastic insinuation that the mother's military efforts had absolved America of any obligations such as gratitude.

After the formal treaty between France and the United States in 1778, the family imagery changed such that greater emphasis was placed on the meddlers in the family struggle. This shift may account for the focus upon the Frenchman in these two rebuses, since Darly published them after the formal treaty had been announced in French newspapers. Subsequently, during the war in October 1779, "THE EUROPEAN DILIGENCE" evoked the family metaphor in a similar manner to warrant Britannia's criticism of European nations: "Cruil Neighbours thus to assist Rebellious Children." In this print the interfering neighbors were not merely taking advantage of a family quarrel, as had been the case in *"Bunkers hill, or the blessed effects of Family quarrels."* Instead, they were the very reason for the Indian's military successes, since France stabbed Britannia and since Holland pushed the wheelbarrow over her fallen body. The Frenchman gloated,

"O Madame 'tis de fine Politique," while the Indian urged him, "Strike Home."

The family metaphor defined the usual characters and moral judgments in "BRITANIA *and Her* DAUGHTER. *A Song*," published on March 8, 1780. Word balloons articulated these roles and the lyrics detailed the drama. Britannia said to the Indian, "Daughter return to your duty, and let me punish those empty Boasters; those base Villains who keep you from your Allegiance, and desturb our Quiet." By evoking the notion of a child's duty, Britannia exerted her parental authority over the Indian. By blaming the "base Villains" for keeping the Indian from her duty, Britannia held the personifications of European nations responsible for the Indian's past behavior; the words "keep from" implied that the Indian would have complied with her parent's demand if it had not been for the interference of the suitors.

The Indian responded, "Mother if you would punish those Villains, who forced me from my Allegiance and desturb our quiet, you must find them at home." The words "forced me from my Allegiance" confirmed the culpability of outsiders for the family strife, while they obfuscated the political issues within the British empire that initially had given rise to the conflict: Occluded were any references to the Stamp Act, the Townshend Duties, the Intolerable Acts, or war atrocities—elided were matters of culpability that had separated the mother and daughter. The Indian continued, "[T]hose Gentlemen are my Allies. We are now Arm'd and seek your Life." The raised tomahawk in one hand and the scalping knife in the other reinforced the blunt threat, while the Indian's placement between two armed personifications depicted her alliance with France and Spain. The daughter's confession of parricidal motives created a tension: On the one hand, the Indian was not culpable if, in fact, she had been forced by her suitors to betray her mother, but, on the other hand, the Indian could become responsible for her own mother's death.

Since the allies of the Indian were her suitors as well as her manipulators, there was an element of courtship in the drama. The representation of France affirmed that he would continue his courtship of America in defiance of parental disapproval. "Sacre Dieu! I vill have your Daughter vether you vill let me or no; and vat you tink besides." The Frenchman then revealed his desire to subdue Britain with the threat, "I vill make you

my Servant." The Spaniard asserted: "Signiora Britania, I'll take care your Daughter shall be true to me. I'll make her wear a Spanish Padlock," affirming that this courtship would result in strict subordination for the daughter. Song lyrics narrated the plot, rich in innuendo and concluded with a wish. The story began with the Indian and Britannia, who "one day had some words. / When behold Monsieur Louis, advanc'd a new whim, / That she should leave her Mother for to live with him." The Indian reacted to the dispute with her mother by consenting to live with the Frenchman. But because the Frenchman "was poor," and because the Indian "wanted fine things," she complied with the Monsieur when he offered to share her with Don Carlos, a Spaniard: "The Don being am'rous was easy brought o're, / And he Cuddled and Kiss'd, as Monsieur did before. / Derry Down." In her greed the Indian prostituted herself, a plot development that probably corresponded to the commercial trade relations that the colonies sought to develop with the European nations. Allusions to family shame and disgrace amplified this unflattering colonial image as brazen courtesan: "Britania beheld her with tears in her eyes / O! Daughter return to your duty she cries."

Unwilling to forgive or to obey her imploring mother, the Indian rejected her, blamed her for mistreatment, and then threatened to kill her.

> If you'd used me kind when I was in your power,
>
> I then had lived with you at this very hour,
>
> But now on my Lovers so much do I doat,
>
> That we'r Arm'd and I'll help'em to cut your old throat.
>
> Derry Down
>
> Then with Hatchet, and Scalping-knife, Miss did advance
>
> On one side of her Spain, on the other side France.

The plot detailed the Indian's wickedness, a combination of ingratitude, misguided action, vengeance, and hatred. Yet the final verse suggested Britannia's willingness to forgive her child by accepting her back into the family—that is, by accepting the American colonies back into the British empire. Instead of describing an appropriate punishment for the Indian, or treating her in the same manner as her allies, the lyrics emphasized France and Spain's culpability for seducing her:

Now for the Old Lady let all of us pray
May Monsieur, and the Don for their perfidy pay,
May young Miss. return to her duty agen,
And may Britons be Free in despight of Base Men
Derry Down.

The song unequivocally condemned the Indian's suitors, while revealing a parental ambivalence toward the Indian, a wicked daughter but nonetheless a member of the family.

Family ties warranted such ambivalence through the child's youth and a conviction that the child had been seduced by a foreigner, an enemy. Another British print endeavored to explain the treaty of the United States with France by suggesting that the child's conduct resulted from being gullible—"[Freedom, Peace, Plenty all in vain advance]," published as the frontispiece of *The Universal Magazine of Knowledge and Pleasure* in 1780. Although the battle was being fought on American soil, this print suggested that the colonies were the aggressors, since it depicted American soldiers shooting at Britannia, Peace, and Plenty. The verses above and below the print described the soldiers as "Brittannia's Children, dupes to France." Yet the verses condemned the children for hypocrisy with the comment "Tyrants they prove, while Patriots they appear." In the foreground, Britannia trampled on a French shield decorated with a fleur-de-lis, but she seemed reluctant to engage her own children in battle, since she turned her body away from them. At her feet was a document referring to America's "TREATY OF ALLIANCE WITH FRANCE." By portraying the colonial children as seduced or duped by France, prints such as these sustained hope that continuing the war was sensible policy, because it could result in the reunification of the British empire: Seduced or duped children could be reformed or educated, since they did not realize what they were doing.

Colonial soldiers were described as children again in *"Mrs. General Washington Bestowing thirteen Stripes on Britania,"* published in the March 1783 issue of *The Rambler's Magazine.* An article with the print explained the title by observing that General Washington was not a man, as had been supposed by most people. "General WASHINGTON," the article solemnly

announced, "is actually discovered to be of the FEMALE SEX." For evidence, the article referred to an exposé "from the Pennsylvania Gazette of Nov. 11, 1782."[51] In the illustration, "Mrs. General Washington" seized Britannia by the hair and raised a scourge over her head, while representations of France, Spain, and Holland urged her to continue hitting her own mother. The general declared, "Parents Should not behave like Tyrants to their Children"—an ironic remark tinged with hypocrisy, since Mrs. Washington behaved like a tyrannical child even as she denounced tyranny. Britannia inquired, "Is it thus my Children treat me"—a question that emphasized the wickedness of children who would whip their parent. Once again Britannia seemed reluctant or unable to defend herself. The "thirteen Stripes" of the title was a pictorial pun that referred simultaneously to the number of rebellious colonies, the thirteen stripes on the official flag of the United States, the exact number of lashes on the whip held by Washington, perhaps even the number of times that Washington would strike Britannia with the whip.

With the advent of preliminary peace negotiations in 1782, notable differences characterized the image of the child, as for instance in "*The* RECONCILIATION *between* BRITANIA *and her daughter* AMERICA," attributed to Thomas Colley and published twice in 1782, once on May 11 by [William] Richardson and again by [William] Humphrey. America and Britannia embraced each other. Each woman held her own liberty pole. Britannia remarked, "Be a good Girl and give me a Buss." The Indian responded, "Dear Mama say no more about it." Not everybody was pleased with these political developments. To the left of the Indian, men representing France and Spain strained on a rope to pull America away from Britannia's arms. France complained, "Begar they will be friends again if you dont pull a little harder." The Spaniard responded, "[M]e do all I can to keep them asunder pull her hair, but take care she Don't kick you." To the right of Britannia, a parliamentarian—probably Lord Charles Fox, since a fox's head and tail poked out from around him—stopped playing the game at his feet enough to complain, "Da-n that Frenchman & his Cousin Don, how they strain to part them." But the central focus was on the hope for a resolution of animosities between mother and child.

In summary, illustrators in eighteenth-century Britain used the image of America as a vulnerable and inexperienced child initially to justify

Britain's benign protection and guidance of a productive member of the family. By doing so, British image makers provided reasons for the parent state to expect gratitude, affection, obedience, and economic support from the child, since these were customary ways for a child to reciprocate for a parent's protection, support, and guidance. In addition, British illustrators used the image of the child to affirm British ownership of the American colonies, as was often suggested by possessives such as "Britannia's child," "her child," and "his children." Indeed, the image of America as a child justified British profits from the colonies, not only because of the territory that Britain possessed and protected in America but also because parents were entitled to the product of their child's labor. In these ways, the image of the family was employed to justify laws such as the commercial trade regulations that had proved so beneficial to Britain's economy.

During the Stamp Act controversy in 1765, when the child refused to provide additional economic support to the mother in the form of taxes, the child's refusal constituted evidence of ingratitude, disaffection, and disobedience. British illustrators portrayed the parent's requests that the child be more self-sufficient as well as the child's insolent response. When the child refused to obey the tax law, the parent relented by revoking the Stamp Act in 1765. That act of lenience seemed not to solve the problems besetting the British empire; there were subsequent disruptions within the American colonies in 1768 and again in 1773. Yet the image of the child was employed to urge moderate conduct, despite the severity of the child's offenses, because America was a part of the family. Perhaps, pamphleteers suggested, the parent had contributed to the problem by failing to moderate the demands to suit the maturing state of the child. By 1774, however, the majority in Parliament concluded that leniency toward America was a discredited policy, because the child had not responded suitably to patient and persistent requests for reform. A policy of lenience gave way to a policy of punishment, embodied in the Intolerable Acts of 1774.

Later, especially after the military violence of 1775, the image of the child provided a basis for powerful emotional and moral appeals condemning America for ingratitude, disobedience, promiscuity, and worse: The child had violated divine and natural law by striking and seeking to kill its own parent. And yet illustrators used the image of the child to explain the colonies' despicable conduct: They were naïve, duped, or seduced by

France. As such, the image allowed for hope through the end of the long war that the British empire might be reunited, since a deceived or licentious child might be educated and reformed. Finally, toward the end of the war, the image of the family displayed the reestablishment of kindred bonds between former enemies, though the daughter's possession of a national flag showed that reunification of the empire had not and would not transpire. With her flag, America displayed her maturity and her independence.

THE IMAGE OF THE CHILD IN AMERICA

In the American colonies, the way Patriots and Loyalists handled the image of the child in their dispute resembled the use of that image by British illustrators in that the family ties of blood, heritage, affection, and mutual interest were commonplace ideas supporting imperial unity, while the issues of protection and gratitude, obedience and liberty, duty and rights were prominent points of division between the rival factions. However, in Britain the majority in Parliament eventually came to emphasize the moral deficiencies of the child, with some in the minority pointing out the parent's shortcomings, while in America the majority of the colonial protesters and the Continental Congress stressed the moral deficiency of the parent, with some Loyalists in the minority pointing out the child's shortcomings. In Britain, the case against the child was made easily because of continuing evidence of colonial ingratitude and defiance, while in America the case against the parent was made as readily because of continuing evidence that the parent was determined to transgress upon American rights.

While British image makers depicted the colonies as a child to affirm their possession of America through expressions such as "our children" or "our child," certain Americans expressed dissatisfaction about the political significance of those possessives. As Benjamin Franklin remarked in a letter to Lord Kames in 1767, "Every Man in England seems to consider himself as a Piece of a Sovereign over America; seems to jostle himself into the Throne with the King, and talks of OUR *Subjects in the Colonies.*" Along similar lines, Silas Downer, a pamphleteer in Rhode Island, complained,

"The language of every paultry scribbler, even of those who pretend friendship for us in some things, is after this lordly stile, *our colonies—our western dominions—our plantations—our islands—our subjects in America—our authority—our government*—with many more of the like imperious expressions. Strange doctrine that we should be the subject of subjects, and liable to be controuled at their will!"[52]

Although these colonists did not believe themselves to be subordinate to their fellow citizens in Britain, even the American protesters professed their love and gratitude to the mother country during the initial colonial responses to the Revenue Act of 1764 and the Stamp Act of 1765. Writing at Boston in 1764, James Otis affirmed without reservation in *The Rights of the British Colonies Asserted and proved*, "We all think ourselves happy under Great-Britain. We love, esteem and reverence our mother country, and adore our King." He added, "[C]ould the choice of independency be offered the colonies, or subjection to Great-Britain upon any terms above absolute slavery, I am convinced they would accept the latter." To the protesters, taxation—not the child's subordination to the mother country—was the fundamental issue disrupting the British empire.[53]

Loyalists routinely evoked the image of parent and child to explain and to criticize the conduct of Britain and the American colonies. In 1774, for instance, the parent and child relationship was depicted in New York by an Anglican minister, Thomas Bradbury Chandler, who inquired in his series of questions titled *The American Querist*, "Whether *Great-Britain* bears not a relation to these colonies, similar to that of a parent to children; and whether any parent can put up with such disrespectful and abusive treatment from children, as *Great-Britain* has lately received from her colonies?" In Pennsylvania, Isaac Hunt requested in *The Political Family*, "Let us now consider *Great-Britain* and her *American colonies* as a family, the establishment of which depends upon unity, friendship, and a *continued* series of mutual good offices." In Maryland, Jonathan Boucher affirmed his faith in the legitimacy of the parent-child analogy in his sweeping generalization about government: "[T]he patriarchal scheme is that which always has prevailed, and still does prevail, among the most enlightened people: and (what is no slight attestation of it's truth) it has also prevailed, and still does prevail, among the most unenlightened."[54]

Loyalists especially evoked the image of the family to articulate the bonds that united Britain and America, as when Thomas Bradbury Chandler referred in 1774, in *A Friendly Address To All Reasonable Americans, On The Subject Of Our Political Confusions*, "to the mutual interest and honour, both of the Parent Kingdom and its American offspring." In Maryland, Jonathan Boucher affirmed confidently in a sermon of 1774, "If both the Mother Country and the Colonies understood, and would pursue, their true interests, their present union might undoubtedly be continued much to their mutual advantage." In his "Farewell Sermon" of 1775 at Queen Anne's Parish, Boucher subsequently contended that those interests were not merely mutual but identical: "I cannot dissociate the idea of a perfect sameness of interest between the two countries, as much as between a parent and a child." Affection also united the parent and child, as Daniel Leonard observed as Massachusettensis when he declared, "The bowels of our mother country yearned towards her refractory, obstinate child."[55]

Indeed, the bonds between the parent and child were heterogeneous, as suggested by a writer in the *Pennsylvania Ledger*, who cautioned that the colonies' independence from Britain would break the bonds "of Religion, of Oaths, of Laws, of Language, of Blood, of Interest, of Commerce, of all those habitudes" that had kept Americans "*united* among themselves, under the peaceful influence of their common parent." On the eve of the military conflicts of 1775, even some of the noteworthy Patriot writers continued to evoke the image of the family to articulate the bonds of blood, heritage, affection, mutual interest, and obligation that unified the British empire. Alexander Hamilton, for example, professed in *The Farmer Refuted: Or, a More Impartial and Comprehensive View of the Dispute Between Great-Britain and the Colonies, Intended as a Further Vindication of the Congress: In Answer to a Letter from A. W. Farmer, Intitled a View of the Controversy* to "earnestly lament the unnatural quarrel, between the parent state and the colonies; and most ardently wish for a speedy reconciliation,—a perpetual and *mutually* beneficial union." The bonds between America and Britain were so fundamental to Abigail Adams that, even though she referred ominously in 1774 to "redress by the Sword," she also alluded to the "three fold cord of Duty, interest and filial affection" binding the colonists to the

British empire: " 'Tis like the Gordean knot. It never can be untied, but the sword may cut it."[56]

Because many colonists regarded the American colonies as grateful and dutiful children during the decade of dissent, and because they saw the tax law as an infringement upon their rights as Englishmen, they began to question the motives underlying the mother country's conduct toward America. One obvious reason for the tax law was the economic gain to be obtained in Britain by shifting some of the government's expenses from British citizens to the colonists—a shift that was justified in Britain by claims that the revenues would be used to defray the expense of defending the colonies. This justification was unacceptable to the colonial protesters, because they recognized that money from some colonies could be used in other colonies, or, worse, in the outlying areas in Canada and elsewhere. To protesters, there was danger here, because if the parliamentarians secured such a shift in the source of tax revenues, they could achieve political popularity in Britain subsequently by reducing the land taxes there. Without representation in Parliament, the colonial protesters recognized, there was no legal means to prevent regular use of such a strategy of taxation.[57]

Yet additional explanations for the parent's conduct were suggested in three colonial prints and one commissioned medal that were produced and distributed between 1765 and 1784. During the Stamp Act controversy in 1765, two satirical prints suggested that prominent British ministers had deceived the mother country into mistreating the colonies. Later, during the initial stages of the war in 1776, another print explained that the mother's character had changed such that she had become corrupt and greedy. The print alleged that the mother's avarice and jealousy motivated her offensive conduct toward her children. Finally, toward the end of the war, *Libertas Americana*, a medal commissioned by Benjamin Franklin, portrayed the colonies as the infant Hercules killing two snakes, a classical allusion that intimated that Britain was no mother country at all. She was rather like Juno: a cruel stepmother with the will to kill an unarmed infant. All these views resembled published explanations offered by Patriots, but these images had the advantage of reaching illiterate and semiliterate audiences.

Although Loyalists routinely employed the images of the parent and child in their political pamphlets, newspapers, and sermons to describe the

relations between Britain and America, they did not produce and distribute pictorial images of Britannia as loving parent of a colonial child during the decade of debate or the war years. They seem not to have recognized the value of pictorial messages for promoting their political ends. They did, however, often evoke the verbal image to remind colonists of the reciprocal obligations between Britain and America, to circumscribe proper colonial demeanor, to instill gratitude and affection for Britain, to prove the child's culpability in the dispute with Britain, sometimes even to articulate what they regarded as the parent's tragic shortcomings.[58]

During the Stamp Act controversy, two versions of "THE DEPLORABLE STATE of AMERICA" were produced and distributed in America, one in Boston sold by Nathaniel Hurd and attributed to John Singleton Copley, the other in Philadelphia sold at the office of the *Pennsylvania Gazette* and attributed to Wilkinson.[59] These prints suggested that the mother's conduct toward her child could be explained as a consequence of French bribery and Scottish influence in government, especially that of Lord Bute, Scottish adviser to King George III. In an attempt to regain territory in America, the Genius of France had bribed Lord Bute—visually represented as a boot—to influence Britannia's conduct toward America. As a consequence of Bute's influence upon Britannia, suggested by the rays from the radiant boot above her, Britannia exercised her maternal authority over America by commanding "Take it Daughter," referring to the Stamp Act in her hand. The mother imposed her will on the daughter, as was underscored by her child's reaction: "I abhor it as Death." The print did not explicitly call the mother a tyrant, but it intimated that the mother had abandoned constitutional principles: The torn fragments of the Magna Charta trailed in the breeze behind Britannia. When Britannia described an object inscribed "Pandora's Box" as "only ye S[tam]p A[c]t," she created a discrepancy that called the mother's integrity into question, even if Bute had misguided her. Beside the liberty tree, a dying personification of Liberty protested, "and canst thou Mother! Oh have pity this horrid Box." Between Liberty and America, a personification of Loyalty observed, "[T]is a horrid blast[.] I fear I shall lose my Support." And yet, because Lord Bute had advised the mother to impose the Stamp Act, the prints by Copley and by

Wilkinson allowed for some hope that the mother herself was not beyond reform.

It was a commonplace throughout the decade of dissent that the mother had mistreated her children because she had been poorly advised by her ministers. As an anonymous author in the *New-York Mercury* inquired on October 21, 1765, "[T]o what can we impute the infatuation of our mother country; by whose baleful advice has she been deluded, encouraged, advised!" This belief that the mother country had been misled by her advisers left hope for redress or reform, because as John Dickinson pointed out in *Letters from a Farmer in Pennsylvania*, "We have a generous, sensible, and humane nation, to whom we may apply. They may be deceived. They may, by artful men, be provoked to anger against us. I cannot believe they will be cruel or unjust; or that their anger will be implacable." In 1774, even though Isaac Wilkins was committed to Loyalist politics, he too drew upon the commonplace distinction between the mother country and her ministers in his admission in *Short Advice to the Counties of New-York* that Great Britain "is the land of liberty, and would gladly dispense that blessing to her children, and to all the world. But her ministers are men, and as such may err; they may ignorantly or inadvertently adopt measures that are injurious to the community, and subversive of its liberties."[60]

Because the colonists valued the family ties between Britain and America, because even the protesters felt such sentiments as gratitude and affection to the mother country, Daniel Dulany attempted in his pamphlet *Considerations On The Propriety Of Imposing Taxes In The British Colonies, For the Purpose of raising a Revenue, by Act Of Parliament* to specify the nature of colonial subordination to Britain. Dulany did so to prove that the colonists could insist upon freedom from taxation by Parliament and yet remain subordinate to that authority. In his effort to articulate a resolution to this tension between the child's due subordination to its parent and its legal rights within the empire, Dulany explained that the mother country had the right to determine patterns of commercial trade through legislation, since "a Denial of it would contradict the Admission of the Subordination, and of the Authority to preserve it, resulting from the Nature of the Relation between the Mother Country and her Colonies." At the same time, Dulany insisted that the colonists were entitled as British subjects to "[t]he Right of Exemption from all Taxes *without their Consent*."[61]

Consent was the critical term in matters of taxation, because consent provided a basis to distinguish a child from a slave, as suggested in Dulany's pointed insinuation: "[I]f the Parliament may in any Case interpose, when the Authority of the Colonies is adequate to the Occasion, and not limited by their Subordination to the Mother-Country, it may in every *Case*, which would make *another* Appellation more proper to describe their Condition, than the Name by which their Inhabitants have been usually called, and have Gloried in." Subsequently, John Dickinson put the matter more bluntly in 1768, when he observed, "Now, a generous humane people, that so often has protected the liberty of *strangers*, is enflamed into an attempt to tear a privilege from her own children, which, if executed, must, in their opinion, sink them into slaves." Dickinson argued, "[T]ho' these colonies are dependent on *Great-Britain*; and tho' she has a legal power to make laws for preserving that dependence; yet it is not necessary for this purpose, nor essential to the relation between a mother country and her colonies . . . that she should raise money on them without their consent." The emphasis upon consent was commonplace throughout the American colonies, in part because consent was an ideal that enabled colonists to distinguish slavery and childhood, in part because it was a means to express a commitment to the exercise of consensual rather than patriarchal authority within the family, and in part because this ideal was the foundation of a representative government. And yet this commonplace emphasis upon the human will was not the most obvious distinction between a child and a slave, although it was regarded as a reasonable line of argument. A more direct distinction than this would have stressed differences between biological generation and economic acquisition.[62]

Dulany's and Dickinson's arguments about the relationships among the family members proceeded from a conviction that the colonies had been obedient children throughout the conflict, a conviction that was explicit in Dickinson's remark in 1765 that the indignation aroused by the Stamp Act was "but the resentment of dutiful children, who have received unmerited blows from a beloved parent." Imagery of child abuse recurred in the pamphlets and newspapers written by colonial protesters and Patriots during the decade of dissent. For instance, a writer in the *Pennsylvania Gazette* alluded on July 6, 1769, to the vicious conduct of a parent country that was "cruelly oppressing an infant country." Another writer in the *Pennsyl-*

vania Journal claimed on June 1, 1774, "An infant that had tottered along a directed walk in a garden, and loaded with flowers had presented them to a mother, would as soon have expected to be knocked down by her." Allusions such as this amplified the vulnerability of the victim, a defenseless "infant," so as to magnify the wickedness of the parent's abusive treatment. Child abuse—or the fear of such abuse—was a powerful emotional appeal.[63]

Loyalists alluded to the youthful age of the child not to magnify the abusive nature of the parent's conduct but rather to justify the colonies' continued dependence upon the British government—even when the Loyalists sought to change the degree of that dependence. Alluding to the absence of colonial representatives in the British Parliament, Galloway contended that during the "infant-state" of the colonies "they were incapable of exercising this right of participating [in] the legislative authority in any mode." In earlier years, Galloway allowed, "This power of parliament was justifiable from necessity at that time over them; they stood in as much need of its protection, as children in an infant-state require the aid and protection of a parent, to save them from a foreign enemy, as well as from those injuries which might arise from their own indiscretions." Galloway maintained, however, that the system of representation should be changed, because "now they are arrived at a degree of Opulence, and circumstances so respectable, as not only to be capable of enjoying this right, but from necessity, and for the security of both countries to require it."[64]

Loyalists endorsed the underlying belief that the child and the parent were bound to reciprocal responsibilities and duties, but they disagreed with the Patriots about who had failed to perform them. Moreover, Jonathan Boucher contended in 1774, "Allegiance and protection are not merely reciprocal duties, entirely dependent the one on the other. Each duty continues to be equally obligatory, and in force, whether the other be performed or not." Boucher insisted, "There is no authority to prove, that a failure of duty on one side will justify a like failure on the other. The disobedience of the child, so far from furnishing the parent with a pretence for withdrawing his authority, is the strongest reason for exerting it."[65]

Protection and support constituted key elements in the Patriots' and the Loyalists' arguments about the colonies' obligations to Britain, much as they had in Britain. Because the parent had provided protection and support

to the child, colonists reasoned, the child had incurred a debt of gratitude and responsibility to its parent. In 1766, for instance, Joseph Reed observed in *Four DISSERTATIONS on the Reciprocal ADVANTAGES of a Perpetual UNION Between GREAT-BRITAIN and Her AMERICAN COLONIES*, "In this weak, this defenceless state, therefore, we must look up to our indulgent parent, whose vigorous, salutary aid we have so often already experienced." Almost a decade later, in 1775, Isaac Hunt maintained, "*Protection* requires *dependence* in return." Jonathan Boucher averred in a sermon of 1775 that the parent's protection facilitated the child's growth and, therefore, the colonies owed gratitude to the parent: "[I]t is neither a complex nor a difficult point to prove, that, owing almost solely to the protection and patronage of the Parent State, we have rapidly risen to a degree of respectability, and 'an height of felicity, scarce ever experienced by any other people.' " Charles Inglis held in *The True Interest of America Impartially Stated, in Certain Strictures on a Pamphlet Intitled Common Sense* that certain colonies owed their very existence to the support that they had received from the parent state: "[J]udge what had been the condition of Virginia, the first colony, and latterly of Georgia and Nova-Scotia, if Great-Britain had not supported them. They must as infallibly have perished, as an infant without its proper food, had not Great-Britain afforded her aid and support."[66]

Loyalists were careful to specify that the nature of the colonies' dependence upon Britain still preserved the colonies' most important rights, as for example in the governor of Massachusetts-Bay's address to the colony's assembly on January 6, 1773. Thomas Hutchinson contended that, "notwithstanding this Dependance," the colonies "will enjoy as great a Proportion of those Rights to which they have a claim by Nature or as Englishmen as can be enjoyed by a Plantation or Colony." In the concluding remarks of a subsequent address to the assembly, Hutchinson argued on March 6, 1773, that "by Means of a nominal Dependence we possessed as great a Share of real Freedom as the Parent State itself upon which we are said to depend." Such efforts by Loyalists to specify the nature of the colonies' dependence upon Britain were strategic: By contending that the colonies continued to enjoy their rights within the British system of government, Loyalists such as Hutchinson sought to counter the Patriot writers' claims that the parent state had failed to distinguish between children and slaves.[67]

During the Stamp Act controversy of 1765, the prints by Copley and Wilkinson had suggested that the mother's conduct was a result of bad advice from her ministers. A decade later, another, more extreme, explanation of her behavior was depicted in an American version of "[*The able Doctor, or America Swallowing the Bitter Draught*]," a woodcut on the cover of FREEBETTER'S NEW-ENGLAND ALMANACK *for the Year 1776*, printed and sold by T. Green. Inside the almanac, a verse described the mother country in terms very different from those that had accompanied the British versions of "*The able Doctor*" in *The London Magazine* and *The Hibernian Magazine* two years earlier. These British publications had both portrayed Britannia as the sympathetic and shamed mother of a daughter who was being tormented by government officials. In contrast, the verse in FREE-BETTER'S NEW-ENGLAND ALMANACK suggested that the mother's character had changed from previous years such that she had become corrupt. Perhaps she was an accomplice of the malicious ministerial assault, even though the mother herself did not touch the child.

The opening lines of the poem in the almanac dwelled upon Britannia's past virtue and glory:

Britannia! once how kind a parent she!

How much beloved!—What duteous children we!

How glow'd our hearts with transport at her name?

How did her spirit all our breasts inflame!

From her we learn'd fair freedom's worth to prize,

And read its thousand blessings in her eyes.

The next several lines asserted that the colonial child had fulfilled all the customary parental expectations:

Our love, which made her interests all our own,

By more than filial tenderness was shown;

How did our eyes at her success o'erflow?

How droop'd our hearts with sadness at her woe!

Was she dishonoured! How we felt the wound!

How we gloried, when with glory she was crown'd . . .

When enemies arose,
Did we not willingly our lives expose?—
Her gen'rous love demanded this return,
And taught our hearts with gratitude to burn.

After emphasizing how dutiful the colonial child had been, the verse stressed how tainted the parent had become:

But now, alas! how sad a change we find,
A tyrant stern succeeds a parent kind!
No semblance of the parent can we trace.
Nor find one single feature of her face.
Would she, whose grandeur first from Freedom rose
Her children in that sacred right oppose
And having taught them to be free and brave,
Would not her own breast her offspring to enslave!

In light of these verses, "[*The able Doctor*]" depicted Britannia as a tyrant—stern, obdurate, hypocritical, untrustworthy.

That the mother's character had changed was a commonplace explanation of her conduct in the pamphlet and newspaper literature throughout America. On February 20, 1766, for instance, "Americus" claimed in the *Pennsylvania Journal*, "[T]hro' her own avidity, she now proceeds to squeeze a supply from the very vitals of the colonies; and prepares to force that assistance from her unhappy children, which they formerly poured in with the utmost alacrity of themselves." In 1768 the anonymous author of *Some Observations of Consequence, In Three Parts. Occasioned by the Stamp-Tax, Lately Imposed on the British Colonies* claimed that the colonial situation could be attributed only to "our Mother's slumbering Delusions" or her desire to "gratify imperious Lust very wantonly, impoliticly, and even very unnaturally in her advanced Years, at the great Expence or Ruin of her legitimate Offspring, and hitherto dutiful Children." In 1775, Samuel Langdon inferred in *Government Corrupted by Vice, and Recovered by Righteousness* that the mother country must have been impelled by her vices "to

wage a cruel war with its own children in these colonies, only to gratify the lust of power, and the demands of extravagance!" In 1776, Enoch Huntington alluded to the change of the mother's character with reproach for "what she once was, and might still have been, had it not been for her own wicked and wanton abuse of the favours Heaven blessed her with."[68]

Allusions to infirmity and disease were mobilized to explain the changes in the mother's character. Sometimes these allusions were combined with references to promiscuity, greed, and an excessive desire for power. In 1775, Alexander Hamilton observed in *The Farmer Refuted*, "If the mother country would desist from grasping at too much, and permit us to enjoy the privileges of freemen, interest would concur with duty, and lead us to the performance of it." Hamilton added, "[A]las! to her own misfortune, as well as ours, she is blind and infatuated." An anonymous writer in the *Pennsylvania Packet* used the imagery of infirmity colorfully and simply on August 21, 1775, when he observed as "Caractacus," "We thrived upon her wholesome milk during our infancy. She then enjoyed a sound constitution. I will not say that it is high time we should be taken from her breast, but I will say, that she has played the harlot in her old age, and that if we continue to press them too closely we shall extract nothing from them but disease and death."[69]

Although the verses that accompanied "[*The able Doctor*]" in FREE-BETTER'S NEW-ENGLAND ALMANACK condemned the mother country, the verses were moderate for the times. By 1776 allegations were rife that the mother country had embarked on a conspiracy to enslave or kill her children. This transition was evident even in the pronouncements of the Continental Congress. In an *Address To The PEOPLE of GREAT-BRITAIN From The DELEGATES Appointed by the several ENGLISH COLONIES*, the Congress of 1774 had complained in a way that had allowed some possibility that the controversy had arisen from the parent's neglect:

WHEN a Nation, led to greatness by the hand of Liberty, and possessed of all the glory that heroism, munificence, and humanity can bestow, descends to the ungrateful task of forging chains for her Friends and Children, and instead of giving support to Freedom, turns advocate for Slavery and Oppression, there is reason to suspect she has either ceased

to be virtuous, or been extremely negligent in the appointment of her rulers.

The pointed contention was that if the British people were genuinely concerned about liberty in the American colonies, then the British people ought to have elected their officials with care. In 1775, only a year later, after enumerating several injustices, the Congress again indicted the character of the parent country, this time in AN ADDRESS OF THE TWELVE UNITED COLONIES OF NORTH-AMERICA, BY THEIR REPRESENTATIVES IN CONGRESS, TO THE PEOPLE OF IRELAND, wherein Congress alluded to "[r]efinements in parental cruelty, at which the genius of Britain must blush! Refinements which admit not of being even recited without horror, or practiced without infamy!"[70]

Strong convictions that the parent had become wicked were distributed widely in the colonies and abroad, an indication that the issues of constitutional law, commerce, and finance had become transformed by the military violence and the family metaphor into a highly charged emotional issue about proper moral conduct within a family. John Carmichael claimed in 1775 that the British were prepared "to murder and butcher their own children in America, that have been so obedient, useful and affectionate." Thomas Paine charged in 1775 that the British "have lost sight of the limits of humanity. The portrait of a parent red with the blood of her children is a picture fit only for the galleries of the infernals." Enoch Huntington averred, "If she be a mother, she is an unnatural, monstrous one, who, if she doth not forget, yet shews she hath 'no compassion' upon her children, but rather delights in their blood."[71]

To judge from the resolutions of Congress and the numerous charges in newspapers, pamphlets, and magazines that the parent was attempting to commit infanticide, an increasing number of colonists became convinced that they were engaged in a struggle with unrelenting evil. Such depictions of the mother country eliminated hope for reconciliation. Strong moral convictions and the outbreak of military violence in 1775 left those who sought a moderate course of action the difficult task of defending the parent's character. John Dickinson, who had written the popular *Letters from a Farmer in Pennsylvania* in 1768 and who had criticized the mother country for her child abuse, pondered in 1775, "[W]hat topics of reconciliation

are now left for men who think as I do, to address our countrymen? To recommend reverence for the monarch, or affection for the mother country?" Dickinson added, "While we revere and love our mother country, her sword is opening our veins."[72]

Loyalists such as Samuel Seabury and Daniel Leonard insisted that those colonists who opposed the British government were not seeing the mother country's character in its true light. Samuel Seabury, an Anglican minister from New York, claimed as much when he amplified upon the children's lack of respect for their parent to evoke indignation toward American leaders in Congress. In 1774, Seabury demanded in *A View of the Controversy Between Great-Britain and her Colonies: Including a Mode of Determining Their Present Disputes, Finally and Effecually; And of Preventing All Future Contentions*: "Do you think, Sir, that Great-Britain is like an old, wrinkled, withered, worn-out hag, whom every jackanapes that truants along the streets may insult with impunity? —you will find her a vigorous matron, just approaching a green old age; and with spirit and strength sufficient to chastise her undutiful and rebellious children." In contrast to Seabury's expression of righteous indignation toward the children, Daniel Leonard of Massachusetts lamented the child's inability to envision clearly the character of the parents, when he speculated: "Could that thick mist that hovers over the land and involves in it more than Egyptian darkness be but once dispelled, that you might see our Sovereign, the provident father of all his people, and Great Britain a nursing mother to these colonies, as they really are, long live our gracious King, and happiness to Britain, would resound from one end of the province to the other." To Leonard and Seabury, the root of the problem was the child's inability to make a mature judgment about the parents' moral character. That difficulty had caused the child to misjudge the other members of the family, and thus to bring about the tragic disruptions within the British empire.[73]

Several Loyalists called attention to the special virtue of the mother, while others admitted that she had some failings, notably excessive leniency. Daniel Leonard posed a rhetorical question to remind colonists of the mother country's virtues: "Has not the government of Great-Britain been as mild and equitable in the colonies as in any part of her extensive dominions? Has she not been a nursing mother to us from the days of our infancy

to this time? Has she not been indulgent almost to a fault?" John Mein speculated as "Sagittarius" that the mother's character was so virtuous that, even though a violent rebellion had broken out in America, the mother's affection for her child would arise from her humane and generous character: "When peace and unanimity are restored, every individual in the Mother Country will manifest their affection for the Colonies; for the generosity and humanity of the English nation are boundless as the heavens." Jonathan Boucher entreated his congregation as early as 1773 to "unite our hands, our hearts, and our prayers, against those enemies (be they who they may) who meditate war, not only against the Parent State, but against every thing that is established, venerable and good."[74]

In response to the Patriots' mounting criticism, Loyalists sometimes acknowledged that the parent state had been less than perfect. Jonathan Boucher did so repeatedly. In 1773 he commented that the colonies were proud "to form our manners and our sentiments on the model of the Parent State, yet much more disposed to copy her follies and her vices than her merits and her virtues." In 1774 he allowed, "That the Parent State has been unwise, I readily grant; contending only, that she has never been unjust." Boucher admitted, "The Mother Country is, for aught I know, chargeable with a thousand errors in her management of the Colonies: this only cannot be laid to her charge, that she has ever governed them with rigour, or oppressed them." In 1775 Boucher claimed that because the child had erected an "altar of Liberty," the child "has excited the jealousy of the Parent State." As late as 1797—over a decade after the war had ended—Boucher was still identifying the parent's shortcomings: "Some blame too, perhaps not a little, should be attributed to the Parent State, for her irresolution and unsteadiness in her colonial administration."[75]

Above all, Loyalists chastised the mother for excessive leniency, a commonplace criticism that Tories in Britain also were stating during debates in Parliament. In America, Thomas Bradbury Chandler articulated a rationale for the mother's leniency when he remarked in his *Friendly Address* of 1774, "[S]he wishes by lenity, forbearance and indulgence to secure our affections, and to render us sensible, that our greatest political happiness must arise from her smiles and fostering protection." John Mein spoke as though he too had been implicated in the parents' excessive leniency—even though he had only recently moved from Boston to London to

evade personal harm—when he observed in SAGITTARIUS'S LETTERS *And Political Speculations. Extracted From the Public Ledger,* "[L]ike over-fond parents we spoilt our children, we ourselves encouraged them to rebel against us, and now we are reaping the fruits of our foolish indulgence." Peter Oliver admonished as late as 1781, "[L]et it be remembered, that, from an Unacquaintance with the Temper of the Colonists, the Lenity of the Parent aimed to subdue the Stubbornness of the Child. It ought to have been known, that manual Correction is justifiable, & then only, where Refractoriness prevails."[76]

At times, the Loyalists' arguments sounded identical to those of the Tories in England, but the Loyalists' arguments served different purposes in the messages to Americans. For instance, the author of *The ADVAN-TAGES Which AMERICA Derives from her COMMERCE, CONNEXION, and DEPENDANCE on BRITAIN*, attributed to Henry Barry and published at Boston, complained in 1775 of colonial ingratitude and disobedience by evoking commonplace ideas that resembled the arguments by James Macpherson and John Shebbeare:

> Great-Britain has hitherto been to you, an indulgent and kind mother; in your infancy she fondly nursed, cherished and preserved you; and is now, in the noon of life, your respectable and powerful protectress; and because that she expects from you, some pittance in return for the manifold advantages she has afforded you, shall you with ingratitude and unfilial impiety reject her? Shall you refuse to share that burden she has accumulated in your necessary defence? And because you vainly think yourselves equal to the contest, shall you tear from her arms those children she so dearly loves?[77]

But in America these arguments served less to justify Britain's policies of punishment than to instill a sense of communal guilt because of violated family expectations. These remarks were not a parent's denunciation of a wayward child but rather the child's recrimination about his or her own past conduct.

To many Loyalists, the child's crimes ranged from disrespect and exaggeration to ingratitude and parricide. As early as 1765, Martin Howard commented in *A Defense of the Letter from a Gentleman at Halifax, To*

His friend in Rhode-Island that the colonies had responded to the British government's military protection and generosity "with all the petulance of children, who, by long indulgence, become impatient of the smallest restraints." He protested that colonists had displayed a tendency "to degrade the mother country, to raise suspicions and jealousies against her, and to blot out of the colonies every trace of duty and gratitude." Joseph Galloway wrote to Franklin on January 13, 1766, that "the people" were "excited to a Degree of Resentment against the Mother Country, beyond all Description." Thomas Bradbury Chandler suggested in *The American Querist* that the child had been "disrespectful and abusive," and he lamented in his *Friendly Address*, "From thinking, we have proceeded to speaking, disrespectfully of our mother country." Loyalists deplored the Patriot writers' use of exaggeration to challenge the authority of the parent, as when Jonathan Boucher remarked, "It is certain no satisfactory evidence has yet been produced, to prove that the injuries we have received from our Parent State are so great as they are represented to be; much less that her intentions towards us are so unfriendly and hostile as her and our enemies wish us to believe they are." Boucher added, "[W]e have been taught to magnify [the British Parliament's] errors, and to exaggerate our wrongs." To the Loyalists, these and other misdeeds—petulance, resentment, exaggeration, and disrespect—were manifestations of the colonies' ingratitude to the mother country. Above all, to these Loyalists the malevolent child needed to be reformed.[78]

In 1775, an allegory was published that elaborated the child's misdeeds and mobilized the image of the family to castigate the American clergy. By drawing upon elements from the biblical story about the prodigal son, the anonymous author—probably the receiver-general of Massachusetts-Bay, Harrison Gray—detailed the colonies' wickedness by representing the colonies as brothers in *A Few Remarks upon Some of the Votes and Resolutions of the Continental Congress*. This allegory cast the complex issues of governance in terms of the relationships among family members in the management of a farm—a well-selected comparison, since political culture in America was predominantly agrarian. The allegory detailed the father's acts of kindness and generosity as well as a son's insulting and rebellious conduct. An allusion to the prodigal son aroused conventional expectations such that the son should have realized the error of his ways and returned

repentant to request the father's forgiveness. But the son violated these customary expectations in the narrative when he enlisted the other siblings' assistance against their father. By using divine law to frame the conspiracy among the siblings as wicked, the allegory then castigated those members of the clergy who were supporting the rebellion, since they were endorsing the prodigal son's violation of the familiar biblical narrative.[79]

Worse than belligerence and rebellion, however, was the child's attempt to kill its own parent. In 1774, Thomas Bradbury Chandler pointed out in *A Friendly Address* that such an attempt could prove fatal to the child: "The blow would reach her, and be felt by her; but the wound would not be mortal. The strength and vigour of her constitution would bear much more, than we are able to inflict. But—the shaft, ungraciously aimed at the vitals of our Mother, on the rebound may prove fatal to ourselves." Subsequently, in 1775, Chandler amplified in *What think ye of the Congress Now?* that "[e]ven a final victory would effectually ruin us; as it would necessarily introduce civil wars among ourselves, and leave us open and exposed to the avarice and ambition of every maritime power in Europe or America." Similarly, in 1775 Henry Barry speculated, "[S]upposing in this unnatural contest you should by draining the blood of a parent rend yourselves from her, you may then imagine you would be in a state of independance, and without the aid of foreign assistance be enabled to maintain it; but be assured, it would then obtrude itself, and that almost every European power would endeavour to subjugate you to its rule."[80]

Because the Loyalists believed that the child had so many failings, they sometimes expressed concerns that the parent might disown the child. Daniel Leonard inquired, "Are we to take up arms and make war against our parent, lest that parent, contrary to the experience of a century and a half, contrary to her own genius, inclination, affection and interest, should treat us or our posterity as bastards and not as sons, and instead of protecting should *enslave* us?" Another Loyalist writer expressed concerns about abandonment by envisioning the child as an orphan:

> When left alone, on Life's sad Stag[e],
> When anxious Cares, his Thoughts engage,
> Of Parent's fost'ring Aid bereft,
> To the wide World, an Orphan left,

Too late, the fatal Truth, perceives,

Too late reflects, and vainly grieves,

His Parent, fondly was beguil'd

Had spar'd the Rod, and spoil'd the Child.

Much like his Tory counterpart in England, the Loyalist writer intimated that the parent's fault was excessive leniency, a moral failing that he magnified through biblical allusions to Proverbs 13:24 and 23:34.[81]

Because America as child had failed to fulfill so many of the customary duties for the parent, and because the child had seemed to be wicked toward the mother, in 1774 Jonathan Boucher lectured his congregation in Maryland about the nature of love and gratitude as applied to imperial relations: "[I]f love be a voluntary offering, gratitude is a debt: and surely it is not a little that the Parent State is entitled to claim from us on the score of past benefits." Boucher castigated his congregation for failing to sacrifice "our lives and fortunes in the service of the Crown." With contempt, he added,

Away with such loyalty, and such affection! —loyalty that is liberal of words only, and proffers it's services most when they are least wanted; and affection that can be attached and engaged only by being coaxed and caressed. The moment our Parent ceases to foster and fondle us, or that we imagine she ceases, our affections are withdrawn; and, instead of loving and reverencing the mother that bore us, we vilify and insult her.[82]

To Boucher, protection and support from the parent required in return the child's affection, service, and, above all, loyalty.

Denials that Britain was parent of the colonies had been commonplace in America long before the outbreak of military violence in 1775. As early as December 2, 1765, a versifier in the *Boston Gazette* had urged the colonists to

SPURN the Relation—She's no more a Mother

Than Lewis to George a most Christian Brother,

In French Ware and Scotch, grown generous and rich,

She gives her dear Children Pox, Slavery and Itch.[83]

To the Loyalists, however, such denials that Britain was the parent country only confirmed that the child was wicked. Joseph Galloway asserted in 1775 in his *Candid Examination Of The Mutual Claims Of Great-Britain, And The Colonies: With A Plan Of Accommodation, On Constitutional Principles*:

> The relation between the sovereign authority and its members, bears a true resemblance to that between parent and child. Their rights and duties are similar. Should a child take umbrage at the conduct of a parent, tell him that he was not his father, nor would he consider himself, or act, as his child *on any terms*; ought the parent to listen to such undutiful language, or could he be justly censured for treating it with neglect, or even with contempt?[84]

To Galloway, the relationship between a parent and a child provided so apt an explanation of the rights and duties of Britain and America that any colonist's attempt to deny the analogy was not merely mistaken, it was irresponsible and contemptible.

Even so, for pragmatic political reasons the Patriots continued to deny that Britain was the mother of the American colonies. To Patriot writers, the image of the family was complicating the formation of crucial alliances with European nations, especially with France, as "The Forester" explained in the *Pennsylvania Packet* on April 22, 1776:

> [W]hile we continue to call ourselves British subjects, the quarrel between us can only be called a *family quarrel*, in which it would be just as indelicate for any other nation to advise, or [in] any ways to meddle or make, even with their offers of mediation, as it would be for a third person to interfere in a quarrel between a man and his wife. Whereas, were we to make use of that natural right which all other nations have done before us, and erect a government of our own, *independent of all the world*, the quarrel could then be no longer called a *family quarrel*, but a *regular war* between the two powers of Britain and America.[85]

Disputes within a family were to be regarded as a private matter. It was necessary to deny the image of the family designating the British empire

so as to justify the engagement of outsiders. But this pragmatic argument was not the sole rationale for rejecting this particular image.

Perhaps the most sophisticated and sustained attempt to appropriate, redefine, and repudiate the image of family as British empire was Thomas Paine's *Common Sense*, published and distributed throughout America, Great Britain, and continental Europe in 1776. The most widely reproduced pamphlet of the American Revolution, *Common Sense; Addressed To The Inhabitants Of America* denounced institutional monarchy and advocated the formation of an independent nation guided by republican principles. In the course of his argumentation, Paine initially appropriated the image of the family to reverse its commonplace implications as they had been articulated by the Loyalists. Then he repudiated the image of the empire as a family altogether, denying that Britain was the parent country of the American colonies. Within a few short months, in a pamphlet titled *The True Interest of America Impartially Stated, in Certain Strictures on a Pamphlet Intitled Common Sense*, Charles Inglis, an Anglican minister from New York, undertook a point-by-point refutation of each of Paine's arguments about the image of the family. Another Loyalist, James Chalmers, wrote *Plain Truth: Addressed to the Inhabitants of America* in response to Paine's *Common Sense*, but he sought only to refute isolated arguments about the image of the family. In the process, Chalmers and Inglis suggested how the image of the family remained central to these Loyalists' thoughts about imperial relations. These exchanges illustrate how Patriots and Loyalists vied to control the potent political implications of the image as used to represent the empire.[86]

Paine initially appropriated the image of the family designating the empire to endorse independence, rather than to sanction colonial subordination. By doing so, he attempted to reverse one of its most conventional implications:

I have heard it asserted by some, that as America hath flourished under her former connection with Great Britain, that the same connection is necessary towards her future happiness and will always have the same effect—Nothing can be more fallacious than this kind of argument: — we may as well assert that because a child hath thrived upon milk, that it is never to have meat, or that the first twenty years of our lives is to

become a precedent for the next twenty. But even this is admitting more than is true.[87]

To Paine, if the image of the family was to be accepted as an apt image of the empire, then the child should mature and separate from the parent; the image of the family could be mobilized to support a rationale for national independence.

In response, Inglis contended that Paine had failed to comprehend the true meaning of the image and that he had violated the proper use of language. After quoting Paine's remarks in *Common Sense* at length, Inglis asserted:

> However glib this quaint simile may run upon paper; or however convincing it may appear to shallow readers; yet, in truth, when examined, it contains a palpable impropriety, and is impertinent to the case before us. Great-Britain is figuratively called the Parent State of the colonies; their connection, therefore, may be properly compared to the *relation* subsisting between parent and child. But to compare our *connection* with Great-Britain to the *literal food* of a child, a thing different from, and not necessarily belonging to that *relation*, is manifestly absurd, and a violation of the propriety of language; as all who are judges of the nature of language must be sensible. The *relation* of parent and child ends not, when the latter has arrived to maturity, although the use of *milk* may be laid aside; and that relation may be still necessary to the happiness of both; the same may be truly affirmed of *connection* with Great-Britain.[88]

Inglis denied that Paine had employed the image of the family properly, since to Inglis food was not essential to the relationship between parent and child. Having rebuffed Paine for his insensitivity to language and reason, Inglis returned to the image of the child in an effort to diagnose a reasonable solution to the problems disrupting the British empire. Inglis conceded that the maturing state of the American colonies required reform of the parent. Then he contrasted his own vague proposal with the radical one in *Common Sense:*

> But if we must stretch the simile further, we find something analogous to the literal food of a child, it is the litteral support afforded by Great-

Britain to the colonies, in their infant state *formerly*; and the administration of the colonies *now*, as well as the general laws of regulation she may make for us. As to any support now, in the above sense, it is confessed the colonies in general do not require it. With respect to the administration of the colonies, and regulating laws proper for them, these should certainly be varied, and adopted to our maturer state. The want of this is the true source of our present calamities; and the attainment of it, by a reconciliation and constitutional union with Great-Britain, is what every honest American should earnestly wish for. But the remedy proposed by our author, would resemble the conduct of a rash, froward stripling, who should call his mother a d-mn-d b--ch, swear he had no relation to her, and attempt to knock her down.[89]

Inglis reasoned that the image of the family affirmed the rightful authority of a parent over a child, a form of dominance that would not cease with maturity, though its modes of expression should be modified as the child grew up. In so reasoning, he affirmed the patriarchal conception of family, derived from such writers as Robert Filmer in *Patriarchia, or the Natural Power of Kings*. This idea of family differed fundamentally from the consensual conception that informed Paine's position in *Common Sense* and derived from such writers as John Locke in his work *On Education* as well as *Two Treatises of Government: in the Former, the False Principles, and Foundation of Sir Robert Filmer, and his followers, Are Detected and Overthrown. The Latter is an Essay Concerning the True Original, Extent, and End of Civil Government.*[90]

In addition, Paine appropriated the image of the family representing the empire to condemn the British government for attempting infanticide. If the parent was so morally corrupt that she had sought to kill her own child, she had forfeited her claims to the child's affection and economic support:

But Britain is the parent country says some. Then the more shame upon her conduct. Even brutes do not devour their young, nor savages make war upon their families; wherefore the assertion[,] if true, turns to her reproach; but it happens not to be true, or only partly so, and the phrase, *parent* or *mother country*, hath been jesuitically adopted by the King and his parasites, with a low papistical design of gaining an unfair bias on

the credulous weakness of our minds. Europe and not England is the parent country of America. This new World hath been the asylum for the persecuted lovers of civil and religious liberty from *every part* of Europe. Hither have they fled, not from the tender embraces of the mother, but from the cruelty of the monster; and it is so far true of England, that the same tyranny[,] which drove the first emigrants from home, pursues their descendants still.[91]

Having initially employed the image of the family to condemn the parent country for immorality, Paine then repudiated the image as a false device used only to sustain British domination over the colonies. To Paine, the image of the family was ideological in that narrow sense that specifies habitual ideas mobilized to perpetuate asymmetrical relationships of power.

In response, Inglis noted that the image of the family had been employed throughout the centuries, not only in England but also in America, to describe the relationship between Britain and America. Therefore the use of such imagery could not have been a matter of the king's or his ministry's conscious political manipulation: "I conceive the present King, or his parasites, as he calls them, were not the first or only persons who adopted this phrase; and therefore, it could not answer such a design. The phrase hath already been used, both here, and in Britain, since the first settlement of the colonies." Inglis then accused Paine of using the unsound argument to insinuate that the king was disloyal to the religious values of the nation, an insinuation that Inglis quickly denounced.[92]

By alluding to the diverse heritage of the citizens in Pennsylvania, Paine's *Common Sense* renounced the family conception of the empire altogether in his remark, "Not one third of the inhabitants, even of this province, are of English descent. Wherefore, I reprobate the phrase of parent or mother country applied to England only, as being false, selfish, narrow and ungenerous."[93] This denunciation elicited a sustained refutation from Inglis, heightening the conscious articulation of the rationale underlying the image of the family, because Inglis's argument enumerated several bases for the belief that Britain was the parent of the colonies.

Whatever circumstances can denominate any country to be the parent state or country of colonies, may be truly predicated of England, with respect to these American colonies. They were discovered at the Expence

of the English crown—first settled by English emigrants, and the governments erected here were formed on the model of the English government, as nearly as the state of things would admit. The colonists were deemed English subjects, and [were] entitled to all the privileges of Englishmen. They were supported and protected at the expence of English blood and treasure. Emigrants, it is true, resorted here from other countries in great numbers; but these were not entitled to all the privileges of English subjects, till naturalized by an act of the English legislature, or some Assembly here; and the prodigious confluence of strangers into the colonies, is a proof of the mild and liberal spirit by which they were cherished and administered. If these particulars do not entitle England to the appellation of mother-country to these colonies, I know not what can; and these particulars cannot be predicated of any other country in Europe besides England.[94]

After enumerating these specific reasons for his belief in the image of the family representing the British empire, Inglis acknowledged the diverse heritage of the population in certain colonies, but he used that diversity as proof of the parent's kind character. To Inglis, the colonies remained the child of the mother country, and they were obligated to obey and to respect Britain. The image of the empire as a family persisted as a locus of the Loyalists' enduring commitment to Britain.

In contrast, the Patriot writers in increasing numbers came to revise and to repudiate the image of the family. Thomas Paine went on to deny that the king was the father of his people. Alluding to the military conflict at Lexington, Paine remarked, "No man was a warmer wisher for reconciliation than myself, before the fatal 19th of April 1775, but the moment the event of that day was made known, I rejected the hardened, sullen tempered Pharoah of England for ever; and disdain the wretch, that with the pretended title of FATHER OF HIS PEOPLE can unfeelingly hear of their slaughter, and composedly sleep with their blood upon his soul."[95] This charge completed Paine's attempt to dispel the image of the family representing the British empire, but Inglis chose not to respond to Paine's denunciation of the king. Instead, after endeavoring to reestablish the image of the mother country, Inglis amplified the ramifications of that image for colonial relations to Britain. The image of the family sustained fundamental

political and moral commitments of so potent a nature that Paine found it necessary to discredit the image.[96]

While the two American versions of "THE DEPLORABLE STATE of AMERICA" had explained the mother's course of conduct by criticizing her advisers, and while the version of "[*The able Doctor*]" from FREEBETTER'S NEW-ENGLAND ALMANACK in 1776 had explained her conduct by detailing her moral depravity, another, more final, explanation developed in a visual work produced during the final war years: Britannia was simply not the mother of the British colonies in America. She never had been. *Libertas Americana*, a medal commissioned by Benjamin Franklin in 1782, insinuated as much by representing the colonies as the infant Hercules strangling two serpents (fig. 36). This classical allusion denied that Britain was the mother of the colonies, because in the classical narrative Juno bore no blood relationship to Hercules. She was his cruel stepmother, who had sent two deadly serpents into his room one evening to murder him while he slept. Hercules killed the serpents by strangling one in each hand, surviving by virtue of his own strength.[97]

The aged Franklin used *Libertas Americana* to affirm that, although the colonies were the youthful victim of an evil plot, they would survive by virtue of their own strength. The imagery on the medal modified the classical allusion, however, by adding a figure of Minerva, who carried a shield decorated with a fleur-de-lis and who defended the infant Hercules from a vicious leopard designating Britain. This embellishment was a public recognition of France's military assistance during the war of independence, especially at the battles of Saratoga and Yorktown, which Franklin planned to commemorate with the medal.

Franklin's *Libertas Americana* became especially well known in the centers of political power in France and the United States, because Franklin presented originals of the medal to the most powerful figures in France: one made of gold for the king, another gold one for the queen, and still others fashioned from silver for prominent ministers in the French court. In addition, he sent several original medals to the United States Secretary of Foreign Affairs, Robert R. Livingston, with requests that he distribute them to every member of the United States Congress—one made from silver for the president of Congress and others from copper sufficient for

the secretary himself and for each of the representatives in Congress. Franklin used *Libertas Americana* not only to commemorate the victories at Yorktown and Saratoga, although that appears to have been his plan in 1782, when he commissioned Augustin Dupré to execute the medal; in 1783, about the same time that he distributed originals of the medal in France and the United States, he also used it as a gift when he initiated diplomatic relations between the United States and Malta. He enclosed one of the medals with his written request that the government establish a policy that would protect American citizens and their property at the ports.[98]

Franklin sought to make the design of *Libertas Americana* known to the citizens of France. He employed Parisian printer Philip Denis Pierres to prepare three hundred copies of a four-page explanation of *Libertas Americana* with parallel French and English texts. These were delivered to Franklin on May 5, 1783. In addition, the design for the medal was reproduced at the top of a broadside titled "EXPLICATION DE LA MÉDAILLE FRAPPÉE PAR LES AMÉRICAINS EN 1782," engraved and distributed as early as April 15, 1784, by J. B. Bradel, who operated his business at the rue de Richelieu-Sorbonne in Paris. Whether Franklin himself employed Bradel to prepare this broadside is not known, though an early type of the Franklin coat of arms was inserted at the bottom of the broadside. In addition, the design for *Libertas Americana* was integrated in a textile pattern by J. B. Huet for mass reproduction on fabric produced at the factory in Jouy. In France there was some popular awareness of the design for *Libertas Americana*, since reproductions of it were distributed among the French public through pamphlets, broadsides, and textiles.[99]

In Germany in 1784, yet another engraved representation of *Libertas Americana* was reproduced in Matthias Christian Sprengel's *Allgemeines historisches Taschenbuch; oder Abriss der merkwürdigsten neuen Welt-begebenheiten enthaltend für 1784 bie Geschichte der Revolution von Nord-America*, to illustrate a German history of the American Revolution (fig. 37). Eventually the design was alluded to in an undated poem by Joseph Bartoli. As a consequence of the distribution of the medal itself as well as the descriptions and reproductions of it in various media, *Libertas Americana* became internationally recognized in France, Malta, Germany, and the United States, not only among some of the most powerful and privileged figures of the period but also among the citizens in some of these nations. To those

familiar with the classical allusion, it was an evident implication of Franklin's *Libertas Americana* that Britain was no longer to be regarded as the mother country of the United States.[100]

In summary, the Loyalists seem not to have recognized the value of pictorial works for reaching the semiliterate and illiterate segments of their audiences. Perhaps Loyalists who were Anglican ministers—Samuel Seabury, Thomas Bradbury Chandler, and Jonathan Boucher, for example—planned to reach those groups through the sermons that they delivered regularly in their parishes. Perhaps these ministers eschewed the palpable image because of the centuries-old anxieties within Christianity about the role of images. Yet that would not explain why other Loyalists also neglected the visual arts as a vehicle to transmit their convictions to the public. Whatever the underlying cause, the Loyalists failed to employ the power of pictorial messages to place a tangible image of America before the eyes of the people.

In their sermons and pamphlets, however, Loyalists used images of the British empire as a family profusely, perhaps habitually, to focus upon the bonds that unified the colonies with Britain, in fact using the image in ways that resembled the use of it by the majority in Parliament. Loyalists endorsed the reciprocal responsibilities of parent and child and criticized the child for failing to fulfill its obligations to the parent. To the Loyalists, the parent was venerable, established, and good. The parent had been a nursing mother, who was generous, affectionate, and humane. Her failing, if she had one, was excessive leniency, which had spoiled the child and allowed it to become disrespectful, abusive, and selfish. Prone to exaggeration, resentment, petulance, and ingratitude, perhaps the child even harbored a secret desire to kill its loving parent—a desire that could prove self-destructive, since the mother's absence could allow civil war to break out among the colonies, or foreign nations to invade and conquer them. Such despicable characteristics of the American child led Loyalists to fear that the mother had ample reason to hate or abandon it. In either case, Loyalists described the child's fate in apocalyptic images of destruction and desolation.

In contrast, colonial protesters employed the image of the child to designate America in a few colonial prints and one medal, commissioned and designed by an American. These images suggested how the protesters

sought to explain the conduct of the mother, who was usually represented in the form of Britannia. Initially, during the Stamp Act controversy in 1765, the images criticized her advisers, thus allowing for hope that the mother was not beyond reform. By 1776, however, criticism had become rife that the mother's own character had changed—perhaps irrevocably. She had become tainted by envy and greed to an extent that she would torment the child for her own satisfaction. Finally, the mother's relationship to the child was denied altogether by an allusion to the colonies as the infant Hercules killing two snakes. In classical mythology, Hercules had no blood relation to Juno, his stepmother, so this allusion served to eliminate any family connection between the colonies and Britain. The colonial protesters often denied the analogy of parent and child—either by contending that the colonies were now an adult or by insisting that Britain had never been the colonies' mother.

CONCLUSION

From its inception, the image designating the British colonies in America as child—an image that lay beneath the very word "colony"—engaged America and Britain in a delicate web of reciprocal expectations and obligations. The anonymous author of *Colonising, Or A Plain Investigation Of That Subject; With A Legislative, Political, And Commercial View Of Our Colonies* expressed a commonplace conviction in 1774, when he wrote, "COLONISING is the act of a powerful and parental people. It is to a state what propagating is to a family."[101] During the decades before the American Revolution, the image of the child had been used repeatedly—in both Britain and America—to portray the colonies as vulnerable and dependent upon Britain. In exchange for the protection and guidance that Britain had provided the child throughout its "infant" state and "nonage," the parent state expected gratitude, obedience, affection, and economic support from the colonies. The image of America as a child sanctioned this sense of colonial indebtedness to Britain. What specific actions were necessary to fulfill the reciprocal obligations became the subject of intense debate in

Britain and America, especially during controversies surrounding the Revenue Act, the Stamp Act, the Townshend Duties, the Intolerable Acts, and the outbreak of military violence in 1775. Conflicting moral convictions, derived from divine and natural law, brought escalating pressure to bear upon the disputes and ultimately tore the fabric of imperial unity.

Throughout the Revolutionary era, the single most important role of the image of the child designating America—its most powerful operation on the imagination—was to shape thoughts about the problems besetting the British empire; by so doing, the image influenced diverse efforts to formulate adequate solutions to the imperial controversy. As Richard Price expressed it to his fellow Englishmen in 1776, " 'But we are the PARENT STATE.' —These are the magic words which have fascinated and misled us."[102] Indeed, the image of the family did mislead spokesmen and image makers, not only in Britain but also in America, by shaping their understandings of what attitudes and actions should be expected of the parent and the child and how these family members were to be reformed or disciplined. The image of the family misled those who accepted it by transfiguring economic, commercial, and constitutional issues into ambiguous family obligations. As a consequence, pragmatic and ideological concerns of a political nature became highly polemical moments of moral indignation, moments that recurred with increasing frequency and intensity until the conflict became so highly polarized that it could be resolved only through subjugation or national independence.

The author of *Licentiousness Unmask'd* evoked a powerful and centuries-old commonplace by asserting, "[S]ubjects have no more right to disobey the legal acts of the supreme authority, than a child has the commands of his father." In light of this belief, derived from the Fifth Commandment and repeated habitually for centuries in Britain and America, the child's disobedience merited punishment, though the proper kind of disciplinary action was debatable. Recall, for instance, that John Shebbeare inquired on behalf of the British ministry, "[W]hen children are refractory; renounce their duty; and even oppose their parent with force, are they not to be chastised and brought back to obedience?" Yet the nature of a suitable punishment was circumscribed by the child's age and the specific offense.[103]

"Nations, as well as Individuals, had their different Ages, which challeng'd a different Treatment," reminisced David Hume about his con-

versation with Lord Bathurst during the early 1770s. "For Instance, My Lord, said I to the old Peer, you have sometimes, no doubt, given your Son a Whipping; and I doubt not, but it was well merited and did him much good: Yet you will not think proper at present to employ the Birch: The Colonies are no longer in their Infancy." "Philo-Britannia" drew upon the biblical parable about the prodigal son when he reasoned in the *Public Advertiser* of September 15, 1768, that Britain should "do as an unhappy Parent would with a disobedient Child, who had wel nigh ruined him; turn him out to the wide World and disinherit him, until he shewed Signs of Reformation." Yet the image of the family placed limitations upon the child's punishment in light of divine and natural law, as indicated as early as 1765 by the anonymous author of *The Necessity Of Repealing The American Stamp-Act Demonstrated*, who made a bitter and ironic allusion to "those who sought to exasperate the government against the colonists with the pleasing prospect of seeing our hands imbrued in the blood of our children." By conceiving of the colonies as a prodigal son or a corrupt child, British writers and image makers proposed solutions to the imperial controversy by endorsing various types of punishment, circumscribed by a customary regard for the well-being of a family member.[104]

Alternatively, in Britain the problem was sometimes regarded as a need to reform the parent. In 1777, after articulating a pathetic image of the parent's moral decline, the anonymous author of *The Case Stated On Philosophical Ground, Between Great Britain And Her Colonies* inquired in the concluding paragraph:

> What is the remedy? As self-evident as the disease. Let the parents (over-weeningly tenacious of domestic authority) recal those ingenious and high-blooded youths into his family once more, and conquer them to his will by the most irresistible of all methods, good usage. To drop the metaphor, let Great Britain, forgetting past causes of provocation and discontent, address the Colonies with kindness and affection, and leave the consequences of refusal to themselves.

The writer affirmed that it was natural for a colony to mature and separate from its mother country, just as it was natural for a child to mature and separate from its parent: "Colonies, when they find themselves able, that

is, *politically come of age*, may, in consequence of an unanimity, nay, a majority of voices, throw off subjection to the parent state: a power derived from God, and authorized by the necessity of things." The child's maturity became a means to redefine the imagery such that it became the parents' moral obligation to allow the child its independence. [105]

Within the British colonies in America, a similar debate raged about whether the parent or the child needed to be reformed and how to undertake that reform. Some American writers used the image of the family to diagnose the child's misbehavior and to urge reform of the child. Loyalists, such as Isaac Wilkins in his *Short Advice to the Counties of New-York*, argued that the child should reform itself, because of the power to be derived from continued imperial unity: "In union with her [Great Britain], we may rise superior to the rest of the world, and set all the kingdoms of the earth at defiance." He added, "But if by our ungrateful treatment of her, she should be induced to withdraw her protection, and give us over to our own imaginations, nothing but anarchy and confusion must ensue, the flames of civil discord would instantly blaze forth, and desolate the land." In 1773 Thomas Hutchinson of Massachusetts urged the assembly to "consider the obvious and inevitable Distress and Misery of Independence upon our Mother Country." [106]

Other American writers advocated reforming the parent and focused on the problems of parental tyranny and corruption. On June 6, 1766, George Mason wrote a complaint to the Committee of London Merchants, revealing his frustration with the way the image of the family had shaped the political conduct of those in the center of power: "The epithets of parent and child have been so long applied to Great Britain and her colonies, that individuals have adopted them, and we rarely see anything from your side of the water free from the authoritative style of a master to a schoolboy." A decade later, in 1776, Jacob Green held the parent country accountable for the imperial unrest, because "she has acted directly contrary to all her obligations to protect and defend us, most unjustly pronounced us rebels, and treated us as such." The Reverend William Smith put the concern with parental reform simply in a sermon at Philadelphia: "[W]e seek not to distress, but to give the parent state an opportunity of saving themselves and saving us before it be too late." As the author of "Justice and Humanity" reasoned in the *Pennsylvania Journal* of November 10, 1768, the "Mother

country" should show "some marks of her paternal affection, if she wishes to receive a willing obedience from her American children."[107]

Expectations about the family were brought to bear on the commercial, economic, and constitutional issues disrupting the empire, and these problems became perceived in terms of the proper conduct of family members, so influencing diverse efforts to articulate adequate solutions. Because the actions of the child and the parent were judged as signs of their moral character, their actions were susceptible to suspicion and moments of moral indignation. In 1783 the anonymous author of *A Retrospective View Of The Causes Of The Difference Between Great Britain and her Colonies in America* summarized the complications that arose when the British conceived of the child as having "warped" principles and when the colonists became convinced that the parent was corrupt:

> [F]or when the principles of the Americans were once warped, and they ceased to think that this country was an indulgent parent, anxious for their happiness, and careful for their safety, they immediately conceived that their fellow subjects in Great Britain were envious of their prosperity, and jealous of their growing power; every thing appeared to them through a jaundiced eye; and, without making any allowance even for the infirmities from which humanity is never exempt, they ascribed to the worst of purposes every act of the government of this country with which their opinion did not happen to coincide. From the same prejudice they esteemed their own actions to be not only justifiable but meritorious.[108]

The moral character of family members became a basis for assessing the actions of each, interpreted through a "jaundiced eye." Each side of the dispute had ample evidence of the other's moral shortcomings; each, its grounds for righteous indignation; each, its underlying sources of guilt.

The mother country's moral character was suspect because she sought to prolong the dependence of her child, while the child's moral character was suspect because of continuing evidence of ingratitude and disobedience. An anonymous member of the Virginia Convention condemned the parent state on February 20, 1776, for attempting to prolong the dependence of her children:

If in a private family, the children, instead of being so educated as to take upon them the function of good citizens, should be brought to years of maturity, under the apparel, food, and discipline of infancy, what laws, natural or civil, would acquit the parent or the child of infamy and criminality? A set of great lounging infants, tied to mamma's apron, with long bibs and pap-spoons, at two-and-twenty, would put the *Sabarite* to the blush. Now, as every moral virtue or vice, almost, is vastly enhanced, when considered in its relation to the community as well as individuals, I insist upon it, that he who would keep a community in a state of infantile dependance, when it became a fit member of the great Republick of the world, would be vastly more criminal and infamous, than the imaginary family I mentioned before.[109]

On the other side of the water, the anonymous author of *A Retrospective View Of The Causes Of The Difference Between Great Britain and her Colonies in America* assured his readers that Americans had behaved in a criminal way and that they would regret it:

In their sober senses, they will reflect upon the advantages they derived from being members of the British empire; and when they are deprived of that assistance which enabled them to advance so rapidly to affluence, they will acknowledge their criminal error in denying that they had incurred any debt of gratitude to their parent country, because, in pro-moting the interests of America, she had a degree of regard to her own.[110]

In each instance, the author averred that the other member of the family had demonstrated the moral shortcomings, which had caused the divisive-ness within the British empire. Yet the comment of each writer revealed a hidden source of guilt.

America's state of maturity became the key idea within the image of the family, because it became a means for determining whether America should be dependent or independent. In 1775, Henry Barry acknowledged in *The ADVANTAGES Which AMERICA Derives from her COMMERCE, CONNEXION, and DEPENDANCE on BRITAIN* that a child could mature in time and become independent, but he stressed that "[i]n the political as well as natural body, the progressions to independance are gradual and imperceptible, and all uncommon attempts to force either, are usually

destructive of their end." Barry cautioned, "[T]ime should therefore accomplish that which human endeavours cannot precipitate, though they too often destroy." Charles Inglis held in 1776 that the colonies required a "few years of peace," during which time America "will rapidly advance to a state of maturity, whereby she may not only repay the parent state amply for all past benefits; but also lay under the greatest obligations." Maturity of the child could eventually mean independence, but even then to the Loyalists it entailed continued obligations to the parent state.[111]

British writers contended that America was not yet strong enough to be independent. To Thomas Blacklock, the Americans' need for economic and military assistance from France was a sign of their dependent state: "If the Americans are internally sufficient for their own necessities, Why do they imbibe with so much avidity, and propagate with so much exultation, every flying report of promised assistance, from the rivals and enemies of Britain? Why are the banners of France and Spain often ostentatiously displayed in terrific prospect?" In contrast, some Americans argued, as did Enoch Huntington, that even if the colonies were dependent, the mother's conduct had "forfeited" their "amity" and "confidence." Still other Americans denied that America was dependent on Britain. Indeed, Benjamin Franklin inquired as early as January 19, 1769, *"Whether the Mother Country"* was *"not rather dependant upon the Colonists, than the Colonists on the Mother Country?"*[112]

Once the image of the colonies as a child or body politic was accepted as a reality, the colonies' progress toward independence seemed ineluctable. To Joseph Cawthorne, "nations, like private persons will naturally and necessarily shake of[f] their *dependence*." As the war was nearing its weary end, another more prominent British writer, Lord Charles Fox, commented in *The Speech Of The Right Honourable Charles James Fox, On American Independence: Spoken in the House of Commons, On Tuesday, July 2, 1782*: "When colonies have power to be free, independence is their natural, as well as political, charter. I cannot state this maxim of policy clearer than by the example of a parent and his children, which is the general metaphor for political dependence." As Thomas Paine put it in *Common Sense*, "I have always considered the independancy of this Continent, as an event which sooner or later must arrive, so from the late rapid progress of the Continent to maturity, the event could not be far of[f]." Thomas Paine

reiterated this conviction in 1777 in *The Crisis. Number III. By the Author of Common Sense*, in the form of a rhetorical question: "To know whether it be the interest of the Continent to be independent, we need only ask this easy, simple question: Is it the interest of a man to be a boy all his life?"[113]

As early as 1774, Richard Wells had portrayed America on the threshold of becoming an adult:

> We look to manhood—our muscles swell out with youthful vigour, our sinews spring with elastic force; and we feel the *marrow of Englishmen in our bones*. The day of independant manhood is at hand—we *feel* our strength, and, with a filial grateful sense of *proper* obedience, would wish to be esteemed the *friend* as well as *child* of Britain. In *domestic* life, we all allow there is a time when youth shall no longer be subject to the controul of age; when reason forbids, and when nature denies. —May Britain think seriously on this important subject; let her weigh the connexion in the strict balance of justice; nay, let her try it on the graduated scale of causes and events, and her judgment will join hand in hand with her equity, and declare we are *men*.

Although Wells's optimism proved to be ill-founded, his conviction that the United States had attained adulthood was becoming commonplace in America. As one writer in *The Pennsylvania Magazine* for January 1775 put it: "America has now outgrown the state of infancy: Her strength and commerce make large advances to manhood."[114]

UNCOMMON IMAGES
OF THE COLONIES

For 'tis not every compact, that puts an end to the
State of Nature between men, but only this one of
agreeing together mutually to enter into one
Community, and make one body Politic.

—JOHN LOCKE, *TWO TREATISES*

The Revolutionary era was a period of experimentation with the images that represented the British colonies in America. Illustrators used many different images, and yet most of the experimental images of this time supported the same commonplace ideas emphasized by the most frequently employed images—the snake, the Indian, and the child. But the more experimental images also brought to light noteworthy themes that were not stressed by the dominant images and that proved valuable for an understanding of the way the British colonies in America were viewed in both America and Britain.

The most significant of the themes introduced by the experimental images was signaled by frequent allusions to the Roman Republic and Empire, sometimes hinted at by the neoclassical garb of the Indian that designated America but portrayed emphatically as various neoclassical personages precipitating the decline of the British empire in ways analogous to the decline of the Roman Empire. At other times the image was that of building a new empire based upon republican principles—that is, building a new Rome in America.

Another experimental image that emerged represented the colonies as the arms and legs of Britannia's dismembered body. This image suggested

more definitely than any other that British and American interests were interrelated to the extent that the empire could survive only through perpetual unity among the British dominions.

Other prints depicted the colonies as various animals, such as a cow, a horse, an ass, a zebra, a buffalo, a yelping dog, a kettle of fish, and the goose that laid golden eggs. The choice of barnyard, aquatic, and exotic animals almost always cast the colonies in a utilitarian light by suggesting that they were a beast of burden or a source of nourishment. Therefore, the British government could exhaust or devour them.

Each type of image designating the British colonies in America as a body politic was an evocative metaphor in that each motif elicited thoughts about different things that interacted to produce a congeries of commonplace ideas, some more salient than others. Each motif was rich in implication, supporting a congeries of commonplace ideas that were condensed and consolidated into the single image. Each emphasized specific attributes of the colonies and at the same time obfuscated other attributes of the emerging nation. Accordingly, each of these motifs entailed specific ways of envisioning the colonies as they were or as they might become, while tacitly precluding other visions of the emerging nation.

The commonplace ideas associated with the images of the snake, the Indian, and the child differed from each other such that each of these motifs was especially suitable to express a particular range of political commitments because it simultaneously revealed and concealed specific attributes of the American community. These dominant motifs also differed fundamentally from two other motifs, which designated the colonies as the limbs of Britannia and as a group of distinct individuals. The image of America as the limbs of Britannia suggested interdependence within the British empire to the extent that it would be impossible for America to constitute a distinct body politic, while the image of America as a group of distinct individuals suggested that only their common purposes unified the group of distinct colonies. It is possible to discern through comparison and contrast how each of these motifs corresponded to a limited range of political commitments.

The principal aim in this final chapter is to reveal the underlying rhetorical structure of the images used for the British colonies in America. In the process of articulating the commonplace ideas associated with these

motifs, many of the experimental images of America will be integrated in the underlying rhetorical structure to illustrate how they too, although used only rarely, manifested recurring ideas about America. The experimental images usually repeated in different forms the ways of thinking about America, and so they can be regarded as elements in the rhetorical structure, which underwent transformation through the emergence of utilitarian attitudes in Britain and republicanism in America. Although the experimental images were in some sense original, they were also reconfigurations of the commonplace.

THE COLONIES ARE A PART OF THE BRITISH EMPIRE

Benjamin Franklin's engraving "MAGNA *Britannia: her Colonies* REDUC'D" had an enduring significance throughout the American Revolution and proved immensely popular among those critical of the British government's American policies (fig. 38). Originally printed at the end of 1765 or the beginning of 1766, Franklin's illustration was distributed in England and America on note cards. During the subsequent decade of dissent, various illustrators reproduced the engraving in modified form in America, France, England, and Holland. Sometime between 1766 and 1769, an enlarged broadside version with an accompanying explanation and moral was produced anonymously in Philadelphia and distributed in America. In December 1768 the frontispiece of a liberal English magazine, *The Political Register*, incorporated the illustration above another pictorial work, *"Its Companion"* (frontispiece). Sometime before 1775 in France, an additional version of Franklin's illustration was printed, modified by the absence of brooms on the ships in the background and by the repositioning of Britannia's spear. Then, on November 29, 1774, M. Darly published yet another British version of the engraving, retitled "BRITTANNIA MUTILATED. *or the Horrid (but true) Picture of Great Brittain. when Depriv'd of her Limbs.* BY HER ENEMIES" (fig. 39). Finally, probably in 1780, a Dutch illustrator adapted yet another version of the print, this one derived from Darly's version but with French and German legends beneath. The idea of the

American colonies as the limbs of a self-destructive empire had recurring relevance throughout the imperial dispute.[1]

The illustrations succinctly dramatized a way of viewing the colonies and their relationship to Britain. The colonies were parts, or limbs, of Britannia. The separateness of the colonies, not only from England but also from each other, was emphasized by labeling Britannia's four severed limbs "Virg-," "Pennsyl-," "New York," and "New-Eng-." These colonial parts were subordinate to Britain, since the colonies constituted the extremities while Britain was the head and torso. Yet, because together the parts formed one body, the print underscored the interdependence of the colonies and England and so identified the cause of one with the cause of the other. Finally, internal divisiveness within the empire, especially the use of force to subjugate the colonies, became the equivalent of suicide for the empire. Although this last association was most emphasized in the accompanying text from the 1767–69 version published in Philadelphia, each of these ideas depended upon the others. The single image resonated with a congeries of commonplace ideas and attitudes.

The visual transfiguration of a violent dispute with the British empire into a form of self-injury or self-destruction was most emphasized by Franklin in his correspondence. He enclosed a copy of the original note card in a letter to this sister, Jane Mecom, with the comment "The Moral is, that the Colonies might be ruined, but that Britain would thereby be maimed." Similarly, the enlarged broadside version published in Philadelphia placed greatest emphasis on the potential harm of internal conflict for both America and Britain. The text on the broadside emphasized that the emblem alluded to a future state if Britain continued to abuse the American colonies: "The above Prophetical Emblem of what wou'd be the Miserable State of Great Britain and her Colonies, Shou'd She persist in restraining their Trade, destroying their Currency, and Taxing their people by Laws made by a Legislature, where they are not represented." "MAGNA *Britannia*" amplified the vital interdependence of the colonies and the rest of the British empire by emphasizing the harmful consequences of employing military force to enforce the Stamp Act in America. By adopting such a policy, Britain would destroy her own means of obtaining nourishment, her resources for military defense, her international stature, perhaps even her life.[2]

"MAGNA *Britannia*" amplified each of these consequences with background and foreground imagery. It visualized the potential economic consequences of enforcing the Stamp Act by placing in the background ships with brooms attached to their masts. A text on the 1766–69 broadside version of the print explained, "The British Ships, the Instruments of her trade, with Brooms on their Topmasts, denoting that they are advertised for Sale, being no longer either necessary or Useful for her people." The placement of Britannia's shield and spear on the ground behind her suggested another harmful consequence: A policy of force to impose the Stamp Act would render the whole empire less able to defend herself should a French or Spanish adversary seize the opportunity to attack her. And yet a third harmful consequence of enforcing the Stamp Act with military force was depicted in the print: "MAGNA *Britannia*" visualized the lost international stature of the whole British empire, as suggested by Britannia's placement in the composition as well as by a comparison of her with Belisarius. Britannia's torso was propped up beside a globe, a placement that showed her inability to dominate world politics should she decide to dismember herself. Draped across the globe and Britannia's lap was a banner reading "DATE OBOLUM BELLISARIO" (Give Belisarius a Penny). This comparison to Belisarius synthesized several appeals: It underscored the colonies' assistance in past international conflicts; it suggested the military harm Britain would do to herself by weakening the colonies; it visualized the loss of international stature resulting from conflict within the British empire. The final appeal from consequence stressed that the dispute within the British empire could destroy the life of the body politic. That was the most emphatic appeal, and it was emphasized in the foreground by the addition of a mutilated English oak, the healthy English oak being a conventional symbol of England. This image, like that of Britannia's mangled body, portended death and decay.

That Britain was entirely to blame for this prospect was implicit in the image, since the head governed the body and was therefore responsible for its conduct. Britain's ethical responsibility was made explicit in the moral following the explanation on the Philadelphia broadside:

The ordaining of Laws in favour of one Part of the Nation to the Prejudice and Oppression of Another is certainly the most erroneous &

Mistaken Policy. An Equal Dispensation of Protection[,] Rights[,] Privelidges[,] and Advantages, is what every Part is entitled to, And ought to enjoy; It being a Matter of no Moment to the State whether a Subject grow Rich and flourishing on the Thames or ye Ohio, in Edinburgh or Dublin. Those Measures Never fail to Create great and Violent Jealousies and Animosities between the People favourd and the People Oppressed. From whence a total Separation of Affections, Interests, Political Obligations and all manner of Connections necessarily Ensues, by which the whole State is Weakened and perhaps ruined forever.

Although the image of the colonies as a limb was useful to stress British culpability in the versions of "MAGNA *Britannia: her Colonies* REDUC'D," it also emphasized that unity of the empire was vital to the colonies' own survival, since their political life depended upon maintaining their connections with Britain.

A politically cautious and moderate Pennsylvanian, John Dickinson, used similar imagery of a body politic for political purposes in his widely distributed *Letters from a Farmer in Pennsylvania*, published in America in 1768. In the pamphlet, a legalistic response to the Townshend Duties, the lawyer from Pennsylvania argued that the duties did not primarily regulate trade but rather were designed to raise revenue to defray defense expenditures. As such, the duties were a tax in disguise, unacceptable to the colonists, because they constituted taxation without representation. Even though Dickinson adamantly denied the authority of Parliament to tax the colonies, he was equally emphatic that the colonies ought to remain a loyal part of the empire: "Torn from the body, to which we are united by religion, liberty, laws, affections, relation, language, and commerce, we must bleed at every vein." Subsequently, that vivid line was cited more than half a decade later by Loyalists such as Daniel Leonard in his letters written over the pseudonym Massachusettensis, as well as by Henry Barry in his pamphlet titled *The ADVANTAGES Which AMERICA Derives from her COMMERCE, CONNEXION, and DEPENDANCE on BRITAIN.* These Loyalists appropriated the imagery as support for their own views that the colonies' political life was very vulnerable. The authors contended that the survival of the colonies depended upon their remaining an obedient and subordinate part of the empire.[3]

In Britain, pamphlets and illustrations employed imagery of the colonies as the limbs of the British empire for the similar political end of maintaining the unity of the empire. In 1775, for instance, one of the most widely-commented-upon British pamphlets, Samuel Johnson's *Taxation no Tyranny; An Answer To The Resolution And Address Of The American Congress*, used the image of the body politic paradoxically both to reassure the colonies that Parliament would respect their best interests and to threaten to destroy them if they did not obey the government:

> A Colony is to the Mother-country as a member to the body, deriving its action and its strength from the general principle of vitality; receiving from the body, and communicating to it, all the benefits and evils of health and disease; liable in dangerous maladies to sharp applications, of which the body however must partake the pain; and exposed, if incurably tainted, to amputation, by which the body likewise will be mutilated.
>
> The Mother-country always considers the Colonies thus connected, as parts of itself; the prosperity or unhappiness of either is the prosperity or unhappiness of both; not perhaps of both in the same degree, for the body may subsist, though less commodiously, without a limb, but the limb must perish if it be parted from the body.[4]

Johnson used the image to suggest that Parliament recognized the need for benign treatment of the colonies, since the health of one portion of the body politic would affect that of another. Yet Johnson coupled this affirmation of mutual interest with the threat that a limb—the American colonies—could be amputated if necessary to save the most vital parts of the body politic. By implication, those who sought to remedy conflict within the body politic were physicians of the state.

The image of the colonies as a limb was employed in some political prints published in England to criticize the physicians for neglecting their duties or complicating the injuries. "THE ENGLISH LION DISMEMBER'D," attributed to Thomas Colley and published by Edward Hedges in March 1780, portrayed the colonies as an amputated paw of the English lion. Lord North, oblivious to the lion's wound, muttered to himself as he trudged onward with a sack marked "BUDGET" over his shoulder. In "BRITANIA'S ASSASSINATION, or————the Republicans Amusement," attrib-

uted to James Gillray and published by Elizabeth D'Archery in May 1782, the American colonies were the severed arm and head of Britannia— probably parts from a statue of her. As the assailants ran away with these parts of her body, prominent politicians in the British government continued to harass and threaten Britannia. John Wilkes, with a copy of his infamous North Briton under his arm, endangered Britannia with a document labeled "libel." (More than a decade earlier, a British court had judged Wilkes's publication to be libel against the king's family.) The Duke of Richmond menaced Britannia by holding a musket over his head as he prepared to strike her. Charles Fox, depicted as a fox, bit Britannia's leg.[5]

Both of these British prints radically transformed the political use of imagery representing the colonies as the limbs of the body politic, since the prints showed the dismemberment of the empire as a consequence of an assault by an Indian representing America. In contrast, Franklin's "MAGNA *Britannia*" had depicted Britannia's dismemberment as the equivalent of self-maiming or suicide. While Franklin's political print had emphasized British culpability for the destruction of the empire, the two British prints stressed that the colonists were responsible for dismembering the empire and that the state physicians were complicating the empire's recovery. To underscore American culpability, the British prints needed to portray America as an autonomous entity with a mind of its own. Such an image implicitly granted, however, that the colonies could conceivably survive apart from the empire, even though the empire would be maimed in the process. What was emphasized and what was obscured in all three prints corresponded to certain political interests and concerns of different factions within the empire.

One of the British derivations of Franklin's "MAGNA *Britannia*" sought to mitigate the implications of suicide. On November 29, 1774, M. Darly's print, "BRITTANNIA MUTILATED. *or the Horrid (but true) Picture of Great Brittain. when Depriv'd of her Limbs*. BY HER ENEMIES," reproduced similar imagery of the dismembered body politic in "MAGNA *Britannia*," but did so to counter the implications of self-destruction in Franklin's design. The text on the print specified that Britannia had been deprived of her limbs "BY HER ENEMIES." Further, the artist depicted Britannia chained to the trunk of the English oak and omitted Britannia's

spear. These changes expanded upon Britannia's role as a victim of unidentified "ENEMIES."

Despite the diversity of emphasis within the visual metaphor of the American colonies as the limbs of the body politic, certain notions about the colonies were sustained throughout these prints. The parts, or limbs, were interdependent with the rest of the British empire. Unity of the empire was vital to the well-being, if not to the survival, of the entire empire. Force and divisiveness were consistently a dangerous if not a deadly wound, regardless of whether the injury was self-inflicted or the result of an assault by an Indian or unspecified enemies. Subordination of certain parts of the empire to other parts was tacit, with the colonies corresponding to the limbs and Britain to the vital parts. One exception was "BRITANIA'S ASSASSINATION," wherein the colonies were Britannia's head and arm. This exception was probably a hyperbole. Most important, each image corresponded to a kind of political viewpoint, "MAGNA *Britannia*" by laying blame upon the British government, two of the English prints by representing the American colonies as an Indian responsible for deep divisions in the body politic. Underlying these political postures, however, was a desire to sustain the unity of the entire British empire.

THE COLONIES ARE DISTINCT AND UNITED

While one cluster of commonplace ideas developed around the unity and separation of the entire British empire envisioned as one body politic, another developed around the unity and separation among the American colonies envisioned as a group of distinct individuals. Between these two general tendencies lay the images that represented intercolonial unity as a snake, an Indian, and a child, as well as numerous other personifications and animalifications of the emerging nation. The representations of the colonies as distinct individuals were developed in several forms, notably as a group of individuals engaged in a mutual struggle that unified them in their opposition to an enemy. Most frequently, however, the desire to depict the colonies as a group of distinct governments was expressed with images

that emphasized the sheer number of colonies—thirteen hearts, hands, candles, stars, pillars, stripes, bees, and the like. Such representations promoted an image of an America that recognized diversity among the colonial governments and did so without exalting one colony at the expense of the others.

In England and in America, the achievement of an enduring inter-colonial union was regarded as improbable, precisely because the colonies were a diverse group of distinct governments with distinct dispositions. Before the Stamp Act controversy of 1765, the colonies had never been able to unite effectively for any purpose, not even to develop a means of mutual defense against the French and the Indians. As late as March 1775, a writer in a British magazine, *The Universal Magazine of Knowledge and Pleasure*, observed that the northern colonies

> are composed of people of different nations, different manners, different religions, and different languages. They have a mutual jealousy of each other, fomented by considerations of interest, power, and ascendancy. Religious zeal too, like a smothered fire, is secretly burning in the hearts of the different sectaries that inhabit them, and, were it not restrained by laws and superior authority, would soon burst out into a flame of universal persecution.

The writer added, "[A]n union seems almost impossible." Similar descriptions of the deep divisions among the colonies had been commonplace throughout the debates over the British government's American policies. An emphasis upon the distinctions among the colonies surfaced also in rhetorical uses of imagery on both sides of the Atlantic, especially among the colonists.[6]

During the controversy in reaction to the Stamp Act, most attempts to unify the colonies were animated by the colonists' outrage at Parliament's policy of American taxation. Paul Revere aptly portrayed this political relationship among the American colonies in "A VIEW OF *the* YEAR *1765*," a print that Revere derived from a British engraving titled "View of the present Crisis." Revere depicted each colony as an individual man or woman so that each had a distinct character. These individuals were united only by their mutual opposition to a tyrannical dragon grasping the Magna Charta

in its claws. The text beneath the image observed, "[E]ach united Province faithful joins against this monster and his cursed Designs." Revere inscribed abbreviations for Rhode Island, New York, Virginia, and New Hampshire near the heads of some of the personifications. The other embodiments of the colonies were denoted with a "u" near each head. A note explained: "u United Provinces." Revere's print indicated that intercolonial unity was fundamentally a reaction against particular policies of the British government; it was not a desirable end in itself.[7]

In England, the colonies were portrayed as individual fish in "STATE COOKS, or THE DOWNFALL of the FISH KETTLE," published on December 10, 1781, by W. Wells in reaction to the defeat of the British military forces at Yorktown (fig. 40). Having spilled these fish on the floor, a mournful King George III fretted: "O Boreas, the Loss of these Fish will ruin us for ever." Lord North in his white apron reassured the king that he and "Minden" would "cook 'em yet." "Minden" was a belittling allusion to Lord George Germain, the Secretary of the State for the colonies, who had disgraced himself at the battle of Minden. Although the two men endeavored to cook thirteen almost identical fish, these fish did not correspond precisely to the thirteen rebellious colonies. Several colonies were combined on one fish labeled "New England," and others were added: "E. Florida," "W. Florida," "Quebec," and "Nova Scotia"—an indication that the illustrator did not know which specific colonies were engaged in the rebellion. All these fish shared a common condition as a lower order of animal. All faced the same fate: They were soon to be devoured.[8]

"A VIEW OF *the* YEAR *1765*" and "STATE COOKS" were two extreme instances of imagistic separation among the colonies. The impulse to depict the colonies as separate political units recurred even among the most pervasively used images advocating unity among them. "JOIN, or DIE" began as a segmented snake in 1754 expressly to emphasize a need for intercolonial unity. The image of the snake remained divided for more than twenty years before it became unified in the forms of the ouroboros and the rattlesnake. While the image of the colonies as a child was usually singular, sometimes they were portrayed as a plural, "children," to distinguish among the individual political units. For instance, versions of *"Poor old England endeavoring to reclaim his wicked American Children"* portrayed the colonies as a group of rascals who assaulted their parent. Even the image of the Indian,

which of the dominant images was the most constant in its depiction of the colonies as a single entity, was portrayed as a group of individuals in "SHELB--NS SACRIFICE" and in "The SAVAGES *let loose.*"

In Britain and in the colonies, illustrators sometimes used images that, at once, depicted both intercolonial unity and recognized distinctions among the colonies. But an inventional problem limited the success with which illustrators could employ imagery of a person or animal to suggest both unity and diversity among the British colonies in America: How was an illustrator working with such an image able to recognize each colonial government's separate and equal status? The variations of "JOIN, or DIE" that had proved so popular among certain northern newspapers were not reproduced in southern newspapers, presumably because there was little dignity in being the tail of any animal, regardless of how few specialized parts it had. Perhaps the most successful resolution of the inventional problem was the use of thirteen rattles representing the distinct colonies in the rattlesnake design. This approach made each colony separate and equal. At the same time, it could accommodate additional members in the inter-colonial union simply by an increase in the number of rattles. This way of portraying growth corresponded to a folk belief that the number of rattles on the snake's tail indicated its age.[9]

One British illustrator attempted to resolve the inventional problem by labeling each of a zebra's thirteen stripes with the name of a colony in "THE CURIOUS ZEBRA. *alive from America!*" printed for G. Johnson on September 3, 1778 (fig. 41). The animal's body unified the labeled stripes, all of which were inscribed toward the middle of the body, presumably to avoid exalting one colony as the head or degrading another as the tail. Most of the colonies' names were arranged from head to tail such that they corresponded geographically from south to north. Even so, Massachusetts, perhaps the most radical of the thirteen, was closest to the rump, even though it was not the most northern colony. Georgia, the last colony to join the rebellion, was ironically closest to the head of the beast. The image of the zebra was used only once to depict the American colonies because the illustrator had blundered in his choice of animal: The image maker con-fused American and African fauna.

Otherwise, when illustrators endeavored to use images of people or animals to represent unity among distinct British colonies in America, the

simplest solution was to employ twelve or thirteen separate individuals engaged in a mutual effort, sometimes represented synecdochically as arms and hands. Twelve almost identical hands held up the central pillar on the title page of the *JOURNAL of the PROCEEDINGS of the CONGRESS, Held at Philadelphia, September 5, 1774*. An almost identical image, modified by its placement within a double-looped ouroboros, recurred on the masthead of the *New-York Journal* from December 15, 1774, until August 29, 1776. After Georgia joined the rebellious colonies, the number thirteen came to represent the distinct but united political units. So the synecdoche was altered such that thirteen hands held up the pillar when the motif was reproduced subsequently on the dedication page of an American edition of *Swan's Collection of Designs in Architecture*, published at Philadelphia in 1775. Subsequently, the image of the thirteen hands upholding a pillar recurred on the North Carolina currency for "Ten Dollars," issued on August 21, 1775, as well as on one of the flags for the "Headman Color" known as the Gostelowe Standard Number One.[10]

Most illustrators used images of material items rather than animals to stress unity and to recognize diversity among the colonies, because thirteen identical stars, stripes, pillars, arrows, or candles were less likely to imply a differing status among the colonies than was a single organism with differentiated parts. Motifs that emphasized the number thirteen were distributed widely on colonial currency throughout America. New York's currency represented the colonies as thirteen candles united in a single candelabra on the note for "FIVE DOLLARS," printed on September 2, 1775, by John Holt (fig. 42) and again on March 5, 1776, by Samuel Loudon. On March 6, 1776, South Carolina currency for "*ONE HUNDRED POUNDS*" depicted thirteen hearts on the note. On July 2, 1780, Rhode Island's currency for "Eight Dollars" featured a harp with thirteen strings, an image that was derived from several issues of the Continental currency for "Eight Dollars" produced between 1775 and 1778.

Another motif that recurred with considerable regularity consisted of twelve or thirteen arrows bound together by a single cord or clenched in a single fist. In June 1775, for instance, South Carolina's currency represented intercolonial unity as twelve arrows bound together by a single cord on the "Five Pounds" note. Almost a year later, on April 2, 1776, North Carolina currency depicted thirteen arrows clenched together in a single

fist on the note for "Two Dollars & an Half." This image of arrows held together was used above the motto "United We Stand" on one of the colonial flags, Gostelowe Standard Number Thirteen. This and still other versions of the thirteen arrows were engraved on powder horns such as those owned by John DeWandeler and by Harmon Stebens, who served in Captain John Graham's Company of the First New York Regiment.[11]

On June 14, 1777, the Continental Congress resolved "That the flag of the thirteen United States be thirteen stripes, alternate red and white: that the union be thirteen stars, white in a blue field, representing a new constellation." Subsequently, on January 14, 1779, the Continental currency for "Forty Dollars" integrated a design consisting of thirteen stars in a circle with the all-seeing eye above them and the word "CONFEDERATION" below them. On February 8, 1779, the currency for South Carolina incorporated an oval design with thirteen stars and thirteen stripes surmounted by a liberty pole on the paper "Eighty Dollars." In "VENERATE THE PLOUGH," published in *The Columbian Magazine, or Monthly Miscellany* of October 1786, a circle of thirteen stars appeared above a woman, who carried an armful of grain behind a farmer tilling the soil. This circle of stars in the form of a halo combined a motif from the flag of the United States with suggestions of Christian virtue. As important, the image identified the thirteen stars with the predominantly agrarian occupations within the new nation. Subsequently, this image was reproduced on the masthead of the *Litchfield Weekly Monitor* from January 1788 to June 1789 and again from May 1790 to August 1794. Thirteen identical stars, stripes, pillars, hearts, arrows, or candles obscured any distinctiveness among the colonies, apart from specifying the number of political units, because each was interchangeable with the other. Lost was a distinctive character for each colony as in Revere's "VIEW OF *the* YEAR *1765*."[12]

Imagery on some of the Continental currency resolved the tensions between unity and distinctness among the colonies by incorporating elements of both; for instance, Continental currency that was issued on February 17, 1776, featured thirteen interlinked rings, a design attributed provisionally to Benjamin Franklin, because there was a preliminary sketch for it among his papers. This design of interlinked rings was circulated on various notes for fractions of a dollar, as for example on "One Sixth of a DOLLAR," "One Third of a DOLLAR," and "Two Thirds of a DOLLAR,"

printed by Hall and Sellers at Philadelphia on February 17, 1776 (fig. 43). The outer circle of the design consisted of thirteen interlinked rings, each of which was inscribed with a colony's name. The rings were arranged geographically from north to south clockwise, with New Hampshire at the top of the circle. At the center of the motif were the words "WE ARE ONE," an oxymoron affirming that a plural was a singular. Around that encircled motto were the words "AMERICAN CONGRESS," the basis for legislative unity among the colonies and the sanctioning authority for the money. Subsequently the image of interlinked rings was widely reproduced in other media, such as flags, coins, currency, peace medals, portraits, buttons, bowls, and plates.[13]

A similar design appeared on one side of the first medal money coined by the United States, the Continental Dollar for 1776. Instead of thirteen rings, there were two strands interwoven thirteen times. On each of the thirteen outer loops was inscribed the name of a colony, distinguished by its identification yet interwoven with the others to form a unified pattern. Subsequently this design recurred on the reverse of a peace medal produced to commemorate the peace treaty on September 4, 1783, *FELICITAS: BRITANNIA ET AMERICA* (Happiness: Britain and America). In 1787 the image of interwoven strands recurred on two types of "Fugio Cent," one with a five-point star within each ring, the other without the stars. These interlinked ring and weave motifs maintained a necessary element of egalitarianism among the colonies, even as the uniformity of the image diminished each colony's distinctive character.[14]

As additional states expected to join the union, the image of interlinked rings underwent changes that suggested how readily material representations of the union allowed for the addition of states. For instance, modified versions of the motif were integrated on the Vermont currency for February 1781. One type of currency in Vermont had the interlinked rings in the usual circle, except that the form was not completely connected at the top of the circle, as for instance on the notes for "*Six Shillings and Eight Pence per Ounce*" and the "*Two Shillings and Six Pence*." Instead, at the center of the top of the circle was a loose fourteenth ring, located between the two ends of the otherwise interconnected circle of rings. This image expressed the expectations in Vermont that the government would join the union. Another type of currency in Vermont placed the thirteen interlinked rings

in a continuous curve rather than a completed circle. A fourteenth ring was inserted above the curve, as though there to be added to the existing states.[15]

During the American Revolution, some of the Continental currency and a preliminary sketch for a commemorative medal integrated yet additional motifs displaying a preoccupation with the number thirteen. On September 26, 1778, for instance, the congressional currency for "Fifty Dollars" had a thirteen-stage pyramid on the back of the note. This image was incorporated eventually on the "REVERSE OF THE GREAT SEAL OF THE UNITED STATES," as for example in an engraving in *The Columbian Magazine* for September 1786. One of the most frequently used images was that of the harp on the "Eight Dollar" note, regularly reissued on the Continental currency between 1775 and 1778. The thirteen individual strings on the harp were combined to form the musical instrument. This image recurred on a colonial flag known as the Gostelowe Standard Number Three, Harmonious Union. The preoccupation with thirteen also surfaced in lesser-known works, such as Du Simitière's preliminary sketch for a commemorative medal in honor of General Washington, in which thirteen small boats were situated in the harbor.[16]

In Britain, the American colonies were portrayed with the number thirteen in various ways, some of which transformed the innocuous into the sinister. In 1779 two versions of a British medal commemorated Howe's victory in Rhode Island by depicting thirteen small boats fleeing from the Island, while victorious British troops marched across the land from three large vessels. On February 27, 1780, "OPPOSITION DEFEATED" portrayed the United States as a man holding a flag emblazoned with the number thirteen. Finally, in some prints the innocuous thirteen stripes from the American flag became a whip with thirteen strands. In the background of "WAR of POSTS," designed by T. Colley and published by W. Richardson on May 1, 1782, a man wielded a thirteen-stripe whip to punish another fellow locked in a stockade. The image of the thirteen-stripe whip recurred in *"Blessed are the* PEACE MAKERS,*"* published on February 24, 1783, by Elizabeth D'Archery, and in *"Mrs. General Washington Bestowing thirteen Stripes on Britania,"* published in the March 1783 issue of *The Rambler's Magazine.*

In his diary a British officer ridiculed the ubiquitous use of the number thirteen to represent the United States in Revolutionary imagery.

A party of naval prisoners lately returned from Jersey, say, that the rations among the rebels are thirteen dried clams per day; that the titular Lord Stirling takes thirteen glasses of grog every morning, has thirteen enormous rumbunches on his nose, and that (when duly impregnated) he always makes thirteen attempts before he can walk; that Mr. Washington has thirteen toes on his feet, (the extra ones having grown since the Declaration of Independence,) and the same number of teeth in each jaw; that the Sachem Schuyler has a top-knot of thirteen stiff hairs, which erect themselves on the crown of his head when he grows mad; that Old Putnam had thirteen pounds of his posteriors bit off in an encounter with a Connecticut bear, (It was then he lost the *balance* of his mind;) . . . that Polly Wayne was just thirteen hours in subduing Stony Point; and as many seconds in leaving it.

The colonists' preoccupation with the number of colonies, a symptom of the underlying desire to maintain some degree of distinction among the united colonies, became a motif that represented the United States in the pictorial messages produced in Britain, where it was transfigured into images of thirteen-stripe whips to emphasize its sinister aspects, while highly contrived descriptions of thirteen elements exploited the preoccupation as a source of satire.[17]

Even after the successful conclusion of the American Revolution, American leaders continued to express astonishment that the colonies had become united in their struggle with Great Britain. In a letter from John Adams to Hezekiah Niles on February 13, 1818, Adams reminisced,

The colonies had grown up under constitutions of government so different, there was so great a variety of religions, they were composed of so many different nations, their customs, manners, and habits had so little resemblance, and their intercourse had been so rare, and their knowledge of each other so imperfect, that to unite them in the same principles in theory and the same system of action, was certainly a very difficult enterprise. The complete accomplishment of it, in so short a time and

by such simple means, was perhaps a singular example in the history of mankind. Thirteen clocks were made to strike together—a perfection of mechanism which no artist had ever before effected.[18]

Adams's comment reflected upon a change in one of the most pervasive commonplace ideas during the years before the Revolution: the belief that the thirteen colonies in America were so distinct that coordinated action among them could be achieved only through their mutual subordination to Britain.

In summary, certain imagistic tensions centered around the issues of unity and distinctiveness—tensions between common benefits through mutual cooperation and individual benefits through local control, tensions between one locus of supreme authority and several loci of diffused authority. These imagistic tensions surfaced at two levels, the one imperial, the other intercolonial. At the imperial level, the unity or separateness of the American colonies and the rest of the British empire was an issue whenever the colonies were portrayed as a limb, part, or support in a larger entity or structure, the whole of which constituted the empire. At the intercolonial level, the unity or distinctiveness among the American colonies was a matter of concern whenever the colonies were portrayed as discrete entities or substances—thirteen separate individuals, hands, hearts, fish, rattles, bees, stars, stripes, pillars, boats, candles, clocks, or links in a chain. Between the two extremes of absolute unity and absolute individuality, the representations of the colonies as a snake, an Indian, and a child evolved to inculcate an emerging though still inchoate sense of American community.[19]

There were vital differences among these images used to designate intercolonial unity among the American governments. Because each type of image emphasized a particular way of envisioning the colonies as they were or as they might become, each gravitated toward a certain range of possibilities along a spectrum of political commitments. The image of the American colonies as the limbs of the body politic was the most conservative motif, because it denied all prospect of an autonomous and healthy American community, insisting that the only prospect of survival for the colonies was through continued subordination within the empire. In contrast, the other common representations—the snake, the Indian, and the child—

affirmed that the colonies formed a unified entity by themselves, apart from the British empire. The colonies possessed a mind and body of their own, with their own interests, concerns, and values.

Between the extremes of unity with the rest of the British empire on the one hand and complete separation among all of the American colonies on the other hand, the dominant images designating the united colonies as a single body politic also promoted corresponding clusters of political commitments. The image of the child was the most conservative of the dominant motifs that represented America as a singular body politic, while the image of the snake was the most radical. The image of the Indian fell near the center and was, moreover, the most complicated of the commonplace motifs because of its associations with gender and race. Yet none of these motifs went so far as to suggest that each colony formed its own complete body politic. They differed fundamentally from images designating each of the colonies as separate persons or fish.

The Colonies Are the Limbs or the Child of Britannia

Closely related to the image of the colonies as the limbs of Britannia was the image of the colonies as the child of Britannia. These motifs were similar in noteworthy respects. The limbs were a part of the body politic, and the child had once been a part of the parent, implying that the American colonies were British in character either by the physiology of the organism or by birth. The images of the limbs and the child identified the colonies with a British heritage. In this respect, these images differed fundamentally from those designating the colonies as a rattlesnake or an Indian, since those were indigenous only to the American continent. Accordingly, the images of the limbs and the child had the potential to emphasize mutual concerns, values, and attitudes within the British empire, while the images of the rattlesnake and the Indian had the potential to underscore differences between the cultures in Britain and the American colonies. Therefore, the images designating the colonies as the limbs or the child of Britannia were

most useful to those who sought to conserve political ties within the empire, while the images of the colonies as a rattlesnake or an Indian were most useful to those who sought to sever such ties.

The use of the limbs and the child to represent America entailed notions of colonial subordination and submission to Britain, though in different forms and to different degrees. Arms and legs were subordinate in the body and submitted to the authority of the mind. A child was subordinate to his or her parent and was expected to submit to the parent's authority. Because these images sanctioned British authority over the colonies, they appealed most to those who wanted or expected to maintain the political ties between America and the rest of the British empire. Since during the decade of dissent, most colonists, including the protesters, wanted to perpetuate their relationship to Britain, the pervasiveness of such images in the protest rhetoric was predictable, the product of habitual patterns of thought. However, as the issue of parliamentary authority broadened from the narrow issue of taxation to the general issue of legislation, especially after the Intolerable Acts of 1774, the image designating the colonies as the limbs of Britannia became most useful only to those who would preserve political links with Britain. In contrast, Patriots in America found the image of the colonies as the limbs of the body politic problematic or repugnant, because it denied all prospect of self-government.

The image of the child differed significantly from the image of the limbs in that the child was the less conservative of these motifs. Although both images placed authority in Britain—either as the mind of the body politic or as the parent—the parent's authority over the child was temporally limited and contingent upon the parent's prudent and proper conduct. While the subordination of a child to a parent was temporary and relative to a tacit network of practical and moral obligations, the subordination of the limbs in the body politic was enduring and absolute. An element of interdependence between Britain and America was featured in both images, but the relationship between parent and child was open to a degree of mutual consent and negotiation, while the relationship between limbs and body was not. Finally, the image of parent and child was useful for attributing distinct motives to Britain and to the American colonies, while the image of the limbs was not. The parent and child behaved from self-interest and for mutual benefit. Both could become culpable for their

conduct. Accordingly, accusation and blame were portrayed more specifi-
cally and more vividly with an image of the family than with that of a
single body politic; a recognition that only one mind governed the body
politic obscured different interests within the empire. Where such differ-
ences existed, they could be portrayed only as a violation of natural biology,
or a disease. In contrast, both parent and child could be motivated by such
vile feelings as greed, envy, selfishness, and hatred, which could culminate
in the extreme acts of parricide or infanticide. These differences made the
image of the limbs more useful to promote conservative political commit-
ments than the image of the child.

It is illuminating to observe both images at work in a pamphlet printed
in 1775 in Philadelphia and written by Isaac Hunt, a conservative and a
Quaker, a friend of Joseph Galloway. Although the title, *The Political
Family*, implied that the image of the family would be employed to describe
the relationship between Britain and America, Hunt's first reference to a
family ended with a shift to the image of the limbs or parts of the body
politic. "In this discourse I shall consider the *mother country* and her *colonies*
as a body politic." Note the singular "a" body politic, not two bodies politic
corresponding to parent and child. Hunt subsequently drew upon the image
of a singular body politic to prove that division of authority between Britain
and the colonies would be unnatural and fatal:

> As in the *natural body* all the inferior springs of life depend upon the
> motions of the *heart*, so in the *body politic* all inferior jurisdictions should
> flow from *one superior fountain*. Two distinct *independent powers* in *one
> civil state* are as inconsistent as *two hearts* in the *same natural body*. Because
> if such a thing can be imagined, they must constantly interfere in their
> operations, so as to reduce the WHOLE to anarchy and confusion, and
> bring on a *dissolution* in the event. A due subordination of the less parts
> to the greater is therefore necessary to the *existence* of BOTH.

Although two hearts in one body would have been unnatural, it would not
have been unnatural for a parent and a child each to have had a heart. The
dissolution of both Britain and the colonies would not necessarily have
followed from the image of parent and child. The image of a singular body
politic was useful for placing issues of authority and survival in absolute

terms. The image of the limbs retained the absolute center of authority in Parliament, while the image of the child did not. Therefore, in consideration of authority and survival, the image of the limbs was more conservative than that of the child.[20]

While the image of the limbs was used to portray dire consequences that could result from divisiveness within the British empire, it was less useful for indicating the sources of such divisiveness, since a singular body politic emphasized one controlling mind. Accordingly, when Hunt wished to attribute motives, to delineate obligations, and to emphasize mutual benefits, he employed the image of parent and child instead. As used by Hunt, the image of the child that represented the colonies also implied a narrative of colonial maturation and separation from Britain. The definition of the relationship between Britain and America as that between parent and child involved a future state of self-government significantly different from that of the image representing America as the limbs of the body politic. An articulation of this future, self-governing state was from Isaac Hunt an important concession, for it entailed a narrative of colonial maturation and separation from Britain. Even so, the images of the limbs and the child appear to have been incompatible aspects of Hunt's views about the colonies' relationship to Britain, since envisioning a separate future state as the limbs of the body politic was impossible.[21]

Hunt's combination of the two images was not an aberration in the Loyalists' argumentation. Such combinations of imagery recurred in pamphlets by Samuel Seabury, Thomas Bradbury Chandler, Joseph Galloway, Henry Barry, and Daniel Leonard. These writers all combined the images of the limbs and the child, sometimes in startling juxtapositions. For example, in *A View of the Controversy Between Great-Britain and her Colonies*, published at New York in 1774, the Anglican minister Samuel Seabury wrote: "The British colonies make a part of the British empire. As parts of the body they must be subject to the general laws of the body. To talk of a colony independent of the mother-country, is no better sense than to talk of a limb independent of the body to which it belongs. In every government, there must be a supreme, absolute authority lodged somewhere." Seabury, like Hunt, alluded to one body when he wished to argue for the ultimate authority of Parliament as a political necessity. Yet his argument that a limb

could not become independent of a body had more logical force than the claim that a child could not become independent of a parent.[22]

Thomas Bradbury Chandler, another Anglican minister and Loyalist from New York, also combined the images of the child and the limbs in 1775 in *What think ye of the Congress Now?* Chandler, like Hunt, used the image of a singular body politic to emphasize the unity of the entire British empire's interests, but for a different reason—that the body would be affected throughout by harm to any limb: "I consider Great-Britain and her colonies, with her other dependencies, as but *one body*, which must be affected throughout by the suffering of any particular *member*. I consider them as constituting *one* great and illustrious *family*, to which I have the honour to belong." Both Chandler and Hunt shifted back and forth between these images in key locations within the pamphlet: Chandler shifted from the image of the limbs to the family in this excerpt from the final paragraph of his conclusion, while Hunt shifted from the image of the family to the limbs in his introductory remarks. Perhaps the placements of the fused metaphors suggested the importance of the images in the political perspectives of these polemicists.[23]

Chandler's use of these two images resembled Hunt's in another respect: Both Hunt and Chandler employed the image of the child to amplify distinct motivations, interests, and obligations. But Chandler modified the image of the family by depicting the colonial community as the plural "sisters," rather than the singular "child." He articulated a shrewd series of arguments and insinuations derived from the plural in a lengthy and elaborate narrative, using the imagery to promote divisiveness among the colonies, since the other sisters' interests were no longer safely promoted as consistent with New York's own. More important, Chandler used the imagery to set up priorities within the family structure by suggesting that the parent's concerns should take precedence over those of the sister colonies. Then, to encourage further divisiveness among the siblings and to justify independent action by New York, he focused upon how unreasonable the other colonies were being in their demands upon their parent. Finally, Chandler evoked the idea of parricide to condemn the sister colonies, while providing yet additional reason for New York to break the alliance with them.[24]

Joseph Galloway, a Loyalist from Pennsylvania, used the images of a human body and a family expressly to integrate considerations of a moral character with those of an imperial nature in *A Candid Examination*. Other options were available, although rarely exercised by Loyalist writers. For instance, Jonathan Boucher, an Anglican minister who preached in Maryland, employed an image of the singular body politic as a tree, in an effort to resolve the tension between the images of the child and the limbs. In a sermon delivered in 1775, Boucher contended, "[W]e were not lopped off the parent trunk as useless or noxious limbs, *to be hewn down, or cast into the fire*; but carefully transplanted here: and we have ever since been assiduously and tenderly cherished by that Parent State, who has emphatically been our *nursing-father* and our *nursing-mother*." To Boucher, the colonies were the offshoots of the English oak and, at the same time, the children of the parent state. Boucher's biblical allusion to Matthew 3:10 reinforced the value of the colonies, which had been fruitful for the British empire, while his reference to the nursing parents enabled him to stress the obligations of the colonies to the rest of the empire.[25]

Whether these Loyalists manipulated such images deliberately or intuitively is difficult to ascertain. In either case, each image was especially well suited to promote specific kinds of claims about the nature of the colonies. The image of the limbs placed absolute authority in Parliament and prophesied the destruction of the empire if divisiveness among the dominions persisted. The image of the child specified motives, obligations, and mutual benefits within the empire and prophesied the eventual separation of the colonies from Britain when the child matured.

Another indication that the image of the limbs was more conservative than the image of the child was the degree to which the latter was subject to reversal in argumentation, as evidenced by Thomas Paine's series of arguments in *Common Sense*. The line between a family obligation and a family imposition was ambiguous. To be sure, there were clear cases of each. But the ways in which political figures handled the child's crimes of ingratitude and disobedience or the parent's crimes of tyranny and oppression were often a matter of political commitment. What to a Loyalist was an act of ingratitude by a disobedient child was to a Patriot a legitimate response to an act of parental tyranny. Such a reversal was not as feasible when the colonies were an arm or a leg of Britannia.

Even though the image of the child was less conservative in its full range of implications than the image of the limbs, the image of the child nevertheless provided a relatively conservative way of portraying the American colonies and their relationship to Britain because—unlike the images of the Indian or the snake—the image of the child always placed those Patriots who used it in a stance of self-justification, almost obligating them to prove or allege that the parent's behavior was sufficiently barbarous to warrant the child's rebellion. For a child to reject or strike a parent required considerable justification and inevitably entailed a profound sense of guilt, since "Honor thy father and thy mother" was a fundamental tenet of religious life—a tenet transfigured onto political life in Britain and America through more than a century of Anglican teachings. These aspects of the image so limited its use that some Patriots—Thomas Paine among them— denied its legitimacy altogether. Such denials liberated the Patriots to use a more aggressive stance of accusation without extensive examination of their own conduct.

THE COLONIES ARE A NEOCLASSICAL GOD OR GODDESS

Images designating the colonies as the limbs or the child of Britannia emphasized a special British heritage, while images designating the colonies as the Indian or the rattlesnake emphasized a special American heritage. Between these two cultures, various uncommon personifications were developed by image makers in Britain and America to represent the colonies as a single body politic. Some of these uncommon images were ambiguous in that they could have referred to either a colonial or a British heritage. Others referred to neither; instead, they alluded to the Roman Republic and Empire, either to portray an analogous decline of the British empire or to depict the formation of a new republic in America.

Some prints portrayed the American colonies as a woman or a man who could have been British, European, or colonial by birth. Even though the same type of personification was rarely used more than once to represent

America, most of these images emphasized commonplace ideas resembling those evoked by the more pervasive images. For instance, the Indian and the child when used to represent the colonies were often portrayed as naïve or uncivilized and therefore in need of the British government's guidance. Further, the Indian and the child were usually depicted as youths or young adults. Similarly, in August 1778, *The London Magazine* depicted the colonies as an unsubstantial young man in "[An Emblematical Print Adapted to the Times]," wherein a lanky fellow representing America had a French cock perched on his shoulder to suggest the alliance between the United States and France. In "*The* DUTCHMAN *in the* DUMPS," published on April 19, 1781, by W. Humphrey, the United States was once again an insignificant youth at the far right of the composition. Because British military forces had seized the Dutch island of St. Eustatius, the representation of the United States commented, "America now, To Old England must bow," to suggest that the colonies were dependent upon control of the island to maintain their rebellion.

The child and the Indian frequently were portrayed as the victims of the British government. Similarly, "SIX MEDALLIONS shewing the chief national servises of his new Friends the old ministry," published circa 1765, depicted the colonies as a young woman who was being molested by two government officials (fig. 44). In the middle medallion on the left, Lord Grenville was shown with a mallet, pressing a "Stamp" onto the face of the young woman. Lord Bute assisted him by pushing her shoulders toward the ground and remarking, "[F]orce her." Grenville exclaimed, "[T]he Bitch Rebels," to indicate the disrespectful attitude of the prominent minister toward the outnumbered colonies. America was the victim of yet another minister in "OPPOSITION DEFEATED," published on February 27, 1780. Lord North rode a bull over a man, who had fallen beneath the animal's hooves and who somehow continued to wave a flag emblazoned with the number thirteen to identify him with America.[26]

So common was it to portray the colonies as a youth or a young adult that "AMERICA *in* FLAMES" was an idiosyncratic print, even though it too portrayed the woman representing America as a victim of the British officials (fig. 45). Published in *The Town and Country Magazine* of December 1774, and again in *The Hibernian Magazine* of January 1775, this print portrayed the American colonies as "a venerable lady" who was being

burned alive. Her victimage resulted from the vicious efforts of Bute, Mansfield, and the Devil himself; the public officials used bellows inscribed "Quebec Bill" and "Masachusets-Bay" to fan the flames. Lord North, who held a copy of the "Boston Port Bill," watched the persecution through a magnifying glass. The text on the facing page in *The Town and Country Magazine* affirmed that America's critical situation "requires the aid and assistance of all the patriotic band, who are exerting their utmost endeavours to quench the flames that threaten the existence of our colonies, for little more than the demolition of an old tea-pot." The tea pot was an allusion to the Boston Tea Party, while the efforts to burn the woman corresponded to the "Boston Port Bill," held so firmly in Lord North's grasp. The image of America as an elderly woman was not repeated apart from this composition, because it suggested that the colonies had attained a mature age, to be followed by the prospect of decline, not the youthful potential for development typically associated with them.[27]

Occasionally the image of the Indian representing the colonies was depicted in a similar state of mind or situation as a representation of Britain, as in a eulogistic print entitled "Sacred to the Memory of William Beckford, Esq. *twice* Lord Mayor of the City of LONDON," printed June 21, 1770. Both the Indian and Britannia were grief stricken by Beckford's death. Somewhat similarly, another eulogistic print, "THE TOMB = STONE," published earlier, in October 1765 during the Stamp Act controversy, had suggested an association between the colonial and British representations during a time of grief. Beneath the platform at the corners were two women, identified as "Britannia" to the left and "America" to the right. Both bare-breasted women occupied a similar position beside the tomb as they wept about the death of William, Duke of Cumberland. The print portrayed similarity of sentiments between America and Britannia, even as it castigated certain political leaders—Grenville, Bute, the Duke of Bedford, and a doglike creature representing Anti-Sejanus—for their disgraceful dance upon the Duke of Cumberland's tomb.

Although "BUNKERS HILL *or America's Head Dress*" and "AMERICA. To Perpetuate to Posterity the Memory of those Patriotic Heroes, who Fought, Bled, & Died" were typical prints in that they depicted America as a young adult, they suggested an atmosphere of experimentation with the image of America. The hairstyle of the woman in "BUNKERS HILL *or*

America's Head Dress," published by Matthew Darly in 1776, established it as one of the many macaronies produced in Britain during the period. The term "macaronies" was used "to describe the dress, hair, and life styles affected by those who traveled in the Continent and, upon their return, greatly exaggerated in their own habits that which they had observed and admired." Women who indulged in such conduct were a commonplace source of humor and disapproval, as in Hannah More's description of eleven "damsels" at a dinner, who "had, amongst them, on their heads, an acre and a half of shrubbery, besides slopes, grass-plats, tulip-beds, clumps of peonies, kitchen gardens, and green-houses." The macaroni in "BUN-KERS HILL *or America's Head Dress*" differed from most in that it did not merely ridicule the social habits of a stereotypical person. Instead, the woman represented the American colonies to imply that their conduct amounted to mere posturing and pretensions. "AMERICA. To Perpetuate to Posterity the Memory of those Patriotic Heroes, who Fought, Bled, & Died" was another experimental image of America in that it portrayed the United States as a woman wearing a plumed headdress and praying at the base of an obelisk (fig. 46). As the figures of Hercules, Liberty, and Plenty approached the woman, a light from above her penetrated the darkness of the passing storm, which had left carnage in its wake. Even though these images were not commonplace in pictorial design, they expressed a commonplace impulse to personify the colonies and later the United States in a manner neither specifically American nor British in physical makeup. In this respect, they differed from the images of the colonies as an Indian or as the child of Britannia.[28]

Allusions to a neoclassical heritage recurred in many of the uncommon personifications, although there was much variety in the nature of such imagery. Indeed, between 1765 and 1783, roughly half of the uncommon personifications of the American colonies featured neoclassical imagery through the garb of the personifications or the setting of the dramas. In addition, the widespread use of the image of America as an eagle on "[The Arms of the United States]" during the final war years evoked connotations of classical republicanism (fig. 47). Neoclassical imagery enabled illustrators to avoid associating the British colonies in America with a corrupt and offensive British government on the one hand or with a reputedly uncivilized and pagan people on the other. Instead, the imagery echoed the ideals

of the Roman Republic or Empire, at once an identification of the colonies with republican virtues and a dissociation of them from the corrupted constitutional monarchy of Great Britain.

Some illustrators and writers drew an analogy to the decline of the Roman Empire to depict the British empire weakened from within by corruption and from without by assaults from foreign powers. Such an analogy was employed in "The ROYAL HUNT, or a PROSPECT of the YEAR 1782," the first in a series of two prints about the implications of the American Revolution for the rest of the British empire. America was represented as one of many pillars, which the Indian and her European allies had toppled from Britain's "Temple of Fame!" The fallen pillars were parts of the structure constituting the British empire, inscribed "AMER-ICA," "TOBAGO," "MARTINIQUE," "EUSTATIUS," and the like. At the same time, the pillars were an allusion to architectural remains among the classical ruins of the Roman Republic. Despite the disconcerting demolition of the British empire by the enemies, Lord Sandwich continued to fiddle in the foreground—an allusion to Nero, who fiddled while Rome burned. The corrupt ministers continued to play games and sing, while neglecting the most vital concerns of the British empire. In the sequel, "ANTICIPA-TION; or, the CONTRAST to the ROYAL HUNT," an attempt to reconstruct the British empire was under way. Conway returned the pillar inscribed "AMERICA" to a standing position, while the former enemies of the British empire stood aside, holding olive branches representing peace. The print expressed optimism about reestablishing peace and, possibly, the reunification of the British empire.

Although Edward Gibbon's thesis about the decline and fall of the Roman Empire had been conceived as early as 1764, the first volume became generally available only in February 1776. Gibbon's description of an empire weakened from within by corruption and from without by assaults from barbarians may have given rhetorical force to some of the neoclassical imagery that was employed during the Revolution to depict the problems of the British empire. Because allusions to the decline of Rome antedated the publication of Gibbon's thesis, however, his intellectual accomplishment was not initially a factor in the use of neoclassical imagery in the political rhetoric of the Revolution, although the publication of the first volume in 1776 may have contributed to subsequent uses of the im-

agery. For instance, an allusion to the decline of the Roman Empire may have given rhetorical force to "[Britannia Attacked by her Enemies]," an ornament for the preface of Edward Barnard's *New, Comprehensive and Complete History of England*, published in 1783 (fig. 48). An Indian, dressed in a classical tunic, attacked representations of Britain from behind with a dagger. The Indian held a thirteen-stripe flag in the other hand to identify with the American colonies. Meanwhile, foreign enemies assaulted the British to divert their attention so that the Indian could be effective in her treachery. This depiction of a complicated international situation depended on a conviction that the Roman Empire went into a decline because of rebellion from within and a military assault from foreign forces.[29]

In Britain, other neoclassical personifications of the United States were employed after the Declaration of Independence, but because the imagery designating America was unstable in the sense that a definite iconographic tradition had not yet been developed, even the sex of the figures in the representations was subject to change. The United States were portrayed as a young man wearing a classical tunic, sandals, and helmet in "[The above is a Design]." He carried a spear and shield and wore a liberty cap to signify his newly won freedom. He fought with a godlike man representing a storm, who hurled bolts of lightning at America on Britannia's behalf. America deflected the lightning toward Britannia with his shield to protect himself and to turn the assault against her. "The Apotheosis of George Washington and Benjamin Franklin," a design used on British textiles circa 1785–90, also incorporated neoclassical imagery (fig. 49). Behind Washington on a chariot was a woman in neoclassical garb, holding a liberty pole. Fame announced Washington's triumphant arrival, and a temple erected on pillars occupied the background. This textile pattern incorporated the thirteen-stripe flag as well as a snake on another flag. Two young Indians led the way to announce Washington's arrival; the Indians held a secondary position, walking while Washington and the neoclassical woman rode in the chariot.

Even before the outbreak of armed violence in 1775, writers in colonial newspapers had drawn upon analogies to the decline of Rome both to deplore the colonies' protests and to speculate about the conditions that would make independence necessary. For instance, on August 31, 1774, the *Pennsylvania Gazette* carried an article—which was reprinted on Sep-

tember 6, 1774, in the *Pennsylvania Staatsbote*—claiming, "When Great-Britain, like Rome, is torne by intestine divisions, and enervated by luxury, and no more able to support her rank amongst the Powers in Europe, then her Colonies, like those of Rome, must fall a prey to foreign power, or think of independence,—but whilst England maintains her present superiority, an independence of the Colonies is a mere elusion." To this writer, the decline of the British empire could be brought about not by a rebellion throughout America but by a corrupt and emasculated British government. Further, the decline of the empire could then justify the colonies' efforts to attain independence, because otherwise the colonies would risk foreign domination.[30]

In stark contrast, the analogy between the British empire and the Roman Empire was drawn categorically to condemn the protesters in *The Patriots of North-America: A Sketch. With Explanatory Notes*, a Loyalist pamphlet published in New York in 1775.

Wild Mobs, to mad Sedition prone,
and Liberty licentious grown,
Must make, the fatal Hour draw near,
Of civil Discord's wild Career,
Must cause, one general Anarchy,
Must end in Loss of Liberty;
And this free Country soon become
Like Carthage, Florence, Greece and Rome
Unless some God, should interpose,
And save it, from domestic Foes.[31]

To this Loyalist writer, the decline of the British empire was being precipitated by colonial mobs, with their decadent conceptions of liberty, and the analogy between the British empire and the Roman Empire justified opposition to the devious efforts of the so-called American Patriots.

These two uses of the analogy were summarized by Daniel Leonard in 1774, when he wrote as Massachusettensis: "The kingdom of Great-Britain was depicted as an ancient structure, once the admiration of the world, now sliding from its base, and rushing to its fall. At the same time

we were called upon to mark our own rapid growth, and [to] behold the certain evidence that America was upon the eve of independant empire."[32] Envisioned in this summary of the political situation were the two dominant uses of neoclassical imagery during the American Revolution: to depict the ineluctable decline of the British empire and to portray the formation of a new American empire founded upon republican virtues, ideals, and principles.

In America, neoclassical imagery recurred among the uncommon personifications of the colonies, especially after the outbreak of military violence in 1775. American illustrators employed diverse images of the colonies as a distinct classical personage to suggest the formation of a separate empire. In keeping with the atmosphere of experimentation with the images designating America, the neoclassical individuals varied in their general appearance, garb, and setting. The colonies were represented as a neoclassical woman in "AMERICA TRIUMPHANT and BRITANNIA in DISTRESS," a frontispiece for WEATHERWISE'S TOWN AND COUNTRY ALMANACK FOR THE YEAR OF OUR LORD 1782 (fig. 50). She held a liberty pole and wore headgear resembling a tiara; near her was a striped flag representing the United States. In the other hand, she held an olive branch representing peace. Close to her were other images associated with the United States: a snake biting its tail and a bow and arrows, possibly a remnant of the image representing America as an Indian. Columbia, another neoclassical representation of the United States, was depicted on the frontispiece of *The Columbian Magazine, or Monthly Miscellany* for 1787. The image of Columbia differed from that of the other neoclassical woman in that she did not hold either a liberty cap or a liberty pole. Eventually, during the nineteenth century, Columbia became a conventional image of the United States, presumably because of the special significance of her name. In a note appended to one of Philip Freneau's poetic dialogues, he affirmed that America was to be called Columbia "by poetical liberty, from its discoverer."[33]

The emergence of neoclassical imagery in the American colonies also can be observed in the imagery representing the state of Virginia, where the image of an Indian on official colonial artifacts was supplanted by a neoclassical figure on official state artifacts. Early during the reign of King George III, the Great Seal of Virginia portrayed an Indian kneeling on

one knee in supplication to the king. The Indian presented the king with a gift of tobacco leaves, the major crop of the colony. By October 5, 1778, in contrast, a neoclassical figure was employed on the colony's currency, "ONE THIRD of a Spanish milled DOLLAR," an image that also appeared on a medal in Virginia during 1780 and on the flags of a regiment from Virginia during the war. This neoclassical woman had one foot firmly placed on the back of the sprawling king, who continued to threaten her with a club. Shattered shackles on the ground revealed the king's previous endeavors to end colonial liberty. The image on the medal was encircled with the words "Rebellion to Tyrants is Obedience to God," an affirmation of divine approval for the colonists' struggle against the British monarch.[34]

After 1779, American illustrators used imagery designating the United States as neoclassical architecture to suggest empire building in America on the scale of a new Rome. The United States, not the British empire, constituted the whole of this new structure, a republic under construction on the American continent. In January 1779, for instance, the frontispiece of *The United States Magazine* included thirteen pillars and thirteen stars combined to constitute the new nation. A lengthy verse associated the architectural imagery with the Roman Empire:

A Bold triumphal *Arch* you see,

Such as by Antiquity

Was raised to Rome's great heroes, who

Did the rage of war subdue.

The Arch high bending doth convey,

In a hieroglyphic way,

What in noble stile like this,

Our United Empire is.

The verses amplified the ability of the United States to grow through the addition of pillars and stars:

The *Pillars* which support the weight,

Are each of them a mighty State:

Thirteen and more the vista shews,

As to vaster length it grows:

For new States shall added be,

To the great Confederacy. . . .

 In the lofty arch are seen,

Stars of lucid ray—*Thirteen.*

And when other states shall rise,

Other stars shall deck these skies.

The material images of thirteen pillars and stars depicted the growth of the United States in a way that few animal images could have conveyed, except for the rattlesnake with its increasing number of rattles. Subsequently, the same image of thirteen pillars and stars recurred on the title page of *The CONTINENTAL ALMANAC FOR THE Year of our LORD,* 1782, by Anthony Sharp.

Later, during the ratification of the United States Constitution in 1788 and 1789, a series of twelve woodcuts in the *Massachusetts Centinel,* used the image of pillars being erected to depict each state's passage of the Constitution (figs. 51–53). The series of woodcuts commented upon the progress of the Constitution through the individual state legislatures by depicting the gradual construction of an architectural structure standing for the new form of government. Each woodcut either announced or predicted the passage of the Constitution in a specific state legislature by portraying that state as a neoclassical column being placed in line with other columns representing states that already had approved the Constitution. This sequence of woodcuts differed from earlier pictorial representations of the United States in that these images sought to transform an underlying conception of government, promoting a change from a loose association of states into a federal edifice. At least nine additional newspapers in Massachusetts, New Hampshire, and New York printed variations of the woodcut series.[35]

That neoclassical imagery became prominent in pictorial representations of the American colonies and the United States, especially after the outbreak of conflict in 1775, suggested that the war had made the imagery of a specifically British heritage unacceptable to the Americans. Even so, the particular choice of neoclassical imagery in political prints about Amer-

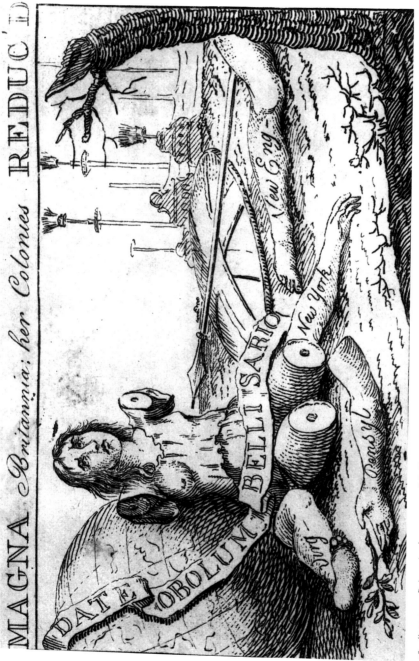

38. "MAGNA *Britannia: her
Colonies* REDUC'D." Maker:
Benjamin Franklin, [circa 1766].

Medium: print; size: 4 1/8" ×
5 7/8". Courtesy of the Library
Company of Philadelphia.

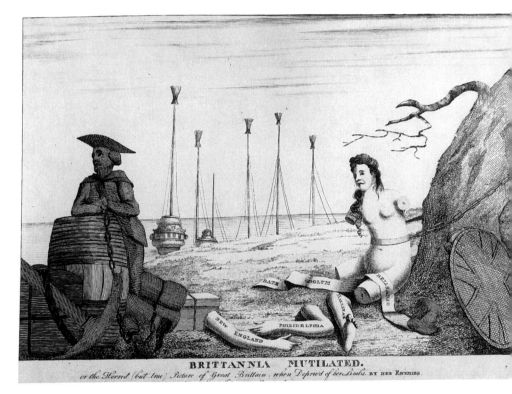

BRITTANNIA MUTILATED.

or the Horrid (but true) Picture of Great Brittain. when Depriv'd of her Limbs. BY HER ENEMIES.

39. "BRITTANNIA MUTILATED.
*or the Horrid (but true) Picture of
Great Brittain. when Depriv'd of
her Limbs.* BY HER ENEMIES,"
November 29, 1774. Publisher:
M. Darly; medium: print; size:
15 1/2″ × 11 3/4″. Photograph
courtesy of the Library Company
of Philadelphia.

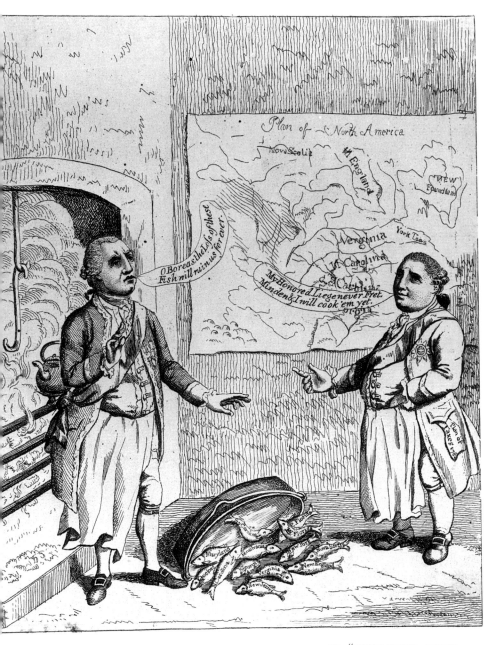

40. "STATE COOKS, or THE
DOWNFALL of the FISH KETTLE,"
December 10, 1781. Publisher:
W. Wells; medium: print; size:
10″ × 8 1/4″. Photograph
courtesy of the British Museum,
Department of Prints and
Drawings.

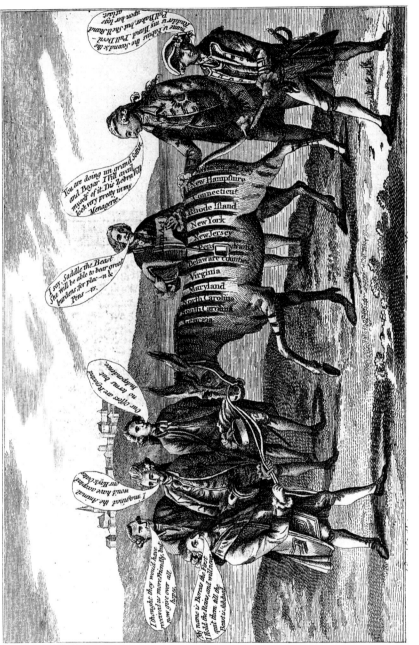

41. "THE CURIOUS ZEBRA. *alive* 6 3/8" × 3 7/8". Photograph
from America! walk in Gem'men courtesy of the British Museum,
and Ladies, walk in." September Department of Prints and
3, 1778. Medium: print; size: Drawings.

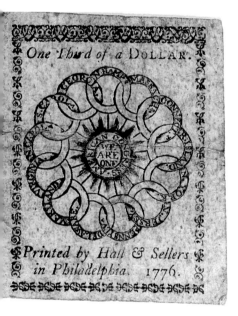

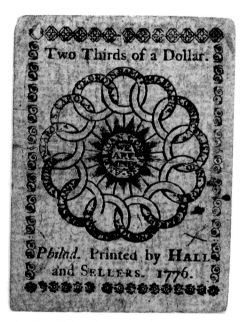

42. New York's "FIVE DOLLARS" Note, 1775. Publisher: John Holt; medium: currency; size: 4 1/4″ × 3 1/8″. Photograph courtesy of the Smithsonian Institution.

43. "One Third of a DOLLAR" and "Two Thirds of a DOLLAR," 1776. Publisher: Hall and Sellers; medium: paper currency. Photograph courtesy of the Library of Congress.

44. "SIX MEDALLIONS shewing the chief national servises of his new Friends the old ministry," [1765]. Medium: print; size: 7 1/2″ × 11″; the diameter of each medallion is 3 1/2″.

Courtesy of the British Museum, Department of Prints and Drawings.

45. "AMERICA *in* FLAMES," *The Town and Country Magazine* 4 (December 1774): opposite 659.

Medium: magazine; size: 5 3/4″ × 3 5/8″. Photograph courtesy of the Library of Congress.

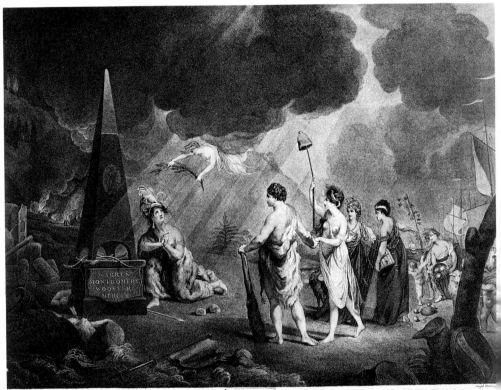

To THOSE, who wish to SHEATHE the DESOLATING SWORD of WAR AMERICA And, to RESTORE the BLESSINGS of PEACE and AMITY, to a divided PEOPLE.

46. "AMERICA. To Perpetuate to
Posterity the Memory of those
Patriotic Heroes, who Fought,
Bled, & Died," [late 1770's?].
Maker: Doolittle; medium: print;
size: 17 1/2" × 23 1/4".
Photograph courtesy of the
Library of Congress.

. Right: "[The Arms of the
United States]," in *The Columbian
Magazine, or Monthly Miscellany*
(September 1786): opposite 33.
Medium: magazine; size: 4 1/2″
7″. Photograph courtesy of the
Library of Congress.

. Below: "[Britannia Attacked
by her Enemies]," [1783]. In
Barnard's *New, Comprehensive and
Complete History of England*, an
ornament for the preface, iii.
Medium: book; size: 7 1/8″ ×
7/8″. Photograph courtesy of
the Library of Congress.

49. "The Apotheosis of George
Washington and Benjamin
Franklin," [circa 1785–90].
Medium: printed cotton textile.
Photograph courtesy of the Henry
Francis duPont Winterthur
Museum.

AMERICA TRIUMPHANT and BRITANNIA in DISTRESS

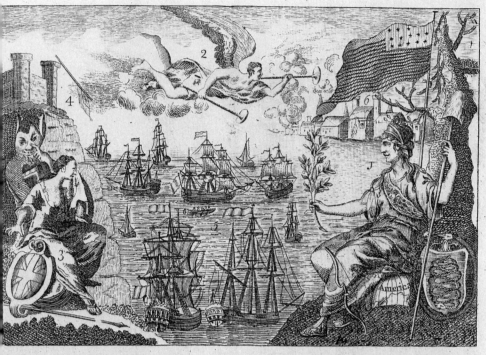

EXPLANATION.

America fitting on that quarter of the globe with the Flag of the United States difplayed over her head, holding in one hand the Olive branch, inviting the fhips of all nations to partake of her commerce, and in the other hand fupporting the Cap of Liberty.

Fame proclaiming the joyful news to all the world.

III. Britannia weeping at the lofs of the trade of America, attended with an evil genius.

IV The Britifh flag ftruck, on her ftrong Fortreffes.

V French, Spanifh, Dutch, &c fhipping in the harbours of America.

VI A view of New-York, wherein is exhibited the Trator Arnold, taken with remorfe for felling his country, and Judas like hanging himfelf.

50. "AMERICA TRIUMPHANT and BRITANNIA in DISTRESS," WEATHERWISE'S *TOWN AND COUNTRY ALMANACK*, 1782, frontispiece. Medium: almanac; size: 4 5/8" × 6 7/8". Photograph courtesy of the Library of Congress.

The C E N T I N

REDEUNT SATURNIA REGNA.

☞ It will rise.

DEL. PEN. N.IER. GEOR. CON. MASSA. MARY. S:CARO.

N.HAMP.

STON, *Wednesday*, June 11.

EIGHTH PILLAR.

e predicted in several preceeding pa-
has the fact been verified. Since our last
ing intelligence of the accession of another
R in support of the *Grand Federal Super-*
, has been received in this town by a vef-
, days from Charlestown. On this event

of celebrating the Ratification of the C
by that State, had been proposed—and
ceed the day after the date of our accou
the plan, it is to be similar to that *origi*
ed in this town ; and besides SIXTY-
ferent orders of FARMERS, MERCH
MECHANICKS, would confist of the S
ters and *Scholars*—the *liberal profeffion*

51. "REDEUNT SATURNIA
REGNA," *Massachusetts Centinel,*
June 1788, p. 101, cols. 1–2.

Medium: newspaper; size: 5 5/8"
× 1 1/8". Photograph courtesy of
the Library of Congress.

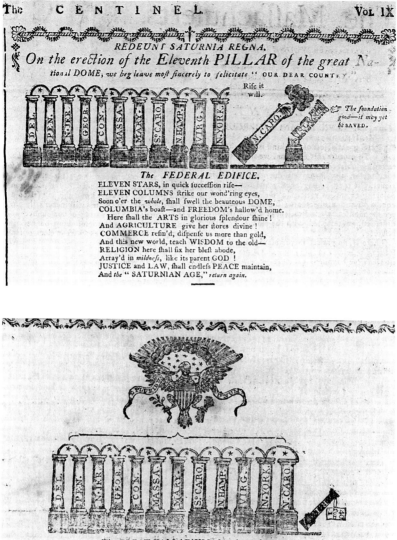

52. Top: "*REDEUNT SATURNIA REGNA. On the erection of the Eleventh PILLAR of the great national DOME,*" *Massachusetts Centinel,* August 1788, p. 160, cols. 2–3. Medium: newspaper; size: 6 1/4" × 4". Photograph courtesy of the Library of Congress.

53. Bottom: "The GREAT PALLADIUM of our happy land," *Massachusetts Centinel,* December 1789, p. 3, cols. 1–2. Medium: newspaper; size: 5 1/2" × 4 3/8". Photograph courtesy of the American Antiquarian Society.

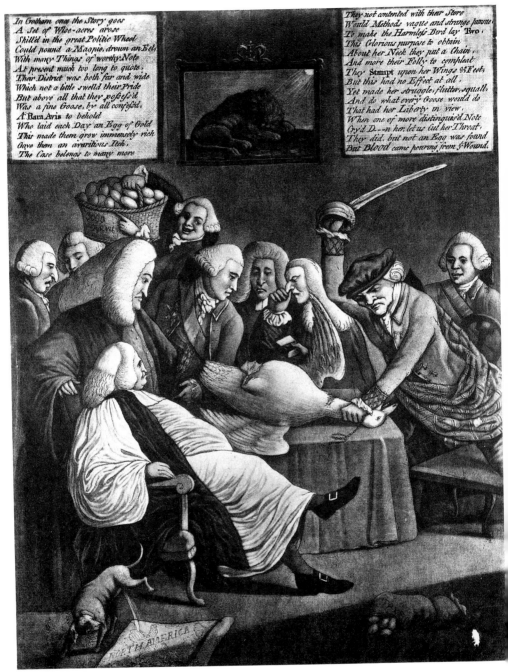

54. "THE WISE MEN *of*
GOTHAM *and their* GOOSE,"
February 16, 1776. Publisher:
W. Humphrey; medium: print;
size: 10″ × 13″. Photograph
courtesy of the Library of
Congress.

55. "LES POULLES AUX
GUINEES. L'Avarice perd tout en
voulant tout gagner," 1776.
Maker. F. Godefroy; medium:
print; size: 7″ × 10″. Photograph
courtesy of the Bibliothèque
Nationale, Département des
Éstampes.

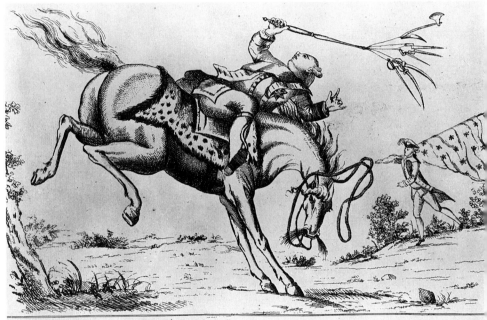

THE HORSE AMERICA, *throwing his Master.*

56. "*THE HORSE* AMERICA,
throwing his Master," August 1,
1779. Publisher: Wm. White;
medium: print; size: 7 1/2″ ×
11 1/2″. Photograph courtesy of
the Library of Congress.

ica was not merely a reaction against other kinds of representation. In the American colonies, the increase of neoclassical imagery was partially the result of European influences on the colonies, since neoclassicism was becoming more pervasive in Europe. That this time was regarded as the Augustan period in Europe may account for neoclassical imagery in some early colonial prints. Above all, in the colonies the burgeoning use of such imagery during the Revolution was the result of the overt emergence of republican sentiments. Before the Intolerable Acts of 1774, colonial protesters consistently based their appeals upon the British constitution in their efforts to seek redress, and they professed allegiance to the king, tacitly accepting the procedures of monarchical government. But during the fall of 1774 and the spring of 1775, the Continental Congress convened, and the resolutions that it passed provoked allegations that a republican spirit had usurped the delegated authority of that body. Equally as important, Thomas Paine's *Common Sense*, the most widely distributed political pamphlet in America throughout the debates over imperial relations, articulated an analysis of the American situation that began with a sustained assault on the institution of constitutional monarchy.[36]

On both sides of the Atlantic, the American Congress was seen as attempting to establish a republican government in place of the constitutional monarchy of Britain. In consequence of that political agenda, imagery from the Roman Republic became appropriate to portray the aspirations of the United States. As early as 1774, the Loyalist writer Daniel Leonard affirmed:

This republican party is of long standing, they lay however, in a great measure, dormant for several years. The distrust, jealousy and ferment raised by the stamp-act, afforded scope for action: At first they wore the garb of hypocrisy; they professed to be friends to the British constitution in general, but claimed some exemptions from their local circumstances; at length [they] threw off their disguise, and now stand confessed to the world in their true characters, American republicans.[37]

Such an allegation became more plausible after the colonial protesters had abandoned the British constitution as the basis for their protests and had publicly denied the merits of monarchical government. Therefore, the

increase in neoclassical imagery was, above all, the result of the gradual but overt emergence of republican virtues, ideals, and principles—political commitments that ultimately transformed the entire American system of government.

THE COLONIES ARE AN INDIAN OR A RATTLESNAKE

The images of the British colonies in America as an Indian and a rattlesnake were similar in their emphasis on indigenous features of an American heritage. As such, both images were especially well suited to express differences between the rebellious colonies and Britain. Further, because the Indian and the snake evoked commonplace ideas about danger, fear, and anxiety, these motifs promoted a view of the colonies as the adversaries of Britain. To judge from the discourse of the time, Indians and snakes had much in common, despite the recognition that a snake was a lower order of animal. These similarities were such that both images promoted more radical expressions of political commitments than the images of the limbs or the child of Britannia.

Even among the well educated, a strong prejudice against Indians was commonplace. While some individuals, such as Thomas Hutchinson and Benjamin Franklin, publicly deplored such attitudes, their comments alluded to a pervasive disdain that characterized white society's attitudes toward Indians, as when Hutchinson remarked, "We are too apt to consider the Indians as a race of beings by nature inferior to us, and born to servitude." In an essay about the middle settlements of North America, the Reverend Andrew Burnaby commented that the colonists' "ignorance of mankind and of learning exposes them to many errors and prejudices, especially in regard to Indians and Negroes, whom they scarcely consider as of the human species."

Because British illustrators used the image of an Indian pervasively to represent the British colonies in America, this usage confirms Fred Junkin Hinkhouse's observation that "though Englishmen regarded the colonies as part of the Empire, they were for the most part ready to receive

them only as inferiors." The image of the snake also dramatized the inferiority of the American colonies, but the colonists themselves chose this motif to portray their convictions about their political and social existence, while the image of the Indian had been imposed upon them for the most part by British illustrators. The colonists employed an image of the rattlesnake partly because they saw themselves as oppressed in a political and social order wherein they were considered inferiors.[38]

Indians and snakes were regarded as dangerous in the discourse of colonists and British government officials, as observed in pamphlets by such diverse writers as Isaac Hunt, Daniel Leonard, and Thomas Pownall. Indeed, to urge support for the cause of the Loyalists, pamphleteers such as Hunt and Leonard reminded the colonists that Britain had provided an able defense against the Indians. More important, because Indians were described as dangerous foes, the use of such an image to represent the American colonies promoted commonplace ideas about them as the adversaries of Britain. Snakes too were depicted as dangerous because they could be poisonous, deceptive, and treacherous. Patriots and Loyalists such as John Hancock and Daniel Leonard condemned the rival political factions for their conniving by describing the opposition as surreptitious vipers, who were poisoning the minds of the people. Because the image suggested the secret endeavors of political factions within America, the image of the rattlesnake evoked thoughts of a deadly adversary.[39]

Images of Indians and snakes were described in discourses to evoke emotions such as fear and anxiety. For instance, Daniel Leonard aroused fear of the Indians to gain support for the Loyalists' cause by indicating that Britain would defend the colonies from Indians' assaults. He referred ominously to "the numerous tribes of savages whose tender mercies are cruelties." The image of a snake fulfilled similar rhetorical functions in other discourses of the period. In *The Royal American Magazine* of December 1774, for instance, "Tertius Cato" remarked: "[S]hall the millions of heroic freeborn Americans, be brought to sue for mercy, for any thing, at the feet of a t[yran]t? O detestable thought! Horrible as a million of snakes folding about the neck, hissing in the ear, breathing in the mouth, and striking their forked, envenomed tongues deep in to the liver." Because the images of the snake and the Indian evoked emotions such as fear and anxiety, and because these images were used to denigrate the political opposition,

these commonplace motifs facilitated a view of the united colonies as an adversary of Britain. Both motifs representing America were well suited to express radical political convictions about the colonies.[40]

THE COLONIES ARE ANIMALS

The representation of the colonies as a snake differed from that of the colonies as an Indian or a child in that a snake was a lower order of animal. Yet the image of the snake designating America stood in stark contrast to most other animals used to represent the American colonies because to the British a rattlesnake had no practical use, at least none that was depicted in the visual communication of the period. In contrast, most of the experimental images designating the colonies as animals emphasized their utility to Britain. The colonies were portrayed as a cow that provided milk, a goose that provided golden eggs, or a kettle of fish that provided nourishment. In other prints the colonies were a beast of burden: a horse, an ass, or a zebra. These innovative and idiosyncratic prints revealed a frankly utilitarian attitude toward the colonies, in keeping with the mercantile expectations of the British government. In these prints the question was never whether the British should use the colonies for their own benefit; rather it was how the British should use the colonies. The prints criticized the ministry for slaughtering the cow instead of milking it, for killing the goose instead of appropriating its golden eggs, for spilling the fish instead of devouring them. While the American colonists consistently portrayed themselves as a snake, an animal that had no practical use, British illustrators were equally consistent about portraying the colonies as various animals that could be used for the advantage of the empire.

Envisioned as an animal, the British colonies in America were neither a society of fellow subjects nor a society with which one could reason. Rather they were a type of property, livestock, which the illustrators in Britain urged the government to use prudently to benefit Britain. For instance, the colonies were a cow in "THE CONTRAST," published probably in 1775. The illustration compared two ways of treating this cow. On the

left, the cow had a stamp tax emblem on its flank. One man tormented the cow by stabbing its hind leg. Already the cow's neck had been slit; its life's blood spurted into a bowl held by another man. In the foreground a third person fed the cow's blood to one English citizen. In contrast, on the right the cow was fed and garlanded with flowers. The cow provided milk for the English people, suggested in the foreground by the full milk pails and by several young girls drinking fresh milk. This way of treating the cow was better than the other way, not simply because the cow was more content but, more important, because it fed several citizens and survived to provide milk in the future. The background imagery amplified the contrast between shortsighted and prudent practices. On the left, a man with an axe chopped down a fruit tree to obtain the harvest, while on the right a boy climbed a fruit tree to gather the produce. A verse beneath the print admonished: "Let us not Cut down the Tree to get at the Fruit. Let us Stroke and not Stab the Cow; for her Milk, and not her Blood, can give us real Nourishment and Strength." The issue was how the colonies should be used: milked for what they were worth or slaughtered.

Before the publication of "THE CONTRAST," the colonies had been compared to cattle in at least two newspaper articles, both published in the *Public Advertiser* of London. On January 2, 1770, the *Advertiser* published three fables, among them one that described the American colonies as cattle: "A HERD of Cows had long afforded Plenty of Milk, Butter, and Cheese to an avaritious Farmer, who grudged them the Grass they subsisted on, and at length mowed it to make Money of the Hay, leaving them to *shift for Food* as they could, and yet still expected to *milk them* as before; but the Cows, offended with his Unreasonableness, resolved for the future *to suckle one another.*"[41] The moral of the story was that the British government's greed, like that of the farmer, could result in a loss of past financial benefits from the American colonies. The story, ascribed to Benjamin Franklin, cautioned the government not to abuse its colonial property, because otherwise the colonies might endeavor to become self-sufficient.

On January 29, an article in the *Advertiser* by "The Colonists' Advocate" also compared the colonies to cattle. By contending that British policies toward America always had been based primarily on self-interest, even during the French and Indian War, the writer ridiculed the argument that the colonies should have been grateful for Britain's self-sacrifice: "It is

an Insult on common Sense to affect an Appearance of Generosity in a Matter of obvious Interest. Is it Generosity that prompts the Rustick to feed his Cow, which yields him Milk? Could we have been enriched by our Colonies, if we had not defended them from the common Enemy?" Envisioned as the equivalent of livestock, the British colonies in America were little more than a source of commodities.[42]

Evidently, the colonists were sensitive to such attitudes, because they compared the colonies to cows to protest their treatment. Richard Wells charged in *A Few Political Reflections Submitted to the Consideration of the British Colonies* that Great Britain's "conduct towards her colonies on the present occasion, must greatly tarnish the glory of her annals. Has she trained up her children, like calves in the stall, to fall bloody victims by her own unnatural cruel hands?" John Dickinson complained in the *Letters from a Farmer in Pennsylvania* that "if when we plow—sow—reap—gather—and thresh—we find, that we plow—sow—reap—gather—and thresh *for others*, whose PLEASURE is to be the SOLE LIMITATION *how much* they shall *take*, and *how much* they shall *leave*, WHY should we repeat the unprofitable toil? *Horses* and *oxen* are content with *that portion of the fruits of their work*, which their owners assign them, in order to keep them strong enough to raise successive crops; but even *these beasts* will not submit to draw for their *masters*, until they are *subdued* by *whips* and *goads*." To Dickinson, the Declaratory Act was "a sentence of bondage" and an effort "to brand us with marks infamously denoting us to be their property, as absolutely as their cattle."[43]

That the colonies were a source of wealth for the British empire was suggested in various prints wherein America was represented in the form of either the hen or the goose that laid golden eggs—a political allegory that had some international appeal, since allusions to it recurred in England, America, and France. For instance, a utilitarian vision of the American colonies characterized "THE WISE MEN *of* GOTHAM *and their* GOOSE," published in London on February 16, 1776, by W. Humphrey (fig. 54). The colonies were the goose that laid the golden eggs, an element of a fable that was employed to criticize the British officials for foolishness and avarice. The illustration contended that the British government should have been content to take the golden eggs as the goose could provide them.

Instead, the government had attempted imprudently to acquire immediate wealth by killing the goose to get all the eggs at once.

The title described the government officials in the illustration as "THE WISE MEN *of* GOTHAM" to affirm an irony: Gotham was a city proverbial for stupid inhabitants. The officials' attitude of disdain toward the colonies was intimated in the foreground, left, where a little dog urinated on a map, inscribed "NORTH AMERICA" and carelessly left on the floor. Foremost among these officials was Lord Bute, dressed in highland garb. His broadsword was poised above his head as he prepared to kill the helpless goose by striking its neck. In the upper left and right corners of the print, verses described the goose:

> A *Rara Avis* to behold
> Who laid each Day an Egg of Gold
> This made them grow immensely rich
> Gave them an avaritious Itch.

The greedy British ministers passed the Stamp Act, which was transformed into a pun in the verses—the "wise" men "stamped" upon the goose:

> They not contented with their Store
> Would Methods vague and strange pursue
> To make the Harmless Bird lay *Two*.
> This Glorious purpose to obtain
> About her Neck they put a Chain,
> and more their Folly to compleat
> They *Stampt* upon her Wings & Feet.

By implication, the goose previously had complied with the plunder of its golden eggs, because now it was being coerced in ways that required restricting its freedom with a chain. In response, the goose struggled for liberty:

> But this had no Effect at all,
> Yet made her struggle, flutter, squall,

And do what every Goose would do
That had her Liberty in view,
When one of more distinguish'd Note
Cry'd D---n her, let us Cut her Throat.
They did, but not an Egg was found
But Blood came pouring from ye Wound.

The ministry lost everything in its impatient and rapacious effort to gain too much too soon. As for the goose, the American colonies, the options were to be plundered for the golden eggs or slaughtered.

In London, the *St. James Chronicle* of March 31, 1774, had previously compared the American colonies to a hen that laid golden eggs: "There is not a Maxim of Religion, Morals, or Politics, more evident than this; that America is a *Hen* that lays her *Golden Eggs* for Britain; and that she must be cherished and supported as Part of the great Family of Britain." The writer did not elaborate, perhaps because he assumed the reader would understand the allegorical implications: British greed would have to give way to more amenable financial policies if Britain was to continue benefiting from the American colonies. The end of the passage shifted to the image of a family, a mixing of metaphors that enabled the writer to portray the British government as supporting a family member even as it plundered a beast. That this fable also had some hold on the imagination of powerful politicians may be illustrated by Horace Walpole's lament in a letter to Horace Mann on June 16, 1779, "We not only killed the hen that laid a golden egg every day, but must defend the very shop where we sold our eggs."[44]

As early as 1765, an American pamphleteer also seems to have thought that the colonies were like the hen that laid golden eggs, but he did not express dissatisfaction that the British government expected golden eggs from the colonies. In 1765, Daniel Dulany commented in *Considerations On The Propriety Of Imposing Taxes In The British Colonies*, one of the most widely distributed pamphlets during the Stamp Act controversy:

The sanguine Genius of one of the *Anti-American* Writers, brings to my Mind the Fable of the Boy and the Hen that laid *Golden Eggs*. He is not

content to wait for the Increase of the *Public Revenue*, by that gradual Process and Circulation of Property, which an Attention to the commercial Interests of the Nation hath establish'd, but is at once for tearing away the Embryo, which, in due Time, might be matur'd into Fullness of Size and Vigour; without ever reflecting, that when the Hen is destroy'd by his Violence, there will be no more GOLDEN EGGS.[45]

Dulany did not object to the British writer's desire to take the "golden eggs," but only to killing the hen in a rash effort to become immediately wealthy. Like most writers during the Stamp Act controversy, Dulany professed to be willing to comply with most of the mercantile expectations of the British government, provided that its profits were realized through conventional trade laws. What Dulany found objectionable was Parliament's effort to tax the colonies without their representation in that government.

Another American writer, Benjamin Franklin, used the image of the hen with golden eggs to inquire in the persona of an Englishman about the prudence of Parliament's policies. In a letter to the *London Chronicle* on August 18, 1768, Franklin remarked, "If . . . the Mother Country gains *two millions* a year by the Colonies, would it not have been wiser to have gone on quietly in the *happy way* we were in, till our gains by those rising and flourishing countries should amount to *three, four*, or *five* millions a year, than by these new-fashioned vigorous measures to kill the goose which lays the golden eggs?" This article, subsequently reprinted in the *Pennsylvania Gazette* on October 12, 1768, questioned the wisdom of the recent duties by drawing upon the commonplace fable, but it too seemed to acquiesce to the expectation that the colonies supply golden eggs for the British empire.[46]

In 1776, yet another engraving, produced and distributed in Paris by F. Godefroy, depicted the British colonies in America as the hen that laid golden eggs. "LES POULLES AUX GUINEES. L'Avarice perd tout en voulant tout gagner" showed a young man in armor reaching upward with his left hand toward an escaping hen (fig. 55). The allegorical allusion to Britain's conflict with America was developed by having the young man hold a symbol of the British government in his right hand, as elaborated in the explanation: *"Un Homme armé tenant le Simbole du Governement sur lequel sont peints trois Léopards, poursuit les Poulles, qui adandonnent le Nid*

où elles pondaient parmi les Roseaux, et volent vers des Fortifications bâlie dans l'interieur du Continent." The subtitle emphasized the usual point: "L'Avarice perd tout en voulant tout gagner." Beneath the subtitle, Godefroy identified the source of the fable as La Fontaine's "Fable de la poulle aux oeufs d'or." French, British, and American image makers used the fable of either the goose or the hen with golden eggs to depict the British colonies in America and to summarize the international situation.

Other visions of the American colonies as fowl occurred in the communication of the period. Americans and English alike depicted the colonies as chicks in need of protection by a mother hen. An anonymous American author explained how the colonies had survived in the past: " 'Tis by the paternal care, the penetrating eye, and the mighty arm of his mother country; who like a hen, when the hawk is near, hovers round her chickens, takes them under her wings, and preserves them from the enemy." Similarly, in 1776, the anonymous author of *Licentiousness Unmask'd* affirmed, "We granted them privileges, we covered them with our wings, we hatched them as a hen does her young."[47]

At least two political prints portrayed the United States as fowl or fish that were food for the British government, an image that suggested the total destruction of the colonies for the nourishment of an empire. Recall that the "STATE COOKS, or THE DOWNFALL of the FISH KETTLE" represented the colonies as fish fit for a feast. Because the government officials wanted to devour the colonies, the print dramatized an extreme form of the utilitarian attitude toward them, suggesting that continued British governance would cause the utter consumption of America (fig. 40). Similarly, "THE ENGLISHMAN IN PARIS," published in London by C. Sheppard in 1777 or 1778, depicted a gluttonous Briton devouring a goose designating America during dinner at a Frenchman's home. The verse beneath the print objected not to the Briton's devouring the goose but rather to his consuming all of the goose without regard for the others at the table:

An American goose came hot from the spit

Egad says the Englishman I'll have a bit

His jaws he applies with wond'rous speed

To devour the viands on which others should feed.

Appalled by the Englishman's lack of social grace, the Frenchman insulted the Briton by describing him as the "brother" of the goose, a lower order of animal. At the same time, the Frenchman's reference to "brother" called to mind the English descent of many Americans and criticized the Briton for consuming them for his own nourishment. Most important, the print expressed British anxiety that France would enter the war to reclaim land in America: France could seek to carve out some of the colonies for itself.

In all of these prints the British colonies in America were represented as animals, while Britain and the British politicians were depicted as humans. The contrast between the images of humans denoting Britain and the images of animals denoting America allowed for the degradation of the colonies such that their subordination or subjugation seemed natural, perhaps even inevitable. The animalification of American society allowed the British to feel justified in exerting authority over the colonies, for humankind's dominion over lesser animals had both a biblical sanction in these predominantly Christian societies and a practical necessity in ordinary life. Such domination was also lucrative. In the animalifications of the American colonies, the impulse to sanction colonial subordination to Britain recurred in a more frankly utilitarian way than suggested by the image of the child. A child was treated well by the parents because of love and affection, not simply because of the work that he or she could perform for the parents.

In at least three British prints, the government's efforts to dominate the American colonies were illustrated as human beings attempting to control a beast of burden. Imagery of America as a beast of burden appeared in Britain as early as June 1755, when the king of Spain was depicted riding "The American Moose-Deer, or away to the River Ohio" in an engraving produced and distributed in Britain by a French engraver. Recall too that on September 8, 1778, "THE CURIOUS ZEBRA" depicted America as an animal that was being saddled, bridled, and steered by various personages. British efforts to subjugate the colonies became transformed into Grenville's efforts to saddle the beast with the stamp tax so that the zebra might bear the burden of placemen and pensioners. America was a beast to be manipulated for gain by the personages in the print.

During the American Revolution, similar imagery was transformed by the colonial rebellion into "*THE HORSE* AMERICA, *throwing his Master,*"

published by William White on August 1, 1779 (fig. 56). As George III fell from the horse's saddle, a French officer with a flag rushed forward to possess the beast. That George III was himself to blame for his fall was implied by the whip with a variety of cutting weapons at the end of the lashes: a tomahawk, a sword, and a bayonet. No beast could have been expected to bear such treatment. These images of the colonies as a horse and of George III as an abusive rider may have been inspired by the Duke of Grafton's comments in the House of Lords. The *Public Advertiser* reported on March 10, 1778, that Grafton had remarked to the effect that "He might compare America, at that Time, to a generous Steed, who had become a little restive, but might by the experienced *Manège* of a good Horseman be easily brought to a gentle Obedience; but when whipped, spurred and harrassed, by a giddy, wanton Rider, become insolent of Controul, and disdained the Reins."[48] The pun on "reigns" would have corresponded to the king, as was suggested by the print. More important, the affirmation of such imagery in Parliament suggested that the animalification of America had some hold on the imagination of prominent political figures in Britain.

Other writers in Britain described America as a beast of burden in the political pamphlets. For instance, the anonymous author of *Remarks On Dr. Price's Observations* held that the Americans were "like some animals, the more they receive discipline, the better they behave, and even at least seem to love you the more." Somewhat similarly, anonymous remarks by a Loyalist, John Mein, published in London over the signature "Sagittarius," suggested how insidious such imagery could become. He compared the colonies to a beast by remarking in the *Public Ledger*, "Like an unbroken colt when first bound in the traces, they will doubtless be very unruly, and will make many efforts to disengage themselves from their enforced subserviency to the laws." But, he added, persistence, time, duty, and affection to their sovereign "will universally prevail amongst them."[49]

That so many British illustrators and writers portrayed the American colonies and later the United States as a beast in the same print with human representations of Britain suggested a mixture of British condescension toward the colonies and a recognition that they were useful to Britain's economy. This attitude was expressed through the image of another human society as an animal, a kind of representation that warranted British dom-

ination over America. Although the animalification of a human society need not have had sinister aspects, such treatment of the American colonies made subordination, subjugation, and consumption seem acceptable, natural, perhaps even ineluctable.

When a human society was identified with the less than human, the resulting vision of that society allowed for the denigration and subjugation of it. That such animalifications of American society held a vivid place in the British vision of America was indicated by the sheer diversity of the illustrators and publishers who chose to depict America as an animal, among them W. Humphrey, C. Sheppard, G. Johnson, Wm. White, W. Richardson, T. Colley, and I. Fielding. Furthermore, influential individuals such as Horace Walpole alluded to America as an animal in correspondence, while parliamentarians such as the Duke of Grafton described America as a horse in speeches before that august body. The animalification of America captured the imagination of these British publishers, propagandists, and politicians. Evidently, this vision of America colored their view of both the problems faced by the British empire and the most proper solutions.

The vision of America as a beast of burden seems to have had some international acceptance. Such images were also produced and distributed in Holland and France. A Dutch illustration portrayed the British colonies in America as a donkey, an animal proverbial for being serviceable, though stubborn and stupid. In "ENGLISCH PRINTET," published probably in 1781, the defiant donkey threw its rider. An explanation beneath the print described "The Englishman on an American ass which flings him to the ground. / Although the long-eared beast is accustomed to bear burdens / He feels this one is too heavy, and will endure no British blows." In France, an allegorical song compared Britain to the master of a horse representing America. The song lyrics, *"Le Cheval et son maître, chanson allégorique"*— transcribed during May 1778 in *Correpondance littéraire, philosophique et critique de Grimm et de Diderot depuis 1753 jusqu'en 1790*—detailed the cruel treatment by the master as well as the horse's revenge. After describing the utility of the horse as well as the abusive treatment by the owner and depicting the horse's brief moment of revenge in the fields as well as the owner's determined effort to punish the animal, the final stanza affirmed the moral and claimed that the allegory described recent actions of the British: If the owner of a horse mistreated it, the horse could

rebel and, worse, the owner could lose the horse altogether by crippling it.[50]

Such animalifications of the colonies were also commonplace in America. One writer for *The Pennsylvania Magazine: or, American Monthly Museum* of March 1776 alluded to the American colonies as a horse to warn the colonists about the British government's motivations. The writer cautioned the colonists to beware the seeming generosity of the British ministers, who were "like a boy who entices a horse with a handful of oats, to fix a bridle in his mouth, and a yoke upon his neck." That the writer chose to portray the colonies as an animal, even though he was concerned for their welfare, suggested in an insidious way his own vision of the colonies' relative stature within the British empire. Other American writers described the colonies as a beast of burden—usually as a horse or an ass—to protest their treatment by Britain. In the August 26, 1765, *Connecticut Courant*, a writer under the pseudonym of "Cato" commented with bitter irony, "O Britain! heap on your Burdens without fear of Disturbance. We shall bear your Yoke as tamely as the overloaded Ass. If we bray with the Pain, we shall not have the Heart to throw off the Load, or spurn the rider." Almost a decade later, in 1774, Samuel Sherwood complained in *A SERMON, Containing, Scriptural Instructions to Civil Rulers, and all Free-born Subjects* that a state of tyranny prevailed whenever rulers regarded "their subjects as an inferior species of beings, made as beasts of burden, for their pleasure or profit." Sherwood professed to "rejoice" that "the most sensible and judicious" of the Americans "know that they are men, and have the spirits of men; and not an inferior species of animals, made to be beasts of burden to a lawless, corrupt administration."[51]

Some prominent Americans indulged in an attitude of condescension toward Britain by depicting America as a human engaged in a struggle with an animal representation of Britain in at least two such instances. But the American image makers elided altogether any implications that Britain was somehow useful to America, as for instance in the works of Paul Revere and Benjamin Franklin. Paul Revere's masthead for the *Massachusetts Spy* portrayed an Indian, representing the United States, engaged in a standoff with a British lion. Benjamin Franklin also developed a design with a human image of the United States engaged in a struggle with animal images of Britain: In his medal *Libertas Americana*, the colonies were the infant

Hercules, who strangled two serpents, representing the British armies at Yorktown and Saratoga. France, in the form of Minerva, protected the infant from a pouncing leopard, yet another animal representing Britain. Otherwise in the visual communication throughout America during the Revolutionary era, the colonies generally were represented as human when the British government was human, or as an animal when the British government was an animal. Apparently the animalification of Britain resulted from intense wartime attitudes toward an enemy.

British image makers typically depicted the animal representing America as somehow useful—a beast of burden, a source of nourishment, a source of wealth. In contrast, the American rattlesnake was portrayed in illustrations neither as desirable food nor as a beast of burden. Few other images of the colonies as animals were not potentially useful to the British. Two possible exceptions portrayed America as a dog. In "THE STATE NURSES," published on October 1, 1781, four dogs represented Holland, France, Spain, and America, all of them yelping to awaken the sleeping British lion. The American dog distinguished itself by demanding "Independence and no Taxation" from a beast that was obviously its physical superior. Because the American dog was black, the color may have implied that it was an especially wicked creature among the otherwise white pack. The American dog urinated on a document labeled "TEA ACT," a conventional way to portray disrespect.

To depict the American colonies as a dog was also disrespectful, as may be ascertained by the text of the other print wherein four dogs represented the same nations, "THE JUNTO. IN A BOWL DISH," published on February 11, 1781. Beneath the print in one of three verses was the comment:

Alas, Old England, must you Fail
And for such Miscreants turn Tail
America Insults the Nation
And says a Fig for your Taxation.

The four dogs swam toward the ministers, who floated in a bowl. The dog representing Holland smoked his pipe even during the pursuit through water.

The American rattlesnake also differed from most of the other animals representing the American colonies in that it appeared innocuous but was deadly to anyone attempting to subdue it. In contrast, most British prints depicted the colonies as docile or relatively harmless creatures. A goose, a dog, a cow, a horse, or a donkey was not a very threatening or formidable image. One exception was the choice of a buffalo in *"Amusement for John Bull & his Cousin Paddy, or, the Gambols of the American Buffalo, in St. James's Street,"* published on May 1, 1783. The buffalo had caused havoc in the street by upturning baskets of fish and bread, which the ministers rushed to gather up for themselves. Because of their selfishness, they ignored the distress of the fallen merchant. The image of the buffalo resembled the image of the rattlesnake in that the animal was deadly and relatively unfamiliar to a British public, but the buffalo's size probably made it unsuitable as a commonplace representation of the colonies, because so large and formidable a creature was obviously something to contend with. The image of the buffalo was not used again to represent America, presumably because of British confidence that the colonies were incapable of attaining independence without outside military assistance. Because of that widespread conviction, the buffalo probably was seen as a hyperbole for American strength. In contrast, the rattlesnake's small size made it appear vulnerable, even though it was deadly.

Finally, the rattlesnake was indigenous to America and therefore differed fundamentally from the various barnyard images of America. Most innovative and idiosyncratic representations of America as an animal in British prints employed familiar and approachable creatures. Exceptions would have been the images designating America as a buffalo or a zebra, both of which were exotic creatures to the British public. But the buffalo was unsuitable because it exaggerated American strength, while the zebra was unsuitable because it was indigenous to Africa. The rattlesnake was foreign to British soil, and the serpentine motif was selected by the colonists themselves to suggest deep divisions between America and Britain.

The image of the rattlesnake was, then, the most radical of the commonplace motifs that represented the American colonies and later the United States. The most radical of the colonial leaders consistently drew upon the image of the snake in their advocacy of protest and rebellion; colonists such as Isaiah Thomas, William Goddard, John Holt, William Bradford, and

Christopher Gadsden all employed the image. Both the rattlesnake and the Indian were indigenous to America. Both images stressed differences between the American colonies and Britain. Both were dangerous to the British, and both conveyed a threatening colonial stance toward the British. But the images of the Indian and the rattlesnake differed in at least three respects that contributed to making the rattlesnake a more radical motif than the Indian. However much the British treated the Indian with condescension because they regarded Indians as childlike in their cultural development, they still considered the Indian a human, which allowed for some possibility for reasoning during a dispute. In contrast, a rattlesnake was incapable of any rational thought, since the animal reacted by instinct for its survival. An Indian was useful to the British because the Indian provided labor and commerce. In contrast, a rattlesnake had no utility of any kind to the British, at least none that was portrayed in the illustrations wherein it represented the American colonies. Finally, the British and Europeans initially chose to represent the American colonies with the images of the child and the Indian. In contrast, the colonists themselves initially chose the image of the snake.

CONCLUSION

Certain tensions surfaced in the imagery designating those British colonies in America that became the United States during the Revolutionary era, centering around the general issues of unity and diversity: tensions between mutual benefits through cooperation and individual benefits through local control, between one locus of supreme authority and several loci of diffused authority. At the imperial level, the unity or separateness of the American colonies from the rest of the British empire was at issue. At the intercolonial level, the unity or separateness among the colonies themselves was a matter in doubt. Related to these most fundamental concerns was another set of tensions that centered around the heritage of the colonial community. Images of indigenous forms of life, such as a rattlesnake or an Indian, suggested a special American heritage to emphasize points of difference be-

tween the colonies and the British empire. Other images, such as the child or the limbs of Britannia, stressed a British ancestry to identify the colonies with a special British heritage. Still other imagery, especially after 1775, portrayed the colonies as having neoclassical features, as though to avoid connecting them with a corrupt British government on the one hand or a reputedly uncivilized people on the other. Yet a third locus of imagistic tension—in addition to those of unity and heritage—had to do with the stature of the American colonies in relation to the rest of the British empire. Most of the images in the visual communication suggested that the colonies were inferior in comparison with Britain: a wayward child, a foreign Indian, a lower order of animal. And yet, because the colonies were useful commercially and politically, and because they were fighting initially to attain their rights under the British constitution and later to establish their independence, the question of stature became transformed into the images of a child who has attained adulthood, an Indian who has broken its chains, a rattlesnake that has struggled with a lion and survived.

If the word "conservative" is taken to mean a desire to perpetuate the existing relationships of power within the British empire, regardless of hardships, dissatisfactions, or felt injustices, then the various resolutions of the imagistic tensions during the period gravitated toward a certain range along a spectrum of political sentiments. That is not to claim that the various images designating America could not have been appropriated by certain factions for their political use. Rather it is to say that the congeries of commonplace ideas entailed by each motif made it potentially more useful than some of the others to express a corresponding range of political sentiments.

The images of the American colonies as the limbs of Britannia, the child, the Indian, and the snake were alike in that the images all assumed that a community, nation, or empire could be portrayed as a living organism, a singular body politic. But these motifs differed from the others in the incipient inferences and entailments that constrained each motif's political usages. The image designating the American colonies as the limbs of Britannia was the most conservative, because it denied all prospect of an autonomous and healthy American community and insisted that the only prospect for survival of the American colonies was through continued subordination within the British empire. In contrast, all three of the other

commonplace motifs—the child, the Indian, and the snake—affirmed that the American colonies formed a unified and complete entity apart from the rest of the British empire. As such, the American community had the potential to live its own life, separated from Britain, even though it could possibly become subdued by another power. Yet none of these three motifs went so far as to suggest that each colony formed its own complete community, and so they differed fundamentally from the images that designated each colony as a separate person or animal.

The images of the colonies as the limbs or the child of Britannia stressed a British heritage, while the images of the colonies as an Indian or rattlesnake stressed an American one. This difference was politically significant because the former suggested points of unity or identification within the British empire, while the latter suggested points of separation or difference within the empire. Accordingly, the images representing America as the limbs or the child of Britannia were potentially more conservative than those representing the colonies as the Indian or the rattlesnake. Even so, the image of the child was less conservative than the image of the limbs designating America in certain respects. The child had a mind and will of its own; the limbs did not. The child's subordination was limited temporally and was contingent upon proper parental guidance and conduct; the limbs' subordination was permanent and ineluctable.

The image of the Indian designating the American colonies resembled the image of the child in that both were human, a feature that distinguished these motifs from the image of the rattlesnake. But because a child was bound to a parent by ties of affection, blood, duty, and language, and because a child could not assault its parent without some sense of guilt or remorse, the image of the child was more conservative than the image of the Indian. The Indian was not ordinarily constrained by such moral ties, except when he or she was described as the child of Britannia. Further, because the Indian was renowned for his abilities in hunting and war, the image of the Indian was regarded as more formidable than the image of the child in designating America. Although the British regarded neither the child nor the Indian as their equal in reasoning ability, the possibility for negotiation existed with both, and so these motifs were in that sense more conservative than was the rattlesnake. Furthermore, because the child and the Indian were useful to Britain in that they could provide valued

labor, money, and commerce, these motifs were more conservative than the image of the snake, since a snake served no useful purpose to Britain.

The image of the snake was the most radical of the commonplace motifs that portrayed the colonies as a united community. Unlike the limbs, whose survival depended upon remaining connected to the body politic, the snake survived by warning its political adversary not to tread upon it, because otherwise it could be deadly. Unlike the image of the child, the image of the rattlesnake was bound by no moral ties to Britain: It could attack with neither guilt nor remorse. Unlike the images of the child or the Indian, the image of the rattlesnake depicted an animal with which any attempt to reason was impossible. The rattlesnake responded by instinct for its survival. The snake had the potential to be sly, cunning, or guileful under oppressive circumstances. It could survive through concealment and deception. Finally, while the images of the colonies as a child and an Indian were developed initially by the British and the Europeans to represent America, the image of the snake was chosen initially by the colonists to represent themselves.

Most of the experimental images designating the American colonies supported the same commonplace ideas about the colonies that were emphasized by the dominant motifs—the snake, the Indian, and the child. Many of the experimental images of the colonies as a person or an animal resembled the dominant motifs in that they implied that the American colonies formed a united community. They also suggested that the colonies had the potential of a youth and that they were the victim of a corrupt British government. Yet some of these images supported commonplace ideas that were not especially emphasized by the dominant motifs. Images of America as an animal stressed a utilitarian attitude toward the colonies, and other images of neoclassical personages alluded to the ancient Roman Empire and Republic. The images of the colonies as an Indian or a child stressed that they were useful to Britain, because they provided labor and commerce. But the utilitarian images of America as various animals differed in the degree of authority that they granted to Britain's government, because an animal could be slaughtered and devoured without insinuations of cannibalism or infanticide. The image of the colonies as an Indian sometimes suggested neoclassical allusions when the Indian wore neoclassical garb or appeared in a neoclassical setting. Yet the neoclassical personi-

fications of America suggested more emphatically the decline of the British empire in ways analogous to the decline of the Roman Empire, and certain neoclassical personifications of the United States suggested that the government was constructing a new Rome in America, founded upon republican virtues, ideals, and principles. These images designating the emerging nation, like the more dominant motifs, promoted political ends because they emphasized certain attributes of the emerging nation while obscuring other attributes.

When these visual metaphors captured the imagination, when their fictional qualities went unnoticed, they had the potential to shape an individual's and a culture's view of political life and its circumstances. If one believed, as did many Patriots in America, that the political existence of the British colonies in America resembled the life of a rattlesnake, one would have sought to let it live. And if Britain threatened to kill the body politic, one would have opposed her in a struggle to survive. Conversely, if one believed that the existence of the colonies resembled that of the arms and legs of Britannia, as did many Loyalists in America and most political figures in Britain, one would have believed that survival itself depended upon perpetuating the connections within the British empire, and one would have fought to end the protests, the rebellion, and, finally, the independence of the United States. Through such imaginative investments by the individual in the community, both sides of the imperial dispute could envision themselves as arguing, demanding, and finally killing in an endeavor to let the American colonies live.

NOTES

ABBREVIATIONS

AAJ — *American Art Journal*

AAS — American Antiquarian Society

AHR — *American Historical Review*

Am. Cont. — Thomas R. Adams, *American Controversy: A Bibliographical Study of the British Pamphlets about the American Disputes, 1764–1783* (Providence, 1980)

Am. Ind. — Thomas R. Adams, *American Independence: The Growth of an Idea; A Bibliographical Study of the American Political Pamphlets Printed between 1764 and 1776 Dealing with the Dispute Between Great Britain and her Colonies* (Providence, 1965)

Am. Rev. — *American Revolution in Drawings and Prints; A Checklist of 1765–1790 Graphics in the Library of Congress*, compiled by Donald Cresswell (Washington, D.C., 1975)

APS — American Philosophical Society

APSR — *American Political Science Review*

AQ — *Art Quarterly*

BEP — *Boston Evening-Post*

BF Papers — *Papers of Benjamin Franklin*, ed. Leonard W. Labaree (New Haven, 1959–present)

BG — *Boston Gazette*

BNYPL — *Bulletin of the New York Public Library*

BWNL — *Boston Weekly News-Letter*

Catalogue — Mary Dorothy George, *Catalogue of Prints and Drawings Preserved in the British Museum*, 11 vols. (London, 1870–1954). The title changes with vol. 5 from *Political and Personal Satires* to *Catalogue of Political and Personal Satires in the British Museum*

CC — *Constitutional Courant*

CG — *Constitutional Gazette*

CJ — *Connecticut Journal*

CWF — Colonial Williamsburg Foundation

ECS — *Eighteenth-Century Studies*

EJ&NHP — *Essex Journal and New-Hampshire Packet*

Engravings	Clarence S. Brigham, *Paul Revere's Engravings* (Meriden, Conn., 1969)
FJNHG	*Freeman's Journal, or New Hampshire Gazette*
Flag	George H. Preble, *Origin and History of the American Flag*, new ed., 2 vols. (Philadelphia, 1917)
JAH	*Journal of American History*
LC	*London Chronicle*
LCPhila	Library Company of Philadelphia
MG	*Massachusetts Gazette*
MG&BNL	*Massachusetts Gazette and Boston News-Letter*
MG&BPB	*Massachusetts Gazette and Boston Post-Boy*
MHS	Massachusetts Historical Society
MMAB	*Metropolitan Museum of Art Bulletin*
Money	Eric P. Newman, *The Early Paper Money of America* (Racine, Wis., 1967)
MS	*Massachusetts Spy*
NM	*Newport Mercury*
NYG	*New-York Gazette*
NYGR	*New-York Gazetteer*
NYJ	*New-York Journal*
NYM	*New-York Mercury*
PA	*Public Advertiser*
PAC	*Pennsylvania Chronicle*
PAG	*Pennsylvania Gazette*
PAH	*Perspectives in American History*
PAJ	*Pennsylvania Journal*
PAL	*Pennsylvania Ledger*
PAMHB	*Pennsylvania Magazine of History and Biography*
PAP	*Pennsylvania Packet*
PAPS	*Proceedings of the American Philosophical Society*
PCSM	*Publications of the Colonial Society of Massachusetts*
PG	*Providence Gazette*
PL	*Public Ledger*
PMHS	*Proceedings of the Massachusetts Historical Society*
PULC	*Princeton University Library Chronicle*
QJS	*Quarterly Journal of Speech*
RG	*Royal Gazette*
SCG	*South Carolina Gazette*

Standards	Edward W. Richardson, *Standards and Colors of the American Revolution* (Philadelphia, 1982)
St.JC	*St. James Chronicle*
VG	*Virginia Gazette*
WEP	*Whitehall Evening Post*
WMQ	*William and Mary Quarterly*
WP	*Winterthur Portfolio*

PREFACE

1. Bernard Bailyn, *The Ideological Origins of the American Revolution* (Cambridge, Mass., 1967).

2. Mary Dorothy George, *English Political Caricature to 1792: A Study of Opinion and Propaganda* (Oxford, 1959), 1. Philip G. Davidson, *Propaganda and the American Revolution, 1763–1783* (Chapel Hill, 1941), 173.

3. George Richardson, *Iconology: or, a Collection of Emblematical Figures Containing Four Hundred and Twenty-Four Remarkable Subjects, Moral and Instructive; in Which Are Displayed the Beauty of Virtue and the Deformity of Vice,* 2 vols. (London, 1777–79), 1:i.

4. Stephen E. Lucas, *Portents of Rebellion: Rhetoric and Revolution in Philadelphia, 1765–1776* (Philadelphia, 1976); Ronald F. Reid, *The American Revolution and the Rhetoric of History* (Annandale, 1978); Kurt W. Ritter and James R. Andrews, *The American Ideology: Reflections of the Revolution in American Rhetoric* (Annandale, 1978); Barbara A. Larson, *Prologue to Revolution: The War Sermons of the Reverend Samuel Davies: A Rhetorical Study* (Annandale, 1978); John F. Wilson, "Jonathan Boucher's Farewell Sermon," in *Language and Cognition,* ed. Lawrence J. Raphael et al. (New York, 1984), 269–81; Judy Hample, "The Textual and Cultural Authenticity of Patrick Henry's 'Liberty or Death' Speech," *QJS* 63 (October 1977): 298–310; Kurt W. Ritter, "Confrontation as Moral Drama: The Boston Massacre in Rhetorical Perspective," *Southern Speech Communication Journal* 42 (Winter 1977): 114–36; J. Vernon Jensen, "British Voices on the Eve of the American Revolution: Trapped by the Family Metaphor," *QJS* 63 (February 1977): 43–50.

5. Jules Prown, "Mind in Matter: An Introduction to Material Culture Theory and Method," *WP* 17 (Spring 1982): 1–2.

6. Thomas J. Schlereth, "Material Culture and Cultural Research," in *Material Culture: A Research Guide*, ed. Thomas J. Schlereth (Lawrence, Kansas, 1985), 12.

7. Robert Blair St. George, *Material Life in America, 1600–1860* (Boston, 1988), 8. Simon J. Bronner, "The Idea of the Folk Artifact," in *American Material Culture and Folklife: A Prologue and Dialogue*, ed. Simon J. Bronner (Ann Arbor, 1985), ix, 3, 13.

8. Stuart Atkins, "Motif," in *Dictionary of the History of Ideas*, ed. Philip P. Wiener (New York, 1973), 3:235.

INTRODUCTION

1. Michael Walzer, *The Revolution of the Saints: A Study in the Origins of Radical Politics* (Cambridge, Mass., 1965), 150, and David G. Hale, *The Body Politic: A Political Metaphor in Renaissance English Literature* (The Hague, 1971), 41–42.

2. For a study of how verbal symbols expressed the belief in an American community, see Richard L. Merritt, *Symbols of American Community, 1735–1775* (New Haven, 1966).

3. [Daniel Leonard], *Massachusettensis* [(Boston, 1775)], Letter IX, February 20, 1775, p. 77, and Letter II, December 19, 1774, p. 15. [Daniel Leonard], *The Origin Of The American Contest With Great-Britain, Or The present political State of the Massachusetts-Bay, in general, And The Town of Boston in particular* (New-York, 1775). Janice Potter points out that Loyalists did not tend to use popular symbols, rituals, and mass rallies, in *The Liberty We Seek: Loyalist Ideology in Colonial New York and Massachusetts* (Cambridge, Mass., 1983), 149–50.

4. Contemporaneous records about the portraits of Conway and Barré include *LC*, November 5–7, 1765, p. 440, col. 1; *PL*, November 7, 1765, p. 1066, col. 4; *The Annual Register . . . for 1765*, 2nd ed. (London, 1778), 51; *BG*, January 26, 1767, p. 3, col. 1; Edward Barnard, *The New, Comprehensive and Complete History of England* (London, 1782), 666. For the portraits and statues of William Pitt, see *VG* (Purdie), April 20, 1769, p. 2, col. 2; *SCG*, May 24, 1770, p. 2, col. 3, and July 3, 1770, p. 3, col. 1; *NYJ*, September 13, 1770, p. 143, col. 2. After the repeal of the Stamp Act, portraits of Pitt

were displayed from private homes in Boston, *MG Extraordinary*, May 22, 1766, p. 2, col. 2.

5. For background on the portraits of Thomas Hutchinson, James II, and Charles I, see Bernard Bailyn, *The Ordeal of Thomas Hutchinson* (Cambridge, Mass., 1974), 4, 138. For the mutilated portrait of Hutchinson, see Peter O. Hutchinson, ed., *The Diary and Letters of His Excellency Thomas Hutchinson, Esq.*, 2 vols. (Boston, 1884–86; reprint ed., New York, 1971), 1:565.

6. Arthur S. Marks, "The Statue of King George III in New York and the Iconology of Regicide," *AAJ* 13 (1981): 61–82; Roger Wolcott, "Erection and Destruction of the Statue of George III, in the City of New York," *PMHS*, 2nd ser., 4 (1887–89): 291–98. On November 22, 1777, Thomas Hutchinson alluded to the head from the destroyed statue of George III in *Diary and Letters*, 2:167. For the destruction of the Royal Arms in American cities, letter from Abigail Adams to John Adams, July 21, 1776, in Lyman H. Butterfield, ed., *Adams Family Correspondence*, 4 vols. (Cambridge, Mass., 1963–73), 2:56; *FJNHG*, July 27, 1776, p. 3, col. 1; *PG*, July 27, 1776, p. 3, col. 2; *CG*, August 3, 1776, p. 2, col. 1; *PAP*, July 25, 1776, p. 4, col. 1. Edmund G. Slafter, "Royal Memorials and Emblems in Use in the Colonies before the Revolution," *PMHS*, 2nd ser., 4 (1887–89): 239–64, esp. 253.

7. Herbert M. Atherton, *Political Prints in the Age of Hogarth: A Study of the Ideographic Representation of Politics* (Oxford, 1974), 26–27.

8. David Alexander and Richard T. Godfrey, *Painters and Engraving: The Reproductive Print from Hogarth to Wilkie* (New Haven, 1980), 6–7. Authoritative surveys of the political prints include Mary D. George's *English Political Caricature to 1792: A Study of Opinion and Propaganda* (Oxford, 1959), 1; Atherton, *Political Prints*; and Michel Jouve, *L'Âge d'or de la caricature anglais* (Paris, 1983), 62.

9. The most authoritative discussion of the role of pamphlets in American political life is Bernard Bailyn, *The Ideological Origins of the American Revolution* (Cambridge, Mass., 1967). The most useful bibliographies of pamphlets during the period are both by Thomas R. Adams, *Am. Cont.* and *Am. Ind.*

10. The woodcut portrait of Richard Mather, prepared by John Foster in 1670, is generally accepted as the first American print. Clarence S. Brigham, "Introduction," in Lawrence C. Wroth and Marion W. Adams, *American Woodcuts and Engravings, 1670–1800* (Providence, 1946), 5–6. Marion B. Stowell, *Early American Almanacs: The Colonial Weekday Bible* (New York, 1977).

Little has been written about the political role of almanacs in England. For a survey, see Bernard Capp, *English Almanacs, 1500–1800* (Ithaca, 1979).

11. The best resource about magazine illustrations in America during the period is Benjamin M. Lewis, *A Guide to Engravings in American Magazines, 1741–1810* (New York, 1959). Philip G. Davidson, *Propaganda and the American Revolution, 1763–1783* (Chapel Hill, 1941), 187, and Brigham, *Engravings.*

12. Stephen Botein, "Printers and the American Revolution," in *The Press & the American Revolution*, eds. Bernard Bailyn and John B. Hench (Worcester, 1980), 41; also, Edward C. Lathem, comp., *Chronological Tables of American Newspapers, 1690–1820; Being a Tabular Guide to Holdings of Newspapers Published in America Through the Year 1820* (Barre, Mass., 1972). Clarence S. Brigham, *History and Bibliography of American Newspapers, 1690–1820*, 2 vols. (Worcester, 1947). Elizabeth C. Reilly, *A Dictionary of Colonial American Printers' Ornaments and Illustrations: A Tribute to Alden Porter Johnson* (Meriden, Conn., 1975).

13. For American paper currency during the Revolutionary era, see Newman, *Money.* For the treasury notes of the period, consult William G. Anderson, *The Price of Liberty: The Public Debt of the American Revolution* (Charlottesville, 1983). For coins, see Q. David Bowers, *The History of United States Coinage as Illustrated by the Garrett Collection* (Wolfeboro, N.H., 1983). For the thirteen interlinked rings, see David P. McBride, "Linked Rings: Early American Unity Illustrated," *Numismatist* (1979): 2374–93.

14. Jouve, *L'Âge d'or*, 54. R. T. H. Halsey, " 'Impolitical Prints': The American Revolution as Pictured by Contemporary English Caricaturists," *BNYPL* 43 (1939): 796. Douglass Adair, "The Stamp Act in Contemporary English Cartoons," *WMQ*, 3rd ser., 10 (1953): 538–42. The most useful catalogs of prints are George, *Catalogue*; Cresswell, comp., *Am. Rev.*; Joan D. Dolmetsch, *Rebellion and Reconciliation: Satirical Prints on the Revolution at Williamsburg* (Williamsburg, 1976); Bibliothèque Nationale, *Collection de Vinck, Un siècle d'histoire de France par l'éstampe, 1770–1871*, Tome 1, *Ancien régime* (Paris, 1909–29).

15. E. P. Richardson, "The Birth of Political Caricature," *Philadelphia Printmaking*, ed. Robert F. Looney (West Chester, Pa., 1977), 71–90, and "Stamp Act Cartoons in the Colonies," *PAMHB* 96 (1972): 275–97. Georgia B. Bumgardner and Mason I. Lowance, Jr., eds., *Massachusetts Broadsides of the*

American Revolution (Amherst, 1976). Georgia B. Bumgardner, ed., *American Broadsides: Sixty Facsimiles dated 1620 to 1800 Reproduced from Originals in the American Antiquarian Society* (Barre, Mass., 1971).

16. The authoritative references for the flags during the Revolutionary era are Preble, *Flag*, and Richardson, *Standards*.

17. For examples of the housewares, see Robert H. McCauley, *Liverpool Transfer Designs on Anglo-American Pottery* (Portland, 1942), nos. 38, 53, 152a, 152b, 154, 164, 182, 263. For decorative porcelain produced in China for the American market after the war, see Jean McClure Mudge, *Chinese Export Porcelain for the American Trade, 1785–1835* (New York, 1962), 107, 112. For the textiles, Hugh Honour, *The European Vision of America* (Cleveland, 1975), no. 214, and Henry-René d'Allemagne, *La Toile imprimée et les indiennes de traite* (Paris, 1942), pl. 136, 146.

18. Davidson, *Propaganda*, 188; *VG* (Purdie), June 6, 1766. *MG&BNL*, May 22, 1766, p. 2, col. 2. *BG*, March 14, 1774, p. 1, col. 1. Du Simitière's sketch, LCPhila.

19. Carl Zigrosser, "The Medallic Sketches of Augustin Dupré in American Collections," *PAPS* 101 (1957): 535–50; Winfried Schleiner, "The Infant Hercules: Franklin's Design for a Medal Commemorating American Liberty," *ECS* 10 (1976–77): 235–44; Lester C. Olson, "Benjamin Franklin's Commemorative Medal, *Libertas Americana*: A Study in Rhetorical Iconology," *QJS* 76 (1990): 23–45.

20. For medals during the Revolutionary era, see Charles W. Betts, *American Colonial History Illustrated by Contemporary Medals* (Boston, 1972); Laurence Brown, *A Catalogue of British Historical Medals, 1760–1960* (London, 1980), vol. 1, *The Accession of George III to the Death of William IV*; Charles Saunier, "Les Médailles françaises de l'indépendance américaine," *Les arts* 172 (1918): 2–6. Zigrosser, "Medallic Sketches," 538, 545, 547. Letter from John F. Mercer to Daniel Morgan, April 24, 1783, in *Letters of Members of the Continental Congress*, 8 vols., ed. Edmund C. Burnett (Washington, D.C., 1921–34), 7:151.

21. For commentary about a wide range of media in America, Kenneth Silverman, *A Cultural History of the American Revolution: Painting, Music, Literature, and the Theatre in the Colonies and the United States from the Treaty of Paris to the Inauguration of George Washington, 1763–1789* (New York, 1976; reprint, New York, 1987). A general reference for visual works produced in

Britain and continental Europe is Hugh Honour, *The New Golden Land: European Images of America from the Discoveries to the Present Time* (New York, 1976).

22. Potter, *The Liberty We Seek*, 149-50.

CHAPTER 1. THE COLONIES ARE A SNAKE

1. John Milton, *Paradise lost. A Poem Written in Ten Books* (London, 1667), bk. 1, sec. 1, 34-35. *PAG*, September 7, 1774, p. 1, col. 2. Jonathan Edwards, "Sinners in the Hands of an Angry God," in *The Works of President Edwards*, 10 vols., ed. Sereno E. Dwight (New York, 1830), 7:170. The King James Bible, published in 1611 and the only widely available English translation until the early 1900s, was the version with which most colonists were likely to be familiar. The serpents in the Bible usually represent evil, but in some passages the serpent is a sign of God's forgiveness, and in others it is a sign of God's presence, perhaps even his blessing; examples include Exodus 4:2-4, Exodus 7:9-10, Mark 16:18, and Luke 10:19.

2. The most comprehensive discussion of the segmented snake is Albert Matthews, "The Snake Devices, 1754-1776, and the *Constitutional Courant*, 1765," *PCSM* (Boston, 1907), 11:409-53.

3. For Revere's prints, Brigham, *Engravings*, 137-38, pl. 69-70.

4. *CC*, September 21, 1765, p. 1, col. 3 [Evans 9941]. Bernard Bailyn, *The Ideological Origins of the American Revolution* (Cambridge, Mass., 1967), 99. John Hancock, *An Oration; Delivered March 5, 1774, at the Request of the Inhabitants of the Town of Boston* (Boston, 1774), 15.

5. *PAJ*, December 27, 1775, p. 1, col. 1. John Vinycomb, *Fictitious and Symbolic Creatures in Art with Special Reference to Their Use in British Heraldry* (London, 1906), 122. In what is probably an apocryphal story, John Paul Jones was not pleased with the rattlesnake imagery on the flag. He ostensibly wrote, "For my own part I could never see how or why a venomous serpent could be the combatant emblem of a brave and honest folk fighting to be free. Of course, I had no choice but to break the pennant as it was given to me. But I always abhorred the device and was glad when it was discarded for one much more symmetrical as well as appropriate, a year or so later." Nicholas Smith, *Our Nation's Flag: In History and Incident*, 2nd ed. (Milwaukee, 1908), 30; Peleg D. Harrison, *The Stars and Stripes and Other American Flags* (Boston, 1906), 105.

Alfred M. Cutler, *The Real First National Flag: An Introductory Study of the Evolution of the Flag of the United States* (Somerville, Mass., 1929), 43–44, has challenged the veracity of the story.

6. *American Letters in the Wedgwood Museum* (East Ardsley, Wakefield, Yorkshire, 1970), Letter 27 (E-18776-25). "Notes on the Exhibition," in *Benjamin Franklin and His Circle: A Catalogue of an Exhibition at the Metropolitan Museum of Art* (New York, 1936), 88, no. 168.

7. Frank H. Sommer, "Emblem and Device: The Origin of the Great Seal of the United States," *AQ* 24 (1961): 63–65. Verien's name has two alternative spellings in the 1724 edition of *Recueil*—on the frontispiece, "Verien," while on the title page, "Verrien." In that edition, "Se rejoindre ou mourir" was printed on pl. 59 in a general section, which suggested that the snake device had a more ancient origin, in Latin, Spanish, or Italian texts. "Se rejoindre ou mourir" also appeared in Verien's earlier book, *Livre curieux et utile pour les sçavans et artistes. . . . Accompangé d'un très grand nombre de dévices, emblêmes, médailles et autre figures hieroglyfiques* (Paris, 1685?), pl. 62.

8. Most historians have attributed "JOIN, or DIE" to Benjamin Franklin, because he was an editor of *PAG*. Matthews, "Snake Devices," 409, has suggested that the evidence is not conclusive, because David Hall was Franklin's partner in the publication of *PAG*. Leonard W. Labaree commented that "there is no documentary evidence of Franklin's personal responsibility for the cartoon, but that it was his idea appears probable," *BF Papers*, 5:272; letter from BF to Partridge, 5:273; however, see letter from Hutchinson to BF, 12:380–81. Martha G. Falls, "Heraldic and Emblematic Engravers of Colonial Boston," in *Boston Prints and Printmakers, 1670–1775, A Conference Held by the Colonial Society of Massachusetts, 1 and 2 April 1971*, vol. 46, *PCSM* (Meriden, Conn., 1973), 218, has speculated that James Turner cut the woodcut of "JOIN, or DIE" for *PAG*.

9. "JOIN, or DIE" appeared in *PAG*, May 9, 1754, p. 2, col. 1; *NYG*, May 13, 1754, p. 2, col. 3; *NYM*, May 13, p. 2, col. 3; *BG*, May 21, p. 3, col. 1; *BWNL*, May 23, p. 1, col. 1. Allusions to "JOIN, or DIE" occurred in *VG*, July 19, 1754, p. 3, col. 1, and *SCG*, August 22, 1754, p. 2, col. 2.

10. Benjamin Franklin, *Benjamin Franklin's Autobiographical Writings*, ed. Carl Van Doren (New York, 1945), 87.

11. *PAG*, May 9, 1754, p. 2, col. 1.

12. *NYG*, May 13, 1754, p. 2, col. 2; *NYM*, May 13, 1754, p. 2, col. 2; *BWNL*, May 23, 1754, p. 1, col. 1; *BG*, May 20, 1754, p. 2, col. 2, through p. 3, col. 1; *BEP*, May 20, 1754, p. 4, col. 1; *SCG*, May 28–June 4, 1754, p. 1, cols. 2–3.

13. *SCG*, June 11–20, 1754, p. 1, col. 1; *BG*, August 13, 1754, p. 3, col. 1. Lois K. Mathews, "Benjamin Franklin's Plans for a Colonial Union, 1750–1775," *APSR* 8 (1914): 393–412, esp. 399.

14. Isaiah Thomas, *The History of Printing in America*, 2 vols. (Worcester, 1810), 2:328–29.

15. *SCG*, August 22, 1754, p. 2, col. 2; *VG*, July 19, 1754.

16. For evidence supporting the attribution to William Goddard, see Thomas, *History of Printing*, 2:323; Matthews, "Snake Devices," 440–43; Ward L. Miner, *William Goddard: Newspaperman* (Durham, N.C., 1962), 50–52. *BEP*, October 7, 1765, p. 3, col. 1; *NM*, October 7, 1765, p. 2, cols. 1–3.

17. The British newspaper was the *Public Ledger*, November 16, 1765, p. 1, col. 4, and p. 2, col. 4. Thomas, *History of Printing*, 2:322. Thomas's remarks were made about the *Constitutional Gazette*, not the *Constitutional Courant*. This was corrected in a later edition, published in 1874, by changing "Gazette" to "Courant" (Matthews, "Snake Devices," 437).

18. *CC*, September 21, 1765, p. 2, cols. 2–3, [Evans 9941].

19. *CC*, September 21, 1765, p. 2, col. 3.

20. According to Merrill Jensen, *Tracts of the American Revolution, 1763–1776* (Indianapolis, 1978), the pamphlet attributed to Daniel Dulany, *Considerations On The Propriety Of Imposing Taxes In The British Colonies, For the Purpose of raising a Revenue, by Act Of Parliament* ([Annapolis], 1765), was "the first of the period to circulate widely throughout the colonies" (94). For examples of the pattern, see [Dulany], *Considerations*, 28, and [John Dickinson], *Letters from a Farmer in Pennsylvania, to the Inhabitants of the British Colonies* (Philadelphia, 1768), 31–32.

21. [Benjamin Church], *An Elegy to the Infamous Memory of Sr. F---- B----* ([Boston], 1769), verso. For a description of the political atmosphere in Boston in 1769, when Church published his pamphlet, consult Bernard Bailyn, *The Ordeal of Thomas Hutchinson* (Cambridge, Mass., 1974), esp. 127–36.

22. *NYG*, January 19, 1775, p. 2, col. 2.

23. Thomas, *History of Printing*, 2:252.

24. *NYG*, August 25, 1774, p. 3, col. 2.

25. *PAJ*, August 31, 1774, p. 3, col. 2.

26. *MS*, September 15, 1774, p. 3, col. 3.

27. *NYJ*, September 15, 1774, p. 4, col. 1.

28. *NYJ*, September 29, 1774, p. 4, col. 1.

29. For a description of Isaiah Thomas's character, see Bernard Bailyn and John B. Hench, eds., *The Press & The American Revolution* (Worcester, 1980), esp. 7.

30. [Daniel Leonard], *Massachusettensis* [(Boston, 1775)], Letter III, January 2, 1775, 35, 27, 74, 23, 107 [Evans 14157].

31. *The Patriots of North-America: A Sketch. With Explanatory Notes* (New-York, 1775), 4–5, 36.

32. Jonathan Boucher, *A View of the Causes and Consequences of the American Revolution; in Thirteen Discourses, Preached in North America between the Years 1763 and 1775* (London, 1797), 349. [Joseph Galloway], *A Candid Examination Of The Mutual Claims Of Great-Britain, And The Colonies: With A Plan Of Accommodation, On Constitutional Principles* (New-York, 1775), 27.

33. Thomas, *History of Printing*, 2:307–8.

34. Sinclair Hamilton, " 'The Earliest Device of the Colonies' and Some Other Early Devices," *PULC* 10 (1949): 117–23. The image from the journal of the Congress recurred on a flag, the Headman Color of 1778, Richardson, *Standards*, 45–56, pl. 12.

35. Vinycomb, *Fictitious and Symbolic Creatures*, 115.

36. *NYG*, January 19, 1775, p. 2, col. 2.

37. Preble, *Flag*, 1:205–6, 216, opposite 193; 2:627; Richardson, *Standards*, 2, 16, 20, 22, 62, 86, 109, 115–16, 118–20, 125–26, 128, 136. Hugh F. Rankin, "The Naval Flag of the American Revolution," *WMQ*, 3rd ser., 11 (1954): 339–53.

38. Preble, *Flag*, 1:193; Richardson, *Standards*, 20, 22, 128. These comments exclude the flags for Sullivan's Life Guards, the Providence Artillery, the Fifth Pennsylvania Regiment, and the First Georgia Regiment, because these designs have not been verified with contemporaneous evidence (Richardson, *Standards*, 20, 86, 120, 125–26).

39. Richardson, *Standards*, 115–16, 136; Preble, *Flag*, 1:205–6, 212. Judy Hample, "The Textual and Cultural Authenticity of Patrick Henry's 'Liberty or Death' Speech," *QJS* 63 (October 1977): 298–310.

40. "An American Guesser," *PAJ*, December 27, 1775, p. 1, col. 1. All quotes in the next few paragraphs are from this article. J. A. Leo Lemay claims that the author was Benjamin Franklin, *The Canon of Benjamin Franklin, 1722–1776* (Newark, 1986), 124–26.

41. The rattlesnake had been used previously in Pennsylvania to represent retribution for harmful British policies, *PAG*, April 11, 1751, p. 2, col. 2; Preble, *Flag*, 1:213–14.

42. Newman, *Money*, 99–100, 104–6, 108; Richardson, *Standards*, 86.

43. Newman, *Money*, 314–15. For the two flags, Preble, *Flag*, 1:216, opposite 193; Richardson, *Standards*, 2, 16, 20, 22, 62, 128; Peter Force, *American Archives: Containing a Documentary History of the English Colonies in North America*, 9 vols. (Washington, D.C., 1837–53), 4th ser., 5:567–68.

44. Newman, *Money*, 228–29; Richardson, *Standards*, 109; Preble, *Flag*, 2:627.

45. Richardson, *Standards*, 136.

46. Preble, *Flag*, 205; Richardson, *Standards*, 115–16, 118–19, pl. 38. "An American Guesser," *PAJ*, December 27, 1775, p. 1, col. 1.

47. William G. Anderson, *The Price of Liberty: The Public Debt of the American Revolution* (Charlottesville, 1983), 131–32. Anderson and the AAS have attributed the engraving to Nathaniel Hurd. At the AAS, five variants of this general type of treasury note were dated for use between June 1, 1777, and January 17, 1778.

48. The MHS holds the two known copies of this unused note.

49. Anderson, *Price*, 133–34. The AAS has attributed this engraving to Nathaniel Hurd, based upon traces of his initials below the snake's head and to the right of the pine tree.

50. Joseph J. Malone has commented upon the military, political, and economic aspects of the original law in 1691 and the modifications of it during the next century in *Pine Trees and Politics: The Naval Stores and Forest Policy in Colonial New England, 1691–1775* (Seattle, 1964), esp. x, 6, 143. [James Macpherson], *The Rights of Great Britain Asserted Against The Claims Of America*, 10th ed. (London, 1776), 31–32.

51. "A Dreamer," *RG*, January 23, 1779, p. 2, col. 4.

52. "Somnolentus," *RG*, January 30, 1779, p. 2, col. 3.

53. Peter Oliver, *Origin & Progress of the American Rebellion*, eds. Douglass Adair and John A. Schutz (San Marino, Calif., 1961), 40, 41, 74, 44, 103.

54. Albert Carlos Bates, *An Early Connecticut Engraver and His Work* (Hartford, 1906).

55. Richardson, *Standards*, 86, pl. 40, 41.

56. The image of Samuel Adams was from *An Impartial History of the War in America* (Boston, 1781), copy 2, 1:325.

57. For examples in American and British prints, see *Am. Rev.*, no. 234, and Brigham, *Engravings*, pl. 34.

58. Richardson, *Standards*, 58, 40. Phoebe Lloyd Jacobs, "John James Barralet and the Apotheosis of George Washington," *WP* 12 (1977): 115–38.

59. *The American Presidency in Political Cartoons, 1776–1976* (Berkeley, 1976), 42–43; *The Image of America in Caricature & Cartoon* (Fort Worth, 1976), 58.

60. Rudolf Wittkower, *Allegory and the Migration of Symbols* (London, 1977), 26.

61. *BF Papers*, 5:273.

62. J. M. Bumsted, " 'Things in the Womb of Time': Ideas of American Independence, 1633 to 1763," *WMQ*, 3rd ser., 31 (1974): 533–64, quote on 536. [John Trenchard and Thomas Gordon], "Of Plantations and Colonies," no. 106, December 8, 1722, *Cato's Letters, Or, Essays on Liberty*, 5th ed. (London, 1748), 4:9.

63. Alison G. Olson, "The British Government and Colonial Union, 1754," *WMQ*, 3rd ser., 17 (1960): 22–34.

64. Olson, "British Government," 31; Bumsted, " 'Things,' " 550. Reed Browning, *The Duke of Newcastle* (New Haven, 1975), 209.

65. [Henry McCulloh], *The Wisdom and Policy of the French in the Construction of Their Great Offices* (London, 1755), 127.

66. Charles H. Lincoln, ed., *Correspondence of William Shirley, Governor of Massachusetts and Military Commander in America, 1731–1760*, 2 vols. (New York, 1912), 2:44; Olson, "British Government," 24.

67. *BF Papers*, 9:90.

68. [Thomas Pownall], *The Administration of the Colonies*, 1st ed. (London, 1764), 33–34, and 2nd ed. (London, 1765), 36–38.

69. [Pownall], *Administration*, 1st ed., 34, and 2nd ed., 37–38. Pownall amplified this point at length in the 2nd ed., 63–64.

70. *BF Papers*, 12:287–88.

71. *BF Papers*, 12:380–81.

72. Lester C. Olson, "Benjamin Franklin's Pictorial Representations of the British Colonies in America: A Study in Rhetorical Iconology," *QJS* 73 (1987): 18–42. Other helpful accounts include Edwin Wolf, 2nd, "Benjamin Franklin's Stamp Act Cartoon," *PAPS* 99 (1955):388–96; *BF Papers*, 13:66–72; Frederic R. Kirkland, "An Unknown Franklin Cartoon," *PAMHB* 73 (1949): 76–79.

73. "Rationalis," *PL*, November 16, 1765, p. 1097, col. 4, p. 1098, col. 1; "From the Public Ledger," *PAJ*, February 20, 1766, p. 1, col. 3. Rationalis may have been an American from Pennsylvania in London; see *PAJ*, February 27, 1766, p. 3, col. 1.

74. *The Annual Register . . . for 1765*, 2nd ed. (London, 1778), 50–51. Jensen, *Tracts*, 80, noted that the *Courant* was the only American publication discussed in *The Annual Register . . . for 1765*.

75. Edward Barnard, *The New, Comprehensive and Complete History of England* (London, 1782), 666.

76. [Nicholas Ray], *The Importance Of The Colonies of North America, And the Interest of Great Britain with regard to them, Considered* (London, 1766), 13.

77. *LC*, July 25–27, 1776, p. 89, col. 3, p. 90, col. 1. Histories of the American flags have quoted Bonvouloir's report, but none have specified the

original source. The earliest known reference was by Preble, *Flag*, 1:212. For the commissioners' correspondence, see Edmund C. Burnett, ed., *Letters of Members of the Continental Congress*, 8 vols. (Washington, D.C., 1921–34), 4:81, and Francis Wharton, ed., *The Revolutionary Diplomatic Correspondence* (Washington, D.C., 1889), 2:760.

78. For example, letter from Josiah Wedgwood to Thomas Bentley, August 8, 1777, in *American Letters*, Letter 27 (E-18776-25); *Benjamin Franklin and His Circle*, 88, no. 168.

79. Richardson, *Standards*, 62.

80. Wendy C. Wick, *George Washington, An American Icon: The Eighteenth-Century Graphic Portraits* (Charlottesville, 1982), 26–29.

81. *Am. Rev.*, no. 211, suggests that the date of Pruneau's work was in "[177?]," but most accounts suggest that it was produced after 1780: Wick, *Washington*, 28; C. H. Hart, *Catalogue of Engraved Portraits of Washington* (New York, 1904), nos. 92–94.

82. Hugh Honour, *The New Golden Land: European Images of America from the Discoveries to the Present Time* (New York, 1976), 149.

83. George, *Catalogue*, 5:288, translates the entire rebus.

84. William Murrell, *A History of American Graphic Humor*, 2 vols. (New York, 1933), 1:34, pl. 27. There was an earlier impression of this print without the owl; see George, *Catalogue*, 5:252, no. 5401A. The owl in the subsequent version has been associated with Franklin by George, *Catalogue*, 5:252, no. 5401, and Michael W. Jones, *The Cartoon History of the American Revolution* (New York, 1975), 96.

85. Although respected sources attribute this print to James Gillray, including George, *Catalogue*, 5:569, the print has been omitted from Gillray's collected works as compiled in Draper Hill, *Mr. Gillray: The Caricaturist* (London, 1965), and *Fashionable Contrasts: Caricatures by James Gillray* (London, 1966).

86. Sommer, "Emblem and Device," 71.

87. Deuteronomy 32:11; Wittkower, *Allegory and the Migration of Symbols*, 44.

CHAPTER 2. THE COLONIES ARE AN INDIAN

1. Robert F. Berkhofer, Jr., *The White Man's Indian: Images of the American Indian from Columbus to the Present* (New York, 1978), esp. 4, 15, 27–29.

2. In two helpful essays, E. McClung Fleming has discussed the image of the colonies as an Indian: "The American Image as Indian Princess, 1765–1783," *WP* 2 (1965): 65–81, and "From Indian Princess to Greek Goddess: The American Image, 1783–1815," *WP* 3 (1967): 37–66. I have not used the term "Indian princess" because numerous prints depicted the Indian as a man.

3. George Richardson, *Iconology: or, a Collection of Emblematical Figures Containing Four Hundred and Twenty-Four Remarkable Subjects, Moral and Instructive; in Which Are Displayed the Beauty of Virtue and the Deformity of Vice*, 2 vols. (London, 1777–79), 1:30–33. Clare LeCorbeiller, "Miss America and Her Sisters: Personifications of the Four Parts of the World," *MMAB* 19 (1961): 217; Hugh Honour, *The European Vision of America* (Cleveland, 1975), chap. 6; Hugh Honour, *The New Golden Land: European Images of America from the Discoveries to the Present Time* (New York, 1976), chaps. 4 and 6.

4. In America, twelve known political prints represented the colonies as an Indian. Of these, seven were derived from British originals. Two were derived from *"A Picturesque View of the State of the Nation for February 1778,"* two were derived from "THE DEPLORABLE STATE of AMERICA," and three from *"The able Doctor, or America Swallowing the Bitter Draught."*

5. Dora M. Clark, *British Opinion and the American Revolution* (New Haven, 1930), and Fred J. Hinkhouse, *The Preliminaries of the American Revolution as Seen in the English Press, 1763–1775* (New York, 1969), esp. 62–65, discuss the salience of economic motives.

6. Benjamin Franklin, *Examination of Doctor Benjamin Franklin, before an August Assembly relating to the Repeal of the Stamp Act, & c.* (Philadelphia, 1766), 12. James Otis, *The Rights of the British Colonies Asserted and proved* (Boston, 1764), 24.

7. Herbert M. Atherton comments on nationalism in "The Allegory of Patriotism," *Political Prints in the Age of Hogarth: A Study of the Ideographic Representation of Politics* (Oxford, 1974).

8. Fleming, "The American Image," 70. For several versions of *"A Picturesque View,"* George, *Catalogue*, 5:285, nos. 5726, 5726A, 5726B,

5726C, 5727. For additional versions, see "A Pastiche of Paintings and Prints," *Annual Report of the Library Company of Philadelphia for the Year 1970* (Philadelphia, 1971), 48–49. This print inspired a Dutch sequel, "[Yorktown]," and it was a motif in the French print "Robe à la Circassienne Garnie à la Chartre."

9. George, *Catalogue*, 5:386.

10. Michael W. Jones, *The Cartoon History of the American Revolution* (New York, 1975), 172.

11. King James, *Two Broad-Sides Against Tobacco: The First given by King James of Famous Memory; His A Counter-Blast to Tobacco* (London, 1672), 2. James Boswell, *Boswell's Life of Johnson*, 6 vols., ed. George B. Hill (New York, 1891), 1:506. Benjamin Bissell, *The American Indian in English Literature of the Eighteenth Century* (New Haven, 1925), 52.

12. Pehr Kalm, *Travels into North America*, 3 vols., trans. John R. Forster (London, 1771), 3:154.

13. [Thomas Pownall], *The Administration of the Colonies*, 2nd ed. (London, 1765), 164.

14. *WEP*, November 27, 1777, quoted in R. T. H. Halsey, " 'Impolitical Prints': The American Revolution as Pictured by Contemporary English Caricaturists," *BNYPL* 43 (1939): 809. For an example of the Indian as a standard by which to judge savagery, *St.JC*, June 13–15, 1775, p. 4, col. 3.

15. Alden T. Vaughan, "From White Man to Redskin: Changing Anglo-American Perceptions of the American Indian," *AHR* 87 (1982): 950. To Berkhofer, a Noble Savage theme emerged during the Revolutionary period in the colonies, but he appears to use the term in a broader sense than does Vaughan, since he refers to the nineteenth-century development as the "romantic savage," not a noble one (*White Man's Indian*, 8, 74–78).

16. Bissell, *American Indian*, 24–29, discusses oratory as an element of the Noble Savage theme. Cadwallader Colden, *The History of the Five Indian Nations of Canada* (London, 1747), 10, 14. [Edmund Burke], *An Account of the European Settlements in America*, 2 vols. (London, 1757), 1:175; quoted in Bissell, *American Indian*, 20.

17. [Daniel Dulany], *Considerations On The Propriety Of Imposing Taxes In The British Colonies, For the Purpose of raising a Revenue, by Act Of Parliament*

([Annapolis], 1765), 30, 28. For the pamphlet's distribution, Adams, *Am. Ind.*, 8–11.

18. [Daniel Leonard], *Massachusettensis* [(Boston, 1775)], Letter VI, January 16, 1775, pp. 51–52 [Evans 14157].

19. [Dulany], *Considerations*, 28, 15.

20. E. P. Richardson, "Stamp Act Cartoons in the Colonies," *PAMHB* 96 (1972): 275–97. Although he lists "The State of the Nation *An:Dom*: 1765 & c." as advertised in *BG*, November 11, 1765, a search for the advertisement did not produce it. Instead, there was an advertisement for "THE DEPLORABLE STATE of AMERICA" (p. 1, cols. 2–3). "*The* STATE *of the* NATION" has been omitted from the colonial prints wherein the colonies were designated as an Indian pending evidence that the print was published there.

21. Frank H. Sommer, "The Metamorphoses of Britannia," in *American Art, 1750–1800: Towards Independence*, eds. Charles F. Montgomery and Patricia E. Kane (New Haven, 1976), 40–49.

22. The advertisements for the print in *BG*, November 11, 1765, p. 1, cols. 2–3, and in *PAG*, November 21, 1765, p. 1, col. 3, affirm that Mercury "signifies Commerce."

23. Richardson, "Stamp Act Cartoons," 283.

24. To compare the colonial and British prints it was necessary to compensate for the difference in the sheer number of prints from each geographical region. Of the 77 known prints wherein an image of the Indian represented the British colonies in America, 65 were from Britain, the other 12 from the colonies. To adjust for this difference, two options were available. One could have reduced the number of prints in the sample from Britain so that the number from each area was equal by taking a random sample. But a smaller sample size would have reduced the reliability of the results. Instead, this study adjusted for the difference in the number of prints by using proportions of attributes within each region. Then proportions were compared.

25. See Vaughan, "From White Man to Redskin." One might dismiss this difference between British and colonial prints as a result of the comparative sophistication of printing processes in England and America. However, the colonial illustrators did tint the skin of Negroes and Indians in the imagery of native Americans and of slave auctions in colonial newspapers and broadsides; see Elizabeth C. Reilly, *A Dictionary of Colonial American Printers' Ornaments and*

Illustrations: A Tribute to Alden Porter Johnson (Meriden, Conn., 1975), nos. 935–41, 1046–54, and 1057–69.

26. Brigham, *Engravings*, 26–29; *BG*, May 19, 1766, p. 3, col. 2; *MG&BNL Extraordinary*, May 22, 1766, p. 2, col. 2.

27. Ann Hulton, "Letter of June 30, 1768," *Letters of a Loyalist Lady* (Cambridge, Mass., 1927), 11–12.

28. Letter from John Andrews, December 18, 1773, *PMHS* 8 (1864–65): 326. Peter Oliver, *Origin & Progress of the American Rebellion*, eds. Douglass Adair and John A. Schutz (San Marino, Calif., 1961), 103.

29. Benjamin W. Labaree, *The Boston Tea Party* (London, 1966; reprint, 1970), 161, 166. For the Shrewsbury case, see *BG*, February 14, 1774, p. 3, col. 1. For the Lyme case, see *CJ*, March 25, 1774, p. 1, cols. 1–2. For the Jones case, see *MS*, March 17, 1774, p. 1, cols. 1–2; *BEP*, April 4, 1774, p. 3, col. 1; *MG&BPB*, March 28–April 4, 1774, p. 3, col. 2. For a description of the second tea party, see *BG*, March 14, 1774, p. 1, col. 1, and *CJ*, March 25, 1774, p. 2, col. 1.

30. *PA*, January 25, 1775, p. 2, col. 4.

31. E. P. Richardson, "Four American Political Prints," *AAJ* 6 (1974): 36–38, argues that *"LIBERTY TRIUMPHANT"* was produced in America.

32. These remarks were appended in an edition of Thomas Paine, *Common Sense* (Philadelphia, 1776), 38. Brigham, *Engravings*, 135.

33. Brigham, *Engravings*, pl. 44.

34. The essay was published in *The Royal American Magazine; or, Universal Repository of Instruction and Amusement* 2 (1775): 21–27. That Indians were regarded as pagans in need of Christian enlightenment can be exemplified by a broadside circulated in 1772 in Massachusetts, "Mr. Occom's Address to his Indian Brethren," *American Broadsides; Sixty Facsimiles Dated 1680 to 1800 Reproduced from Originals in the American Antiquarian Society*, ed. Georgia B. Bumgardner (Barre, 1971), no. 23.

35. *"A Picturesque View of the State of the Nation for February 1778"* originated in Britain, where the image of a colonist disguised as an Indian was used in additional prints to represent the American Congress—for example, in "THE OLIVE REJECTD," published on May 4, 1778. A number of prints with French captions and texts were ostensibly "gravé à Boston" or "Philadelphie"—

others included "L'ANGLETERRE SUPPLIANTE," "L'ANGLETERRE EXPIRANTE," and DEDIÉ AUX GENERAUX DE L'ARMÉE DE LA GRANDE BRETAGNE PAR UN ZELATEUR DE LA LIBERTÉ." The concerns expressed with some of these prints seem more French than American—for example, the overt desire to humiliate Britain in "L'ANGLETERRE SUPPLIANTE." Extant copies of all these prints are held by the Bibliothèque Nationale (Paris).

The version of "A PICTURESQUE VIEW of the State of GREAT BRITAIN for 1778. Taken from an English copy" is reproduced in Sydney George Fisher, *The True History of the American Revolution*, 3rd ed. (Philadelphia, 1912), 358. At that time it was held at the Boston Public Library.

36. Richardson, *Standards*, 45, 76–79, 92, 113, 190, 203–4, 214.

37. Isaiah Thomas, *The History of Printing in America*, 2 vols. (Worcester, 1810), 2:266.

38. Garry Wills, *Inventing America: Jefferson's Declaration of Independence* (New York, 1979), 377. *PAP*, August 26, 1777, p. 1, cols. 1–2. Articles ascribed to Burgoyne: *PAP*, August 26, 1777, p. 4, col. 1; *PAJ*, September 10, 1777, p. 2, col. 3.

39. Henry W. Dwight to Theodore Sedgwick, February 18, 1779, MHS, Briton Sedgwick Papers. John Ferdinand Dalziel Smyth, *A Tour of the United States of America*, 2 vols. (London, 1784), 1:345–46; Vaughan, "From White Man to Redskin," 942.

40. Berkhofer, *White Man's Indian*, 29.

41. Stephen E. Lucas, *Portents of Rebellion: Rhetoric and Revolution in Philadelphia, 1765–1776* (Philadelphia, 1976), chap. 5. Although his evidence was germane to Pennsylvania, the phenomena that he described were also manifested in the other colonies.

CHAPTER 3. THE COLONIES ARE A CHILD

1. [Thomas Blacklock], *Remarks On The Nature and Extent of Liberty, as compatible with the Genius of Civil Societies; On the Principles of Government and the proper Limits of its Powers in Free States; And, on the Justice and Policy of the American War. Occasioned by Perusing the Observations of Dr. Price on These Subjects* (Edinburgh and London, 1776), 29.

2. Edwin G. Burrows and Michael Wallace, "The American Revolution: The Ideology and Psychology of National Liberation," *PAH* 6 (1972): 168. This insightful article has been criticized and supplemented by Jay Fliegelman, *Prodigals and Pilgrims: The American Revolution Against Patriarchal Authority, 1750–1800* (Cambridge, England, 1982), esp. 38–40. Melvin Yazawa, *From Colonies to Commonwealth: Familial Ideology and the Beginnings of the American Republic* (Baltimore, 1985). For seventeenth-century uses of the image, see Michael Walzer, "The Attack upon the Traditional Political World," in *The Revolution of the Saints: A Study in the Origins of Radical Politics* (Cambridge, Mass., 1965).

3. [Blacklock], *Remarks*, 29.

4. [John Dickinson], *Letters from a Farmer in Pennsylvania, to the Inhabitants of the British Colonies* (Philadelphia, 1768), 24; *Am. Cont.*, 1:93–94.

5. Isaac Hunt, *The Political Family: Or A Discourse, Pointing Out the Reciprocal Advantages, Which Flow from an Uninterrupted Union Between Great-Britain and Her American Colonies* (Philadelphia, 1775), 29–30.

6. Similarly, *BF Papers*, 13:163.

7. The consensual conception of the family had emerged during the eighteenth century in reaction to the patriarchal conception of the family, which had dominated British life in the seventeenth century. Both conceptions of family had been used in British political life during the late seventeenth century, the patriarchal conception to sanction the absolute authority of the king in Robert Filmer's *Patriarchia, or the Natural Power of Kings* (London, 1680) and the consensual conception to question such authority in John Locke's *Two Treatises of Government: in the Former, the False Principles, and Foundation of Sir Robert Filmer, and his followers, Are Detected and Overthrown. The Latter is an Essay Concerning the True Original, Extent, and End of Civil Government* (London, 1690). Burrows and Wallace, "American Revolution," esp. 169–89; Gordon Schochet, *Patriarchalism in Political Thought: The Authoritarian Family and Political Speculation and Attitudes, Especially in Seventeenth-Century England* (New York, 1975).

8. Richard Price, *Observations On The Nature Of Civil Liberty, The Principles Of Government, And The Justice And Policy Of The War With America* (London, 1776), 37; *Am. Cont.*, 1:433–40.

9. [Blacklock], *Remarks*, 67, similarly, 44.

10. *The Case Stated On Philosophical Ground, Between Great Britain And Her Colonies: Or The Analogy Between States And Individuals, Respecting the Term of Political Adultness, Pointed Out* (London, 1777), 50–51. Adams suggests that this pamphlet, though imprinted 1777, was published early in 1778, *Am. Cont.*, 2:544. Price, *Observations*, 37. [Blacklock], *Remarks*, 44.

11. [Dickinson], *Letters from a Farmer*, 26. [Daniel Leonard], *Massachusettensis* [(Boston, 1775)], 102–3.

12. [Nicholas Ray], *The Importance Of The Colonies of North America, And the Interest of Great Britain with regard to them, Considered* (London, 1766), 6; similarly, 16; for the British and American eds., *Am. Cont.*, 1:67–68. *The Necessity Of Repealing The American Stamp-Act Demonstrated: Or, A Proof that Great Britain must be injured by that Act* (London, 1765), 33.

13. [Thomas B. Chandler], *The American Querist: Or, Some Questions Proposed Relative To The Present Disputes Between Great Britain And Her American Colonies* ([New York], 1774), 4. Jonathan Boucher, *A View of the Causes and Consequences of the American Revolution; in Thirteen Discourses Preached in North America between the Years 1763 and 1775* (London, 1797), 528–30. Religious instruction about the political significance of the Fifth Commandment was commonplace in Britain throughout the seventeenth century and in Massachusetts during the eighteenth, Schochet, *Patriarchalism*, 6; Yazawa, *From Colonies to Commonwealth*, 20. [James Macpherson], *The Rights Of Great Britain Asserted Against The Claims Of America: Being An Answer To The Declaration Of The General Congress*, 10th ed. (London, 1776), 97; *Am. Cont.*, 1: 309–15, 412.

14. [Joseph Cawthorne], *A PLAN To Reconcile Great Britain and her Colonies, And Preserve The DEPENDENCY Of America* (London, 1774), 5.

15. [William Knox], *The Claim Of The Colonies To An Exemption from Internal Taxes Imposed By Authority of Parliament, Examined* (London, 1765), 36. [Richard Wells], *A Few Political Reflections Submitted to the Consideration of the British Colonies* (Philadelphia, 1774), 10–11.

16. [Thomas B. Chandler], *What think ye of the Congress Now?* (New-York, 1775), 27. *Licentiousness Unmask'd; Or, Liberty Explained* (London, [1776]), 48.

17. Donald Schön, "Generative Metaphor: A Perspective on Problem-Setting in Social Policy," *Metaphor and Thought*, ed. Andrew Ortony (Cambridge, England, 1980), 254–83. J. M. Bumsted, " 'Things in the

Womb of Time': Ideas of American Independence, 1633 to 1763," *WMQ*, 3rd ser., 31 (1974): 535. *Remarks On Dr. Price's Observations On The Nature Of Civil Liberty, & c.* (London, 1776), 38.

18. *LC*, quoted in Fred J. Hinkhouse, *The Preliminaries of the American Revolution as Seen in the English Press, 1763–1775* (New York, 1969), 163; similarly, *LC*, March 5–8, 1774, p. 231, col. 1 and p. 232, col. 1. Letter from Chesterfield to his son, December 27, 1765, in Philip D. Stanhope, *Letters Written by the Late Philip Dormer Stanhope, Earl of Chesterfield, To His Son* (Philadelphia, 1833), 359; also in *The London Magazine* 43 (April 1774): 65. [Dickinson], *Letters from a Farmer*, 17.

19. [Blacklock], *Remarks*, 43.

20. [James Stewart], *A Letter to the Rev. Dr. Price F. R. S. Wherein His Observations on the Nature of Civil Liberty, the Principles of Government, & c. Are Candidly Examined; His Fundamental Principles Refuted, and the Fallacy of His Reasoning from These Principles Detected* (London, 1776), 25–26.

21. "Anti-Sejanus," *LC*, November 28–30, 1765, p. 523, col. 2, and January 25–28, 1766, p. 92, col. 3.

22. *LC*, March 8–11, 1766, p. 236, col. 2. *The Gentleman's Magazine: and Historical Chronicle* 36 (March 1766): 140–41. Bruce I. Granger, *Political Satire in the American Revolution, 1763–1783* (Ithaca, 1960), 48.

23. For similar reasoning about the debt, "J. B.," *PL*, November 8, 1765, p. 2, col. 1. Again during the controversy surrounding the Townshend Duties, the ministry would insist that all it wanted was for the colonies to bear a fair share of the burdens. For example, [William Knox], *The Present State Of The Nation: Particularly with respect to its Trade, Finances, &c. & c. Addressed To The King and both Houses of Parliament* (London, 1768), 37. Twelve editions of this pamphlet were published in 1768 in English, French, Spanish, and Italian; *Am. Cont.*, 1:99–102.

24. *Licentiousness Unmask'd*, 40, 45.

25. Benjamin Franklin, *Examination of Doctor Benjamin Franklin, before an August Assembly relating to the Repeal of the Stamp Act, & c.* (Philadelphia, 1766), 11–12.

26. Laurence Brown, *A Catalogue of British Historical Medals, 1760–1960*, (London, 1980), vol. 1, *The Accession of George III to the Death of William IV*,

nos. 100, 101, 105. *The Oxford Magazine or Universal Museum* 11 (June 1774): opposite 164.

27. *The London Magazine; or, Gentleman's Monthly Intelligencer* 43 (April 1774): 185.

28. *The Hibernian Magazine* 3 (May 1774): 282–83.

29. *The Westminster Magazine* 2 (April 1774): 168.

30. The exchange was recorded in a letter, February 11, 1765, from Jared Ingersoll, a colonial agent in London, to Thomas Fitch. It was initially recorded in 1766 in *Mr. Ingersoll's Letters Relating to the Stamp Act* (New Haven, 1766), 15, and subsequently in *Collections of the Connecticut Historical Society*, vol. 18, *The Fitch Papers: Correspondence and Documents During Thomas Fitch's Governorship of the Colony of Connecticut, 1754–1766*, vol. 2 (Hartford, 1920), 322–23. The authenticity of this exchange has been questioned, but John Gorham Palfrey indicates that Francis Dana also sent home a report of the speech, *History of New England*, 5 vols. (New York, 1966), 5:287–88. For a commentary on the dispute, see Lawrence Henry Gipson, *Jared Ingersoll: A Study in American Loyalism in Relation to British Colonial Government* (New Haven, 1920), 1401–14, n. 3. For my purposes, it is sufficient that people at the time believed that Barré gave the speech, as the publication of Ingersoll's letters in 1766 would have suggested to contemporaries. J. Vernon Jensen, "British Voices on the Eve of the American Revolution: Trapped by the Family Metaphor," *QJS* 63 (February 1977): 43–50.

31. Letter from Jared Ingersoll to Thomas Fitch, *Mr. Ingersoll's Letters*, 16, and also in *Fitch Papers*, 322–23.

32. [Ray], *Importance of the Colonies*, 9, 12. *Am. Cont.*, 1:262–63.

33. Josiah Tucker, *A Letter To Edmund Burke, Esq; Member Of Parliament . . . In Answer To His Printed Speech, Said To Be Spoken In The House Of Commons On The Twenty-Second Of March, 1775* (Gloucester and London, 1775), 55–56.

34. *Remarks On Dr. Price's Observations On The Nature Of Civil Liberty, &c.* (London, 1776), 50. The anonymous author of *Licentiousness Unmask'd*, 43, also rebuffed Price.

35. Edmund Burke, *The Speech of Edmund Burke, Esq; On Moving His Resolution For Conciliation with the Colonies, March 22, 1775* (London, 1775), 13.

36. [Ray], *Importance of the Colonies*, 11. For the remark by Temple Luttrell, see William Cobbett and T. C. Hansard, *The Parliamentary History of England, From the Earliest Period to the Year 1803*, 41 vols., 1st ser. (London, 1806–20), 18:344–45.

37. [Cawthorne], *A Plan*, 7.

38. [Macpherson], *Rights*, 97; *Am. Cont.*, 1:309–15, 412.

39. Edmund Burke, *Speech of Edmund Burke, Esq. On American Taxation, April 19, 1774* (London, 1775), 53; Adams lists ten editions of this pamphlet in 1775, *Am. Cont.*, 1:260–62.

40. [John Shebbeare], *An Answer To The Printed Speech Of Edmund Burke, Esq; Spoken In The House of Commons, April 19, 1774* (London, 1775), 206.

41. [Shebbeare], *Answer*, 206–7.

42. [Macpherson], *Rights*, 27. [Shebbeare], *Answer*, 200. *Remarks On Dr. Price's Observations*, 48.

43. Cobbett and Hansard, *Parliamentary History*, 17:1198.

44. [Shebbeare], *Answer*, 108. [Macpherson], *Rights*, 94–95. *Licentiousness Unmask'd*, 20.

45. At the MHS, a photocopy of *"THE FEMALE COMBATANTS"* has the dateline on it, "Publish'd According to Act Jany 26, 1776." "Slut," *Oxford English Dictionary*.

46. The excerpt from William Pitt's address of March 2, 1770, was recorded in a letter, March 6, 1770, from Mr. Johnson, agent for Connecticut, to Governor Trumbell, in Jared Sparks, ed., *The Works of Benjamin Franklin*, rev. ed., 10 vols. (Philadelphia, 1840), 7:468.

47. *The Westminster Magazine* 4 (April 1776): 216–19; this passage had been printed in [Macpherson], *Rights*, 85–86.

48. *Independency The Object Of The Congress In America. Or, An Appeal to Facts* (London, 1776), 40. [Blacklock], *Remarks*, 45.

49. Which of the versions was published first is an issue, Joan D. Dolmetsch, *Rebellion and Reconciliation: Satirical Prints on the Revolution at Williamsburg* (Williamsburg, 1976), 90.

50. *The Case Stated*, 56–57, xxix.

51. *The Rambler's Magazine* 1 (March 1783): 113. According to R. T. H. Halsey, " 'Impolitical Prints': The American Revolution as Pictured by Contemporary English Caricaturists," *BNYPL* 43 (1939): 817, no such article appeared in that issue of *PAG*.

52. Benjamin Franklin to Lord Kames, either April 11, 1767, or February 25, 1767, *BF Papers*, 14:62–64, 116, quote from 14:165. [Silas Downer], *A Discourse, Delivered in Providence, in the Colony of Rhode-Island, upon the 25th, Day of July, 1768* (Providence, 1768), 8.

53. James Otis, *The Rights of the British Colonies Asserted and proved* (Boston, 1764), 51. Similarly, "A Friend to the Colony," *PAJ*, February 13, 1766, p. 1, col. 2.

54. [Chandler], *American Querist*, 5. Hunt, *Political Family*, 29. Boucher, *A View*, 526–27.

55. [Thomas B. Chandler], *A Friendly Address To All Reasonable Americans, On The Subject Of Our Political Confusions* (New York, 1774), 47. Boucher, *A View*, 369–70, 592. [Leonard], *Massachusettensis*, 33.

56. "Extracts from the Sentiments of a Foreigner on the Disputes of Great Britain and America," *PAL*, January 20, 1776, p. 1, col. 2. [Alexander Hamilton], *The Farmer Refuted: Or, a More Impartial and Comprehensive View of the Dispute Between Great-Britain and the Colonies, Intended as a Further Vindication of the Congress: In Answer to a Letter from A. W. Farmer, Intitled a View of the Controversy* (New York, 1775), 78. Letter from Abigail Adams to Catherine S. Macauley, [October 1774], in Lyman H. Butterfield, ed., *Adams Family Correspondence*, 4 vols. (Cambridge, Mass., 1963–73), 1:177–79.

57. For an example of each point of view, see "J. B.," *PL*, November 8, 1765, p. 1070, col. 1, and Franklin, *Examination*, 2.

58. Janice Potter, *The Liberty We Seek: Loyalist Ideology in Colonial New York and Massachusetts* (Cambridge, Mass., 1983), 149–50.

59. Advertisements for Copley's version of the print were in *BG*, November 11, 1765, p. 1, cols. 2–3; *PAG*, November 21, 1765, p. 1, col. 3. E. P. Richardson, "Stamp Act Cartoons in the Colonies," *PAMHB* 96 (1972): 284, notes an advertisement for Wilkinson's version in the *Pennsylvanische Staatsbote*, January 20, 1766.

60. *NYM*, October 21, 1765, p. 1, col. 3. [Dickinson], *Letters from a Farmer*, 17. [Isaac Wilkins], *Short Advice to the Counties of New-York* (New York, 1774), 6.

61. [Daniel Dulany], *Considerations On The Propriety Of Imposing Taxes In The British Colonies, For the Purpose of raising a Revenue, by Act Of Parliament* ([Annapolis], 1765), 14, 34, 28.

62. [Dulany], *Considerations*, 16. [Dickinson], *Letters from a Farmer*, 27, 24.

63. [John Dickinson], *The Late Regulations Respecting The British Colonies On The Continent of America Considered* (Philadelphia, 1765), 36. "L," *PAG*, July 6, 1769, p. 2, col. 1; *PAJ*, June 1, 1774, p. 1, col. 1. Similarly, [Hamilton], *Farmer Refuted*, 52.

64. [Joseph Galloway], *A Candid Examination Of The Mutual Claims Of Great-Britain, And The Colonies: With A Plan Of Accommodation, On Constitutional Principles* (New York, 1775), 41.

65. Boucher, *A View*, 360–61. Another example is Hunt, *Political Family*, 25–26.

66. [Joseph Reed], *Four DISSERTATIONS on the Reciprocal ADVANTAGES of a Perpetual UNION Between GREAT-BRITAIN and Her AMERICAN COLONIES* (Philadelphia, 1766), diss. 3, p. 98. John Morgan, Stephen Watts, and Frances Hopkins composed the first, second, and fourth essays, respectively. Hunt, *Political Family*, 6. Boucher, *A View*, 475–76. [Charles Inglis], *The True Interest of America Impartially Stated, in Certain Strictures on a Pamphlet Intitled Common Sense* (Philadelphia, 1776), 39.

67. Thomas Hutchinson, *The Speeches of His Excellency Governor Hutchinson, to the General Assembly of the Massachusetts-Bay. At a Session Begun and Held on the 6th of January, 1773. With the Answers of His Majesty's Council and the House of Representatives Respectively* (Boston, 1773), 13, 125–26.

68. *PAJ*, February 20, 1766, p. 1, col. 1. *Some Observations of Consequence, In Three Parts. Occasioned by the Stamp-Tax, Lately Imposed on the British Colonies* ([Philadelphia], 1768), 44–45. Samuel Langdon, *Government Corrupted by Vice, and Recovered by Righteousness. A Sermon Preached Before the Honorable Congress of the Colony of the Massachusetts-Bay* (Watertown, 1775), 19. Enoch Huntington, *Happy Effects of Union, and the Fatal Tendency of Divisions.*

Shewn in a Sermon, Preached Before the Freemen of the Town of Middletown (Hartford, 1776), 13–14.

69. [Hamilton], *Farmer Refuted*, 45–46. "Caractacus," *PAP*, August 21, 1775, p. 3, cols. 2–3.

70. The theme of conspiracy has been studied extensively by Bernard Bailyn, *The Ideological Origins of the American Revolution* (Cambridge, Mass., 1967). For a reassessment, Gordon S. Wood, "Conspiracy and the Paranoid Style: Causality and Deceit in the Eighteenth Century," *WMQ*, 3rd ser., 39 (1982): 401–41. Congress endorsed the address to Britain on October 21, 1774, *JOURNAL of the PROCEEDINGS of the CONGRESS, Held at Philadelphia, September 5, 1774* (Philadelphia, 1774), 78. *Address To The PEOPLE of GREAT-BRITAIN From The DELEGATES Appointed by the several ENGLISH COLONIES* ([Philadelphia, 1774]). *AN ADDRESS OF THE TWELVE UNITED COLONIES OF NORTH-AMERICA BY THEIR REPRESENTATIVES IN CONGRESS, TO THE PEOPLE OF IRELAND* (Philadelphia, 1775), 6.

71. John Carmichael, *A Self-Defensive War Lawful, Proved in a Sermon* (Philadelphia, 1775), 32. [Thomas Paine], "Thoughts on Defensive War," *The Pennsylvania Magazine* 1 (July 1775): 313. Philip S. Foner, ed., *The Complete Writings of Thomas Paine*, 2 vols. (New York, 1945), 2:52. Huntington, *Happy Effects*, 20.

72. John Dickinson to Arthur Lee, April 29, 1775, in Richard H. Lee, ed., *Life of Arthur Lee*, 2 vols. (Boston, 1829), 2:311.

73. [Samuel Seabury], *A View of the Controversy Between Great-Britain and her Colonies: Including a Mode of Determining Their Present Disputes, Finally and Effecually; And of Preventing All Future Contentions* (New York 1774), 32–33. [Leonard], *Massachusettensis*, 38.

74. [Leonard], *Massachusettensis*, 9. [John Mein], SAGITTARIUS'S LETTERS *And Political Speculations. Extracted From the Public Ledger* (Boston, 1775), 103. Boucher, *A View*, 323.

75. Boucher, *A View*, 192, 372, 371, 490, xxxviii.

76. [Chandler], *Friendly Address*, 25. [Mein], SAGITTARIUS'S LETTERS, 22. Peter Oliver, *Origin & Progress of the American Rebellion*, eds. Douglass Adair and John A. Schutz (San Marino, Calif., 1961), 76.

77. [Henry Barry], *The ADVANTAGES Which AMERICA Derives from her COMMERCE, CONNEXION, and DEPENDANCE on BRITAIN* ([Boston], 1775), 4.

78. [Martin Howard], *A Defense of the Letter from a Gentleman at Halifax, To His friend in Rhode-Island* (Newport, 1765), 4–6. Joseph Galloway to Benjamin Franklin, January 13, 1766, *BF Papers*, 13:36. [Chandler], *American Querist*, 5. [Chandler], *Friendly Address*, 25. Boucher, *A View*, 417. Similarly, Oliver, *Origin & Progress*, 60, and [Mein], SAGITTARIUS'S LETTERS, 11.

79. [Harrison Gray?], *A Few Remarks upon Some of the Votes and Resolutions of the Continental Congress* ([Boston], 1775), 14–17; for the attribution to Gray, *Am. Ind.*, 130.

80. [Chandler], *Friendly Address*, 42. [Chandler], *What think ye?*, 25. [Barry], *ADVANTAGES*, 14.

81. [Leonard], *Massachusettensis*, 104. *The Patriots of North-America: A Sketch. With Explanatory Notes* (New York, 1775), 31–32.

82. Boucher, *A View*, 373–74.

83. *BG*, December 2, 1765, p. 2, col. 3.

84. [Galloway], *Candid Examination*, 50.

85. "The Forester," *PAP*, April 22, 1776, p. 1, col. 3.

86. Thomas Paine's pamphlet was published in at least 25 editions, more than double those for any other American pamphlet during the decade of dissent, *Am. Ind.*, xi. Additional editions were published in Britain and continental Europe, *Am. Cont.*, 1:422–28. Winthrop D. Jordan, "Familial Politics: Thomas Paine and the Killing of the King, 1776," *JAH* 60 (1973): 295.

87. [Thomas Paine], *Common Sense; Addressed To The Inhabitants Of America* (Philadelphia, 1776), 32. The edition employed for this discussion is the earliest one listed by Adams, available in the AAS Imprint Series under Evans 14954.

88. [Inglis], *True Interest*, 38.

89. [Inglis], *True Interest*, 38–39.

90. For an analysis of the patriarchal and consensual conceptions of the family, see Burrows and Wallace, "American Revolution," and Fliegelman, *Prodigals and Pilgrims*, esp. 38–39.

91. [Paine], *Common Sense*, 34.

92. [Inglis], *True Interest*, 41.

93. [Paine], *Common Sense*, 36.

94. [Inglis], *True Interest*, 40–41.

95. [Paine], *Common Sense*, 47. Jordan, "Familial Politics," 294–308, undertakes a psychoanalytic interpretation of Paine's *Common Sense*.

96. [Inglis], *True Interest*, 71. For the exchanges between Thomas Paine and James Chalmers about the image of the family, *Common Sense*, 70–71, and *Plain Truth: Addressed to the Inhabitants of America, Containing Remarks on a Late Pamphlet, Entitled Common Sense* (Philadelphia, 1776), 42, 47.

97. Carl Zigrosser, "The Medallic Sketches of Augustin Dupré in American Collections," *PAPS* 101 (1957): 535–50; Winfried Schleiner, "The Infant Hercules: Franklin's Design for a Medal Commemorating American Liberty," *ECS* 10 (1976–77): 235–44.

98. *BF Papers* has not been completed for these years. In the meantime, consult Benjamin Franklin, *Writings of Benjamin Franklin*, 10 vols., ed. Albert H. Smyth (New York, 1906), 9:28, 33–34, 71–72, 96, 98; Benjamin Franklin, *The Works of Benjamin Franklin*, 12 vols., ed. John Bigelow (New York, 1904), 10:101–2, 107, 145, 188.

99. *Affiches, annonces, et avis divers*, avril 15, 1784, no. 46, p. 225, col. 2. Zigrosser, "Medallic Sketches," 538.

100. Matthias Christian Sprengel, *Allgemeines historisches Taschenbuch; oder Abriss der merkwürdigsten neuen Welt-begebenheiten enthaltend für 1784 bie Geschichte der Revolution von Nord-America* (Berlin, 1784), unnumbered pp. after 182.

101. *Colonising, Or A Plain Investigation Of That Subject; With A Legislative, Political, And Commercial View Of Our Colonies* (London, 1774), 7.

102. Price, *Observations*, 37.

103. *Licentiousness Unmask'd*, 14. For the use of this commonplace in England during the seventeenth century, Schochet, *Patriarchalism*, 6. [Shebbeare], *Answer*, 206.

104. Ernest C. Mossner, *The Life of David Hume* (Austin, 1954), 554. "To the Printer," *PA*, September 15, 1768, p. 4, col. 3. *The Necessity of Repealing*, 24.

105. *The Case Stated*, 128–29, 6.

106. [Wilkins], *Short Advice*, 5. Hutchinson, *Speeches*, 82.

107. George Mason to the Committee of London Merchants, June 6, 1766, in Kate M. Rowland, *The Life of George Mason, 1725–1792*, 2 vols. (New York, 1892), 1:382. [Jacob Green], *Observations: on the Reconciliation of Great-Britain and the Colonies* (Philadelphia, 1776), 14. William Smith, *A Sermon on the Present Situation of American Affairs. Preached in Christ-Church, June 23, 1775* (Philadelphia, 1775), 20; another 12 editions of this sermon were published in Britain, *Am. Cont.*, 1:333–36. "Justice and Humanity," *PAJ*, November 10, 1768, p. 2, col. 1.

108. *A Retrospective View Of The Causes Of The Difference Between Great Britain and her Colonies in America: And A Consideration Of Some Probable Consequences of the Dismemberment of the Empire* (London, 1783), 28–29.

109. "Extract of a Letter from a Member of the Virginia Convention," February 20, 1776, in Peter Force, *American Archives: Containing a Documentary History of the English Colonies in North America*, 9 vols. (Washington, D.C.: 1837–53), 4th ser., 4:1210. For earlier expressions of concern about the parent's desire to prolong the child's dependence, see Bumsted, " 'Things'," 539–40, 547–48, 550–51.

110. *A Retrospective View of the Causes*, 120.

111. [Barry], *ADVANTAGES*, 8. [Inglis], *True Interest*, 71.

112. [Blacklock], *Remarks*, 44–45. Huntington, *Happy Effects*, 20. Green, *Observations*, 9. *PAG*, January 19, 1769, p. 1, col. 1. These and other of Franklin's essays against the Townshend Duties have been identified in *Benjamin Franklin's Letters to the Press, 1758–1775*, ed. Verner Crane (Chapel Hill, 1950), esp. docs. 52, 55–56, 60–62, 66–67, 69–72, 76, 80.

113. [Cawthorne], *A Plan*, 2. Charles James Fox, *The Speech Of The Right Honourable Charles James Fox, On American Independence: Spoken in the House of Commons, On Tuesday, July 2, 1782* (London, [1782]), 3. [Paine], *Common Sense*, 46. [Thomas Paine], *The Crisis. Number III. By the Author of Common Sense* (Philadelphia, [1777]), 33. Yazawa identifies several germane discourses, *From Colonies to Commonwealth*, esp. 96, 182.

114. [Wells], *A Few Political Reflections*, 33–34. *The Pennsylvania Magazine* 1 (January 1775): 9.

CHAPTER 4. UNCOMMON IMAGES OF THE COLONIES

1. Lester C. Olson, "Benjamin Franklin's Pictorial Representations of the British Colonies in America: A Study in Rhetorical Iconology," *QJS* 73 (1987): 18–42. Other helpful accounts include Edwin Wolf, 2nd, "Benjamin Franklin's Stamp Act Cartoon," *PAPS* 99 (1955): 388–96; *BF Papers,* 13:66–72; Frederic R. Kirkland, "An Unknown Franklin Cartoon," *PAMHB* 73 (1949): 76–79.

2. *BF Papers,* 13:189; Wolf, 2nd, "Stamp Act Cartoon," 390.

3. [John Dickinson], *Letters from a Farmer in Pennsylvania, to the Inhabitants of the British Colonies* (Philadelphia, 1768), 16. [Daniel Leonard], *Massachusettensis* [(Boston, 1775)], 64; [Daniel Leonard], *The Origin Of The American Contest With Great-Britain, Or The present political State of the Massachusetts-Bay, in general, And The Town of Boston in particular* (New York, 1775), 86; [Henry Barry], *The ADVANTAGES Which AMERICA Derives from her COMMERCE, CONNEXION, and DEPENDANCE on BRITAIN* ([Boston], 1775), 12.

4. [Samuel Johnson], *Taxation no Tyranny; An Answer To The Resolution And Address Of The American Congress* (London, 1775), 28–29. *Am. Cont.,* 2:918.

5. *Catalogue,* 5:387, 579.

6. Edmund and Helen Morgan, *The Stamp Act Crisis: Prologue to Revolution* (Chapel Hill, 1953), 294. *The Universal Magazine of Knowledge and Pleasure* 56 (March 1775): 117. [Thomas Pownall], *The Administration of the Colonies,* 2nd ed. (London, 1765), 63–64; *BF Papers,* 9:90; [Joseph Galloway], *A Candid Examination Of The Mutual Claims Of Great-Britain, And The Colonies: With A Plan Of Accommodation, On Constitutional Principles* (New-York, 1775), 44.

7. Brigham, *Engravings,* both prints on pl. 5.

8. *Am. Rev.,* 344.

9. *The Columbian Magazine, or Monthly Miscellany* 3 (January 1789): 32.

10. *Standards,* 190.

11. For the flag and powder horns, *Standards,* 193, 50.

12. For the resolution about the flag, *Journals of Congress Containing the Proceedings from January 1 1777 to January 1 1778* (New York, [1778]), 3:235.

A reverse image of "VENERATE THE PLOUGH" recurred with the additional motto "LIBERTY AND PEACE," on the masthead of the *Litchfield Monitor* from January 2, 1788, until June 8, 1789, and again from May 13, 1790, until August 20, 1794.

13. Other fractional notes that had this interlinked ring motif were for "Half A DOLLAR," "Two Thirds of a DOLLAR," and "One Third of a DOLLAR," all issued on February 17, 1776. Franklin's sketch is in APS, *BF Papers*, 58:151. *Standards*, 99–101, 209. David P. McBride, "Linked Rings: Early American Unity Illustrated," *Numismatist* (1979): 2389–91.

14. Examples of both Fugio coins are held by the MHS.

15. William Bentley, *Diary of William Bentley*, 4 vols. (Salem, Mass., 1905–14), 1:99.

16. The image of a harp with thirteen strings was used on the Continental currency for "Eight Dollars" on these issues: May 10, 1775, November 29, 1775, February 17, 1775, May 9, 1776, July 22, 1776, November 2, 1776, February 26, 1777, May 20, 1777, April 11, 1778, and September 26, 1778. For the flag, *Standards*, 190.

17. Bruce I. Granger, *Political Satire in the American Revolution, 1763–1783* (Ithaca, 1960), 203. To some extent, this was also the case in France. For example, see Louis Petit de Bachaumont, *Mémoires secrets pour servir à l'histoire de la république des lettres en France, ou journal d'un observateur*, 36 vols. (Londre, 1784), entry for 10 janvier 1778, 11:59–60.

18. Letter from John Adams to Hezekiah Niles, February 13, 1818, in C. F. Adams, ed., *Works of John Adams*, 10 vols. (Boston, 1850–56), 10:283.

19. For a careful commentary on this tension as expressed in the language of the era, Max Savelle, "Nationalism and Other Loyalties in the American Revolution," *AHR* 67 (1962): 901–24.

20. Isaac Hunt, *The Political Family: Or A Discourse, Pointing Out the Reciprocal Advantages, Which Flow from an Uninterrupted Union Between Great-Britain and Her American Colonies* (Philadelphia, 1775), 5, 6–7.

21. Hunt, *Political Family*, 29–30.

22. [Samuel Seabury], *A View of the Controversy Between Great-Britain and her Colonies: Including a Mode of Determining Their Present Disputes, Finally and Effecually; And of Preventing All Future Contentions* (New York, 1774), 9, 24.

For examples from Daniel Leonard, see *Massachusettensis*, 41–42, 58, 108; also in [Leonard], *Origin*, 56–57.

23. [Thomas B. Chandler], *What think ye of the Congress Now? Or, An Enquiry, How Far The Americans are Bound To Abide by, and Execute the Decisions of, The Late Congress* (New-York, 1775), 48, my emphasis.

24. Chandler, *What think ye?*, 45–46.

25. [Joseph Galloway], *A Candid Examination*, 4–5, 9–10, 50. John E. Ferling, *The Loyalist Mind: Joseph Galloway and the American Revolution* (University Park, 1977), 69. Jonathan Boucher, *A View of the Causes and Consequences of the American Revolution; in Thirteen Discourses, Preached in North American between the Years 1763 and 1775* (London, 1797), 475.

26. Some prints of "SIX MEDALLIONS" were sent from Britain to America, letter from Thomas Hollis to Jonathan Mayhew, June 19, 1766, in "Thomas Hollis and Jonathan Mayhew: Their Correspondence, 1759–1766," ed. Bernhard Knollenberg, *PMHS* 69 (October 1947–May 1950): 191.

27. *The Town and Country Magazine* 6 (December 1774): 659.

28. Joan D. Dolmetsch, *Rebellion and Reconciliation: Satirical Prints on the Revolution at Williamsburg* (Williamsburg, 1976), 87. Hannah More, *The Memoirs of the Life and Correspondence of Hannah More*, 4 vols., ed. William Roberts (London, 1834), 1:100; quoted in Wilmarth S. Lewis, *Three Tours Through London in the Years 1748—1776—1797* (New Haven, 1941), 55–56.

29. Jane E. Norton, *A Bibliography of the Works of Edward Gibbon* (Oxford, 1940), 36–37, 41.

30. *PAG*, August 31, 1774, p. 1, col. 1. The version from the *Pennsylvanische Staatsbote* was quoted in Willi Paul Adams, "Colonial German-Language Press," in *The Press & the American Revolution*, eds. Bernard Bailyn and John B. Hench (Worcester, 1980), 207.

31. *The Patriots of North-America: A Sketch. With Explanatory Notes* (New-York, 1775), 12.

32. [Leonard], *Massachusettensis*, 15.

33. *Am. Rev.*, 285. Philip Freneau, *The Poems of Philip Freneau: Poet of the American Revolution*, 3 vols., ed. Fred L. Pattee (Princeton, 1902–7), 2:10.

34. *Standards*, 6, 135–36.

35. One or more woodcuts were printed in the *Boston Independent Chronicle*, *EJ&NHP*, *BG*, *MG*, *Hampshire Chronicle*, *New Hampshire Gazette*, *New Hampshire Spy*, *Freeman's Oracle: or New-Hamsphire Advertiser*, and *Albany Gazette*.

36. Denunciations of the Congress for republican principles can be found in the following: [Seabury], *A View of the Controversy*, 37; *Independency The Object Of The Congress In America* (London, 1776), 17; [James Macpherson], *The Rights Of Great Britain Asserted Against The Claims Of America: Being An Answer To The Declaration Of The General Congress*, 2nd ed. (London, 1775), 17, 35.

37. [Leonard], *Massachusettensis*, 93.

38. Thomas Hutchinson, *The History of the Colony of Massachusetts-Bay*, 3 vols. (Boston, 1764), 1:283. Rev. Andrew Burnaby, "Travels through the Middle Settlement in North America, in the Years 1759 and 1760," *The Oxford Magazine* 12 (January 1775): 61. Bernard Romans, *A Concise Natural History of East and West Florida* (New York, 1775), 38–39. For an extensive treatment of such sentiments about Indians, see Alden T. Vaughan, "From White Man to Redskin: Changing Anglo-American Perceptions of the American Indian," *AHR* 87 (1982): 917–53. Fred J. Hinkhouse, *The Preliminaries of the American Revolution as Seen in the English Press, 1763–1775* (New York, 1969), 108.

39. [Thomas Pownall], *The Administration of the Colonies*, 2nd ed. (London, 1765), 164. Hunt, *Political Family*, 31; [Leonard], *Massachusettensis*, 21. John Hancock, "An Oration," *The Royal American Magazine* 1 (March 1774): 86. "A Dreamer," *RG*, January 23, 1779, p. 2, col. 4. "Somnolentus," *RG*, January 30, 1779, p. 2, col. 3. *The Patriots of North-America*, 4–5.

40. [Leonard], *Massachusettensis*, 8. *St.JC*, June 13–15, 1775, p. 4, col. 3. For additional examples, Paine, *Common Sense*, 38, and *MS*, August 23–25, 1770, p. 2, col. 3. "Tertius Cato," *The Royal American Magazine* 1 (1774): 455–56.

41. *PA*, January 2, 1770, p. 1, col. 4. For the attribution, *Benjamin Franklin's Letters to the Press, 1758–1775*, ed. Verner W. Crane (Chapel Hill, 1950), 166.

42. *PA*, January 29, 1770, p. 2, col. 1.

43. [Richard Wells], *A Few Political Reflections Submitted to the Consideration of the British Colonies* (Philadelphia, 1774), 12. [Dickinson],

Letters from a Farmer, 68, and *The Political Writings of John Dickinson, 1764–1774*, ed. Paul L. Ford (New York, 1970), 495–96.

44. *St.JC*, March 31, 1774, p. 1, col. 2. Letter from Horace Walpole to Horace Mann, June 16, 1779, in *Horace Walpole's Correspondence with Sir Horace Mann*, in *The Yale Edition of Horace Walpole's Correspondence*, 48 vols., eds. W. S. Lewis, Warren H. Smith, and George L. Lam (New Haven, 1967), 8:485.

45. [Daniel Dulany], *Considerations On The Propriety Of Imposing Taxes In The British Colonies, For the Purpose of raising a Revenue, by Act Of Parliament* ([Annapolis], 1765), appendix, 53.

46. "'To the Printer of the London Chronicle," *LC*, August 16–18, 1768, p. 165, col. 1; also *PAC*, October 12, 1768, p. 1, col. 3.

47. "An Address to the Inhabitants of Cortlandt's Manor," *Rivington's NYGR*, February 16, 1775, p. 1, col. 2. *Licentiousness Unmask'd; Or, Liberty Explained* (London, [1776]), 40.

48. *PA*, March 10, 1778, p. 3, col. 1.

49. *Remarks On Dr. Price's Observations On The Nature Of Civil Liberty, &c.* (London, 1776), 22. [John Mein], SAGITTARIUS'S LETTERS *And Political Speculations. Extracted From the Public Ledger* (Boston, 1775), 13.

50. F. M. Grimm and D. Diderot, *Correpondance littéraire, philosophique et critique de Grimm et de Diderot depuis 1753 jusqu'en 1790*, 18 vols. (Paris, 1829–31), 10:31–32.

51. *The Pennsylvania Magazine* 2 (March 1776): 134. "Cato," *Connecticut Courant*, August 26, 1765. Samuel Sherwood, *A SERMON, Containing, Scriptural Instructions to Civil Rulers, and all Free-born Subjects* (New Haven, 1774), 21, vi.

INDEX

NAMES AND SUBJECTS

A

Adams, Abigail, 166
Adams, John, 65, 69, 217
Adams, Samuel, 22, 53–55, 69, 102
Affection, 125, 131, 133, 135, 138, 145–47,
 150, 152, 157, 163, 164, 166, 168, 169,
 176–78, 181, 182, 186, 191, 192, 194,
 196, 206
Albany, 25
Albany Congress, 25, 26, 42, 58, 59, 62
Aldridge, A. Owen, xv
Alienation, 79, 102–5, 107, 108, 112, 113,
 115, 118–22
Allegory, 6–9, 11, 41, 77, 78, 102, 103
Alliance, 69–71, 73, 90–93, 95, 100
Almanacs, xiii, 2, 7–10, 22, 54, 112, 115,
 173, 175, 189, 232, 234
Almon, I., 98
"Americus," 174
Analogy, 27, 125–29, 131, 132, 148, 155,
 165, 168, 176, 183, 185, 192, 228–35
Andrews, James, xvi
Andrews, John, 111
Animalification, 247–49
"Anti-Sejanus," 135–36, 227
Antoinette, Marie, 12, 189
Architectural structures, 6, 43
Arnold, Benedict, 5
Ass, 202, 238, 247, 248
Atherton, Herbert M., xviii
Atlantic Ocean, 37, 73
Audiences, 167, 191

B

Bailyn, Bernard, xv
Balance of budget, 80
Balance of power, 83, 93, 94
Balance or scale. See Scale or balance
Barnard, Edward, 64, 65, 230
Barralet, John James, 55
Barré, Isaac, 5, 144, 145
Barrow, J., 10, 69–71
Barry, Henry, 179, 181, 197, 198, 206, 222
Bartoli, Joseph, 190
Bathurst, Lord, 194
Beast of burden, 202, 212, 238, 240, 245–49
Bedford, Duke of, 227
Bedwell, Thomas, 54
Belisarius, 205

Bentley, Thomas, 24
Berkhofer, Robert F., Jr., 75, 122
Bernard, Francis, 30–32
Bible, 8, 21, 27, 34–36, 41, 47, 66, 72, 127,
 130, 148, 151, 180–82, 193, 194, 224,
 225, 245
Bill of Rights, 142
Blacklock, Thomas, 125–29, 134, 154, 198
Bladen County, 50
Board of Trade, 58
Body politic, xiv, xvi, 1, 2, 5–7, 10, 14, 16–
 19, 53, 62, 78, 107, 201, 202, 204–8, 218–
 25, 236, 252–55
Boitard, Louis Peter, 77
Bonvouloir, Achard, 65
Booklets, 7
Books, 1, 13, 21, 27, 33, 35, 36, 41, 43, 54,
 56, 64, 65, 67, 72, 74–76, 99, 101, 117,
 127, 148, 182, 186, 190, 201, 213, 230,
 247. See also Bible; Emblem books; Index of
 Titles for specific titles
Boston, 3–5, 7, 8, 10, 11, 13, 22, 23, 26–28,
 30–33, 35–38, 51, 54, 77, 105–17, 119–
 22, 165, 168, 178, 179, 182, 210–11, 214,
 237, 248
Boston Common, 109
Boston Harbor, 103, 107
Boston Massacre, 11
Boston Port Bill, 4, 32, 33, 112, 227
Boston Tea Party, 103, 110–12, 116, 140
Boucher, Jonathan, 41, 130, 165, 166, 171,
 172, 178, 180, 182, 191, 224
Bowles, John, 10
Bowles, Thomas, 10
Bowls, 215. See also Housewares
Bradel, J. B., 190
Bradford, Thomas, 34
Bradford, William, 34, 250
Britannia, 17, 18, 62, 63, 76, 82–84, 87, 88,
 91–94, 96–100, 105–8, 112–15, 117, 119,
 121, 131–45, 150–54, 156–64, 167, 168,
 173–76, 183, 186, 187, 189–92, 194–96,
 201–8, 218–26, 228, 236, 238, 245, 251–
 54. See also Pictorial representations of Britain
British lion, 49, 56, 66, 69, 73, 82, 92, 117,
 118, 142, 153, 207, 208, 248, 249, 252. See
 also Pictorial representations of Britain; Royal
 Arms
Broadsides, xiii, xv, 2, 7, 9, 10, 13, 77, 102,
 103, 112, 115, 120, 125, 167, 190, 203,
 205. See also Prints
Bronner, Simon J., xvii

Brunswick County, 50
Brunton, Richard, 53, 67
Buffalo, 202, 250
Burgoyne, John, 70, 118
Burke, Edmund, 101, 145, 146, 148
Burnaby, Reverend Andrew, 236
Burrows, Edwin, xv
Bute, Lord, 84, 87, 91, 106–8, 110, 141–43,
 153, 168, 226, 227, 241
Buttons, 215

C

"Caractacus," 175
Caricatures, xiv, xv, 6, 9, 13, 64, 66–71, 126,
 151, 155. See also Index of Titles for specific
 titles; Prints
Carmichael, John, 176
Carthage, 231
Cartoons. See Caricatures; Prints
Catholic church, 2
Cawthorne, Joseph, 131, 147, 198
Chain, 31
Chains, as metaphor for slavery, 88, 110, 113,
 130, 175, 233
Chalmers, James, 184
Chandler, Thomas Bradbury, 130, 132, 165,
 166, 178, 180, 181, 191, 222–24
Charles I, 5, 57
Chesterfield, Lord, 133, 141
Children, xiii, xv, xvii, 2, 3, 7, 14–18, 76, 77,
 82–84, 87, 88, 93, 94, 102, 107, 108, 112,
 113, 125–99, 201, 202, 209, 211, 218–26,
 228, 236, 238, 245, 251–54
Church, Benjamin, 7, 30–32
Church of England, 2
Classical temple, 77, 86, 96
Claypoole, James, Jr., 10
Coercive acts. See Intolerable Acts
Coffeehouses, xiv, 7, 9
Coins, 215
Colden, Cadwallader, 61, 101
Colley, Thomas, 88, 92, 96, 162, 207, 208,
 216, 247
Colonial agents, 25, 57, 62
Colonial charters, 3, 62, 72
Colony union, xiv, 9, 17, 23, 25–27, 29–32,
 38, 41–46, 57–61, 63–65, 68, 75–82, 92,
 101, 103, 105, 108–14, 119–23, 218, 251
Columbia, 232
Columbus, Christopher, 122
Commerce, 3, 16–18, 79–81, 83, 86, 90, 100,
 105, 106, 116, 131, 166, 176, 193, 196,
 204, 205
Committee of London Merchants, 195
Committees of correspondence, 38
Community, xviii, 1–3, 6, 18, 109
Concealment, 15, 39, 41, 47, 53, 72, 116,
 118. See also Disguise
Conciliatory propositions, 68
Concord, 2, 22, 42
Congress, 9, 11, 12, 24, 41, 42, 44, 48, 52,
 53, 65, 69–71, 89, 90, 115, 116, 120, 132,
 149, 154, 164, 175–77, 181, 216, 223, 235
Consent, 130, 169, 170
Conservative, 3, 14, 16, 218, 219, 252–54

Conspiracy, xv, 113
Constitution, U.S., 3, 8, 17, 18, 23, 56, 72,
 78, 80, 88, 101, 103, 107, 123, 131, 137,
 142, 148, 149, 152, 157, 168, 175, 176,
 181, 186, 193, 196, 210, 234, 235. See also
 Magna Charta
Continental Navy Jack, 45, 66. See also Flags
Conway, Henry Seymour, 5, 62, 96, 229
Cooper, Samuel, 53
Copley, John Singleton, 77, 105–8, 119, 122,
 168
Cornwallis, Charles, 70
"Cosmopolite," 131, 147
Cow, 90, 116, 202, 238–40, 250
Cromwell, Oliver, 112
Culpepper Minute Men Flag, 45, 50. See also
 Flags
Cultural practices, 4
Cumberland, William, Duke of, 227
Currency, xiii, xiv, 2, 7, 9–11, 13, 49, 50. See
 also Index of Titles under Currency; Paper
 currency
Customs, 145

D

D'Archery, Elizabeth, 10, 92, 207, 208, 216
Darly, M., 68, 88, 121, 154, 156–58, 203,
 208. See also Darly, Mary; Darly, Matthew
Darly, Mary, 10. See also Darly, M.
Darly, Matthew, 10, 227, 228. See also Darly,
 M.
Davidson, Donald, xvi
Dawkins, Henry, 10
Debates, xiv, 125, 129, 141, 143–51, 178,
 192, 195
Deception, 21, 36, 41, 52, 53, 68, 69, 72, 93,
 99, 102, 107, 159–61, 163
Declaration of Independence, 6, 51, 118, 133,
 217
Declaratory Act, 240
Dedication pages, 13, 213
Deference, 106, 110, 120
Delaware River, 68
Devices, xiv, 8, 9, 25, 28, 32–35, 40, 43, 63,
 65, 71, 73, 117. See also Currency; Prints
Devil, 82, 85, 87, 98, 111, 113, 153, 227
DeWandeler, John, 214
Diaries, xv, 109, 111, 125, 217
Dickinson, John, 30, 126, 129, 133, 169, 170,
 176, 177, 206, 240
Discord, 87
Disguises, 103, 110, 111, 115–17, 120, 122,
 235
Divine law, 130, 133, 140, 163, 181, 193–95
Dog, 92, 107, 117, 118, 202, 227, 241, 249,
 250
Donkey, 247, 250
Doolittle, Amos, 10
Dowdeswell, William, 150
Downer, Silas, 164
Downing, George, 57
Drums, xiii, 2, 23, 51
Du Simitière, Pierre Eugène, 11, 216
Dublin, 206
Dulany, Daniel, 30, 104, 169, 170, 242

Duplessis, Joseph Siffred, 68
Dupré, Augustin, 12, 100, 101, 167, 189, 190, 248
Dutchman, 89–92, 94, 95, 102, 116, 158, 162. *See also* Holland; Pictorial representations of Holland
Dwight, Henry, 119

E

Eagle, xiii, 3, 24, 55, 56, 69, 72–74, 228
Earthenware, 24
Edinburgh, 206
Editors, 22, 24, 25, 27, 29, 32, 34–36, 38, 42–44, 50, 52, 62, 115, 117, 119, 120, 211, 213, 250. *See also individual editors*
Edwards, Jonathan, 21
Effigies, 5, 6
Emblem books, 13, 25, 76. *See also* Index of Titles *under* Emblem books
Emblems, 8–10, 37, 38, 43, 46, 47, 52, 57, 63, 121, 204
Emotions, xv, 5, 14, 16, 52, 53, 57, 58, 72, 78, 91, 101, 110, 119, 125, 127, 130, 131, 133, 135, 138, 145–47, 150, 152, 157, 160, 163–66, 168, 169, 171, 173, 176–79, 181, 182, 186, 191, 192, 194, 196, 206, 236
English civil war, 2
English oak, 205
Essays, 8, 10, 29, 64, 115, 142
Ethnocentrism, 80, 102
Etymology, xvi, xvii
Eustatius, 229

F

Fame, 96, 110, 117, 229, 230
Faneuil Hall, 5
Father Time, 71
Ferguson, Leland, xvii
Fielding, I., 247
Filmer, Robert, 186
First Georgia Battalion or Regiment, 49, 54
First New York Regiment, 214
Fish, 202, 211, 218, 219, 238, 244
Flags, xiii, xiv, 2, 4, 10, 11, 13, 22, 45–50, 54, 55, 65, 66, 68, 73, 76, 78, 88, 89, 97, 115–17, 119, 123, 162, 164, 213–16, 226, 233. *See also* Index of Titles *under* Flags
Fliegelman, Jay, xv
Florence, 231
Florida, 118, 211
Food, 96
Fort George, 107
Fortune, 111
Four Continents, 76, 77
Fourth Continent, 15, 75–77, 123. *See also* Indian; Native Americans
Fox, Lord Charles, 95, 153, 162, 198, 208
Frames, 5, 6, 11, 13, 54, 68
France, 59, 65–68, 70, 71, 73, 78, 84, 87, 89–97, 99, 100, 102, 107, 126, 128, 130, 134, 145, 153, 157–62, 164, 168, 183, 189, 190, 198, 203. *See also* Pictorial representations of France

Franklin, Benjamin, 12, 22, 25, 26, 57, 59–63, 65, 68, 69, 75, 80, 84, 97, 164, 167, 180, 189, 190, 198, 203–5, 208, 209, 211, 214, 230, 236, 239, 243, 248
French and Indian War, 23, 26, 27, 41, 57–59, 134, 139, 140, 144, 210
French cock, 66, 69–71, 73, 82, 133, 152
French Revolution, 74
Frenchmen, 80, 84, 89, 91, 94, 96, 116, 141, 152, 153, 157–60, 162, 168, 245
Freneau, Philip, 211
Frontispieces, 7, 8, 53, 67, 86, 161, 232, 233. *See also* Index of Titles *under* Prints; Prints

G

Gadsden, Christopher, 50, 251
Gadsden Flag, 50. *See also* Flags
Galloway, Joseph, 41, 171, 180, 183, 221, 222, 224
Gatteaux, Nicholas Marie, 101
Genius of France, 134, 168
George, Mary Dorothy, xiv, xv
George III, 3, 5, 6, 11, 32, 37, 43, 49, 69, 79, 87, 97, 98, 102, 106, 114, 117, 118, 168, 182, 186–88, 211, 232, 246
Georgia, 13, 32, 43, 45, 46, 49, 54, 172, 212, 213
Germain, Lord George, 211
Germany, 157, 190. *See also* Pictorial representations of Germany
Gibbon, Edward, 229
Gibraltar, 70, 96
Gillray, James, 10, 70, 101, 207, 208
Goddard, William, 28, 250
Godefroy, F., 243, 244
Goose, 202, 238, 240–45, 250
Gordon, Thomas, 57
Gorget, 49, 54
Gostelowe Standards. *See* Flags
Grafton, Duke of, 153, 246
Graham, Captain John, 214
Gray, Harrison, 180
Great Seal of Virginia, 232
Greece, 231
Green, Jacob, 195
Green, T., 7, 112, 173, 175, 189
Grenville, George, 80, 83, 226, 227, 245
Guile, 21, 23, 24, 31, 34, 35, 41, 55, 72

H

Habersham, John, 49, 54, 55
Hall, David, 215
Hamilton, Alexander, 166, 175
Hancock, John, 23, 43, 53, 55, 69, 237
Hart, Thomas, 66
Hedges, Edward, 10, 207, 208
Hen, 240, 242–44
Henry, Patrick, 38, 45, 50, 57
Heraldry, xiv, 23, 43, 74
Hercules, 189–92, 228, 249
Heritage, 14, 16, 18, 21, 22, 86, 104, 114, 118, 125, 145, 164, 166, 168, 187, 225–33, 251, 255
Hillsborough, Lord, 85

Hinkhouse, Fred Junkin, 236
Hitchcock, William, 10, 69
Hogarth, William, 9
Holland, 80, 89–92, 94, 102, 116, 203. *See also* Dutchman; Pictorial representations of Holland
Holt, John, 29, 32, 36, 42–44, 213, 250
Hopkins, Ezek, 65, 66, 68
Horse, 202, 238, 240, 245–48, 250
Housewares, xiii, 2, 4, 10, 11, 13, 215
Howard, Martin, 179
Howe, Richard, 68
Howe, William, 68
Huet, J. B., 190
Hulton, Ann, 111
Hume, David, 193
Humphrey, William, 10, 68, 71, 240–42, 247
Hunt, Isaac, 7, 127, 165, 172, 221, 222, 237
Huntington, Enoch, 175, 176, 198
Hurd, Nathaniel, 51, 168
Hutchinson, Thomas, 5, 22, 23, 25, 62, 172, 195, 236

I

Iconography, 44
Iconology, xvi, 74, 76
Identification, 48, 63, 72, 73, 92, 97, 112, 114, 118, 119, 218, 219, 251–54
Ideology, xv, 187
Illuminated displays, 2, 4, 10, 11, 105, 109, 110, 113, 119
Illustrations, xiii, 2, 4, 7–11, 13, 22, 24, 25, 27, 43, 49–51, 54–56, 65–71, 77–79, 82–87, 93, 95, 98, 100, 103, 105–10, 112, 114, 115, 117–21, 125, 126, 133–43, 151–62, 164, 168, 173–75, 189, 190, 199, 201–3, 207, 209–11, 213–16, 219–22, 226, 227, 230, 232–34, 247, 248. *See also* Prints
Illustrators, 15, 16, 73, 77–79, 90–92, 96, 97, 108, 109, 120, 125, 126, 162–64, 167, 168, 228–36, 238–50. *See also individual illustrators*
Imperial unity, 17, 86, 164, 166, 168, 218, 251
Independence, 3, 4, 16, 18, 31, 41, 56–60, 68–70, 73, 88, 92, 97, 102, 126, 133, 158, 165, 166, 184, 195, 197, 198
Indian, xv, xvii, xviii, 2, 3, 10, 14–18, 75–123, 126, 133, 134, 136–39, 141, 142, 153, 157–62, 168, 174, 201, 202, 208–11, 218, 219, 225–30, 232, 233, 236–38, 248, 251–54. *See also* Native Americans
Inglis, Charles, 172, 184–88, 198
Intolerable Acts, 3, 4, 8, 24, 25, 32, 34, 38, 112, 113, 131, 140–43, 159, 163, 193, 203, 207, 208, 213, 220, 226, 227, 231, 235, 237, 242, 248

J

James I, 99
James II, 5
Jay, John, 52
Jefferson, Thomas, 56
John Bull, 90, 91

Johnson, G., 212, 245, 247
Johnson, Samuel, 99, 207
Jones, Isaac, 111
Jouy, 11, 190
Juno, 167, 189, 192

K

Kalm, Pehr, 99
Kames, Lord, 164
Kerber, Linda, xv
Knox, William, 131

L

Labor, 16, 18, 80, 81
Langdon, Samuel, 174
Language, 3, 145, 166
Law, 3, 17, 29, 40, 51, 56, 60, 61, 63, 81, 131, 137, 145, 148, 152, 157, 166, 176, 193, 196, 205. *See also* Constitution, U.S.; Magna Charta
Leonard, Daniel, 4, 5, 38, 39, 104, 129, 166, 177, 181, 206, 222, 231, 235, 237
Letters, xv, 4, 24, 38, 52, 57, 62, 65, 111, 125, 166, 180, 195, 204, 206, 217, 231, 242
Lexington, 2, 22, 42, 188
Liberty, 29, 63, 64, 69, 85, 89, 98, 101, 106, 107, 110, 113, 116–18, 123, 168, 187, 228
Liberty cap, 42, 54, 67, 89, 97, 117, 232
Liberty pole, 54, 67, 76, 83, 88, 89, 97, 110, 113, 117, 232
Liberty tree, 66, 106, 108, 109, 168
Lion. *See* British lion
Liverpool, 11
Livingston, Robert R., 189
Locke, John, 1, 186, 201
Logo. *See* Mottoes and slogans
London, 2, 10, 25, 40, 54, 57, 61–63, 65, 67–69, 73, 80–84, 86, 87, 101, 102, 105–8, 112, 121
Loudon, Samuel, 213
Louis XVI, 12, 97, 107, 189
Louisburg, 82
Loyalists, 3, 5, 13–15, 24, 38–41, 52, 53, 66, 73, 98–100, 102, 104, 121, 129, 164–68, 171, 172, 177, 178, 180, 181, 184–89, 191, 195, 198, 206, 219–25, 231, 235, 237. *See also individual loyalists*
Loyalty, 168
Lucas, Stephen, xvi
Luttrell, Temple, 146
Lyme, Connecticut, 111

M

Macpherson, James, 130, 147, 149, 150, 154, 179
Magazines, xiii, xv, 2, 7–10, 84, 86, 87, 98, 101, 112, 114, 115, 136–42, 153, 154, 161, 167, 173–74, 176, 199, 203, 214, 216, 226, 227, 232, 233, 237, 248. *See also* Index of Titles *under* Magazines
Magna Charta, 42, 44, 107, 142, 168, 210
Malta, 190

INDEX

Mann, Horace, 242
Manners, 145
Mansfield, Lord, 84, 91, 141, 153, 227
Map, 113
Mars, 134, 135
Martinique, 229
Marvel, Andrew, 63, 64
Maryland, 26, 30, 42, 104, 165, 169, 170, 182, 242
Mason, George, 195
"Massachusettensis," 4. *See also* Leonard, Daniel
Massachusetts, 4, 5, 7, 13, 22, 25, 30, 32–39, 42, 45, 50, 51, 53, 54, 59, 62, 77, 103, 105–17, 119–22, 172, 175, 189, 212, 234, 235
Massachusetts Navy Flag, 45. *See also* Flags
Mastheads, 9, 22, 24, 28, 32–36, 38–40, 42–44, 49, 50, 61, 62, 103, 115, 117–21, 213
Material culture, xvii
McCrea, Jane, 99
McCulloh, Henry, 58, 59
Mecom, Jane, 204
Medals, xiii, 2, 4, 10, 12, 100, 101, 126, 140, 191, 215, 216, 233
Media, xiii, 4–5, 10, 12, 65. *See also specific media*
Medicine, 113, 183
Mein, John, 178, 246
Mercantile policies, 16, 81, 89, 103
Mercer, John Francis, 12
Mercury, 106
Metaphor, 6, 27, 28, 31, 87, 122, 202
Migration, 53, 65–67, 73
Military defense, 1, 92, 93, 118, 161, 162
Military flags. *See* Flags
Milton, John, 21
Milton, Massachusetts, 5
Minerva, 106, 189
Minuteman, 51
Mohawk Indians. *See also* Indian; Native Americans
More, Hannah, 228
Morgan, Daniel, 12, 101
Motifs, xiii, xv, xvii, 3, 10, 14, 16, 18, 23, 26, 41, 44, 48, 49, 73, 79, 115, 117, 202, 218, 219, 252–54
Motives, xvii, 202
Mottoes and slogans, xiv, 8, 9, 13, 14, 22, 23, 25, 26, 29, 30, 32, 34, 38, 41, 45, 48–51, 54, 55, 57, 62, 65–67, 71, 97, 117, 214, 215, 233
Mud Island, 68
Mulhouse, 11

N

Nationalism, 2, 80
Native Americans, 23, 26, 27, 41, 57–59, 75, 79, 80, 98–101, 109, 114, 115, 118–23, 236, 237. *See also* Indian
Natural law, 130, 131, 133, 140, 163, 181, 193, 194
Negotiations, 14, 96–98, 162, 215
Neptune, 91, 134
New England, 7, 22, 26, 28, 34, 38, 45, 46, 57, 62, 66, 111, 112, 115, 173, 175, 189, 204, 211, 232
New Hampshire, 211, 234
New Jersey, 26, 62
New London, Connecticut, 112
New York City, 5, 25
New York State, 10, 13, 26, 32, 34, 38, 39, 43, 52, 61, 62, 65, 204, 211, 213, 234
Newcastle, 58
Newspapers, xiii, xv, 2, 6, 8–10, 13, 15, 22–24, 26, 28, 29, 32–40, 43, 44, 46–49, 51, 52, 61–65, 72, 103, 108, 109, 111, 115, 117–21, 125, 162, 167, 168, 174, 176, 195, 212, 234. *See also* Index of Titles *under* Newspapers; Prints
Niagara, 82
Niles, Hezekiah, 217
Noble Savage, 100, 101, 122
Nonimportation, 132
Norman, John, 10, 54
North, Lord, 84, 85, 87, 91, 92, 95, 113, 141, 151, 153, 207, 211, 216, 226, 227
North Briton, 208
North Carolina, 13, 26, 45, 49, 50, 213, 214
Nova Scotia, 172, 211
Numismatics. *See* Coins; Medals

O

Ohio, 82, 206
Olive branch, 150
Oliver, Peter, 53, 111, 179
Oral cultures, xvii
Orators, 16, 21, 101, 130, 145, 146, 148, 165, 166, 171, 172, 178, 180, 182, 191, 224
Otis, James, 55, 80, 165
Ouroboros, 24, 42, 43, 45, 50, 51, 54, 68, 213, 232. *See also* Rattlesnake; Serpent; Snake

P

Paine, Thomas, 56, 114, 176, 183–89, 198, 199, 224, 225, 235
Paintings, xiii, 2, 4, 5, 10, 22, 50, 53, 54, 67, 68
Pamphlets, xiii, xv, 2, 6–8, 10, 13, 100, 125–36, 138, 143–51, 154, 155, 163, 165–69, 171, 172, 174, 176–81, 183–88, 192–99, 219–26, 236, 237. *See also* Index of Titles *under* Pamphlets
Pandora's Box, 106
Paper currency, 49, 50, 213–16, 233
Parades, 11
Parent, 125–27, 129–36, 138–41, 143–55, 163, 164, 166–72, 174–83, 185–89, 191, 192, 194–96, 198, 224
Paris, 2, 13, 25, 41, 65, 67–69
Parker, James, 62
Parliament, 3, 5, 16, 18, 22–24, 29, 30, 33, 38, 60, 61, 63, 78–85, 90, 95, 98, 101, 104–6, 110, 112, 113, 142–48, 150, 151, 164, 167, 207, 210
Partridge, Richard, 25, 57, 59
Patriarchy, xv, 15, 79, 81, 165, 170, 186
Patriotism, 22, 24, 36, 53, 55, 67

INDEX

Patriots, 13, 39, 50, 55, 104, 110, 111, 164, 167, 172, 178, 180, 183–89, 224, 225, 237
Peace commissioners, 68, 121, 157, 158
Peace negotiations, 96–98, 162, 215
Peale, Charles Willson, 54, 67
Pedestals, 6
Pennsylvania, 13, 22, 23, 25–27, 32, 34, 35, 41, 45–48, 50, 51, 52, 54, 57, 61, 62, 65, 105, 108, 116–19, 187, 188, 204, 206
Personifications. *See* Fame; Liberty; Loyalty; Plenty
Philadelphia, 7, 8, 10, 13, 42, 43, 54, 55, 65, 105, 108, 112, 116, 117, 127, 168, 195, 203–5, 213
Pictorial communication, 2–4, 7–14, 16–18, 77, 86, 102, 105, 106, 110, 120, 218, 219, 252–54
Pictorial representations of America, xiii–xv, xvii, 2, 3, 7, 9–11, 14–19, 22–28, 42–56, 63–110, 113–23, 125, 126, 133–39, 141–43, 150–64, 167, 168, 174, 181, 189–92, 201, 202, 204, 207–30, 232–34, 236–55
Pictorial representations of Britain, 17, 18, 22, 32, 33, 45, 49–51, 56, 62, 63, 66, 68–70, 73, 76, 82–84, 86–93, 96–100, 105–8, 113, 114, 116–19, 133–36, 138, 141–43, 151–54, 156–63, 168, 173, 174, 189, 192, 203–6, 210, 248, 249, 252
Pictorial representations of Congress, 89, 115, 116, 120. *See also* Congress
Pictorial representations of England, 85, 86, 91, 116, 205, 207, 224, 244
Pictorial representations of Fourth Continent, 75–77, 123. *See also* Fourth Continent
Pictorial representations of France, 66, 69–71, 73, 78, 80, 82, 84, 87, 89–97, 99, 102, 107, 116, 134, 135, 141, 152, 153, 157–60, 162, 168, 189, 245, 249. *See also* France; French cock; Frenchmen; Genius of France
Pictorial representations of Germany, 69. *See also* Eagle; Germany
Pictorial representations of Holland, 69, 70, 73, 78, 80, 89–92, 94, 95, 102, 116, 158, 162, 249. *See also* Dutchman; Holland
Pictorial representations of Scotland, 85, 86, 107
Pictorial representations of Spain, 69, 70, 73, 78, 87, 90–97, 99, 102, 116, 141, 153, 159, 160, 162, 249
Pierres, Philip Denis, 190
Pine tree, 45, 50, 51, 65
Pingo, T., 140
Pitt, William, 5, 11, 82, 83, 89, 100, 107, 110, 136, 139, 140, 152
Plates, 13, 215. *See also* Housewares
Plenty, 86, 161, 228
Poetry, 4, 80, 86, 94, 96, 107, 108, 232, 240–42. *See also* Song sheets; Verse
Political orientation, xvii
Portraits, 5, 6, 8, 13, 22, 24, 45, 49, 50, 53–56, 65–68, 87, 105, 110, 215
Potter, Janice, xv
Powder horns, xiii, 2, 214
Pownall, Thomas, 60, 61, 63, 100, 237
Price, Richard, 128, 129, 145, 146, 193
Pridden, J., 83

Printmakers, 6, 9. *See also individual printmakers*
Printmaking, 7, 13
Print shops, 6, 9, 10
Printers, 9
Prints, xiii, xv, 6–14, 53–56, 65–67, 77, 79, 82, 89, 108, 109. *See also* Index of Titles
Proclamations, 125
Proctor, John, 46
Products, 18, 81
Prostitute, 82, 83, 99, 102
Prostitution, 82, 83, 99, 102, 175
Providence, Rhode Island, 28
Prown, Jules, xvii
Pruneau, Noel, 67
Pseudonyms, 4, 38, 63, 64, 131, 135–36, 147, 174, 175, 178, 183, 194, 227, 237, 248
Public addresses, 13
Public celebrations and demonstrations, 10, 11, 105
Public forums, 5, 9
Pubs, xiv, 9
Putnam, Israel, 69, 217

Q

Quebec, 211
Quebec Bill, 227

R

Racial other, 14, 15, 77, 79, 81, 84, 85
Radical, 3, 14, 219, 250–54
Rape, 12, 15, 79, 84, 85, 112, 141
"Rationalis," 63, 64
Rattlesnake, 13, 22–24, 45–55, 65–73, 234, 236–38, 249–53. *See also* Ouroboros; Snake
Ray, Nicholas, 65, 129, 145, 146
Reason, 4, 14, 79, 99
Rebuses, 8, 70, 88, 157, 158
Reed, Joseph, 172
Reid, Ronald, xvi
Religion, 80, 114, 115, 120, 121, 130, 133, 140, 145, 163, 166, 181, 187, 191, 193, 194, 214, 217. *See also* Catholic church; Church of England
Representation, 3, 29, 80, 167
Representations, pictorial, 6, 26
Republicanism, 3, 14, 17–19, 58, 74, 102, 201, 203, 235
Revenue Act of 1764, 165, 193
Revere, Paul, 8, 10, 11, 22, 33, 51, 105, 109, 110, 112–15, 117, 119–22, 210, 211, 214, 248
Revolutionary War years, 44–55, 65–71, 73, 74, 87–98, 115–19, 151–63, 189–91, 207, 208, 211–16, 221–24, 226, 228–35, 238, 240, 242–50, 252
Rhetoric, xiv, xvi, xvii, 23, 24, 30, 79, 90, 111, 115, 130, 193
Rhetorical criticism, xvii
Rhetorical iconology, xvi
Rhetorical structure, 4, 14, 202, 203
Rhetorical topos, 41, 203
Rhode Island, 29, 45, 211, 213, 216
Richardson, George, xvi, 76
Richardson, William, 10, 69, 216, 247

Richmond, Duke of, 208
Rituals, 13
Rivington, James, 36, 38, 52
Rockingham, Lord, 149
Rodney, Admiral, 91
Roman Republic and Empire, 17, 19, 73, 86, 225, 229–33, 255
Rome, 229–31, 233, 255
Royal Arms, 6, 22, 28, 32, 43, 51

S

"Sagittarius," 178. See also Mein, John
Sandwich, Lord, 84, 91, 141, 142, 229
Saratoga, 189, 249
Satires, xiv, 13, 80
Savagery, 16, 75, 88, 98–102, 112–14, 118–23
Scale or balance, 80, 93, 94
Schlereth, Thomas, xvii
Scotland, 85, 86, 107
Scott, Reverend James, 135, 136
Sculpture, 4, 5. See also Statues
Seabury, Samuel, 177, 191, 222
Seals, 13, 24, 55, 65, 232
Sermons, 13, 21, 41, 166, 168, 171, 178, 180, 182, 191, 195, 224, 248. See also Index of Titles under Pamphlets, Speeches
Serpent, 21, 35, 36, 41, 107. See also Ouroboros; Rattlesnake; Snake
Sexual other, 14, 15, 79, 81, 84
Sexual violation. See Rape
Shakespeare, William, 21, 155
Sharp, Anthony, 7, 234
Sharp, William, 54, 67
Shebbeare, John, 148–50, 179, 193
Shelburn, Lord, 98
Shelley, Percy Bysshe, 74
Sheppard, C., 244, 247
Sherwood, Samuel, 248
Shirley, William, 59
Shop windows, xiv
Shrewsbury, 111
Slogans. See Mottoes and slogans
Smith, Reverend William, 195
Snake, xiii, 13, 14, 21–38, 40–57, 59, 61–73, 119, 126, 201, 202, 209, 211, 212, 218, 219, 225, 230, 232, 234, 236–38, 249–55. See also Ouroboros; Rattlesnake; Serpent
Snake biting its tail. See Ouroboros
Song sheets, 10, 82, 83, 93, 126, 136–38, 247
Sons of Liberty, 110, 111, 113
South Carolina, 13, 26–28, 45, 49, 50, 58, 64, 65, 66, 213, 214
South Carolina Navy Ensign, 45, 49, 65, 66. See also Flags
Spain, 90, 198. See also Pictorial representations of Spain; Spaniard
Spaniard, 87, 90–96, 99, 102, 116, 141, 153, 159–62. See also Pictorial representations of Spain; Spain
Speaking pictures, xvi. See also Iconology
Speeches, xvi, 125. See also Index of Titles under Speeches
Sprengel, Matthias Christian, 190
St. George, Robert Blair, xvii

St. Jago, 91
Stamp Act, xiii, 3, 5, 10, 11, 22, 23, 25, 28–30, 60, 61, 63, 64, 76, 78–83, 100, 102, 104–10, 119, 131, 133, 135–41, 144, 149, 150, 159, 163, 167–69, 173, 192, 193, 203–5, 210, 211, 214, 226, 227, 235, 239, 241, 242, 248
Stamp Act Congress, 42, 65
Statues, xiii, xiv, 2, 4–6, 10, 92
Stebens, Harmon, 214
Stewart, James, 135, 136
Stewart, Walter, 50, 54, 55
Stony Point, 217
Subversion, xv
Synecdoche, 92

T

Tapestries, xiv. See also Textiles
Taxation, 3, 29, 72, 79–81, 83, 104, 106, 108, 149, 165, 167, 204, 206. See also Boston Tea Party; Stamp Act
Teapot, 71, 112, 227
Textiles, xiii, 2, 10–12, 100, 190, 230. See also Flags; Tapestries
Thames, 206
Thistle, 107
Thomas, Isaiah, 22, 29, 33, 38, 115, 117, 119, 120, 250
Ticondrage, 118
Title pages, 7, 8
Tobago, 229
Townshend, Charles, 144
Townshend, Viscount, 95
Townshend Duties, 5, 25, 30, 84, 143, 150, 159, 193, 205, 206
Trade. See Commerce
Transformation, xv, xvi, 5, 13, 14, 17, 19, 24, 42, 45, 46, 48, 49, 51, 72, 111, 117, 120, 123, 203
Treason, 40, 41, 69
Treasury notes, 13, 51
Trenchard, John, 57
Trumbell, John, 67
Tucker, Josiah, 145

U

Union Jack, 45, 50, 68
Utilitarian concerns, 14, 17–19, 203

V

Verien, Nicholas, 13, 25
Vermont, 215
Vernacular artifacts, xvii
Verses, 31, 33, 35, 36, 43, 69, 70, 73, 80, 86, 108, 141, 161, 182. See also Index of Titles under specific titles; Poetry; Song sheets
Vinycomb, John, 43
Virginia, 26, 28, 38, 45, 49, 50, 62, 97, 172, 204, 211, 232

W

Wallace, Michael, xv
Walpole, Horace, 242

Washington, George, 22, 53–56, 65, 67–69, 161, 162, 217, 230
Wayne, Anthony, 12, 217
Wedgwood, Josiah, 24
Wedgwood earthenware, 24
Wells, Richard, 131, 199, 240
Wells, W., 94, 211, 244
Westmoreland County Battalion Flag, 45–46, 50. See also Flags
Weston, Massachusetts, 111
Wharton, Charles, 53, 67
Whigs, 14, 23, 39
White, William, 246, 247
Wilkes, John, 55, 72, 153, 208
Wilkins, Isaac, 169, 195
Wilkinson, (first name unknown), 10, 105, 108, 119, 168, 173
Will, Jon. Martin, 66
Williams, I., 99
Williamsburg, 13
Wittkower, Rudolf, 74
Woodbridge, New Jersey, 62
Woodcuts, 6–9, 13, 22, 25–28, 45, 49–51, 54, 112, 115, 117–21, 173, 175, 189, 211–16, 232, 234. See also Index of Titles *under* Prints; Prints
Worcester, Massachusetts, 38
Writers. *See* Diaries; Letters; Magazines; Newspapers; Pamphlets
Written records, xv, xvii

Y

Yazawa, Melvin, xv
Yorktown, 189, 211, 249

Z

Zebra, 202, 212, 238, 245, 250

Books See also *Emblem Books*

Allgemeines historisches Taschenbuch, 190
The Annual Register . . . for 1765, 5, 64, 65
Bible, 21, 34–36, 41, 66, 72, 127, 130, 148, 151, 180–82, 193, 224, 225, 245
The Constitutions of the Several Independent States of America, 67
Correpondance littéraire, philosophique et critique de Grimm et de Diderot depuis 1753 jusqu'en 1790, 247
Henry VI, Part II, 21
The History of Printing in America, 27, 33, 117
The History of the Five Indian Nations of Canada, 101
An Impartial History of the War in America, 54
Julius Caesar, 21
King Lear, 21
The New, Comprehensive and Complete History of England, 65, 230
On Education, 186
Patriarchia, or the Natural Power of Kings, 186
Revolt of Islam, 74
Richard II, 21
Romeo and Juliet, 21
Swan's Collection of Designs in Architecture, 43, 213
Travels into North America, 99
Troilus and Cressida, 21
Two Treatises of Government, 1, 186, 201
The White Man's Indian: Images of the American Indian from Columbus to the Present, 75

Coins

"Continental Dollar for 1776" (coin), 215
"Fugio Cent" (two versions), 215

Currency

"Continental dollar," 9
"Eight Dollars" (for Continental Congress), 213, 216, 218
"Eight Dollars" (for Rhode Island), 213
"Eighty Dollars" (for South Carolina), 214
"FIFTEEN POUNDS *Currency*" (for South Carolina), 49
"Fifty Dollars" (for Continental Congress), 216
"FIVE DOLLARS" (for New York), 213
"Five Pounds" (for South Carolina), 213, 214
"Forty Dollars" (for Continental Congress), 214
"ONE EIGHTH *of a* DOLLAR" (for North Carolina), 50
"ONE HUNDRED POUNDS" (for South Carolina), 213
"One Sixth of a DOLLAR" (for Continental Congress), 214
"One Third of a DOLLAR" (for the Continental Congress), 214
"ONE THIRD of a Spanish milled DOLLAR" (for Virginia), 233
"SEVENTEEN SPANISH MILLED DOLLARS" (for Georgia), 49

TITLES

Almanacs

Bickerstaff's *BOSTON ALMANACK*, 7
The CONTINENTAL ALMANAC FOR THE Year *of our LORD, 1782*, 7, 234
Edes & Gill's *North-American Almanack*, 7
FREEBETTER'S NEW-ENGLAND ALMANACK, *for the Year 1776*, 7, 112, 173, 175, 189
Massachusetts Calendar; or an ALMANACK for *the Year of our Lord Christ 1774*, 7, 22
PHILADELPHIA ALMANACK for the YEAR *of Our Lord 1780*, 7, 54
WEATHERWISE'S TOWN AND COUNTRY ALMANACK FOR THE YEAR OF OUR LORD *1781*, 7, 115
WEATHERWISE'S TOWN AND COUNTRY ALMANACK FOR THE YEAR OF OUR LORD *1782*, 7, 232

"Six Shillings and Eight Pence per Ounce" (for
 Vermont), 215
"Ten Dollars" (for North Carolina), 213
"TWENTY DOLLARS" (for North Carolina), 50
"TWENTY SPANISH MILLED DOLLARS" (for
 Georgia), 49
"Two Dollars & an Half" (for North Carolina),
 213, 214
"Two Shillings and Six Pence" (for Vermont), 215
"Two Thirds of a DOLLAR" (for Continental
 Congress), 214

Emblem books

Iconology, 76
Livre curieux et utile pour les sçavans, et artistes,
 13, 25
*Recueil d'emblêmes[,] dévices, médailles, et figures
 hieroglyphiques*, 13, 25

Essays

"The Whitehall Pump: A Vision," 142

Flags

Color of the 2nd New Hampshire Regiment of
 1777, 11
Continental Navy Jack, 45, 66
Culpepper Minute Men Flag, 45, 50
Gadsden Flag, 50
George Washington's life guards, 55
Gostelowe Standard Number Eleven, 117
Gostelowe Standard Number Four, 117
Gostelowe Standard Number One, 213
Gostelowe Standard Number Thirteen, 214
Gostelowe Standard Number Three,
 Harmonious Union, 216
Headman Color, 213
Massachusetts Navy Flag, 45
Philadelphia Light Horse, 117
Second Pennsylvania Regiment, 50
South Carolina Navy Ensign, 45, 49, 65, 66
Webb's Additional Continental Regiment of
 1777, 117
Westmoreland County Battalion Flag, 45, 46, 50

Illuminated displays

"A VIEW *of the* OBELISK *Erected under* LIBERTY-
 TREE *in* BOSTON *on the Rejoicings for the
 Repeal of the* —— *Stamp-Act*," 10, 11, 105,
 109, 110, 113, 119

Letters

Cato's Letters, 57
Diplomatic correspondence about designs on
 flags, 65
From Benjamin Franklin to Jane Mecom, 204

From Benjamin Franklin to Richard Partridge,
 57
From Cadwallader Colden to Benjamin Franklin,
 62
From George Mason to London merchants, 195
From Horace Walpole to Horace Mann, 242
From John Adams to Hezekiah Niles 217
From John Andrews 111
From Joseph Galloway to Benjamin Franklin,
 180
From Josiah Wedgwood to Thomas Bentley, 24
From Thomas Hutchinson to Benjamin
 Franklin, 62
Letters from a Farmer in Pennsylvania, 30, 126,
 169, 176, 206, 240
Massachusettensis, 4, 38, 166, 206, 231

Magazines

The Columbian Magazine, 8, 214, 216, 232
The Gentleman's Magazine, 136
The Hibernian Magazine, 8, 84, 141, 173, 226
The London Magazine, 8, 84, 86, 101, 112,
 141, 173, 2
The Oxford Magazine, 8, 114, 140
The Pennsylvania Magazine, 8, 199, 248
The Political Register, 8, 84, 203
The Rambler's Magazine, 8, 98, 161, 216
The Royal American Magazine, 8, 112, 114, 115,
 237
Scots Magazine, 101
The Town and Country Magazine, 8, 226, 227
The United States Magazine, 8, 233
The Universal Magazine, 8
The Westminster Magazine, 8, 87, 142, 153, 154

Mastheads

Constitutional Courant, 22, 28, 61–62
Massachusetts Spy Or, Thomas's Boston Journal, 32,
 33, 38, 103, 115, 117–21
New-York Journal, 32–34, 42, 44, 213
Pennsylvania Journal, 32, 34, 35
Virginia Gazette, 49, 50

Medals

Brigadier General Anthony Wayne, 101
Brigadier General Daniel Morgan, 12, 100, 101
FELICITAS: BRITANNIA ET AMERICA,
 215
Libertas Americana, 12, 167, 189, 190, 248
"THE MAN WHO HAVING SAVED THE PARENT
 PLEADED WITH SUCCESS FOR HER
 CHILDREN," 140
Médaille diplomatique, 100, 101

*Newspapers; for specific titles of woodcuts
 see Mastheads and Prints*

Boston Evening-Post, 27, 28
Boston Gazette, 11, 26, 27, 111, 182
Boston Weekly News-Letter, 26, 35, 36

INDEX

Connecticut Courant, 248
Constitutional Courant, 22, 28–30, 61–64
London Chronicle, 5, 65, 133, 135, 136, 243
Massachusetts Centinel, 234
Massachusetts Gazette and Boston News-Letter, 11, 109
Massachusetts Gazette and Boston Post-Boy, 4
Massachusetts Spy Or, Thomas's Boston Journal, 9, 22, 32–39, 103, 115, 117, 119, 120, 121
Newport Mercury, 28
New-York Gazette, 26
New-York Gazetteer, 22, 32–38, 43, 44
New-York Journal, 9, 22, 32, 34–37, 42–44, 51, 213
New-York Mercury, 26, 169
Pennsylvania Gazette, 13, 21, 25–27, 57, 61, 108, 168, 170, 243
Pennsylvania Journal, 9, 22, 23, 32, 34, 35, 46–48, 51, 52, 63, 65, 118, 170, 174, 195
Pennsylvania Ledger, 166
Pennsylvania Packet, 118, 175, 183
Pennsylvania Staatsbote, 231
Public Advertiser, 112, 194, 239, 246
Public Ledger, 5, 63, 246
Royal Gazette, 52
South Carolina Gazette, 26–28
St. James Chronicle, 242
Virginia Gazette, 9, 11, 26, 28, 50

Paintings

Benjamin Franklin, 22, 68
Charles I, 5
James II, 5
John Habersham, 49, 54
George Washington, 67
Thomas Hutchinson, 5
Walter Stewart, 50, 54

Pamphlets

AN ADDRESS OF THE TWELVE UNITED COLONIES OF NORTH-AMERICA, BY THEIR REPRESENTATIVES IN CONGRESS, TO THE PEOPLE OF IRELAND, 176
Address To The PEOPLE of GREAT-BRITAIN From The DELEGATES Appointed by the several ENGLISH COLONIES, 175
The Administration of the Colonies, 60, 61, 63, 100
The ADVANTAGES Which AMERICA Derives from her COMMERCE, CONNEXION, and DEPENDANCE on BRITAIN, 179, 197, 198, 206
The American Querist: Or, Some Questions Proposed Relative To The Present Disputes Between Great Britain And Her American Colonies, 130, 165, 180
An Answer To The Printed Speech Of Edmund Burke, Esq; Spoken In The House of Commons, April 19, 1774, 148
A Candid Examination Of The Mutual Claims Of Great-Britain, And The Colonies: With A Plan Of Accommodation, On Constitutional Principles, 41, 183, 224

The Case Stated On Philosophical Ground, Between Great Britain And Her Colonies: Or The Analogy Between States And Individuals, Respecting the Term of Political Adultness, Pointed Out, 128, 155, 194
Cato's Letters, Or, Essays on Liberty, 57
The Claim Of The Colonies To An Exemption from Internal Taxes Imposed By Authority of Parliament, Examined, 131
Colonising, Or A Plain Investigation Of That Subject; With A Legislative, Political, And Commercial View Of Our Colonies, 192
Common Sense; Addressed To The Inhabitants Of America, 184–89, 198, 224, 235
Considerations On The Propriety Of Imposing Taxes In The British Colonies, For the Purpose of raising a Revenue, by Act Of Parliament, 30, 104, 169, 170, 242
The Crisis. Number III. By the Author of Common Sense, 199
A Defense of the Letter from a Gentleman at Halifax, To His friend in Rhode-Island, 179
An Elegy to the Infamous Memory of Sr. F---- B-----, 7, 30–32
The Farmer Refuted: Or, a More Impartial and Comprehensive View of the Dispute Between Great-Britain and the Colonies, Intended as a Further Vindication of the Congress: In Answer to a Letter from A. W. Farmer, Intitled a View of the Controversy, 166, 175
A Few Political Reflections Submitted to the Consideration of the British Colonies, 131, 240
A Few Remarks upon Some of the Votes and Resolutions of the Continental Congress, 180
Four DISSERTATIONS on the Reciprocal ADVANTAGES of a Perpetual UNION Between GREAT-BRITAIN and Her AMERICAN COLONIES, 172
A Friendly Address To All Reasonable Americans, On The Subject Of Our Political Confusions, 166, 178, 180, 181
Government Corrupted by Vice, and Recovered by Righteousness, 174
The Importance Of The Colonies of North America, And the Interest of Great Britain with regard to them, Considered, 65, 129, 145, 146
Independency The Object Of The Congress In America. Or, An Appeal to Facts, 154
JOURNAL of the PROCEEDINGS of the CONGRESS, Held at Philadelphia, September 5, 1774, 42, 213
Letters from a Farmer in Pennsylvania, to the Inhabitants of the British Colonies, 30, 126, 169, 176, 206, 240
Licentiousness Unmask'd; Or, Liberty Explained, 132, 138, 151, 193, 244
Massachusettensis, 4, 38, 166, 206, 231
A Narrative of the Capture and Treatment of John Dodge, by the English at Detroit, 98
The Necessity Of Repealing The American Stamp-Act Demonstrated: Or, A Proof that Great Britain must be injured by that Act, 130, 194
Observations On The Nature Of Civil Liberty, The Principles Of Government, And The Justice And Policy Of The War With America, 128
On American Taxation, 148

Origin & Progress of the American Rebellion, 53,
 111, 179
*The Origin Of The American Contest With Great-
 Britain, Or The present political State of the
 Massachusetts-Bay, in general, And The Town of
 Boston in particular,* 4
*The Patriots of North-America: A Sketch. With
 Explanatory Notes,* 39, 40, 231
*Plain Truth: Addressed to the Inhabitants of
 America,* 184
*A Poetical Epistle to his Excellency George
 Washington, Esq.,* 53, 67
*The Political Family: Or A Discourse, Pointing Out
 the Reciprocal Advantages, Which Flow from an
 Uninterrupted Union Between Great-Britain and
 Her American Colonies,* 7, 127, 165, 221, 222
*Remarks On Dr. Price's Observations On The
 Nature Of Civil Liberty, & c.,* 146, 149, 246
*Remarks On The Nature and Extent of Liberty, as
 compatible with the Genius of Civil Societies; On
 the Principles of Government and the proper
 Limits of its Powers in Free States; And, on the
 Justice and Policy of the American War.
 Occasioned by Perusing the Observations of Dr.
 Price on These Subjects,* 125
*A Retrospective View Of The Causes Of The
 Difference Between Great Britain and her
 Colonies in America,* 196, 197
*The Rights Of Great Britain Asserted Against The
 Claims Of America: Being An Answer To The
 Declaration Of The General Congress,* 130,
 147, 149, 154
*The Rights of the British Colonies Asserted and
 proved,* 165
*A SERMON, Containing, Scriptural Instructions
 to Civil Rulers, and all Free-born Subjects,* 248
Short Advice to the Counties of New-York, 169,
 195
*Some Observations of Consequence, In Three Parts.
 Occasioned by the Stamp-Tax, Lately Imposed on
 the British Colonies,* 174
*The Speech of Edmund Burke, Esq; On Moving His
 Resolution For Conciliation with the Colonies,
 March 22, 1775,* 146
*Taxation no Tyranny; An Answer To The Resolution
 And Address Of The American Congress,* 207
*The True Interest of America Impartially Stated, in
 Certain Strictures on a Pamphlet Intitled
 Common Sense,* 172, 184–88, 198
*A View of the Controversy Between Great-Britain
 and her Colonies: Including a Mode of
 Determining Their Present Disputes, Finally and
 Effecually; And of Preventing All Future
 Contentions,* 177, 222
*What think ye of the Congress Now? Or, An
 Enquiry, How Far The Americans are Bound To
 Abide by, and Execute the Decisions of, The Late
 Congress?* 132, 181, 223, 224
*The Wisdom and Policy of the French in the
 Construction of Their Great Offices,* 58

Portraits, painted and printed

Benjamin Franklin, 22, 68
Charles I, 5

Ezek Hopkins, 65, 66
George III, 5, 6, 87
George Washington, 22, 54–56, 65, 67
Henry Seymour Conway, 5
Isaac Barré, 5
James II, 5
James Otis, 55
John Habersham, 49, 54
John Hancock, 55
John Wilkes, 55
Samuel Adams, 22, 54, 55
Thomas Hutchinson, 5
Thomas Jefferson, 56
Walter Stewart, 50, 54
William Pitt, 5

Powder horns

Of John DeWandeler, 214
Of Harmon Stebens, 214

Prints

*"The able Doctor, or America Swallowing the Bitter
 Draught"* (version in *The London Magazine*),
 84, 85, 88, 112, 140–41
*"The able Doctor, or America Swallowing the Bitter
 Draught"* (version in *The Hibernian
 Magazine*), 84, 85, 88, 140–42
*"The able Doctor, or America Swallowing the Bitter
 Draught"* (version in *The Royal American
 Magazine*), 112
*"[The able Doctor, or America Swallowing the
 Bitter Draught]"* (version in FREEBETTER'S
 NEW-ENGLAND ALMANACK), 112, 173–
 75, 189
"[The above is a Design]," 230
"THE ALLIES—Par nobile Fratrûm!" 98
"America in Distress," 113, 114, 121
"[America to her Mistaken Mother]," 88, 158
"AMERICA TRIUMPHANT and BRITANNIA in
 DISTRESS," 232
"AMERICA. To Perpetuate to Posterity the
 Memory of those Patriotic Heroes, who
 Fought, Bled, & Died," 227, 228
"The American Moose-Deer, or away to the
 River Ohio," 245
"The AMERICAN RATTLE SNAKE," 70
"The American Rattlesnake presenting Monsieur
 his Ally a Dish of Frogs," 70
"L'AMÉRIQUE INDÉPENDANTE," 101
*"Amusement for John Bull & his Cousin Paddy, or,
 the Gambols of the American Buffalo, in St.
 James's Street,"* 250
"L'ANGLETERRE EXPIRANTE," 101
"L'ANGLETERRE SUPPLIANTE," 101
"ANTICIPATION; or, the CONTRAST to the
 ROYAL HUNT," 95, 229
"ARGUS," 101
"The [Ass]-headed and [Cow-Heart]-ed
 Ministry making the British [Lion] give up
 the Pull," 70
"La balance de la puissance," 93
"The Ballance of *Power,"* 93

"THE BALLANCE, or the Americans Triumphant," 83

"The BELLIGERANT PLENIPO'S," 97

"Blessed are the PEACE MAKERS," 216

"THE BLESSINGS OF PEACE," 97

"[Britain, America, *at length be Friends*]," 86

"BRITAIN'S RIGHTS maintaind; or *FRENCH AMBITION* dismantled," 77, 82, 133, 134

"BRITANIA *and Her* DAUGHTER. *A Song,"* 93, 159–61

"BRITANIA'S ASSASSINATION, *or————the Republicans Amusement,"* 92, 207–9

"Britannia in Distress," 114

"BRITANNIA PROTECTED *from the Terrors of an* INVASION" *or "A loud-crying Woman & a Scold shall be sought out to drive away the Enemies,"* 92

"[Britannia to America]," 68, 157

"The BRITISH LION *engaging* FOUR POWERS," 69

"BRITISH RESENTMENT *or the* FRENCH *fairly* COOPTD *at Louisbourg,"* 82

"BRITTANNIA MUTILATED. *or the Horrid (but true) Picture of Great Brittain. when Depriv'd of her Limbs.* BY HER ENEMIES," 203, 208

"The Bull Broke Loose," 91

"The BULL OVER-DROVE: or the DRIVERS in DANGER," 91

"The BULL ROASTED; or the POLITICAL COOKS Serving their CUSTOMERS," 91

"BUNKERS HILL *or America's Head Dress,"* 227, 228

"Bunkers hill, or the blessed effects of Family quarrels," 87, 88, 151, 153, 154, 158

"A certain Cabinet Junto," 114, 121

"The Chevalier D'————n producing his Evidence against certain Persons," 85

"The CLOSET," 99

"THE COMMISSIONERS," 121, 156, 157

"COMMODORE HOPKINS, *COMMANDER in CHIEF of the AMERICAN FLEET,"* 66

"THE CONTRAST," 238

"The COURT COTILLION, Or the Premïers new Parl+ + + + +t Jig," 85

"THE CURIOUS ZEBRA. *alive from America!,"* 212, 245

"DEDIÉ AUX MILORDS DE L'AMIRAUTÉ ANGLAISE PAR UN MEMBRE DU CONGRÉS AMÉRICAIN," 116

"The DEPLORABLE STATE of AMERICA or SC—H GOVERNMENT" (Copley's version), 77, 105–8, 119, 121, 168, 189

"The DEPLORABLE STATE of AMERICA or SC—H GOVERNMENT" (London version), 77, 105–8, 122

"The DEPLORABLE STATE of AMERICA or SC—H GOVERNMENT" (Wilkinson's version), 105, 108, 119, 168, 189

"DOMINION of the SEAS," 97

"DON'T TREAD ON ME" (version in the *Virginia Gazette*), 50

"Dutch GRATITUDE display'd," 94

"The DUTCHMAN *in the* DUMPS," 226

"An East View of GRAY'S FERRY near Philadelphia with the TRIUMPHAL ARCHES & c. *erected for the Reception of General Washington, April 20th, 1789,"* 55

"Eight Dollars" (currency for Continental Congress), 213, 216

"Eight Dollars" (currency for Rhode Island), 213

"Eighty Dollars" (currency for South Carolina), 214

"[An Emblematical Print Adapted to the Times]," 226

"ENGLISCH PRINTET," 247

"THE ENGLISH LION DISMEMBER'D *Or the Voice of the Public for an Enquiry into the Public Expenditure,"* 92, 207, 208

"THE ENGLISHMAN IN PARIS," 244

"THE EUROPEAN DILIGENCE," 158

"Explication de ce tableau touchant l'etat de la Nation d'Angleterre," 90

"EXPLICATION DE LA MÉDAILLE FRAPPÉE PAR LES AMÉRICAINS EN 1782, 190

"AN EXTRAORDINARY *Gazette, or the* DISAPOINTED POLITICIANS," 66

"THE FEMALE COMBATANTS," 151, 152, 154

"FIFTEEN POUNDS *Currency*" (currency for South Carolina), 49

"Fifty Dollars" (currency for Continental Congress), 216

"FIVE DOLLARS" (currency for New York), 213

"Five Pounds" (currency for South Carolina), 214

"THE FLIGHT of the CONGRESS," 69

"Forty Dollars" (currency for Continental Congress), 214

"[Freedom, Peace, Plenty all in vain advance]," 161

"The General P—s, or Peace," 97

"GEORGE WASHINGTON Comander and Chief of ye Armies of ye UNITED STATES of AMERICA" (Brunton's version), 54

"GEORGE WASHINGTON commandant en chef des armées des Etats-unis de l'Amérique," 67

"GEORGE WASHINGTON Commander and Chief of ye Armies of ye UNITED STATES OF AMERICA" (Wharton's version), 53, 67

"Goody Bull or the Second Part of the Repeal," 82, 136–39

"The Grand Cricket Match," 98

"The Great Financier, or British Economy for the Years 1763, 1764, 1765," 80–82, 88

"HOPKINS COMMANDANT EN CHEF la Flotte Américaine," 66

"The HORRORS of WAR a VISION Or a Scene in the Tragedy of K: Rich[ar]d: 3," 95

"THE HORSE AMERICA, throwing his Master," 246

"INDÉPENDANCE DES ÉTATS-UNIS," 101

"Its Companion," 84, 203

"JACK ENGLAND Fighting the FOUR CONFEDERATES," 91

"JOHN BULL TRIUMPHANT," 91

"JOIN OR DIE" (version in *An Elegy to the Infamous Memory . . .*), 30, 31

"JOIN OR DIE" (version in the *Boston Evening-Post*), 29

"JOIN, or DIE" (version in the *Boston Gazette*), 26, 27

"JOIN, or DIE" (version in the *Boston Weekly News-Letter*), 26, 27, 35
"JOIN OR DIE" (version in the *Constitutional Courant*), 23, 29, 30
"JOIN OR DIE" (version in the *Massachusetts Spy*), 22, 33, 38
"JOIN, or DIE" (version in the *New-York Gazette*), 26, 27
"JOIN, or DIE" (version in the *New-York Journal*), 22, 32
"JOIN, or DIE" (version in the *New-York Mercury*), 26, 27
"JOIN, or DIE" (version in the *Pennsylvania Gazette*), 25, 26
"JOIN, or DIE" (version in the *Pennsylvania Journal*), 22, 34
"LABOUR IN VAIN *or let them tug & be Da-nd*," 91
"*LIBERTY ENLIGHTNED*," 95
"*LIBERTY TRIUMPHANT*; or the Downfall of *OPPRESSION*," 113
"*The Little Admiral giving the Enemy's of Great Britain a Flagellation*," 91
"LOOK ON THIS PICTURE, AND ON THIS," 56
"MAGNA *Britannia: her Colonies* REDUC'D" (Benjamin Franklin's note card), 62, 63, 203–6, 208, 209
"MAGNA *Britannia: her Colonies* REDUC'D" (broadside version produced at Philadelphia), 203–6
"MAGNA *Britannia: her Colonies* REDUC'D" (version in *The Political Register*), 84, 203–6
"MAL LUI VEUT MAL LUI TOURNE DIT LE BON HOMME RICHARD," 90
"*Mrs. General Washington Bestowing thirteen Stripes on Britania*," 161, 162, 216
"THE NEW COUNTRY DANCE, *as DANCED at* C**** July the 30th 1766," 83
"ONE EIGHTH *of a* DOLLAR" (currency for North Carolina), 50
"*ONE HUNDRED POUNDS*" (currency for South Carolina), 213
"One Sixth of a DOLLAR" (currency for the Continental Congress), 214
"One Third of a DOLLAR" (currency for Continental Congress), 214
"ONE THIRD of a Spanish milled DOLLAR" (currency for Virginia), 233
"OPPOSITION DEFEATED," 216, 226
"The [Parliament] dissolvd, or, The DEVIL turn'd FORTUNE TELLER," 85
"*The Parricide. A Sketch of Modern Patriotism*," 87, 151, 153, 154
"*PEACE Porridge all hot. The best to be got*," 97
"*The Persevering Americans, or the Bitter Draught Return'd*," 112
"A PICTURESQUE VIEW of the State of GREAT BRITAIN for 1778. Taken from an English copy," 11, 90, 115, 116
"A PICTURESQUE VIEW of the State of GREAT BRITAIN for 1780," 11, 90, 115, 116
"*A Picturesque View of the State of the Nation for February 1778*," 11, 90, 115, 116
"*A Political Concert*," 66, 97
"The POLITICAL SEE-SAW or MINHIR NIC FROG TURN'D BALANCE MASTER," 94

"*Poor old England endeavoring to reclaim his wicked American Children*," 154–56, 211
"POOR OLD ENGLAND! Or 1778. *Or the Bl-s-d Effects of a Wise Administration*," 90
"LES POULLES AUX GUINEES. L'Avarice perd tout en voulant tout gagner," 243, 244
"PREROGATIVES DEFEAT or LIBERTIES TRIUMPH," 95
"THE PRESENT STATE OF GREAT BRITAIN," 89
"PROCLAMATION of PEACE," 98
"THE PROVIDENTIAL DETECTION," 56
"*The RECONCILIATION between BRITANIA and her daughter* AMERICA," 88, 96, 162
"*A retrospective View of a Certain Cabinet Junto*," 114
"REVERSE OF THE GREAT SEAL OF THE UNITED STATES," 216
"*Rodny's new Invented Turn about*," 91
"The *ROYAL HUNT*, or a *PROSPECT* of the YEAR 1782," 95, 229
"Sacred to the Memory of William Beckford, Esq. *twice* Lord Mayor of the City of LONDON," 227
"The SAVAGES *let loose*, OR The *Cruel* FATE *of the* LOYALISTS," 98, 121, 212
"Se rejoindre ou mourir," 25
"SEVENTEEN SPANISH MILLED DOLLARS" (currency for Georgia), 49
"SHELB—NS SACRIFICE *Or the recommended Loyalists, a faithful representation of a Tragedy shortly to be performed on the Continent of America*," 98, 121, 212
"SIX MEDALLIONS shewing the chief national servises of his new Friends the old ministry," 226
"*Six Shillings and Eight Pence per Ounce*" (currency for Vermont), 215
"THE STATE COOKS MAKING PEACE _____ PORRIDGE," 96
"STATE COOKS, or THE DOWNFALL of the FISH KETTLE," 211, 244
"THE STATE NURSES," 249
"*The* STATE *of the* NATION [*Anno Domino*] *1765 & c.*," 83
"The STATE PEDLARS, Or, the NATIONAL CONTRAST," 140, 142
"THE TAKEING OF MISS MUD I'LAND," 68
"*The* TEA-TAX-TEMPEST, *or* OLD TIME *with his* MAGICK-LANTHERN," 71
"Ten Dollars" (currency for North Carolina), 213
"TOESTAND DER ENGELISCHE NATIE," 90
"THE TOMB = STONE," 227
"The TRIUMPH of AMERICA," 83
"The TRIUMVERATE or BRITANIA in DISTRESS," 89
"Tu la voulu," 66
"TWENTY DOLLARS" (currency for North Carolina), 50
"TWENTY SPANISH MILLED DOLLARS" (currency for Georgia), 49
"Two Dollars & an Half" (currency for North Carolina), 214
"*Two Shillings and Six Pence*" (currency for Vermont), 215

"Two Thirds of a DOLLAR" (currency for Continental Congress), 214
"Unite and Conquer" (version in the *Boston Gazette*), 26
"Unite & Conquer" (version in the *Boston Weekly News-Letter*), 26
"UNITE OR DIE" (version in the *New-York Journal*), 32, 34
"*La Vache à lait représente le Commerce de la Grande-Bretagne*," 90
"VENERATE THE PLOUGH," 214
"A VIEW OF PART OF THE TOWN OF BOSTON IN NEW-ENGLAND AND BRITTISH SHIPS OF WAR LANDING THEIR TROOPS! 1768," 114
"A VIEW *of the* OBELISK *Erected under* LIBERTY-TREE *in* BOSTON *on the Rejoicings for the Repeal of the* ―――― *Stamp-Act*," 10, 11, 105, 109, 110, 113
"View of the present Crisis," 210
"A VIEW OF *the* YEAR *1765*," 210, 211, 214
"VIVE LA PAIX À JAMAIS," 101
"Die Wage der Macht," 93
"WAR of POSTS," 216
"Wegens de Staat der ENGELSCHE NATIE in't Jaar 1778," 90
"[*When fell Debate & civil Wars shall cease*]," 86
"*The Whitehall Pump*," 87, 140, 142
"THE WISE MEN *of* GOTHAM *and their* GOOSE," 240–42
"WONDERS, WONDERS, WONDERS & WONDERS," 97

Rebuses

"[America to her Mistaken Mother]," 88, 158
"The [Ass]-headed and [Cow-Heart]-ed Ministry making the British [Lion] give up the Pull," 70
"[Britannia to America]," 68, 157

Seals

Great Seal of Virginia, 232
War Department Seal, 13, 55
Wedgwood intaglio seal, 24, 65

Song lyrics

"BRITANIA *and Her* DAUGHTER. *A Song*," 93, 159–61
"*Goody Bull or the Second Part of the Repeal*," 82, 83
"Le Cheval et son maître, chanson allégorique," 247
"The WORLD turned upside down, OR The OLD WOMAN taught WISDOM," 136–39

Speeches; additional texts are listed under the medium in which the speech was recorded

"Farewell Sermon," Jonathan Boucher, 166
On American Taxation, Edmund Burke, 148
The Speech of Edmund Burke, Esq; On Moving His Resolution For Conciliation with the Colonies, March 22, 1775, 145, 146
"Sinners in the Hands of an Angry God," Jonathan Edwards, 21

Statues

George III, 5, 6
William Pitt, 5

Textiles

"The Apotheosis of George Washington and Benjamin Franklin," 230
"Hommage de l'Amérique à la France," 11, 100
"Libertas Americana," 11, 190

Treasury notes

Notes for Massachusetts Bay, 51

Verses

An Elegy to the Infamous Memory of Sr. F―――― B――――, 7, 30–32
"An Explanation of a Political Print of the Able Doctor," 141
"[Freedom, Peace, Plenty all in vain advance]," 161
"*On the* BRITISH MINISTRY, *and* New-England, *the* Head *of the* AMERICAN SNAKE," in the *Massachusetts Spy*, 37
"*On the* BRITISH MINISTRY, *and* New-England, *the* Head *of the* AMERICAN SNAKE," in the *New-York Journal*, 37
The Patriots of North-America: A Sketch. With Explanatory Notes, 39, 40, 231
A Poetical Epistle to his Excellency George Washington, Esq., 53, 67
"to Neighbour H O L T On his EMBLEMATICAL TWISTIFICATION," 43
Untitled, in the *Boston Gazette*, 182
Untitled, in the *Boston Weekly News-Letter*, 35
Untitled, in the *Massachusetts Spy*, 36
Untitled, in the *New-York Gazetteer*, 34, 36
Untitled, in the *Pennsylvania Journal*, 35